Nikon[®] D300s

DUMMIES®

Nikon® D300s FOR DUMMIES®

by Julie Adair King

Nikon® D300s For Dummies®

Published by Wiley Publishing, Inc. 111 River Street Hoboken, NJ 07030-5774

www.wiley.com

Copyright © 2010 by Wiley Publishing, Inc., Indianapolis, Indiana

Published by Wiley Publishing, Inc., Indianapolis, Indiana

Published simultaneously in Canada

No part of this publication may be reproduced, stored in a retrieval system or transmitted in any form or by any means, electronic, mechanical, photocopying, recording, scanning or otherwise, except as permitted under Sections 107 or 108 of the 1976 United States Copyright Act, without either the prior written permission of the Publisher, or authorization through payment of the appropriate per-copy fee to the Copyright Clearance Center, 222 Rosewood Drive, Danvers, MA 01923, (978) 750-8400, fax (978) 646-8600. Requests to the Publisher for permission should be addressed to the Permissions Department, John Wiley & Sons, Inc., 111 River Street, Hoboken, NJ 07030, (201) 748-6011, fax (201) 748-6008, or online at http://www.wiley.com/go/permissions.

Trademarks: Wiley, the Wiley Publishing logo, For Dummies, the Dummies Man logo, A Reference for the Rest of Us!, The Dummies Way, Dummies Daily, The Fun and Easy Way, Dummies.com, Making Everything Easier, and related trade dress are trademarks or registered trademarks of John Wiley & Sons, Inc. and/or its affiliates in the United States and other countries, and may not be used without written permission. Nikon is a registered trademark of Nikon Corporation. All other trademarks are the property of their respective owners. Wiley Publishing, Inc., is not associated with any product or vendor mentioned in this book.

LIMIT OF LIABILITY/DISCLAIMER OF WARRANTY: THE PUBLISHER AND THE AUTHOR MAKE NO REPRESENTATIONS OR WARRANTIES WITH RESPECT TO THE ACCURACY OR COMPLETENESS OF THE CONTENTS OF THIS WORK AND SPECIFICALLY DISCLAIM ALL WARRANTIES, INCLUDING WITH-OUT LIMITATION WARRANTIES OF FITNESS FOR A PARTICULAR PURPOSE. NO WARRANTY MAY BE CREATED OR EXTENDED BY SALES OR PROMOTIONAL MATERIALS. THE ADVICE AND STRATEGIES CONTAINED HEREIN MAY NOT BE SUITABLE FOR EVERY SITUATION. THIS WORK IS SOLD WITH THE UNDERSTANDING THAT THE PUBLISHER IS NOT ENGAGED IN RENDERING LEGAL, ACCOUNTING, OR OTHER PROFESSIONAL SERVICES. IF PROFESSIONAL ASSISTANCE IS REOUIRED, THE SERVICES OF A COMPETENT PROFESSIONAL PERSON SHOULD BE SOUGHT. NEITHER THE PUBLISHER NOR THE AUTHOR SHALL BE LIABLE FOR DAMAGES ARISING HEREFROM. THE FACT THAT AN ORGANIZA-TION OR WEBSITE IS REFERRED TO IN THIS WORK AS A CITATION AND/OR A POTENTIAL SOURCE OF FURTHER INFORMATION DOES NOT MEAN THAT THE AUTHOR OR THE PUBLISHER ENDORSES THE INFORMATION THE ORGANIZATION OR WEBSITE MAY PROVIDE OR RECOMMENDATIONS IT MAY MAKE. FURTHER, READERS SHOULD BE AWARE THAT INTERNET WEBSITES LISTED IN THIS WORK MAY HAVE CHANGED OR DISAPPEARED BETWEEN WHEN THIS WORK WAS WRITTEN AND WHEN IT IS READ.

For general information on our other products and services, please contact our Customer Care Department within the U.S. at 877-762-2974, outside the U.S. at 317-572-3993, or fax 317-572-4002.

For technical support, please visit www.wiley.com/techsupport.

Wiley also publishes its books in a variety of electronic formats. Some content that appears in print may not be available in electronic books.

Library of Congress Control Number: 2009940285

ISBN: 978-0-470-57153-8

Manufactured in the United States of America

10 9 8 7 6 5 4 3 2 1

About the Author

Julie Adair King is the author of many books about digital photography and imaging, including the best-selling *Digital Photography For Dummies*. Her most recent titles include a series of *For Dummies* guides to popular digital SLR cameras, including the Nikon D5000, D3000, D90, D60, and D40/D40x. Other works include *Digital Photography Before & After Makeovers*, *Digital Photo Projects For Dummies*, *Julie King's Everyday Photoshop For Photographers*, *Julie King's Everyday Photoshop Elements*, and *Shoot Like a Pro!*: *Digital Photography Techniques*. When not writing, King teaches digital photography at such locations as the Palm Beach Photographic Center. A graduate of Purdue University, she resides in Indianapolis, Indiana.

Author's Acknowledgments

Any author knows that the support and skill of a good editor is invaluable. I've had the phenomenal good fortune to work with not just one awesome editor, but three: project editor Kim Darosett, copy editor Heidi Unger, and technical editor Dave Hall. Guys, there's just no way for me to ever thank you enough for everything you do. Without your talents, knowledge, and dedication, this book simply would not have been possible.

I'm also grateful to everyone else on the *For Dummies* team, including Katherine Crocker in the production department and Steve Hayes, Mary Bednarek, and Andy Cummings in editorial.

Finally, thanks to all my family and friends for helping through the tough times and for making the good times even better.

Publisher's Acknowledgments

We're proud of this book; please send us your comments at http://dummies.custhelp.com. For other comments, please contact our Customer Care Department within the U.S. at 877-762-2974, outside the U.S. at 317-572-3993, or fax 317-572-4002.

Some of the people who helped bring this book to market include the following:

Acquisitions and Editorial

Project Editor: Kim Darosett **Executive Editor:** Steven Hayes

Copy Editor: Heidi Unger

Technical Editor: David Hall

Editorial Manager: Leah Cameron Editorial Assistant: Amanda Graham Sr. Editorial Assistant: Cherie Case

Cartoons: Rich Tennant
 (www.the5thwave.com)

Composition Services

Project Coordinator: Katherine Crocker **Layout and Graphics:** Samantha K. Cherolis

Proofreader: Joni Heredia

Indexer: BIM Indexing & Proofreading Services

Publishing and Editorial for Technology Dummies

Richard Swadley, Vice President and Executive Group Publisher

Andy Cummings, Vice President and Publisher

Mary Bednarek, Executive Acquisitions Director

Mary C. Corder, Editorial Director

Publishing for Consumer Dummies

Diane Graves Steele, Vice President and Publisher

Composition Services

Debbie Stailey, Director of Composition Services

Contents at a Glance

Introduction	1
Part 1: Fast Track to Super Snaps	5
Chapter 1: Getting the Lay of the Land	7
Chapter 2: Fast and Easy: (Almost) Automatic Photography with the D300s	
Chapter 3: Controlling Picture Quality and Size	
Chapter 4: Monitor Matters: Picture Playback, Live View, and Movie Recording	
and movie recording	03
Part 11: Taking Creative Control	137
Chapter 5: Getting Creative with Exposure and Lighting	139
Chapter 6: Manipulating Focus and Color	
Chapter 7: Putting It All Together	
Part 111: Working with Picture Files	257
Chapter 8: Downloading, Organizing, and Archiving Your Picture Files	259
Chapter 9: Printing and Sharing Your Pictures	
Part 1V: The Part of Tens	305
Chapter 10: Ten More Ways to Customize Your Camera	307
Chapter 11: Ten Features to Explore on a Rainy Day	
Index	349

Table of Contents

Introduction	1
A Quick Look at What's Ahead	1
Part I: Fast Track to Super Snaps	
Part II: Taking Creative Control	
Part III: Working with Picture Files	2
Part IV: The Part of Tens	
Icons and Other Stuff to Note	
Practice, Be Patient, and Have Fun!	
Fractice, be ratient, and have run:	4
Part 1: Fast Track to Super Snaps	5
Chapter 1: Getting the Lay of the Land	.7
Looking at Lenses	
Checking lens compatibility	
Factoring in the crop factor	9
Getting shake-free shots with vibration reduction (VR) lenses	10
Attaching and removing lenses	
Setting the focus mode (auto or manual)	13
Adjusting the Viewfinder Focus	
Ordering from Camera Menus	
Decoding the Displays	
Working with Memory Cards	
Using two cards at the same time	
Formatting cards	
Exploring External Camera Controls	26
Topside controls	
Back-of-the-body controls	29
Front-left controls	
Front-right controls	
Hidden connections	
Asking Your Camera for Help	
Reviewing Basic Setup Options	
Cruising the Setup menu	
Browsing the Custom Setting menu	

Chapter 2: Fast and Easy: (Almost) Automatic Photography with the D300s	47
Preparing for Automatic Shooting	
Taking the Shot: The Basic Recipe	
Tweaking the Recipe: Easy Adjustments for Better Results	
Adding flash	
Changing the shutter-release mode	
Adding some creative flavor with flexible programmed au	
Chapter 3: Controlling Picture Quality and Size	65
Diagnosing Quality Problems	66
Considering Resolution (Image Size)	
Pixels and print quality	
Pixels and screen display size	70
Pixels and file size	71
Resolution recommendations	72
Understanding the Image Quality Options	74
JPEG: The imaging (and Web) standard	
NEF (RAW): The purist's choice	
TIFF: A mixed bag	
Summing up: My take on which format to use when	87
Chapter 4: Monitor Matters: Picture Playback,	
Live View, and Movie Recording	89
Customizing Basic Playback Options	90
Adjusting playback timing	
Enabling automatic picture rotation	
	91
Customizing the Multi Selector's role during playback	
	92
Customizing the Multi Selector's role during playback Viewing Images in Playback Mode Viewing multiple images at a time	92 94 96
Customizing the Multi Selector's role during playback Viewing Images in Playback Mode Viewing multiple images at a time Zooming in for a closer view	92 94 96
Customizing the Multi Selector's role during playback Viewing Images in Playback Mode	92 94 96 98
Customizing the Multi Selector's role during playback Viewing Images in Playback Mode Viewing multiple images at a time Zooming in for a closer view Viewing Picture Data Enabling hidden data-display options	92 94 96 98 100
Customizing the Multi Selector's role during playback Viewing Images in Playback Mode Viewing multiple images at a time Zooming in for a closer view Viewing Picture Data Enabling hidden data-display options File Information mode	92 94 96 100 100
Customizing the Multi Selector's role during playback Viewing Images in Playback Mode Viewing multiple images at a time Zooming in for a closer view Viewing Picture Data Enabling hidden data-display options. File Information mode Highlights display mode	
Customizing the Multi Selector's role during playback Viewing Images in Playback Mode Viewing multiple images at a time Zooming in for a closer view Viewing Picture Data Enabling hidden data-display options. File Information mode Highlights display mode RGB Histogram mode	
Customizing the Multi Selector's role during playback Viewing Images in Playback Mode Viewing multiple images at a time Zooming in for a closer view Viewing Picture Data Enabling hidden data-display options. File Information mode Highlights display mode RGB Histogram mode Shooting Data display mode	
Customizing the Multi Selector's role during playback Viewing Images in Playback Mode Viewing multiple images at a time Zooming in for a closer view Viewing Picture Data Enabling hidden data-display options File Information mode Highlights display mode RGB Histogram mode Shooting Data display mode GPS Data mode	
Customizing the Multi Selector's role during playback Viewing Images in Playback Mode Viewing multiple images at a time Zooming in for a closer view Viewing Picture Data Enabling hidden data-display options File Information mode Highlights display mode RGB Histogram mode Shooting Data display mode GPS Data mode Overview Data mode	
Customizing the Multi Selector's role during playback Viewing Images in Playback Mode Viewing multiple images at a time Zooming in for a closer view Viewing Picture Data	
Customizing the Multi Selector's role during playback Viewing Images in Playback Mode	
Customizing the Multi Selector's role during playback Viewing Images in Playback Mode	
Customizing the Multi Selector's role during playback Viewing Images in Playback Mode	

Protecting Photos	115
Exploring Live View Shooting	116
Choosing your Live View shooting mode	118
Customizing the Live View display	
Taking still pictures in Tripod mode	122
Taking pictures in Handheld mode	125
Recording movies	126
	120
Part 11: Taking Creative Control	137
Chantar 5: Cotting Croative with Evneaure and Lighting	120
Chapter 5: Getting Creative with Exposure and Lighting	
Introducing the Exposure Trio: Aperture, Shutter Speed, and ISO	140
Understanding exposure-setting side effects	
Doing the exposure balancing act	147
Meet the Exposure Modes: P, S, A, and M	148
Reading (And Adjusting) the Meter	150
Setting ISO, Aperture, and Shutter Speed	153
Adjusting aperture and shutter speed	153
Controlling ISO	156
Choosing an Exposure Metering Mode	159
Applying Exposure Compensation	163
Using Autoexposure Lock	
Expanding Tonal Range with Active D-Lighting	
Exploring Flash Photography with the D300s	171
Setting the flash mode	
Adjusting flash output	
Locking flash exposure on your subject	
Exploring a few additional flash options	182
Bracketing Exposures	185
Bracketing exposure and flash	187
Bracketing Active-D Lighting	192
Chapter 6: Manipulating Focus and Color	
Understanding Focusing Basics	195
Choosing a Focus mode: M, S, or C?	
Choosing an AF-area mode: One focus point or many?	200
Selecting (and locking) a focus point	201
Autofocusing with still subjects: Single Point+Single-servo AF.	
Focusing on moving subjects: Dynamic	
Area+continuous-servo AF	205
Basic autofocus with Auto Area+Single Point AF	
Putting the AF-ON button to work	
Exploring a few last autofocus tweaks	
Manipulating Depth of Field	

Controlling Color	220
Correcting colors with white balance	221
Changing the White Balance setting	223
Fine-tuning White Balance settings	225
Creating White Balance presets	
Bracketing white balance	
Choosing a Color Space: sRGB versus Adobe RGB	
Taking a Quick Look at Picture Controls	239
Chapter 7: Putting It All Together	243
Recapping Basic Picture Settings	244
Setting Up for Specific Scenes	244
Shooting still portraits	
Capturing action	
Capturing scenic vistas	
Capturing dynamic close-ups	255
Part 111: Working with Picture Files	257
Chapter 8: Downloading, Organizing, and Archiving	250
Your Picture Files	259
Sending Pictures to the Computer	260
Connecting the camera and computer	
Starting the transfer process	
Downloading and Organizing Photos with the Nikon Software	
Downloading with Nikon Transfer	
Browsing images in Nikon ViewNX	
Viewing picture metadata	
Organizing pictures	
Processing RAW (NEF) Files	
Processing RAW images in the camera	
Processing RAW files in ViewNX	
Copying Pictures Between Memory Cards	282
Chapter 9: Printing and Sharing Your Pictures	285
Preventing Potential Printing Problems	
Match resolution to print size	286
Allow for different print proportions	
Get print and monitor colors in synch	
Preparing Pictures for E-Mail	293
Creating small copies using the camera	
	295
Downsizing images in Nikon ViewNX	295 298
	295 298 301

Creating Custom Menu Banks	a
	308
Creating Your Own Menu	310
Adding Text Comments to Your Files	313
Embedding a Copyright Notice	315
Choosing Your Own File and Folder Names	317
Customizing a Trio of Buttons	320
Locking Exposure with the Shutter Button	325
Changing the Behavior of the Command Dials	326
Customizing the Multi Selector Center Button	327
Uncoupling the Buttons and Command Dials	
Chapter 11: Ten Features to Explore on a Rainy Day	
	331
Applying the Retouch Menu Filters	
Applying the Retouch Menu FiltersRemoving Red-Eve	
Removing Red-Eye	334
Removing Red-EyeShadow Recovery with D-Lighting	334 335
Removing Red-Eye Shadow Recovery with D-Lighting. Two Ways to Tweak Color	334 335 336
Removing Red-EyeShadow Recovery with D-Lighting Two Ways to Tweak ColorCreating Monochrome Photos	
Removing Red-Eye Shadow Recovery with D-Lighting. Two Ways to Tweak Color	

Introduction

ikon. The name has been associated with top-flight photography equipment for generations. And the introduction of the D300s has only enriched Nikon's well-deserved reputation, offering all the control a photographer could want — and then some. In fact, this camera offers so *many* features that sorting them all out can be more than a little confusing, especially if you're new to digital photography, SLR photography, or both.

Therein lies the point of *Nikon D300s For Dummies:* Through this book, you can discover not just what each bell and whistle on your camera does, but also when, where, why, and how to put it to best use. And unlike many photography books, this one doesn't require any previous knowledge of photography or digital imaging to make sense of things. In classic *For Dummies* style, everything is explained in easy-to-understand language, with lots of illustrations to help clear up any confusion.

In short, what you have in your hands is the paperback version of an in-depth photography workshop tailored specifically to your Nikon picture-taking powerhouse.

A Quick Look at What's Ahead

This book is organized into four parts, each devoted to a different aspect of using your camera. Although chapters flow in a sequence that's designed to take you from absolute beginner to experienced user, I've also tried to make each chapter as self-standing as possible so that you can explore the topics that interest you in any order you please.

The following sections offer brief previews of each part. If you're eager to find details on a specific topic, the index shows you exactly where to look.

Part 1: Fast Track to Super Snaps

Part I contains four chapters that help you get up and running.

- Chapter 1, "Getting the Lay of the Land," offers a tour of the external controls on your camera, shows you how to navigate camera menus to access internal options, and walks you through initial camera setup and customization steps.
- Chapter 2, "Fast and Easy: (Almost) Automatic Photography with the D300s," explains how to enjoy something close to point-and-shoot simplicity by using the programmed autoexposure mode. It also covers such basics as selecting the Release mode and enabling flash.

- Chapter 3, "Controlling Picture Quality and Size," introduces you to two critical camera settings: Image Size and Image Quality, which control resolution (pixel count), file format, file size, and picture quality.
- Chapter 4, "Monitor Matters: Picture Playback, Live View, and Movie Recording" offers just what its title implies. Look here to find out how to review and erase photos, take pictures in Live View mode, and record and edit HD movies.

Part 11: Taking Creative Control

The chapters in this part help you unleash the full creative power of your camera.

- Chapter 5, "Getting Creative with Exposure and Lighting," covers the all-important topic of exposure, starting with a review of the basics and then detailing every exposure option from metering modes to flash modes.
- Chapter 6, "Manipulating Focus and Color," provides help with controlling those aspects of your pictures. Head here for information about your camera's many autofocusing options, for tips on how to manipulate depth of field, and for details about color controls such as white balance.
- Chapter 7, "Putting It All Together," summarizes all the techniques explained in earlier chapters, providing a quick-reference guide to the camera settings and shooting strategies that produce the best results for specific types of pictures: portraits, action shots, landscape scenes, and close-ups.

Part 111: Working with Picture Files

This part of the book, as its title implies, discusses the often-confusing aspect of moving your pictures from camera to computer and beyond.

- Chapter 8, "Downloading, Organizing, and Archiving Your Picture Files," guides you through the process of transferring pictures from your camera memory card to your computer. Look here, too, for details about using the camera's built-in tool for processing files that you shoot in the Nikon RAW format (NEF).
- Chapter 9, "Printing and Sharing Your Pictures," helps you turn your digital files into "hard copies" that look as good as those you see on the camera monitor. This chapter also explains how to prepare your pictures for online sharing, create digital slide shows, and, for times when you have the neighbors over, display your pictures and movies on a television screen.

Part 1V: The Part of Tens

In famous *For Dummies* tradition, the book concludes with two "top ten" lists containing additional bits of information and advice.

- Chapter 10, "Ten More Ways to Customize Your Camera," details options that let you tweak the behavior of certain camera buttons and dials, set up custom filenaming, and otherwise make the camera bow to your personal preferences.
- ✓ Chapter 11, "Ten Features to Explore on a Rainy Day," presents information about some camera features that, while not found on most "Top Ten Reasons I Bought My D300s" lists, are nonetheless interesting, useful on occasion, or a bit of both.

Icons and Other Stuff to Note

If this isn't your first *For Dummies* book, you may be familiar with the large, round icons that decorate its margins. If not, here's your very own icondecoder ring:

A Tip icon flags information that will save you time, effort, money, or some other valuable resource, including your sanity. Tips also point out techniques that help you get the best results from specific camera features.

When you see this icon, look alive. It indicates a potential danger zone that can result in much wailing and teeth-gnashing if ignored. In other words, this is stuff that you really don't want to learn the hard way.

Lots of information in this book is of a technical nature — digital photography is a technical animal, after all. But if I present a detail that is useful mainly for impressing your technology-geek friends, I mark it with this icon.

I apply this icon either to introduce information that is especially worth storing in your brain's long-term memory or to remind you of a fact that may have been displaced from that memory by some other pressing fact.

Additionally, I need to point out other details that will help you use this book:

- Other margin art: Replicas of some of your camera's buttons and onscreen symbols also appear in the margins of some paragraphs. I include these to provide a quick reminder of the appearance of the feature being discussed.
- Software used in this book: Providing specific instructions for performing photo organizing and editing tasks requires that I feature specific software. In sections that cover file downloading, printing, and e-mail sharing, I selected Nikon ViewNX and Nikon Transfer, both of which ship free with your camera and work on both the Windows and Mac operating systems. Rest assured, though, that the tools used in ViewNX and Nikon Transfer work very similarly in other programs, so you should be able to adapt the steps to whatever software you use. (I recommend that you read your software manual for details, of course.)
- ✓ **Software menu commands:** In sections that cover software, a series of words connected by an arrow indicates commands that you choose from the program menus. For example, if a step tells you to "Choose File⇔Convert Files," click the File menu to unfurl it and then click the Convert Files command on the menu.

Practice, Be Patient, and Have Fun!

To wrap up this preamble, I want to stress that if you initially think that digital photography is too confusing or too technical for you, you're in very good company. *Everyone* finds this stuff a little mind-boggling at first. So take it slowly, experimenting with just one or two new camera settings or techniques at first. Then, each time you go on a photo outing, make it a point to add one or two more shooting skills to your repertoire.

I know that it's hard to believe when you're just starting out, but it really won't be long before everything starts to come together. With some time, patience, and practice, you'll soon wield your camera like a pro, dialing in the necessary settings to capture your creative vision almost instinctively.

So without further ado, I invite you to grab your camera, a cup of whatever it is you prefer to sip while you read, and start exploring the rest of this book. Your D300s is the perfect partner for your photographic journey, and I thank you for allowing me, through this book, to serve as your tour guide.

Part I Fast Track to Super Snaps

"Remember, when the subject comes into focus, the camera makes a beep. But that's annoying, so I set it on vibrate."

In this part . . .

aking sense of all the controls on your D300s isn't something you can do in an afternoon — heck, in a week, or maybe even a month. But with the help of the chapters in this part, you can start taking great pictures right away.

Chapter 1 addresses some basic setup steps, such as adjusting the viewfinder to your eyesight and getting familiar with the camera menus, buttons, and dials. Chapter 2 helps you set up your camera for the easiest possible operation and take your first shots, and Chapter 3 explains how you can control picture quality and file size. Wrapping up this part, Chapter 4 shows you how to use your camera's picture-playback, Live View, and movie-recording features.

Getting the Lay of the Land

In This Chapter

- Attaching and using an SLR lens
- Adjusting the viewfinder to your eyesight
- Selecting from menus
- Working with memory cards
- Getting acquainted with your camera
- Customizing basic operations

still remember the day that I bought my first SLR film camera. I was excited to finally move up from my one-button point-and-shoot camera, but I was a little anxious, too. My new pride and joy sported several unfamiliar buttons and dials, and the explanations in the camera manual clearly were written for someone with an engineering degree. And then there was the whole business of attaching the lens to the camera, an entirely new task for me. I saved up my pennies a long time for that camera — what

You may be feeling similarly insecure if your Nikon D300s is your first SLR, although some of the buttons on the camera back may look familiar if you've previously used a digital point-and-shoot camera. If your D300s is both your first SLR and first digital camera, you may be doubly intimidated.

if my inexperience caused me to damage the thing

before I even shot my first pictures?

Trust me, though, that your camera isn't nearly as complicated as its exterior makes it appear. With a little practice and the help of this chapter, which introduces you to each external control, you'll quickly become as comfortable with your camera's buttons and dials as you are with the ones on your car's dashboard. This chapter also guides you through the process of mounting and using an SLR lens, working with digital memory cards, navigating your camera's menus, and customizing basic camera operations.

Looking at Lenses

One of the biggest differences between a point-and-shoot camera and an SLR (single-lens reflex) camera is the lens. With an SLR, you can swap out lenses to suit different photographic needs, going from an extreme close-up lens to a super-long telephoto, for example. In addition, an SLR lens has a movable focusing ring that gives you the option of focusing manually instead of relying on the camera's autofocus mechanism.

Digital SLR lenses are incredibly complex pieces of optical equipment. I don't have room in this book to go into a lot of detail about the science of lenses, nor do I think that an in-depth knowledge of the subject is terribly important to your photographic success. But the next few sections share a couple of tidbits that may be of help when you're first getting acquainted with your lens, shopping for lenses, or trying to figure out whether the bag of old lenses you inherited from your uncle Ted or found on eBay will work with your D300s.

Checking lens compatibility

You can mount a wide range of lenses on your D300s. But some lenses aren't fully compatible with all camera features. For example, with some lenses, you can't take advantage of the autofocusing system and must focus manually instead.

Your camera manual has a complete listing of all the lens types that can be mounted on the D300s and explains what features are supported with each type. But for maximum compatibility, look for these types: Type D or G AF Nikkor, AF-S Nikkor, or AF-I Nikkor. (The latter is an older, expensive professional lens that is no longer sold but might be available on the resale market.)

All the aforementioned lens types (as well as some others) offer CPU (central processing unit) technology, which allows the lens to talk to the camera. This feature is critical to getting maximum performance from the autofocusing system, exposure metering system, and so on. That's not to say that you can't use a non-CPU lens; you just lose the option of using some camera features. An option on the Setup menu helps you get the most functionality possible with a non-CPU lens; check out the section "Cruising the Setup menu," toward the end of this chapter, for details.

The information in this book assumes that you are using a CPU lens that supports all the camera's functions. If your lens doesn't meet that criteria, be sure to check the camera manual for specifics on what features are unavailable or need to be implemented differently.

Factoring in the crop factor

Every lens can be characterized by its *focal length*, which is measured in millimeters. Focal length determines the camera's angle of view, the apparent size and distance of objects in the scene, and *depth of field* (how much of the scene can be rendered in sharp focus).

According to photography tradition, a focal length of 50mm is described as a "normal" lens. Most point-and-shoot cameras feature this focal length, which is a medium-range lens that works well for the type of snapshots that users of those kinds of cameras are likely to shoot. A lens with a focal length under 35mm is characterized as a *wide-angle* lens because at that focal length, the camera has a wide angle of view and produces a large depth of field, making it good for landscape photography. A short focal length also has the effect of making objects seem smaller and farther away. At the other end of the spectrum, a lens with a focal length longer than 80mm is considered a *tele-photo* lens and often referred to as a *long lens*. With a long lens, angle of view narrows, depth of field decreases, and faraway subjects appear closer and larger, which is ideal for wildlife and sports photographers.

It's important to know, however, that when you mount a lens on the D300s, the angle of view is different than the lens' stated focal length. This variation, which holds true for most digital cameras, occurs because of the difference in size between a 35mm film negative — the standard around which lens focal lengths are measured — and the size of an image sensor, which is the light-sensitive component of a digital camera.

With a D300s, the effective angle of view is equivalent to that produced by a focal length about 1.5 times the actual focal length. For example, a 50mm lens on the D300s produces the same angle of view as a 75mm lens on a 35mm film camera. $(50 \times 1.5 = 75.)$

The end result is the same as if you shot a photo with your film camera and then cropped away some of the perimeter, as illustrated in Figure 1-1. For this reason, the value used to calculate the effective angle of view — 1.5 on the D300s, but it varies from camera to camera — is sometimes called a camera's *crop factor*. You may also see this value referred to as the *lens multiplier*.

Figure 1-1: Like most dSLR image sensors, the one on the D300s can't capture the entire angle of view that the lens can "see" when mounted on a 35mm film camera.

Although the area the lens can capture changes when you move a lens from a 35mm film camera to a digital body, depth of field isn't affected, nor are the spatial relationships between objects in the frame. So when lens shopping, you gauge those two characteristics by looking at the stated lens focal length — no film-to-digital conversion math is required.

Getting shake-free shots with vibration reduction (VR) lenses

Some Nikon lenses, including the one featured in this book, offer a feature called *vibration reduction*. On Nikon lenses, this feature is indicated by the initials VR in the lens name. If you use a non-Nikon lens, the feature may go by another name: *anti-shake*, *vibration compensation*, and so on.

Whatever the name, the feature attempts to compensate for small amounts of camera shake that can occur when you handhold your camera and use a slow shutter speed, a lens with a long focal length, or both. Even a small amount of camera movement can produce blurry images, so vibration reduction is a definite Good Thing. Although it can't work miracles, it does enable most people to capture sharper handheld shots in many situations than they otherwise could. Note that VR is only designed to avoid the blur caused by camera movement, though; if your subject is moving, it may appear blurry due to a too-slow shutter speed. You can explore that issue in Chapter 5.

Here are the basics you need to know about using vibration reduction with Nikon lenses:

- ✓ For handheld shooting, set the VR switch to the On position, as shown in Figure 1-2. Now vibration reduction will engage whenever you press the shutter button halfway as well as just after you press the button all the way to take the picture. You may notice some slight movement of the scene in the viewfinder while the VR mechanism does its thing.
- Check your lens manual for recommendations about disabling VR for tripod shooting. When you use a tripod, vibration reduction can have detrimental effects because the system may try to adjust for movement that isn't actually occurring. So for some of its VR lenses, Nikon recommends setting the switch to the Off position for tripod shooting, assuming that the tripod is "locked down" so the camera is immovable. Some lenses offer a tripod-detection feature, however, that is specially designed for tripod shooting. To get the specifics for your lens, dig out your lens manual.

If you use a non-Nikon lens, check your lens manual to find out whether the manufacturer recommends disabling the anti-shake feature for tripod shooting and whether the lens offers a choice of vibration-reduction modes. Also,

some lenses have additional options that switch between different types of stabilization (the switch may be called Active/Normal or something similar); again, refer to the lens manual for specifics.

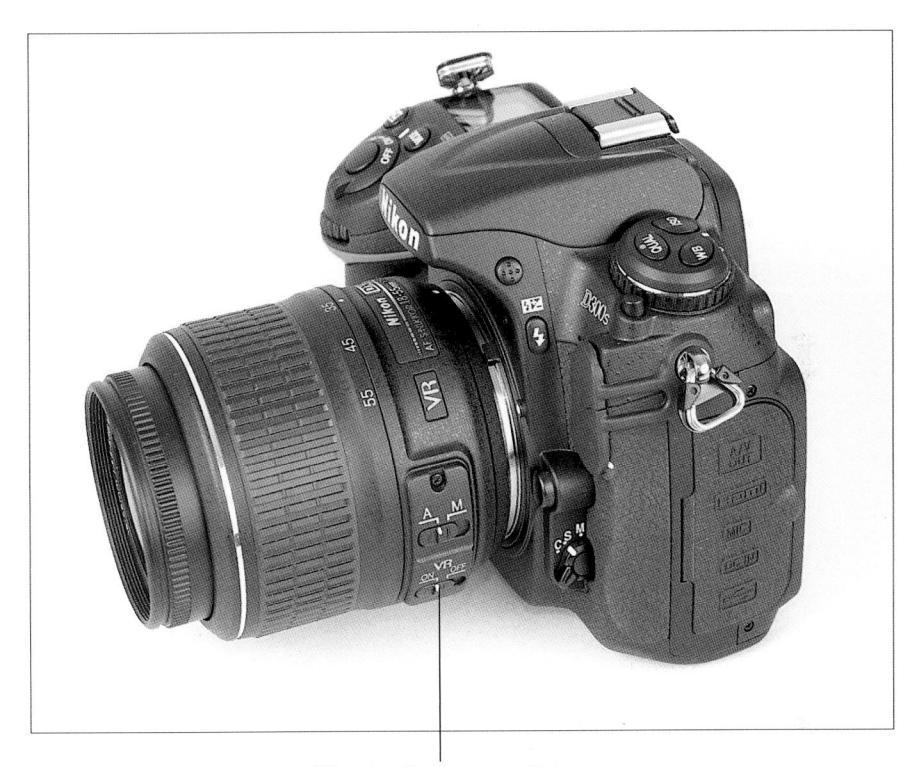

Vibration Reduction switch

Figure 1-2: Vibration reduction can enable you to get sharper handheld shots.

Attaching and removing lenses

Whatever lens you choose, follow these steps to attach it to the camera body:

- 1. Remove the cap that covers the lens mount on the front of the camera.
- 2. Remove the cap that covers the back of the lens.
- 3. Hold the lens in front of the camera so that the little white dot on the lens aligns with the matching dot on the camera body.

Official photography lingo uses the term *mounting index* instead of *little* white dot. Either way, you can see the markings in question in Figure 1-3.

The figure (and others in this book) shows you the D300s with an 18–55mm AF-S VR Nikon lens. If you buy a lens from a manufacturer other than Nikon, your dot may be red or some other color, so check the lens instruction manual.

Keeping the dots aligned, position the lens on the camera's lens mount.

When you do so, grip the lens by its back collar, not the movable, forward end of the lens barrel.

5. Turn the lens in a counterclockwise direction until the lens clicks into place.

To put it another way, turn the lens toward the side of the camera that sports the shutter button, as indicated by the red arrow in the figure.

6. On a CPU lens that has an aperture ring, set and lock the ring so the aperture is set at the highest f-stop number.

Mounting index dots

Figure 1-3: When attaching the lens, align the index markers as shown here.

Check your lens manual to find out whether your lens sports an aperture ring and how to adjust it. To find out more about apertures and f-stops, see Chapter 5.

9

To detach a lens from the camera body, take these steps:

- 1. Locate the lens-release button, labeled in Figure 1-3.
- 2. Press the lens-release button while turning the lens clockwise (away from the shutter button) until the mounting index on the lens is aligned with the index on the camera body.

Again, the mounting indexes are the little guide dots labeled in Figure 1-3. When the dots line up, the lens should detach from the mount.

3. Place the rear protective cap onto the back of the lens.

If you aren't putting another lens on the camera, cover the lens mount with the protective cap that came with your camera, too.

Always attach and remove lenses in a clean environment to reduce the risk of getting dust, dirt, and other contaminants inside the camera or lens. For added safety, point the camera body slightly down when performing this maneuver; doing so helps prevent any flotsam in the air from being drawn into the camera by gravity.

Setting the focus mode (auto or manual)

In addition to the lens-related features covered in the preceding sections, make note of the following two controls, which you use to set the focusing method to manual or autofocusing:

Lens focus mode switch: Assuming that your lens offers autofocusing as well as manual focusing, it likely has a switch that you use to choose between the two options. The switch might be labeled A/M, as shown in Figure 1-4, or AF/MF. Some lenses offer a setting called AF/M (or something similar), which enables you to set initial focus using autofocusing and then refine focus manually. (This feature is typically called autofocus with manual override.) Check your lens manual for specifics, and check the Nikon manual to confirm that your lens can autofocus with the D300s.

Your lens also has a focusing ring that you twist to bring the scene into focus when you use manual focusing. The placement of the focusing ring varies from lens to lens; Figure 1-4 shows the ring as it appears on the Nikon 18–55mm AF-S VR lens.

✓ **Focus mode selector:** Also shown in Figure 1-4, this switch sets the camera's internal focusing mechanism to manual focusing (M) or one of two autofocusing options (C and S).

Chapter 2 provides focusing basics; Chapter 6 details the myriad autofocusing options on your camera and offers a few manual-focusing tips as well.

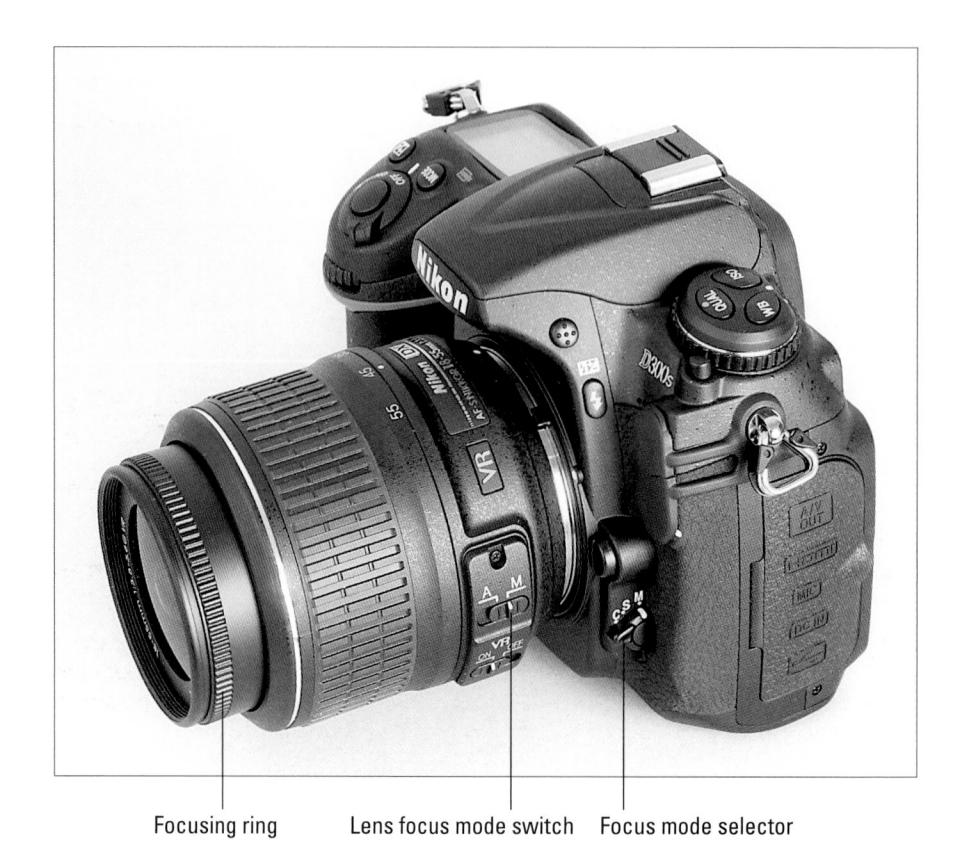

Figure 1-4: Set the focus mode both on the camera body and the lens.

Adjusting the Viewfinder Focus

Tucked behind the right side of the rubber eyepiece that surrounds the view-finder is a tiny dial called a *diopter control*. With this control, labeled in Figure 1-5, you can adjust the focus of your viewfinder to accommodate your eyesight.

If you don't take this step, scenes that appear out of focus through the viewfinder may actually be sharply focused through the lens, and vice versa. Here's how to make the necessary adjustment:

- 1. Remove the lens cap from the front of the lens.
- 2. Look through the viewfinder and concentrate on the markings in the viewfinder frame, shown on the right side of Figure 1-5.

The markings relate to focusing, which you can read more about in Chapters 2 and 6. Depending on your selected focus options, you may see only the brackets and not the little rectangle in the middle of the frame.

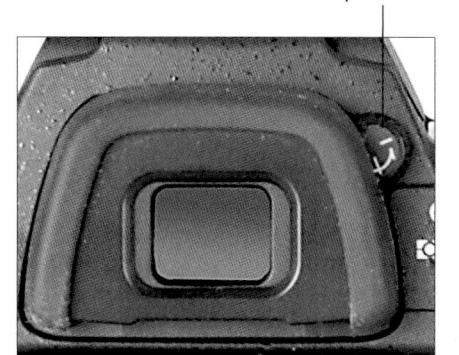

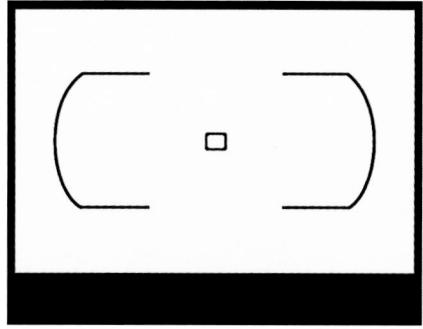

Figure 1-5: Use the diopter adjustment control to set the viewfinder focus for your eyesight.

Diopter control

3. Rotate the diopter adjustment dial until the viewfinder markings appear to be in focus.

The Nikon manual warns you not to poke yourself in the eye as you perform this maneuver. This warning seems so obvious that I laugh every time I read it — which makes me feel doubly stupid the next time I poke myself in the eye as I perform this maneuver.

Ordering from Camera Menus

You access many of your camera's features via internal menus, which, conveniently enough, appear when you press the Menu button. Features are grouped into six main menus, described briefly in Table 1-1.

Table 1-1	D300s Menus	
Symbol	Open This Menu	to Access These Functions
	Playback	Viewing, deleting, and protecting pictures
Δ	Shooting	Basic photography settings
0	Custom Setting	Advanced photography options and some basic camera operations
Y	Setup	Additional basic camera operations

(continued)

Table 1-1 (continued)		
Symbol	Open This Menu	to Access These Functions
of l	Retouch	Built-in photo retouching options
侵回	My Menu/Recent Settings	Your custom menu or 20 most recently used menu options

After you press the Menu button, you see on the camera monitor a screen similar to the one shown in Figure 1-6. Along the left side of the screen, you see the icons shown in Table 1-1, each representing one of the available menus. The icon that is highlighted or appears in color is the active menu; options on that menu automatically appear to the right of the column of icons. In the figure, the Shooting menu is active, for example.

Figure 1-6: Use the Multi Selector to navigate menus.

I explain all the important menu options elsewhere in the book; for now, just familiarize yourself with the process of navigating menus and selecting options therein. The Multi Selector, shown on the right in Figure 1-6, is the key to the game. Press the edges of the Multi Selector to navigate up, down, left, and right through the menus.

In this book, the instruction "Press the Multi Selector left" means to press the left edge of the control. "Press the Multi Selector right" means to press the right edge, and so on.

Here's a bit more detail about navigating menus:

- ✓ **Select a menu.** Press the Multi Selector left to jump to the column containing the menu icons. Then press up or down to highlight the menu you want to display. Finally, press right to jump over to the options on the menu.
- Select and adjust a function on the current menu. Again, use the Multi Selector to scroll up or down the list of options to highlight the feature you want to adjust and then press the OK button. Settings available for the selected item then appear. For example, if you select the Image Quality item from the Shooting menu, as shown on the left in Figure 1-7, and press OK, the available Image Quality options appear, as shown on the right in the figure. Repeat the old up-and-down scroll routine until the choice you prefer is highlighted. Then press OK to return to the previous screen.

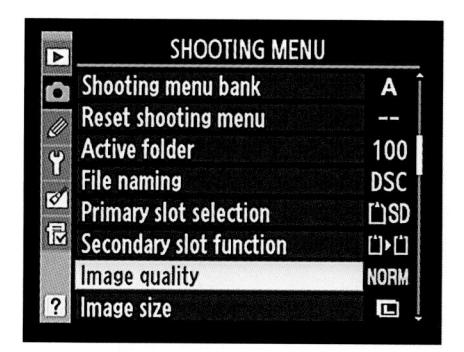

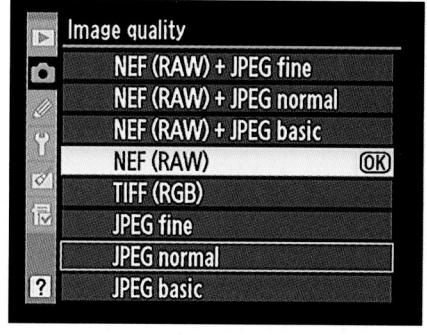

Figure 1-7: Select the option you prefer and press OK again to return to the active menu.

In some cases, you may see a right-pointing arrowhead instead of the OK symbol next to an option. That's your cue to press the Multi Selector right to display a submenu or other list of options (although pressing OK usually works just as well).

In many cases, you can press the center button of the Multi Selector instead of the OK button to choose menu items. But that option doesn't always work, so to keep things simple in this book, I discuss just the OK button.

✓ Create a custom menu or view your 20 most recently adjusted menu items. The sixth menu is actually two menus bundled into one. The My Menu screen, shown in Figure 1-8, enables you to create your own custom menu that contains your favorite options. Chapter 10 details the steps involved in making and using your menu.

Through the Choose Tab option on the menu, you can switch to the Recent Settings menu, shown on the right in the figure. This menu lists the 20 menu items you ordered most recently. So if you want to adjust those settings, you don't have to wade through all the other menus

looking for them — just head to this menu instead. The Recent Settings screen also contains a Choose Tab option so that you can switch back to the My Menu screen at any time.

The menu icon changes depending on which of these two functions is active: Table 1-1 shows both icons.

Save collections of menu settings in banks. The D300s gives you the option of creating up to four banks to store different groupings of Shooting menu settings. You get another four banks for storing Custom Setting menu settings. The banks enable you to quickly change from settings designed for one type of picture to options that work better for a different subject. Chapter 10 explains the whole process; for now, just note that you can see which bank is active at the top of the respective menu and in the Information screen, as shown in Figure 1-9. Press the Info button to display the Information screen; see the next section for more details.

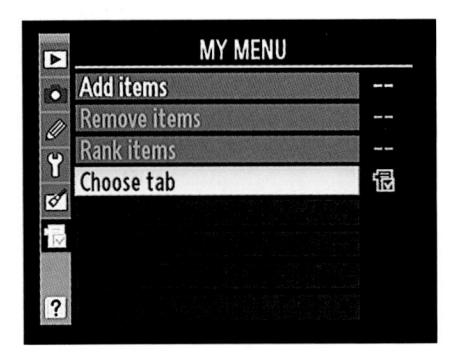

Figure 1-8: The My Menu screen lets you design a custom menu; the Recent Settings menu offers quick access to the last 20 menu options you selected.

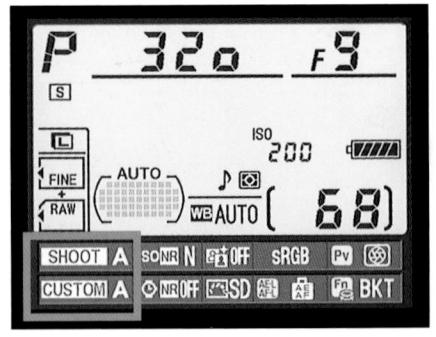

Figure 1-9: Check the menu or Information screen to see which banks are active.

Decoding the Displays

Your D300s gives you three ways to monitor the most critical picture-taking settings:

✓ **Control panel:** The LCD panel on top of the camera offers an array of shooting data, as shown on the left in Figure 1-10. The data that appears depends on what camera features you're currently using.

You can illuminate the panel temporarily by rotating the On/Off switch past the On position to the little light bulb marker, shown on the right in the figure, and then releasing the switch.

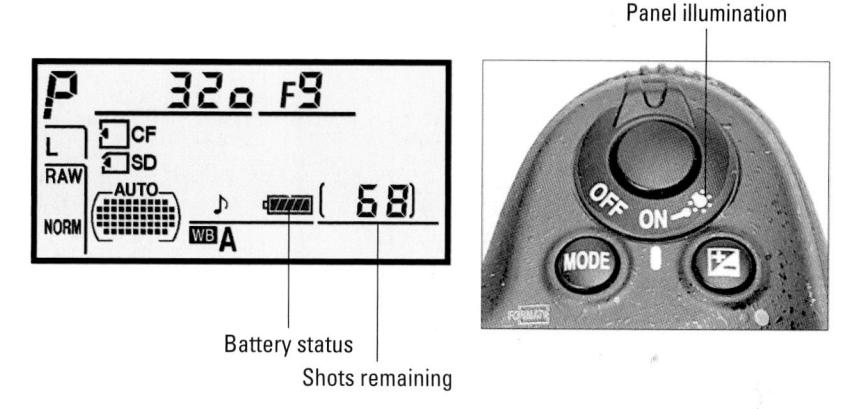

Figure 1-10: Rotate the On/Off switch to the light bulb position to illuminate the Control panel.

Information display: If your eyesight is like mine, making out the tiny type on the Control panel can be difficult. Fortunately, you can press the Info button to display the Information screen on the monitor. As shown in Figure 1-11, this screen displays the current shooting settings at a size that's a little easier on the eyes. See the section "Customizing shooting and display options" for information on how to adjust the display colors. You can choose a bluish background with dark text, or as shown in this book, a black background with light text. Like the

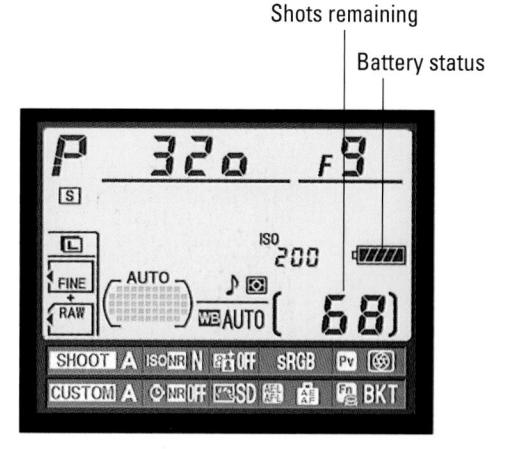

Figure 1-11: Press the Info button to view picture-taking settings on the monitor.

Control panel, the Information screen data varies depending on what shooting settings are currently in force.

The Information screen has a hidden power, too: After the screen is displayed, you can press Info again to activate the control strip at the bottom, as shown on the left in Figure 1-12. You then can quickly adjust any of the settings on the two rows of the strip. Use the Multi Selector to highlight a setting — a little tooltip (text label) appears to identify it — and then press OK. The camera then zips you directly to the menu containing the available settings, as shown on the right in the figure. Make your choice and press OK again to exit the menu. You can then adjust another setting or press Info one more time to turn off the display.

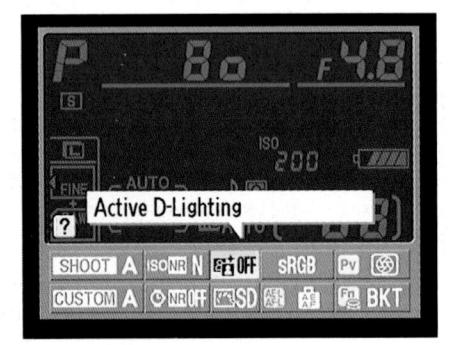

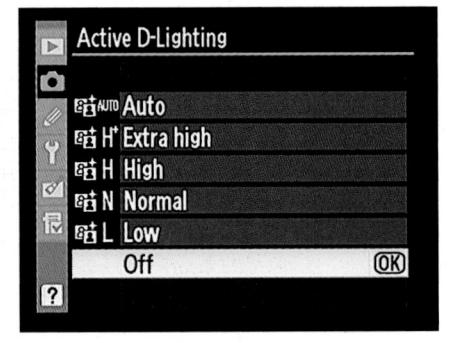

Figure 1-12: Press the Info button while the Information screen is displayed to gain quick access to the settings at the bottom of the screen.

Viewfinder: You can view some camera settings in the viewfinder as well. For example, the data in Figure 1-13 shows the current metering mode icon, shutter speed, f-stop, exposure mode ISO setting, and number of shots remaining. As with the other displays, the viewfinder information that appears depends on what action you're currently undertaking.

If what you see in Figures 1-10 through 1-13 looks like a big confusing mess, don't worry. Many of the settings relate to options that won't mean anything to you until you make your way through later chapters and

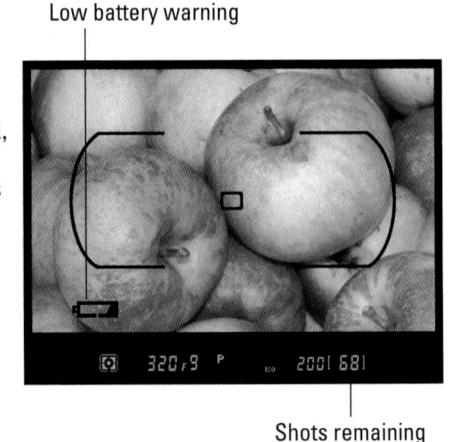

Figure 1-13: You also can view some camera information at the bottom of the viewfinder.

explore the advanced exposure modes. But do make note of the following two key points of data that are helpful even when you shoot in the fully automatic modes:

- ▶ Battery status indicator: A full battery icon like the one in Figures 1-10 and 1-11 shows that the battery is fully charged; if the icon appears empty, go look for your battery charger. When the battery gets seriously low, a warning symbol appears in the viewfinder, as shown in Figure 1-13. You can disable the viewfinder warning if you like; see the section "Customizing shooting and display options" later in this chapter for details.
- Pictures remaining: Labeled in Figures 1-10, 1-11, and 1-13, this value (68, in the figures) indicates how many additional pictures you can store on the current memory card.

The value is presented a little differently if the card can hold more than 999 pictures. The initial K appears next to the value to indicate that the first value represents the picture count in thousands. For example, $1.0 \mathrm{K}$ means that you can store 1,000 more pictures (K being a universally accepted symbol indicating 1,000 units). The number is then rounded down to the nearest hundred. So if the card has room for, say, 1,230 more pictures, the value reads as $1.2 \mathrm{K}$.

When no card is installed in the camera, the symbol [-E-] appears in the shots-remaining area of the displays. See the next section for tips about installing and using memory cards.

Working with Memory Cards

Instead of recording images on film, digital cameras store pictures on *memory cards*. Your D300s can use two types of memory cards, both shown in Figure 1-14. The cards go into the slots hidden under the cover on the right side of the camera, as shown in Figure 1-15.

Always turn off the camera before inserting or removing memory cards to avoid potential damage to the card and the camera. And note these additional details about using and caring for your cards:

✓ **SD (or SDHC) cards:** The smaller card slot accepts an *SD card* (for Secure Digital). You can also use the new, high-capacity Secure Digital cards, which are labeled SDHC, as well as Eye-Fi SD cards, which enable you to send pictures to your computer over a wireless network. (Because of space limitations, I don't cover Eye-Fi connectivity in this book; if you want more information about these cards, you can find it online at www.eye.fi.)

Place the card in the slot with the label facing the back of the camera, as shown in Figure 1-15. Push the card into the slot until it clicks into place; the memory card access light (circled in the figure) blinks for a

second to let you know the card is inserted properly. To remove the card, depress the memory card slightly until you hear a little click and then let go. The card should pop halfway out of the slot, enabling you to grab it by the tail and remove it.

That little switch labeled *lock switch* in Figure 1-14 enables you to lock your card, which prevents any data from being erased or recorded to the card. Press the switch toward the bottom of the card to lock the card contents; press it toward the top of the card to unlock the data.

CompactFlash (CF) cards (Type 1 only): The second slot accepts this type of card, which is larger and thicker than SD cards. The D300s can use only Type 1 CompactFlash cards, unlike its older sibling, the D300, which could use Type II CF cards as well as another media type called a MicroDrive.

Again, orient the card with the label facing the back of the camera, as shown in Figure 1-15. Push the card firmly into the slot until the little gray eject button, labeled in the figure, pops up. The access light will illuminate when the card is correctly inserted. To remove the card, depress the eject button. The card should pop partially out of the slot; grab the card and pull it the rest of the way out of the camera.

CompactFlash cards don't have a locking switch like SD cards, but you can use the camera's Protect feature, covered in

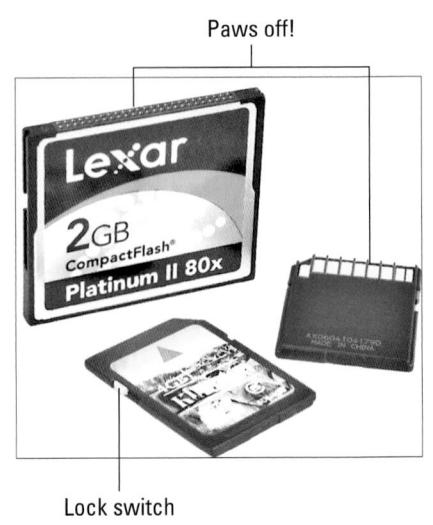

Figure 1-14: Your camera can use SD and CompactFlash cards.

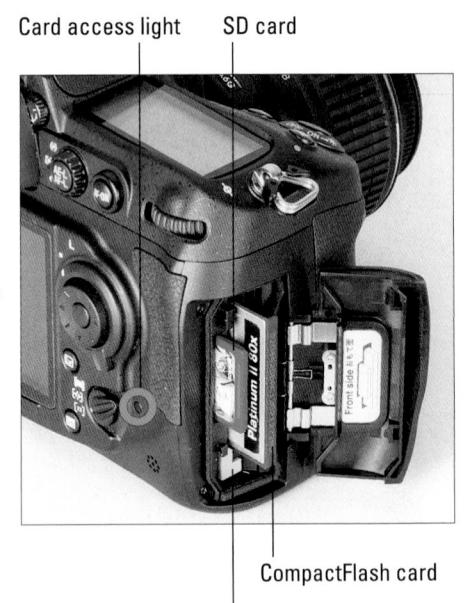

CF card eject button

Figure 1-15: Insert cards with the labels facing the back of the camera.

Chapter 4, to prevent accidental erasure of photos stored on either CompactFlash or SD cards.

Try to avoid touching the card contact areas, highlighted in Figure 1-14. On an SD card, the gold area on the back of the card is the sensitive area; on a CompactFlash card, the little pinholes on the edge of the card comprise the danger zone. Always store cards in the protective cases they came in or in a memory card wallet after removing them from the camera. Keep cards away from extreme heat and cold as well.

Using two cards at the same time

You can put a memory card in each slot if you choose. If you do install both cards, you have three choices for how the camera feeds your photo and movie files to the cards:

- Overflow: The camera fills up your preferred card and then automatically switches to the other one.
- ✓ Backup: The camera records each picture or movie to both cards. This option gives you some extra security should one card fail, you have a backup on the other card.
- ✓ Raw Primary/JPEG Secondary: This option relates to the Image Quality option, which determines the file format of still photos. (Chapter 3 has details.) If you select an Image Quality setting that records the photo both in the RAW (NEF) format and the JPEG format, you can tell the camera to store all the RAW versions on one card and put the JPEGs on the other. If you select this option but use an Image Quality setting that captures only a single file type, the camera uses the Backup setting, sending a copy of the file to each card.

The Raw Primary/JPEG Secondary option gives you an easy way to get your pictures to someone who doesn't have the time or knowledge to deal with RAW files, which must be processed using special software or the in-camera converter before they can be shared online, viewed in many consumer photo programs, or printed at retail sites. (Chapter 8 explains.) When you're done shooting, just hand over the card containing the JPEG versions, which can be viewed, shared, and printed immediately. Of course, unless you're really generous, you'll ask that someone to supply the card or return it after downloading the pictures.

To set up your two-card system, visit the Shooting menu. First, select the card you want to use as the primary file destination, as shown in Figure 1-16. Next, select Secondary Slot Function to access the three options for using the backup slot, as shown in Figure 1-17.

A couple of other critical points about using two cards:

✓ You can tell which secondary slot function is in force by looking at the Image Quality readout of the Information display, highlighted on the left in Figure 1-18. The little card symbols tell you what's going where. The rectangular symbol represents the CompactFlash card; the symbol with the

angled corner represents the SD card. In the figure, the symbols show that the camera is set up to send RAW files to the SD card and the JPEG versions to the CF card. ("Fine" represents one of three available settings for JPEG files, as covered in Chapter 3.) If you see the same file data for each card — for example, the word RAW appears in both cards — the Backup option is selected. And if the file type label appears in only one card, with the other card appearing empty, the Overflow option is selected.

When both cards are installed, symbols representing each card also appear in the Control panel, as shown on the right in Figure 1-18. Otherwise, only the symbol for the single installed card appears. You can't glean anything about the primary and secondary card functions from this display, however.

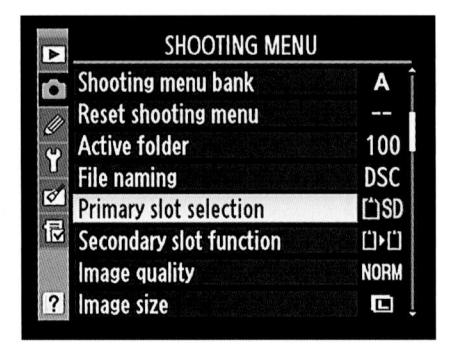

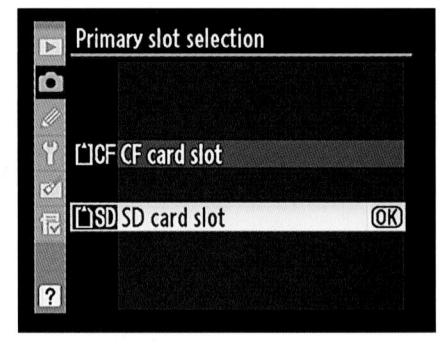

Figure 1-16: Use this option to specify which of the two cards should be the primary storage closet for your pictures.

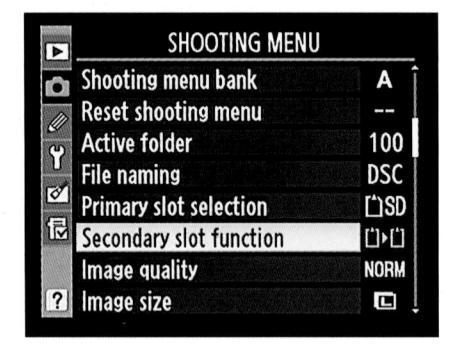

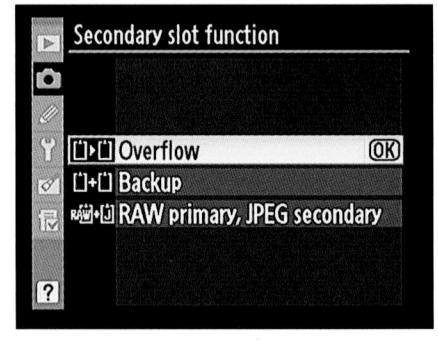

Figure 1-17: These options tell the camera how you want to make use of your second card.

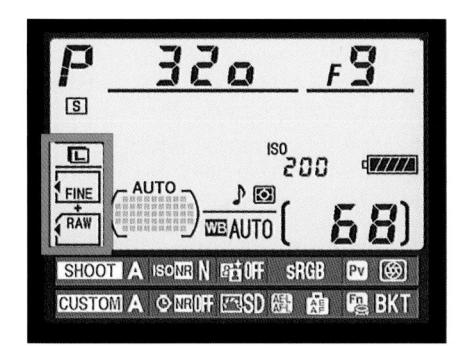

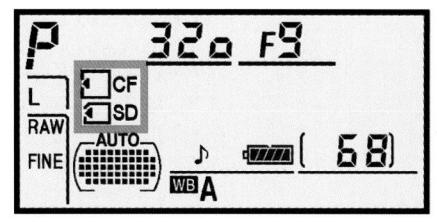

Figure 1-18: These symbols represent your memory cards.

- ✓ The shots remaining value (68, in the figures) indicates how many more pictures you can store at your current picture-taking settings. When you set the second card to the Backup or RAW/JPEG option, this value is based on whichever card contains the least amount of free space. For the Overflow option, the value tells you the shots remaining for the primary card until you fill that card and then switches to indicate the amount of free space on the overflow card.
- ✓ You can copy pictures from one card to another using an option on the Playback menu. For details on that feature plus other playback information, see Chapter 4.

Formatting cards

The first time you use a new memory card or insert a card that has been used in other devices, such as MP3 players or phones, you should *format* it. Formatting ensures that the card is properly prepared to record your pictures. Formatting after you download pictures to your computer is also a good idea. However, don't use your computer's file-management tools to format the card; the camera is better equipped to do the job.

Formatting erases *everything* on your memory card. So before formatting, be sure that you have copied any pictures or other data to your computer.

You can format a card in two ways:

✓ **Simultaneously press and hold the Mode and Delete buttons.** See the little red Format labels next to the buttons? They're reminders that you use these buttons to quickly format a memory card. Hold the buttons down for about two seconds, until you see the letters *For* blink in the Control panel on top of the camera, as shown in Figure 1-19.

After you press the buttons, the Control panel also displays the icon for the memory card that's designated as your primary card and will be formatted if you go forward. If you have two cards installed in the camera, you can switch to the other card by rotating the main command dial. You also see the shots remaining value, which indicates how many pictures you can fit on the memory card at the current Image Quality and Image Size settings. (If the card contains any pictures, the number will grow after

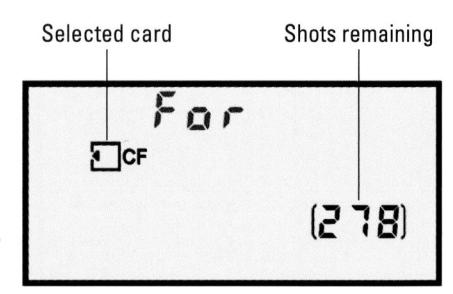

Figure 1-19: To format a memory card, press the Delete and Mode buttons until you see this message in the Control panel; then press both buttons again.

pictures, the number will grow after you complete formatting because those images will be erased.)

While the display is blinking, press and release both buttons again. When formatting is complete, the *For* message disappears, and the Control panel display returns to normal.

✓ Choose the Format Memory Card command from the Setup menu.

When you select the command, you're asked to select which card you want to format. After taking that step, you see a screen where you need to confirm your decision to format the card. Highlight Yes and press the OK button to go forward.

If you insert a memory card and see the letters *For* blink in the Control panel, you must format the card before you can do anything else.

Exploring External Camera Controls

Scattered across your camera's exterior are a number of buttons, dials, and switches that you use to change picture-taking settings, review and edit your photos, and perform various other operations. In later chapters, I discuss all your camera's functions in detail and provide the exact steps to follow to access them. This section provides just a basic road map to the external controls plus a quick introduction to each.

One note before you move on: Many of the buttons perform multiple functions and so have multiple "official" names. The Protect button, for example, is also known as the Help button. In the camera manual, Nikon's instructions refer to these multi-tasking buttons by the name that's relevant for the current function. I think that's a little confusing, so I always refer to each button by the first moniker you see in the lists here.

Topside controls

Your virtual tour begins with the bird's-eye view shown in Figure 1-20. There are a number of controls of note here:

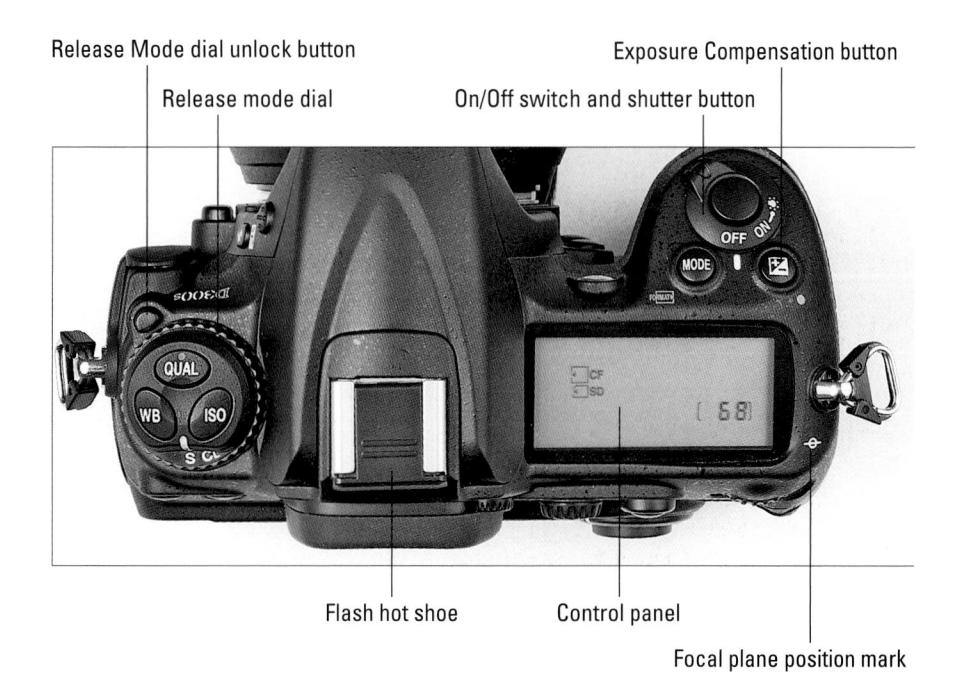

Figure 1-20: Press and hold the Release Mode dial unlock button before rotating the dial.

- ✓ **Control panel:** You can view many picture-taking settings on this LCD panel. See the earlier section "Decoding the Displays" for more info.
- ✓ On/Off switch and shutter button: Okay, I'm pretty sure you already figured this combo button out. But remember that you can illuminate the Control panel by rotating the On/Off switch past the On position to the little light-bulb icon. Moving the switch to that position also activates the exposure meters. After you release the switch, the panel backlight and meters remain active for about six seconds or until you take a picture. You can also turn off the panel light by rotating the switch to the light-bulb position again.

Through options on the Custom Setting menu, you can change the delay time for the meter shutoff and also choose to display the Information screen along with lighting up the Control panel when you move the switch to the light-bulb position. See the section "Reviewing Basic Setup Options," toward the end of this chapter, for details.

- **Exposure Compensation button:** When working in the camera's three autoexposure modes (P, S, and A), you can apply an exposure-adjustment feature called Exposure Compensation by pressing this button while rotating the main command dial (the one on the back of the camera; refer to Figure 1-21). Chapter 5 explains. You also press this button along with the Oual button to reset the main picture-taking settings to their default options; see the end of this chapter for details. (The green dot by each button reminds you of their shared function.)
- **Release Mode dial:** You use this dial to switch from normal shooting. where you take one picture with each press of the shutter button, to one of the camera's other Release modes, including Self-Timer mode. A letter representing the selected mode appears at the bottom of the dial. For example, in Figure 1-20, the S (Single Frame) mode is selected. See the end of Chapter 2 for a look at all your options.

In order to rotate the dial, you must press and hold the little lock-release button found just above the dial and labeled in Figure 1-20.

- Unal button: You can press this button while rotating the main com-
- mand dial to quickly adjust the Image Quality setting, explained in Chapter 3. Pressing the button while rotating the sub-command dial (the one on the front of the camera) adjusts the Image Size setting, also covered in Chapter 3. And as mentioned a few sentences ago, you also use the Qual button with the Exposure Compensation button to restore the default options for the main picture-taking settings.

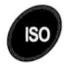

✓ **ISO button:** Pressing this button while rotating the main command dial gives you a quick way to adjust the ISO Sensitivity setting, which determines the camera's sensitivity to light. Chapter 5 discusses ISO.

- **WB button:** The WB stands for *white balance*, which is a color-related feature covered in Chapter 6. You can access the basic white-balance options quickly by pressing this button while rotating the main command dial.
- Flash hot shoe: A hot shoe is a connection for attaching an external flash head. The contacts on the shoe are covered by a little black insert, as shown in the figure; you need to remove it to attach your flash.

Should you ever need to know the exact distance between your subject and the camera, the focal plane position mark labeled in Figure 1-20 is key. The mark indicates the plane at which light coming through the lens is focused onto the negative in a film camera or the image sensor in a digital camera.

Basing your measurement on this mark produces a more accurate camera-tosubject distance than using the end of the lens or some other external point on the camera body as your reference point.

Back-of-the-body controls

Traveling over the top of the camera to its back side, shown in Figure 1-21, you encounter the following controls:

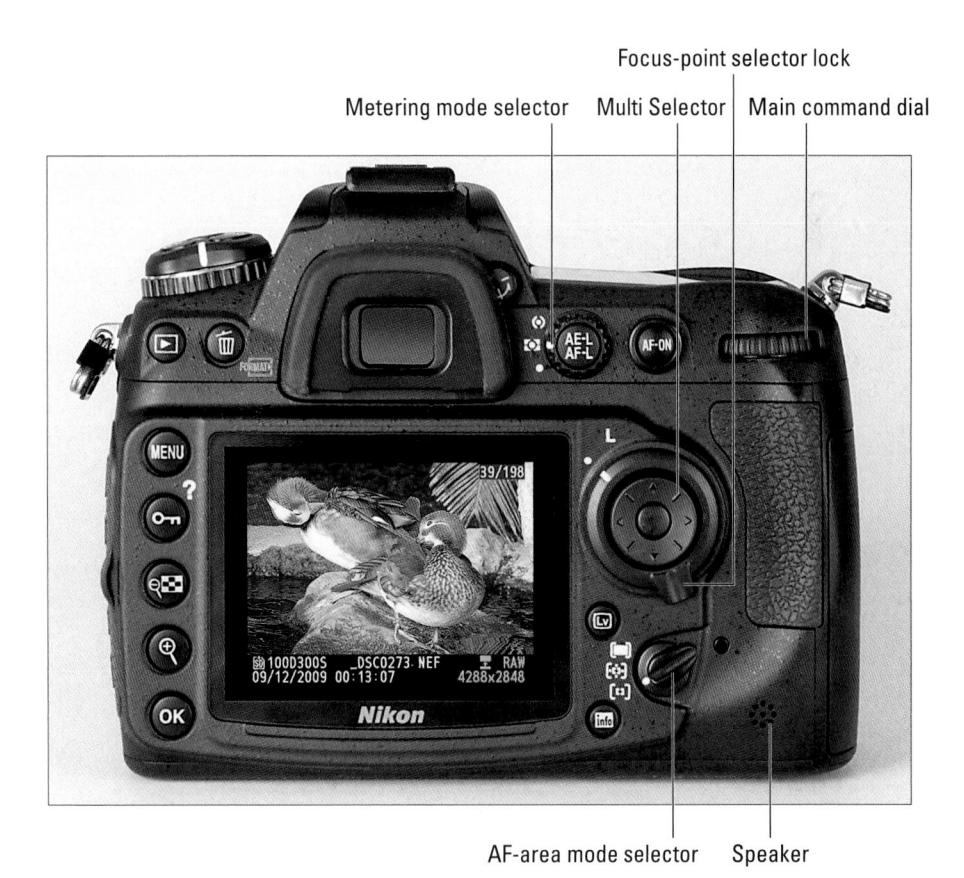

Figure 1-21: You use the Multi Selector to navigate menus and access certain other camera options.

Main command dial: After you activate certain camera features, you rotate this dial, labeled in Figure 1-21, to select a specific setting. For example, to choose a White Balance setting, you press the WB button as you rotate the main command dial. (Chapter 6 explains white balancing.)

- ✓ **AF-ON button:** When taking still photos, you can press this button to set focus instead of pressing the shutter button halfway. See Chapter 6 for a discussion of the pros and cons of this option. The button also plays a focusing role when you take advantage of Live View shooting or record movies. See Chapter 4 for details about Live View shooting and movie recording.
- Metering mode selector: Use this switch to select an exposure metering mode, which determines what part of the frame the camera considers when calculating exposure. Chapter 5 has details on this one as well.

- ✓ **AE-L/AF-L button:** When you're using automatic focus and exposure, you can lock in the current focus and exposure settings by pressing and holding this button. Chapter 5 explains. You can assign other functions to the button as well. Instructions in this book assume that you stick with the default setting, but if you want to explore your options, see Chapter 10.
- ✓ **Multi Selector:** You press the outer edges of the Multi Selector left, right, up, or down to navigate camera menus. You press the center button to perform a variety of functions within menus as well as during shooting and playback. Chapter 10 explains ways to select which functions the center button performs, but again, stick with the default settings while you're working with this book.
- ✓ Focus-point selector lock switch: This switch enables you to lock focus on a specific part of the frame when you use autofocusing. Chapter 6 provides the how-tos.

- ✓ **Live View button:** You press this button to engage the Live View preview, which enables you to compose your shot using the monitor instead of the viewfinder. Switching to Live View mode is also the first step in recording a movie. Chapter 4 talks about both subjects.
- ✓ **AF-area mode selector:** This switch also is related to customizing the camera's autofocusing behavior. Again, look in Chapter 6 for further info.

✓ Info: Press this button to activate the Information screen, which you can investigate in the earlier section "Decoding the Displays."

Playback button: Press this button to switch the camera into picture review mode. Chapter 4 details the features available to you in this mode.

Delete button: Sporting a trash can icon, the universal symbol for delete, this button enables you to erase pictures from your memory

card. Chapter 4 has specifics.

The little red Format label below the button reminds you that you can press this button together with the Mode button — which also sports the label — to quickly format a memory card. See the earlier section "Working with Memory Cards" for details.

Menu button: Press this button to access menus of camera options. See the next section for details on navigating menus.

- **✓ Protect/Help button:** This button serves two purposes:
 - *Protect:* In playback mode, pressing the button locks the picture file hence the little key symbol that appears on the button face so that it isn't erased if you use the picture-delete functions. (The picture *is* erased if you format the memory card, however.) See Chapter 4 for details.
 - *Help:* You also can press this button to display helpful information about certain menu options. See "Asking Your Camera for Help," later in this chapter, for details.

Zoom Out/Thumbnail button: In playback mode, pressing this button enables you to display multiple image thumbnails on the screen and reduces the magnification of the currently displayed photo. Note the minus sign in the magnifying glass icon — the universal symbol to zoom out. See Chapter 4 for a complete rundown of picture playback options.

- ✓ **Zoom In button:** In playback mode, pressing this button magnifies the currently displayed image and also reduces the number of thumbnails displayed at a time. This time, the magnifying glass icon has a plus sign plus for zoom in.
- ✓ OK button: You press this button as the last step in many camera operations, such as selecting menu items and applying photo corrections from the Retouch menu.

As for the monitor, I show it in this book without its protective plastic cover. But when the camera isn't in use, it's a good idea to keep the cover on to protect the screen from scratches and other damage.

Also note the tiny little speaker on the lower-right corner of the camera back. When you play movies that contain sound, the audio comes wafting through those little holes.

Front-left controls

On the front-left side of the camera body, shown in Figure 1-22, you find the following controls:

✓ Flash button: Pressing this button pops up the camera's built-in flash. Chapter 2 provides some flash basics; Chapter 5 goes into more detail. The little round bumps on the button help you to distinguish the button from its neighbor, described next, without taking your eye away from the viewfinder.

✓ Flash mode/Flash Compensation button:

By pressing this button and rotating the main command dial, you can adjust the flash mode (normal, red-eye reduction, and so on). And by pressing the button and rotating the sub-command dial (found just below the shutter button), you can adjust the flash power. See Chapter 5 for help with both features.

You press this button before removing the lens from your camera.

✓ Lens-release button:

lens from your camera. See the first part of this chapter for help with mounting and removing lenses.

✓ Focus mode selec-

tor: This switch sets the camera to either manual focus mode (M) or one of two autofocus modes (S and C). See the Flash mode button

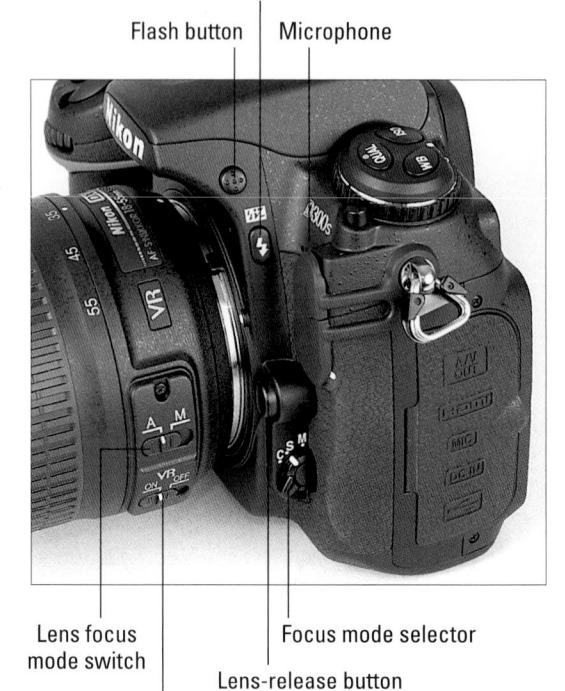

Vibration Reduction switch

Figure 1-22: Press the Flash button to pop up the built-in flash.

modes (S and C). See the earlier section "Setting the focus mode (auto or manual)" for a few more details; see Chapter 6 for the whole story.

Also note the three little holes right below the D300s label, just partially visible in the figure. These holes lead to the camera's internal microphone, included for capturing sound when you record movies. Chapter 4 explains the art of movie making.

Front-right controls

Wrapping up the list of external controls, the front-right side of the camera offers the following features, labeled in Figure 1-23:

Sub-command dial: This dial is the counterpart to the main command dial on the back of the camera. As with the main dial, you rotate this one to select certain settings, usually in conjunction with pressing another button.

Depth-of-Field Preview button

AF-assist/Self-Timer/Red-**Eye Reduction lamp:** In dim lighting, a beam of light sometimes shoots out from this little lamp to help the camera's autofocus system find its target. In general, leaving the AF-assist option enabled is a good idea, but if you're shooting at an event where the light from the lamp may be distracting, you can disable it through an option on the Custom Setting menu. Chapter 6 explains this and other autofocus features.

The lamp also lights before the shutter is released in Self-Timer mode and before the flash fires in Red-Eye Reduction flash mode. Chapter 2 offers more information about both of these features.

✓ Depth-of-Field Preview button: By pressing this button, you can see how different aperture settings affect depth of field, or the zone of sharp focus in your image. Chapter 5 explains aperture Sub-command dial AF-assist lamp

Function (Fn) button

Figure 1-23: You can assign the Function button to perform a variety of operations.

settings, and Chapter 6 delves into depth of field. Chapter 10 shows you how to assign a different function to the button.

► Function (Fn) button: By default, pressing this button while rotating the main command dial or sub-command dial enables you to adjust settings related to autobracketing, covered in Chapter 5. Pressing the button by its lonesome displays those settings in the Control panel and Information screen.

As with the Depth-of-Field Preview button, you can change the operation that's accomplished by pressing the button or pressing the button while rotating the command dials. Again, see Chapter 10 for the scoop.

Hidden connections

Hidden under little covers on the left and left front side of the camera, you find inputs for connecting the camera to various devices.

Under the two little rubber covers on the front-left side of the camera, shown in Figure 1-24, you find the following:

- ✓ Flash sync terminal: You can connect some external flash units to the camera via a cable, known as a sync cable, here. I don't cover this type of flash in the book, but Chapter 5 covers flash basics.
- Ten-pin remote terminal: This terminal enables you to connect a variety of devices, including remote-control and GPS units. Again, the size of this book doesn't allow coverage of these accessories, but the device manuals should tell you everything you need to know.

Ten-pin remote terminal

Figure 1-24: You can plug in an external flash cord, remote control, or GPS unit here.

Around the corner from the two terminals, open the cover on the left side of the body to reveal these connections, shown in Figure 1-25:

- ✓ A/V and HDMI jacks: Use these to connect your camera to a television through a regular audio/video cable or high-def (HDMI) cable. The camera comes with the standard A/V cable; the HDMI cable is sold separately. Chapter 9 offers more details.
- ✓ **Stereo microphone jack:** If you're not happy with the audio quality provided by the internal microphone, you can plug in an external microphone here. The jack accepts a 3.5mm microphone plug. See Chapter 4 for all things movie-related.
- ✓ AC adapter connection: Here's where you plug in the optional AC power adapter.
- ✓ USB port: You can connect your camera to your computer through this port, using the USB cable found in your camera box. Chapter 8 has details.

If you turn the camera over, you find a tripod socket, which enables you to mount the camera on a tripod that uses a ¼-inch screw, plus the battery chamber. The other little rubber cover is related to the optional MB-D10 battery pack; you remove the cover when attaching the battery pack.

Asking Your Camera for Help

Programmed into your camera's internal software is a handy information help line — a great tool for times when you forget the purpose of a particular feature or would like a little picture-taking guidance.

Figure 1-25: Open the cover on the side of the camera to reveal these connections.

? If you see a small question mark in the lower-left corner of a menu, press

and hold the Protect button to display information about the current shooting mode or selected menu option. (The little question mark symbol just above the button reminds you of this function.) For example, Figure 1-26 shows the Help screen associated with the Active D-Lighting setting. If you need to scroll the screen to view all the Help text, keep the button depressed and scroll by using the Multi Selector. Release the button to close the information screen.

[D	SHOOTING MENU	
	JPEG compression	i i
	NEF (RAW) recording	■
6	White balance	AUTO
8	Set Picture Control	⊡SD
\$200550	Manage Picture Control	
包	Color space	SRGB
	Active D-Lighting	0FF
?	Long exp. NR	OFF !

Improves the level of detail in highlight and shadow areas under high contrast conditions. At settings other than "Off", the "Contrast" and "Brightness" items in the Picture Control menu will be adjusted automatically, and the number of pictures that can be taken in a single

Help symbol

Figure 1-26: Press and hold the Protect button to display onscreen help.

Reviewing Basic Setup Options

Your camera offers scads of options for customizing its performance. Later chapters explain settings related to actual picture taking, such as those that affect flash behavior and autofocusing. The rest of this chapter details options related to initial camera setup, such as setting the date and time, adjusting monitor brightness, and the like.

Cruising the Setup menu

Start your camera customization by opening the Setup menu. Figure 1-27 shows you all the menu options; press the Multi Selector up and down to scroll from one screen to the next.

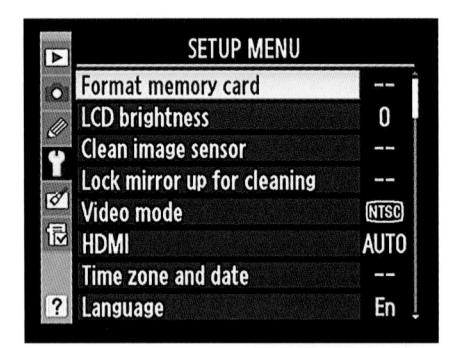

Figure 1-27: Visit the Setup menu to start customizing your camera.

Here's a quick rundown of each menu item:

- ✓ LCD Brightness: This option enables you to make the camera monitor brighter or darker. But if you take this step, what you see on the display may not be an accurate rendition of your image. Crank up the monitor brightness, for example, and an underexposed photo may look just fine. So I recommend sticking with the default setting (0). As an alternative, you can display the histogram, an exposure guide that I explain in Chapter 4, when reviewing your images.
- ✓ Clean Image Sensor: Your D300s has an internal cleaning system designed to keep a filter that's fitted on to the image sensor that's the part of the camera that actually captures the image free of dust and dirt.
 - By choosing the Clean Image Sensor command, you can perform a cleaning at any time. Just choose the command, press OK, select Clean Now, and press OK again. You also can tell the camera to perform automatic cleaning every time you turn the camera on or off, only at startup, only at shutdown, or never; to do so, select Clean At Startup/Shutdown instead of Clean Now. Then press the Multi Selector right, highlight the cleaning option you prefer, and press OK.
- Lock Mirror Up for Cleaning: This feature is necessary when cleaning the camera image sensor (or, technically, the aforementioned filter) an operation that I don't recommend that you tackle yourself because you can easily damage the camera if you don't know what you're doing.
 - If you want to use mirror lock-up to avoid camera shake when shooting long-exposure images, note that you do so through the Mirror Up setting on the Release Mode dial, explained in Chapter 2, and not this Setup menu option.
- ✓ Video Mode: This option is related to viewing your images and movies on a television, a topic I cover in Chapter 9. Select NTSC if you live in North America or other countries that adhere to the NTSC video standard; select PAL for playback in areas that follow that code of video conduct.
- ✓ HDMI: See Chapter 9 for information about this setting, which relates to options involved with connecting your camera to an HDMI (high-def) device.
- Time Zone and Date: When you turn on your camera for the first time, it displays this option and asks you to set the current date and time. Keeping the date/time accurate is important because that information is recorded as part of the image file. In your photo browser, you can then see when you shot an image and, equally handy, search for images by the date they were taken.

On a related note: If you see the message "Clock" blinking in the Control panel, and you have already set the date and time, the internal battery that keeps the clock running is depleted. Simply charging the main camera battery and then putting that battery back in the camera sets the clock ticking again, but you need to reset the camera time and date.

- ✓ Language: This option determines the language of text on the camera monitor. You have 17 choices, ranging from English to Swedish to Korean.
- ✓ Image Comment: See Chapter 10 to find out how to use this feature, which enables you to add text comments into a picture file. You can view those comments during picture playback and when browsing photos in Nikon ViewNX, the software that shipped with your camera. The text does *not* appear on the image itself.
- ✓ **Auto Image Rotation:** This option is one of two that determines whether pictures are rotated to the correct orientation (horizontal or vertical) in playback mode. Chapter 4 has details.
- ✓ Image Dust Off Ref Photo: This feature enables you to record an image that serves as a point of reference for the automatic dust-removal filter available in Nikon Capture NX 2. I don't cover this accessory software, which must be purchased separately, in this book.
- ▶ Battery Info: Select this option to view detailed information about your battery, as shown in Figure 1-28. The Bat Meter data shows you the current power remaining as a percentage value, and the Pic Meter value tells you how many times you've pressed and released the shutter button since the last time you charged the battery. The final readout,

Battery Age, lets you know how much more life you can expect out of the battery before it can no longer be recharged. When the display moves toward the right end of the little meter, it's time to buy a new battery.

The screen in Figure 1-28 shows the display as it appears when you use the regular camera battery. If you attach the optional battery pack, see its manual and the camera manual to find out how to interpret the data that's reported.

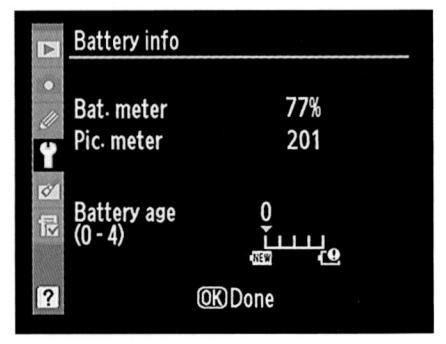

Figure 1-28: You can check the health of your battery via the Battery Info menu item.

✓ Wireless Transmitter: If you purchase the optional WT-4 wireless transmitter to connect your camera to a wireless network, you can set up the connection through

- this menu option. As with other optional accessories, I must refer you to the product manuals for details, as the publisher absolutely refuses to let me turn this book into a 10-inch-thick tome.
- ✓ Image Authentication: This feature may interest you if you do the kind of work that demands that you can prove that a photo has not been altered. (Think crime-scene photographer or insurance-claims specialist.) When you turn this feature on, the camera embeds some invisible data into the file that tags the photo as the original. If the photo is later altered, that data reveals the change. Unfortunately, you need to buy Nikon's Image Authentication software to detect and interpret the data; it costs about \$650. I'm guessing that's why the default setting for this option is Off.
- Copyright Information: By following the steps in Chapter 10, you can add a hidden copyright notice to your photo files. The copyright data can then be read in some photo software, including the free browser software that ships with your camera (Nikon ViewNX).
- ✓ Save/Load Settings: Through this feature, you can save a file that records the major menu settings and store the file on your memory card. (The camera manual contains a list of the settings that are preserved.) If you later want to use all those settings again, you just load the file from the memory card. This option is especially useful in a work situation where several photographers share the same camera if you don't like your co-worker's settings, you can quickly load your own onto the camera.
 - The camera stores your settings in a file that has the name NCSETUP5. If you're using two memory cards in the camera, the file goes on the one that's selected as the primary card. Don't change the filename, or you won't be able to reload the settings later.
- ✓ **GPS:** If you purchase the optional Nikon GPS tracking unit for your camera, this menu item holds settings related to its operation. This book doesn't cover this accessory, but the camera manual provides some help to get you started.
- ✓ Virtual Horizon: Here's a cool aid for shooting pictures that require your camera to be level with the horizon. When you turn this option on, the monitor displays a little gauge that acts sort of like a built-in level. When the camera is level to the horizon, the arrow at the top of the display turns green, as shown in Figure 1-29. (If the entire display is gray, without the little degree markers, the camera is tilted too far forward or backward for the system to do its thing.) Unfortunately, the display shows only on the monitor and not in the viewfinder, so it's mostly of use when you're shooting in Live View mode or setting up your camera on a tripod. However, you can display an alignment grid in the viewfinder, an option covered a little later in this chapter.

A	SETUP MENU	
O	Image authentication	0FF
0	Copyright information	0FF
ů.	Save/load settings	
	GPS	
0	Virtual horizon	
包	Non-CPU lens data	No. 1
	AF fine tune	
?	Firmware version	

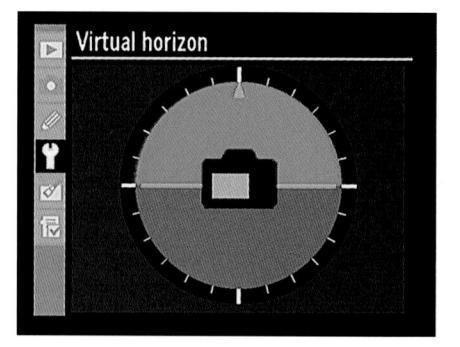

Figure 1-29: The Virtual Horizon display helps you make sure the camera is level.

Non-CPU Lens Data: A CPU lens is equipped with technology that enables it to transmit certain data about the lens to the camera. That data helps the camera's autofocusing and exposure systems work correctly. When you use a non-CPU lens, you lose access to certain D300s features. (Your manual spells them out.) But you can gain back a little of the lost functionality by "registering" your lens through this Setup menu option. You simply assign the lens a number — you can register up to nine non-CPU lenses — and then enter the maximum aperture and focal length of each lens.

- ✓ **AF Fine Tune:** If your focus always seems slightly off when you use autofocusing, you may be able to improve the situation through this feature. It enables you to create a custom focusing adjustment for up to 12 lens types, telling the camera to set the focus point just a tad in front of or behind where it normally would. Nikon recommends *not* using this feature unless it's absolutely necessary, and even then, you may want to get some expert assistance.
- Eye-Fi Upload: Your camera can work with some Eye-Fi memory cards, which enable you to send your pictures over a wireless network to your computer. If you do put one of the cards in the camera, this option appears on the Setup menu and contains settings for making the transfer. When no Eye-Fi card is installed, the option doesn't appear, as in the figures in this book

Unfortunately, Eye-Fi cards are significantly more expensive than regular cards. But if you do use the cards and you find yourself in a situation where wireless devices are not allowed, choose Disable from the Eye-Fi upload menu to shut off the signal. For the whole story on Eye-Fi, including help with setting up your wireless transfers, visit the company's Web site at www.eye.fi.

Firmware Version: Select this option and press OK to view what version of the camera firmware, or internal software, your camera is running. You see two separate firmware items, A and B. At the time this book was written, both items were in version 1.0.0.

Keeping your camera firmware up-to-date is important, so visit the Nikon Web site (www.nikon.com) regularly to find out whether your camera sports the latest version. You can find detailed instructions on how to download and install any firmware updates on the site.

Browsing the Custom Setting menu

Displaying the Custom Setting menu, whose icon is a little pencil, takes you to the left screen shown in Figure 1-30. Here you can access six submenus that carry the labels A through F. Each of the submenus holds clusters of options related to a specific aspect of the camera's operation. Highlight a submenu and press OK to get to those actions, as shown on the right.

Figure 1-30: Select one of the six submenus and press OK to access the available options.

A few important points about this menu:

- After you jump to the first submenu, you can simply scroll up and down the list to view options from other submenus. You don't have to keep going back to the first screen in Figure 1-30, selecting the submenu, pressing OK, and so on.
- An asterisk above a letter, as in the highlighted option on the right in Figure 1-30, indicates that you selected a setting other than the default setting. See the last section of this chapter to find out how to restore the camera defaults.
- ✓ In the Nikon manual, instructions sometimes reference these settings by a menu letter and number. For example, "Custom Setting a1" refers to

- the first option on the Autofocus submenu. I try to be more specific in this book, however, so I use the actual setting names. (Really, we've all got enough numbers to remember, don't you think?)
- Notice that those option letter/number labels are assigned colors to indicate their submenu categories: Autofocus options are red, metering/ exposure options are yellow, and so forth.

With those clarifications out of the way, the following sections describe only the customization options related to basic camera operations. Turn to the index for help locating information about other Custom Setting options.

Adjusting automatic monitor shutdown

To help save battery power, your camera automatically shuts off the monitor after a period of inactivity. You can specify how long you want the camera to wait before taking that step through the Monitor Off Delay option, found on the Timers/AE Lock portion of the Custom Setting menu, as shown in Figure 1-31. You can specify the auto-off timing for picture playback, menu displays, and the Information display. Additionally, you can adjust the length of time the camera displays a picture immediately after you press the shutter button, known as the Image Review period. Chapter 4 talks more about viewing your photos.

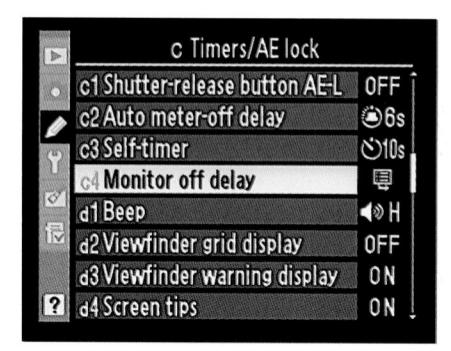

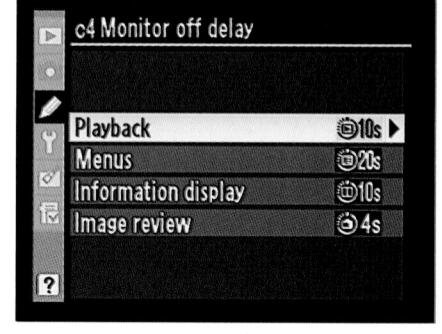

Figure 1-31: Visit the Timers/AE Lock submenu to adjust the timing of automatic monitor shut-off.

Customizing shooting and display options

Head for the Shooting/Display section of the Custom Setting menu, shown in Figure 1-32, to tweak various aspects of how the camera communicates with you, as well as to control a couple of basic shooting functions. Later chapters discuss options related to picture-taking; the following affect the basic camera interface:

Figure 1-32: Sick of hearing your camera? Turn it off with the Beep option.

▶ Beep: By default, your camera beeps at you after certain operations, such as after it sets focus when you shoot in autofocus mode. If you're doing top-secret surveillance work and need the camera to hush up, set this option to Off. Or just lower the volume from the default, High, to Low. On the Information and Control panel displays, a little musical note icon appears when the beep is enabled.

Also check out the Release mode section of Chapter 2 for information about the Quiet mode, which tamps down camera noise even further.

✓ Viewfinder Grid Display: You can display tiny gridlines in the viewfinder, as shown in Figure 1-33, by setting this option to On. The gridlines are a great help when you need to ensure the alignment of objects in your photo — for example, to make sure that the horizon is level in a landscape. If you're using Live View mode or a tripod, the Virtual Horizon feature discussed earlier in the chapter is an alternative, but it requires using the monitor and not the viewfinder.

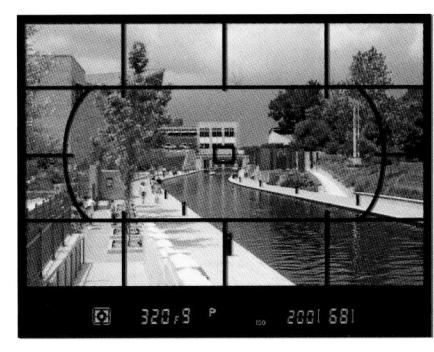

Figure 1-33: The viewfinder grid is another aid for ensuring that the horizon is level in the frame.

✓ Viewfinder Warning Display: By default, you see a low-battery warning in the viewfinder when your battery is about to give out. (Refer to Figure 1-13, earlier in this chapter.) If you don't want to see the warning — it can be annoying if you know your battery's low but you have to keep shooting as long as possible anyway — turn this option off.

- ✓ Screen Tips: If you don't want to see the little help labels that appear when you adjust settings via the Information display, turn this option Off. For a look at what I'm talking about, revisit Figure 1-12.
- ✓ **File Number Sequence:** This option controls how the camera names your picture files. If you set this option to Off, the camera restarts file numbering at 0001 every time you format your memory card or insert a new memory card. Numbering is also restarted if you create custom folders (an advanced option covered in Chapter 11).

As for the Reset option, it tells the camera to look at the largest file number on the current card (or in the selected folder) and then assign the next highest number to your next picture. If the card or selected folder is empty, numbering starts at 0001. Then the camera behaves as if you selected the On setting.

Should you be a really, really prolific shooter and snap enough pictures to reach folder 999, and that folder contains either 999 pictures or a photo that has the file number 9999, the camera will refuse to take another photo until you choose that Reset option and either format the memory card or insert a brand new one.

✓ **Information Display:** Normally, the camera tries to make the data on the display easier to read by automatically shifting from black text on a light background to light text on a black background, depending on the ambient light. If you prefer one display style over the other, visit this menu item and change the setting from Auto to Manual. You can then select either Dark on Light (for dark lettering on a light background) or Light on Dark (for light lettering on a dark background).

In this book, I show the Information screen using the Dark on Light display because it reproduces better in print.

✓ **LCD Illumination:** This setting affects a backlight that can be turned on to illuminate the Control panel. When the option is set to Off, as it is by default, you can illuminate the panel briefly by rotating the On/Off switch past the On setting, to the little light bulb marking. The backlight turns off automatically a few seconds after you release the switch.

If you instead set the LCD Illumination option to On, the backlight comes on automatically anytime the exposure meters are activated (which happens when you press the shutter button halfway). See Chapter 5 for more about the exposure meters. Be aware that this option consumes more battery power than simply using the On/Off switch to light up the panel when you really need it.

Exposure Delay Mode: If you turn this option on, the camera waits to record your picture until about one second after you press and release the shutter button. What's the point? Well, a tiny mirror inside the camera moves every time you press the shutter button to take a picture. For shots that require a long exposure time, there is a slight chance that the vibration caused by that mirror movement will blur the picture. So by delaying the actual image capture a little, the odds of that mirror-related blur are lessened. (For Live View shooting, this option works only when you use Tripod mode.)

For normal shooting, leave the Exposure Delay Mode setting at its default, Off. And check out Chapter 2 for information on using the camera's self-timer function as an alternative option when you want to delay the shutter release.

MB-D80 Battery Type and Battery Order: You don't need to worry about these options unless you buy the optional MB-D80 battery adapter that enables you to power your camera with AA batteries. If you go that route, select the MB-D80 Battery Type option to specify which type of AAs you're using. (Be sure to read the manual for a list of which AA batteries are acceptable, as well as some other details about using them.) Then use the Battery Order option to tell the camera whether you want it to draw power from the battery pack or the regular camera battery when you have both installed. The Control panel displays the letters BP when the battery pack is the current power source.

Customizing controls

On the Controls section of the Custom Setting menu, you find options that enable you to change the function or behavior of some of the camera's buttons and dials. Chapter 10 talks about most of these options — I purposely put this information at the back of the book in hopes that you would leave things at their default settings until you've fully explored all the other chapters. If you change the settings, instructions you find along the way won't work.

There are a few Controls options, though, that I suggest you check out now:

On/Off Light Switch: Normally, rotating the On/Off switch past the On position to the light bulb symbol illuminates the Control panel. But if you set the option highlighted on the left in Figure 1-34 to the setting shown on the right, rotating the switch activates the Information screen as well as the Control panel. (The menu and manual use the light bulb symbol instead of the text name I've given it here.) You may find this maneuver easier than pressing the Info button to light up the Information display. The downside is that you use power to light up the Control panel when what you really want to see is the Info display. I leave it up to you to make the call.

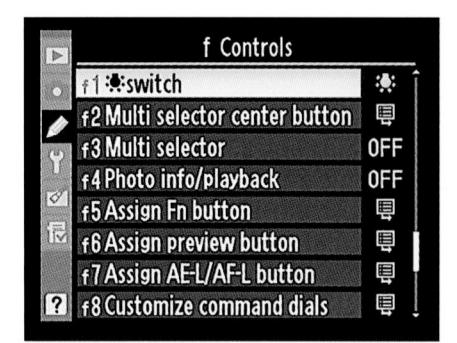

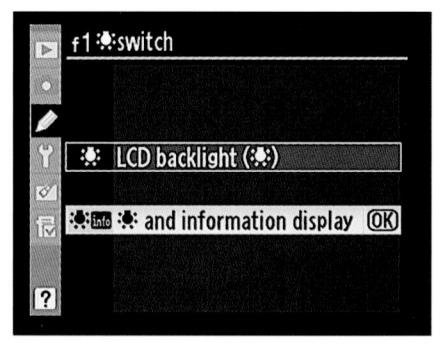

Figure 1-34: Select this setting if you want to use the On/Off switch to activate the Information screen as well as the Control panel light.

No Memory Card?: I suggest setting this option to Release Locked, which disables the shutter button when no memory card is in the camera. At the default setting, Enable Release, you can take a temporary picture, which appears in the monitor with the word "Demo" but isn't recorded anywhere. (The feature is provided mainly for use in camera stores, enabling salespeople to demonstrate the camera without having to keep a memory card installed.)

Restoring default settings

Should you ever want to return your camera to its original, out-of-the-box state, the camera manual contains a complete list of all the default settings.

You can also partially restore default settings by taking these steps:

- Reset all Shooting Menu options. Open the menu, choose Reset Shooting Menu, and press OK.
- Reset all Custom Setting Menu options. Choose the Reset Custom Settings option at the top of the menu.

✓ Restore critical picture-taking settings without affecting options on the Custom Setting menu. Use the two-button reset method: Press and hold the Exposure Compensation button and the Qual button simultaneously for longer than two seconds. (The little green dots near the buttons are a reminder of this function.) See the camera manual for a list of exactly what settings are restored.

When you restore the camera defaults, only the settings for the current Shooting bank and Custom Setting bank are affected. For an introduction to the bank system, refer to the section "Ordering from Camera Menus," earlier in this chapter.

Fast and Easy: (Almost) Automatic Photography with the D300s

In This Chapter

- Enjoying the ease of P (programmed autoexposure) mode
- Getting comfortable with the basic picture-taking process
- Selecting a shutter-release mode
- Enabling flash
- Dipping your toe in creative waters with flexible programmed auto

ne look at the D300s tells you that it's a complex piece of equipment, laden with options that provide precise control over focus, color, exposure, and every other aspect of your pictures. What may not be so obvious is that with the proper camera setup, your D300s can, in fact, offer point-and-

shoot simplicity.

Of course, you likely bought this book for help with your camera's advanced options, and that's what the rest of this book covers. But so that you can take great shots while you're learning, this chapter shows you how to operate your camera in the easiest, most automatic way possible. It's not quite as simple as using the Full Auto modes found on beginner cameras, but it's close — "Almost Auto," if you will.

The first part of the chapter shows you how to set up your camera to take advantage of this stress-free approach to D300s photography. Then you're introduced to a basic recipe that guides you through the process of framing, focusing, and snapping your first pictures. Following that, you can find out how to tweak the basic recipe by adding flash, changing the shutter-release mode, and manipulating exposure settings to take a little more creative control over your photos.

Preparing for Automatic Shooting

The "almost automatic" photography technique that I describe in this chapter is based on a specific camera setup. Most of the settings you need to use are the camera defaults — that is, the ones that were in force when you first opened your camera box. Nikon chose these settings because they produce good results in most situations, so it makes sense to rely on them until you have a chance to investigate exactly how each camera option affects your pictures.

Of course, if you're like me, you've probably fiddled with some of the settings since you got your camera — flipped a switch here, rotated a dial there, and so on. So the following steps show you how to get back to square one and make a few other tweaks that get you set up for easy-breezy shooting.

Don't be put off by the length of the steps, by the way: First, it takes a lot more time to explain everything in text than it does to actually accomplish the task at hand. Second, because all the settings remain intact unless you later change them, you need to go through the steps only once — you don't have to repeat them before each picture.

Also note that the steps assume that you haven't yet created any custom menu banks, an advanced topic you can explore in Chapter 10. If you have created banks, be aware that restoring the defaults in Steps 2 and 3 affects the active bank.

1. Set the exposure mode to P (programmed autoexposure).

In this mode, the camera calculates the correct exposure for you; you don't need to know anything about f-stops, shutter speeds, and other exposure settings to get a good exposure. If you *do* know about those settings, though, you still have some control over them even in P mode; see the last section in this chapter for details.

To set the exposure mode, press the Mode button and rotate the main command dial until you see the letter P in the upper-left corner of the Control panel, as shown in Figure 2-1. The P also appears in the view-finder and Information display, also shown in the figure.

Note: If you use a non-CPU lens, you can't use the P mode; you are limited to A (aperture-priority autoexposure) or M (manual). See Chapter 5 for help using both modes; see Chapter 1 for more about non-CPU lenses.

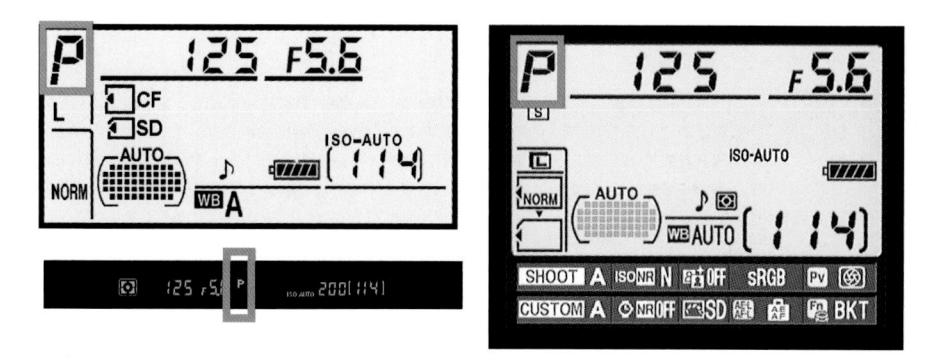

Figure 2-1: The P mode enables you to enjoy the simplicity of fully automatic exposure.

2. Restore all Custom Setting menu and Shooting menu options.

To restore the Custom Setting menu options, open that menu and highlight Reset Custom Settings, as shown on the left in Figure 2-2. Press OK, highlight Yes, and press OK again. Note, however, that this step also resets many basic camera setup options, such as the volume of the beep signal, in addition to those that affect actual photography. Chapter 1 details those options if you want to revisit them.

To restore the Shooting menu defaults, follow the same steps but choose Reset Shooting Menu, as shown on the right in Figure 2-2, from the top of the Shooting menu.

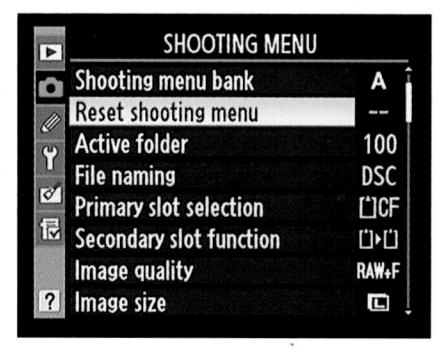

Figure 2-2: Choose these options to quickly restore all Shooting menu and Custom Setting menu options to the default settings.

3. Perform a two-button reset to restore a few additional picture-taking settings.

To perform this type of reset, press the Qual and Exposure Compensation buttons together for more than two seconds. The Control panel shuts off briefly while the reset is occurring; when the panel reappears, release the buttons.

4. Reopen the Shooting menu, select ISO Sensitivity Settings and turn the ISO Sensitivity Auto Control option on, as shown in Figure 2-3.

ISO Sensitivity determines your camera's sensitivity to light. Enabling the ISO Sensitivity Auto Control option gives the camera permission to adjust the light sensitivity if needed to produce a good exposure. Leave all the other settings at their defaults, shown on the right in the figure. And see Chapter 5 for the whole story on this option and ISO in general.

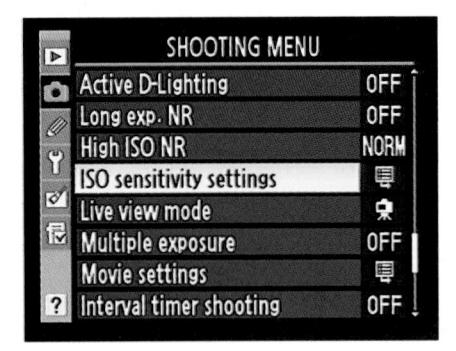

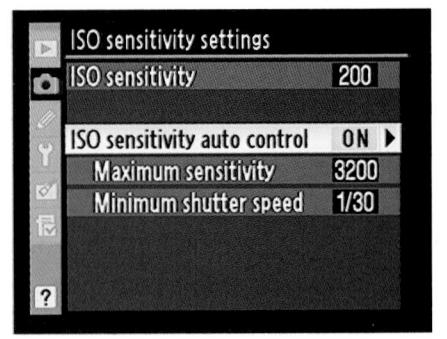

Figure 2-3: Enable ISO Sensitivity Auto Control to give the camera permission to increase ISO (light sensitivity) if needed to properly expose the photo.

When you enable the feature, the ISO Auto label appears in the displays. (Refer to Figure 2-1.) If the camera's about to adjust ISO for you, the label blinks.

5. Set the Metering mode selector to the Matrix setting, as shown on the left in Figure 2-4.

This option determines which part of the frame the camera considers when calculating the correct exposure. The setting shown in Figure 2-2 represents the *matrix* mode — which is a fancy way of saying that the camera bases exposure on the entire frame. See Chapter 5 to find out more.

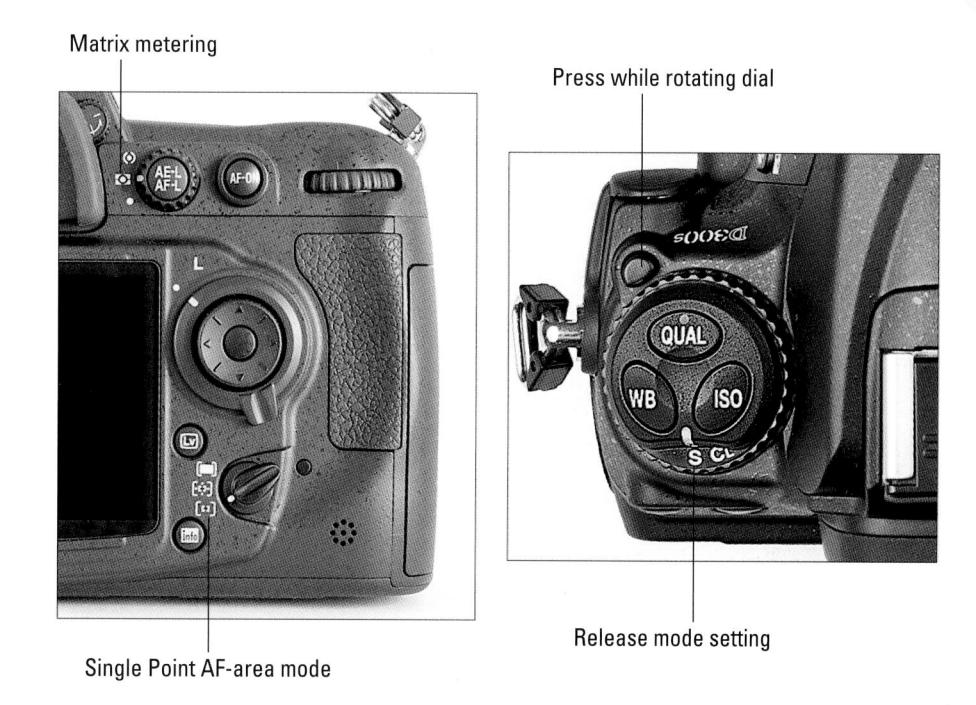

Figure 2-4: Use these Metering mode, AF-area mode, and Release mode settings.

6. Set the AF-area mode switch to the Single Point position, as shown in Figure 2-4.

The AF-area mode setting determines which part of the frame the camera uses to calculate focus. In the Single Point mode, the camera focuses on the object at the center of the frame by default.

7. Set the Release mode to S, as shown on the right in Figure 2-4.

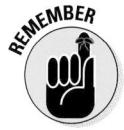

To change the setting, press and hold the little black button labeled in the figure as you rotate the Release Mode dial.

The S (Single Frame) Release mode tells the camera to record one picture each time you press the shutter button. For other options, see "Changing the shutter-release mode," later in this chapter.

That's it. Your camera is now set up to operate in its most automatic modes. The next section walks you through the process of actually taking a picture — wow, and only about 50 pages into the book!

Taking the Shot: The Basic Recipe

After you set up your camera as described in the preceding section, the process of taking a picture is pretty much the same as with any fully automatic, point-and-shoot camera you may have used. The biggest variation is that you can choose to focus manually instead of sticking with autofocus.

Follow these steps to frame, focus, and shoot:

1. Set the focus mode (manual or automatic).

You set the mode through the Focus mode selector switch, shown in Figure 2-5. For manual focusing, set the switch to M; for autofocusing, choose S, as shown in the figure.

shown in the figure.

The S stands for *single-servo* autofocus. Check out Chapter 6 for complete details on this autofocus mode as well as its companion, C (continuous-servo autofocus).

If your lens also has a focus mode switch, set it to your desired focus option as well. Figure 2-5 shows the switch as it appears on some Nikon lenses. On this lens, setting the switch to A enables autofocusing; M is for manual focusing.

Also turn on vibration reduction (VR, on Nikon lenses) if your lens offers it and you're handholding the camera. For tripod shooting, check the lens manual to find out which setting the manufacturer recommends.

Lens focus mode switch

Focus mode selector

Figure 2-5: You may need to set the focus mode on the lens as well as on the camera body.

2. Frame your subject so that it appears under the autofocus point, as shown in Figure 2-6.

The *autofocus point* is the little black rectangle shown in the center of the frame in Figure 2-5. You see the single autofocus point any time you set the camera's Focus mode selector switch to the M or S position.

3. If focusing manually, twist the focusing ring on the lens to focus.

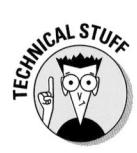

4. Press and hold the shutter button halfway down.

At this point, a couple of things happen:

- The camera meters the light in the scene and establishes the initial exposure settings.
- If you're using autofocusing, the camera sets focus on the object under the autofocus point. You also see the green focus indicator lamp in the viewfinder, as shown in Figure 2-7, and hear a beep if the autofocus system is successful in locking focus.
- If you're focusing manually, you don't hear a beep, but the focus lamp does light when the object under the autofocus point comes into focus. (This focus aid works only with lenses that offer a maximum aperture of at least f/5.6, however. See the last section of this chapter for an introduction to aperture settings.)

With autofocusing, focus remains locked as long as you keep the shutter button halfway down, even if you reframe the shot.
The exposure settings are

Autofocus point

2500 r 8 P Board 2001 881

Figure 2-6: Frame your subject so that it falls under the autofocus point.

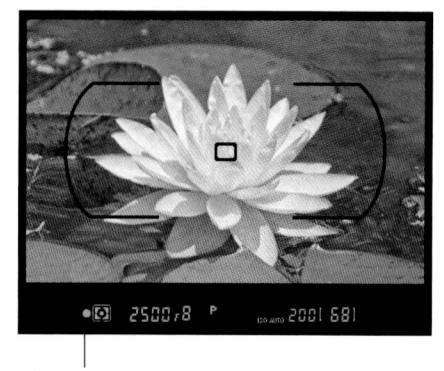

Focus lamp

Figure 2-7: The focus indicator lamp lights when the object under the focus point comes into focus.

adjusted up to the time you take the picture, however.

While the camera sends the image data to the camera memory card, the memory card access lamp lights. (It's the little light just to the right of the AF-area mode selector.) Don't turn off the camera or remove the memory card while the lamp is lit, or you may damage both camera and card.

See Chapter 4 to find out how to switch to playback mode and take a look at your picture.

A couple of additional tips about focusing:

- ✓ By default, the camera does not let you take the picture in S autofocus mode until focus has been established. You can change this behavior through an option called AF-S Priority Selection, found on the Custom Setting menu and covered in Chapter 6.
- ✓ In manual focusing mode, the camera assumes that you know what you're doing and records the picture even if the scene isn't in focus. Be sure that you adjust the viewfinder to your eyesight, as outlined in Chapter 1, so that you can gauge focus accurately.
- You don't have to use the autofocus point in the center of the frame as your focusing target. You can move the point to another position within the frame. First, set the Focus-point selector lock switch to the position shown in Figure 2-8. Then press the Multi Selector to move the focus point. You can move the point to any of 51 positions within the bounds of the autofocusing brackets, also labeled in the figure. For example, I moved the autofocus point directly over the museum sign in the figure. (The 51-point availability relies on the default setting for a Custom Setting menu option called AF Point Selection; see Chapter 6 for more details.) If the point doesn't move when you press the Multi Selector, give the shutter button a half press and release it to wake up the camera's metering system and then try again.
- If you have trouble focusing, you may be too close to your subject; every lens has a minimum focusing distance. Your lens manual spells out this detail.
- A blurry photo is not always the result of poor focus; the problem can also be caused by a slow shutter speed. The last section of this chapter introduces you to shutter speed and how you can adjust that setting.

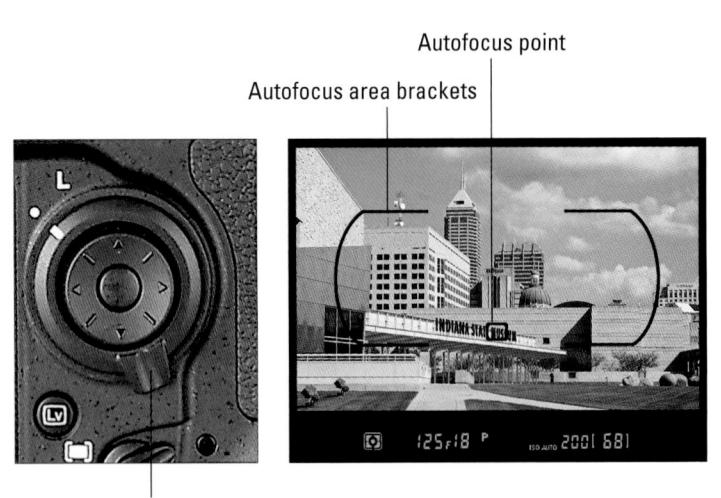

Focus-point selector lock

Figure 2-8: You can press the Multi Selector to reposition the autofocus point.

Tweaking the Recipe: Easy Adjustments for Better Results

After you're comfortable with the basic picture-taking recipe outlined in the preceding section, try out the variations presented in the next three sections.

Adding flash

On most point-and-shoot cameras, the flash fires automatically if the camera thinks additional light is needed to expose the picture. The D300s, however, leaves all flash control in your hands.

You can enable or disable the built-in flash as follows:

- ✓ **To enable flash:** Press the Flash button, shown in Figure 2-9, to raise the built-in flash.
- ✓ To go flash-free: If the flash unit is up, just press it gently back down. The flash will not fire when you take the picture.

47

If you do use flash, you must also select a flash mode, which affects the behavior of the flash. The current mode appears in the Information display and Control panel, as shown in Figure 2-10. (To display the Information screen, press the Info button.) The viewfinder display doesn't

Flash mode/Flash Compensation button

Figure 2-9: Need more light? Just press the Flash button to engage the built-in flash.

advise you of the specific flash mode but instead just shows the universal lightning bolt icon, as shown in the figure, when the flash is enabled, charged, and ready to fire. (The flash needs a moment or two to recharge between shots; be sure to wait until the symbol appears before you take your next picture.)

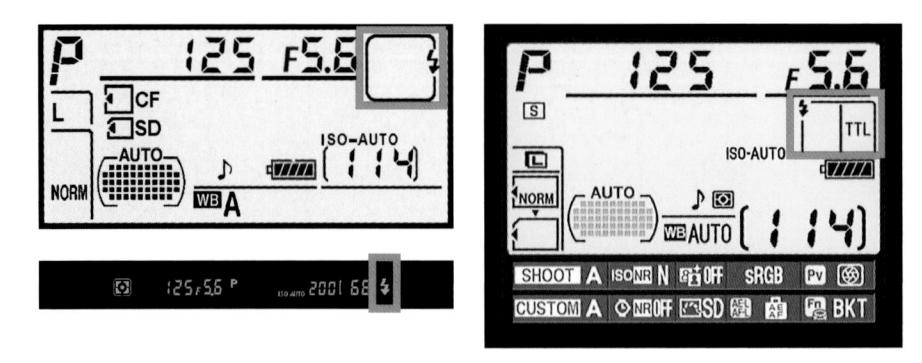

Figure 2-10: The Control panel and Information display show the flash mode; the viewfinder symbol indicates when the flash is charged and ready to use.

In the P exposure mode, you can set the flash to five different flash modes, all of which I cover thoroughly in Chapter 5. But when you use the automatic shooting strategy suggested in this chapter, keep things simple by using one of the following two modes, represented in the displays by the icons you see here:

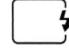

Front-curtain sync (normal flash): Don't worry about what "front-curtain sync" means for now. Just think of this mode as "regular flash."

✓ Red-eye reduction: In this mode, the Red-Eye Reduction lamp on the front of the camera lights up when you press the shutter button halfway. The purpose of this light is to attempt to shrink the subject's pupils, which helps reduce the chances of red-eye. The flash itself fires when you press the shutter button the rest of the way. If you use this option, be sure to warn your subject to expect the prelight and keep smiling until the actual flash goes off.

The letters TTL that appear with the flash mode in the Information display stand for *through the lens* and refer to the fact that the camera calculates the proper flash exposure by reading the light that's coming through the lens.

Changing the shutter-release mode

Introduced in the first part of this chapter, the Release mode determines how the shutter release is triggered. You adjust the setting through the Release Mode dial, shown again on the left in Figure 2-11 to save you the chore of flipping back to its first appearance in the chapter.

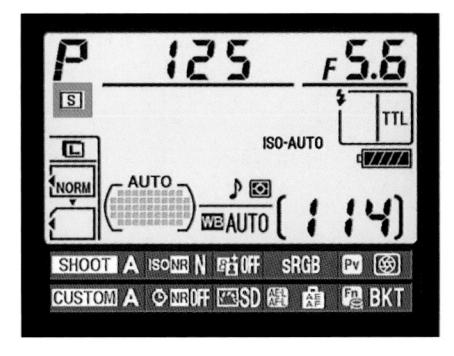

Figure 2-11: You can choose from six Release modes.

To change the setting, press and hold the little black button just above the Qual button while rotating the main command dial. The letter displayed next to the white marker represents the selected setting. For example, in Figure 2-11, the S is aligned with the marker, showing that the Single Frame mode is selected. For all but two Release modes (Quiet and Mirror Up), the Information display shows you the current mode as well, as shown on the right in Figure 2-11. Your camera offers six release modes, which work like so:

- S
- ✓ **Single Frame:** This setting, which is the default, records a single image each time you press the shutter button completely. In other words, this is normal-photography mode.
- CL
- Continuous Low: Sometimes known as *burst mode*, this mode records a continuous series of images as long as you hold down the shutter button. At the default setting, Continuous Low mode can capture a maximum of three frames per second. But you can set the maximum capture number to any number from one to seven frames per second. Just open the Custom Setting menu, select the Shooting/Display submenu, and then select CL Mode Shooting Speed, as shown in Figure 2-12. The Release mode symbol in the information display shows you the current setting; for example, if you use the default setting, you see the 3 fps in the display.

Why would you want to capture fewer than the maximum number of shots? Well, frankly, unless you're shooting something that's moving at a really, really fast pace, not too much is going to change between frames when you shoot at 7 frames per second. So when you set the burst rate that high, you typically just wind up with lots of shots that show the exact same thing, wasting space on your memory card. So I keep this value set to the default, three, and then if I want that max burst rate, I use the Continuous High setting, explained next.

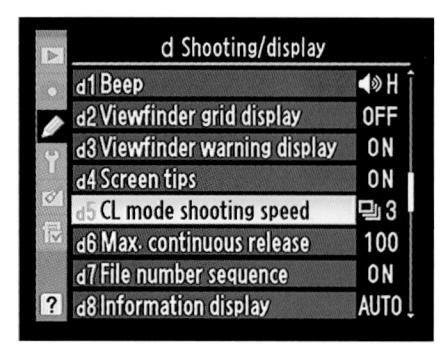

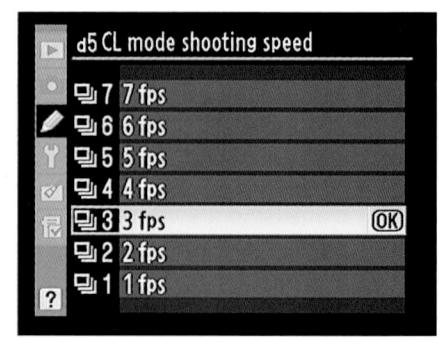

Figure 2-12: You can specify the maximum frames-per-second rate for Continuous Low Release mode.

CH

Continuous High: This mode works just like Continuous Low except that it records up to seven frames per second. You can't adjust the frame rate for this mode.

Neither of the Continuous modes, by the way, works when you enable flash because the flash can't recycle fast enough to permit the rapid capture rate. And the actual number of frames you can record per second depends on several factors. At a slow shutter speed, the camera may not be able to reach the maximum frame rate. (See Chapter 5 for an explanation of shutter speed.) The maximum burst rate also drops when you capture photos as 14-bit NEF (RAW) files (explained in Chapter 3) or enable Vibration Reduction. On the other hand, you may be able to

achieve a slightly higher frame rate when you use the optional AC power adapter or battery pack; see the camera manual for details if you're interested.

In addition, you can tweak both modes by limiting the maximum number of shots the camera takes with each press of the shutter button. Again, the idea behind this feature is simply to prevent firing off lots of wasted frames. To make the adjustment, use the Max Continuous Release option, found on the Custom Setting menu, just below the CL Mode Shooting Speed option, as shown in Figure 2-13.

Figure 2-13: This option limits the number of shots recorded with each press of the shutter button in the Continuous Low and Continuous High modes.

Self-Timer: Want to put yourself in the picture? Select this mode and then press the shutter button and run into the frame. As soon as you press the shutter button, the autofocus-assist illuminator on the front of the camera starts to blink, and the camera emits a series of beeps (assuming that you didn't disable its voice, a setting I cover in Chapter 1). A few seconds later, the camera captures the image.

At the default settings, the capture-delay time is 10 seconds. But you can adjust the delay time by visiting the Custom Setting menu. After you pull up the menu, choose the Timers/AE Lock submenu and then select

the Self Timer option, as shown in Figure 2-14. You can select a capture-delay time of 2, 5, 10, or 20 seconds.

MUP

Mirror Up: One of the components involved in the optical system of an SLR camera is a tiny mirror that moves when you press the shutter button. The small vibration caused by the movement of the mirror can result in slight blurring of the image when you use a very slow shutter speed, shoot with a long telephoto lens, or take extreme

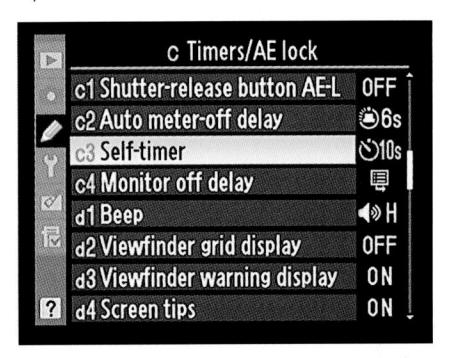

Figure 2-14: You can adjust the self-timer capture delay via the Custom Setting menu.

close-up shots. To eliminate the possibility, the D300s offers a feature known as *mirror lockup*, which you enable by setting the Release mode to Mirror Up. When you enable this feature, the mirror movement is completed well before the shot is recorded, thus preventing any camera shake.

Mirror lockup shooting requires a slightly different shutter-button technique: You must press the shutter button fully twice to take the picture. After framing and focusing, press the button all the way down to lock up the mirror. At this point, you can no longer see anything through the viewfinder. Don't panic — that's normal. The mirror's function is to enable you to see in the viewfinder the scene that the lens will capture, and mirror lockup prevents it from serving that purpose. To record the shot, let up on the shutter button and then press it all the way down again. (If you don't take the shot within about 30 seconds, the camera will record a picture for you automatically.)

For good results, always use a tripod when using mirror lockup to eliminate any chance of camera shake. Adding a remote-control shutter-release cable further ensures a shake-free shot — even the action of pressing the shutter button can move the camera enough to cause some slight blurring. (Or you can just wait the 30 seconds needed for the camera to take the picture automatically, if your subject permits.)

Q

✓ Quiet: This Release mode setting is designed for situations when you want the camera to be as silent as possible. It disables the autofocus beep and also decreases the internal sounds the camera makes from the time you fully depress the shutter button to the time you lift your finger off the button.

When you use Self-Timer mode or trigger the shutter release with a remote control — that is, any time you take a shot without your eye to the viewfinder — you should remove the little rubber cup that surrounds the viewfinder and then insert the little viewfinder cover that shipped with your camera. (Dig around in the accessories box — the cover is a tiny black piece of plastic, about the size of the viewfinder.) Otherwise, light may seep into the camera through the viewfinder and affect exposure. You can also simply use the camera strap or something else to cover the viewfinder in a pinch.

Adding some creative flavor with flexible programmed auto

Your camera has four *exposure modes*, P, S, A, and M, which determine how much control you have over two critical exposure settings, aperture and shutter speed. You select the mode by pressing the Mode button while rotating the main command dial. The current mode setting appears in the upper-left corner of the Control panel, and it's also displayed in the viewfinder and Information screen, as shown in Figure 2-15. The aperture and shutter speed settings appear in the areas highlighted in the figure.

What does [r 37] in the viewfinder mean?

When you look in your viewfinder to frame a shot, the initial value shown in brackets at the right end of the viewfinder display indicates the number of additional pictures that can fit on your memory card. For example, in the left viewfinder image below, the value shows that the card can hold 68 more images.

As soon as you press the shutter button halfway, that value changes to instead show you how many pictures can fit in the camera's *memory buffer*. In the right image here, for example, the "r 37" value tells you that 37 pictures can fit in the buffer.

The buffer is a temporary storage tank where the camera stores picture data until it has time to fully record that data onto the camera memory card. This system exists so that you can take a continuous series of pictures without having to wait between shots until each image is fully written to the memory card.

When the buffer is full, the camera automatically disables the shutter button until it catches up on its recording work. Chances are, though, that you'll very rarely, if ever, encounter this situation; the camera is usually more than capable of keeping up with your shooting rate.

125 F18 P 13 2001 581

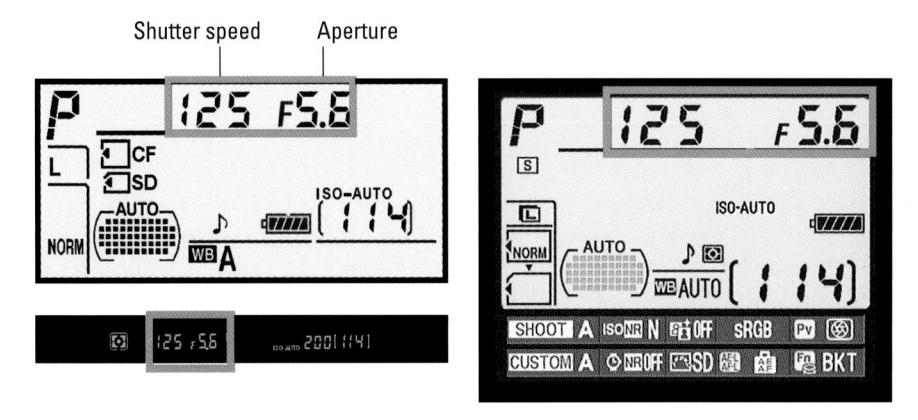

Figure 2-15: The P mode offers fully automatic exposure but still gives you some control over aperture (f-stop) and shutter speed.

For the most automatic operation of your D300s, the P (programmed autoexposure) is the way to go. In this mode, the camera selects both the aperture and shutter speed for you so that you can get a perfectly exposed photo with no photography experience at all.

If you *are* familiar with the basics of exposure, you know that aperture and shutter speed affect your picture in ways beyond exposure. The aperture setting, measured in *f-stops*, affects *depth of field*, or the distance over which sharp focus is maintained in a scene. And shutter speed, measured in seconds, determines whether any movement of either the camera or the subject creates blur in the photo.

Chapter 5 details all the ins and outs of aperture and shutter speed, but here's the (very) short story:

✓ A low f-stop number keeps less of the scene in focus than a high f-stop setting. So if you're shooting a portrait, for example, and want that classic, soft-focus background, you want a low f-stop number. For example, in Figure 2-16, I used an f-stop

Figure 2-16: To throw the background out of focus, I used an aperture of f/5.6.

of f/5.6. If you instead want the background to be sharper, you select a higher f-stop number. I took that approach to capture the landscape in Figure 2-17, setting the aperture to f/16. In this photo, notice that the walkway remains sharply focused over a great distance. Keep in mind that you can affect this characteristic in other ways, including the lens focal length and your distance to the subject; Chapter 6 spells out this issue.

✓ A fast shutter speed freezes motion; a slow shutter speed blurs it. Shutter speed refers to the duration of the exposure, and it's measured in seconds. The exact shutter speed needed to stop action depends on the speed of the subject, however. For example, in Figure 2-18, I caught my romping furkid in mid-flight at a shutter speed of 1/160 second. You might need a faster shutter speed to capture a motorbike or

Figure 2-17: For this scene, I wanted to maintain sharp focus over a large distance, so I set the aperture to a high number (f/16).

boat, but a slower speed might work fine for a flower swaying gently in the breeze. Experimentation is key, in other words.

If you're handholding the camera, you need to avoid very slow shutter speeds to avoid camera shake that can blur your entire photo. How slow you can go also varies depending your lens and your capabilities. If your lens offers vibration reduction, enabling that feature can help you get better results when handholding the camera.

Why get into all of this now, you ask, when the point of this chapter is easy-breezy, automatic photography? Because the P exposure mode allows you to choose from more than one combination of aperture and shutter speed. All of them produce the same exposure, but they deliver different results in terms of depth of field and motion blur (or lack of it). So you have the choice of choosing the combination that the camera originally selects or choosing a different combination that results in the shutter speed or aperture that suits your creative goals.

Nikon refers to the ability of the camera to present different aperture/shutter speed combinations as *flexible programmed autoexposure*.

Try out these steps to get comfortable with the P mode:

- 1. Looking through the viewfinder, frame your shot.
- 2. Press the shutter button halfway to fire up the autoexposure meter.

Now the camera reports its suggested aperture and shutter speed in the view-finder. Take your eye away from the viewfinder, and you can also view the settings in the Control panel and Information display.

The shutter speed values in the displays represent fractions of a second. For example, the shutter speed in Figure 2-19 is 1/160 second. For shutter speeds of 1 second or more, a gueste mark appears after the

Figure 2-18: If your subject is moving, make shutter speed a priority over f-stop; select a high speed to freeze action.

quote mark appears after the value — 1 second appears as 1", 2 seconds as 2", and so on.

3. To view other shutter speed/aperture combinations, rotate the main command dial.

How many combinations are available depends on the lighting conditions and the aperture range offered by your lens. (Every lens offers a specific range of f-stops.)

As soon as you rotate the dial, an asterisk appears next to the P in the displays, as shown in Figure 2-19. When you rotate the dial enough to shift back to the original shutter speed/f-stop combo, the asterisk disappears.

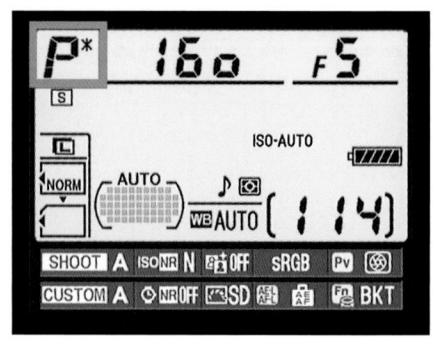

Figure 2-19: The asterisk means that you've adjusted the f-stop and shutter speed from the combination originally suggested by the camera.

Again, any of the combos will produce a good exposure in terms of image brightness. So if you don't care to think about all the depth-of-field/motion blur stuff right now, you can just stick with the original settings the camera selects.

Actually, I should qualify that last statement just a little: Any of the settings will produce a good exposure if the lighting conditions are good. But in very dim lighting or very bright lighting, the camera may not be able to deliver a good exposure. To find out how to deal with exposure and lighting miscues, head for Chapter 5. For more help with focusing and color, check out Chapter 6.

Controlling Picture **Quality and Size**

In This Chapter

- Reviewing factors that lead to poor photo quality
- Exploring resolution, pixels, and ppi
- Calculating the right resolution for traditional print sizes
- ▶ Deciding on the best file format: JPEG or NEF?
- Picking the right JPEG quality level
- ▶ Understanding the tradeoff between picture quality and file size

lmost every review of the D300s contains glowing reports about the camera's top-notch picture quality. As you've no doubt discovered for yourself, those claims are true, too: This baby can create large, beautiful images.

What you may *not* have discovered is that Nikon's default Image Quality setting isn't the highest that the D300s offers. Why, you ask, would Nikon do such a thing? Why not set up the camera to produce the best images right out of the box? The answer is that using the top setting has some downsides. Nikon's default choice represents a compromise between avoiding those disadvantages while still producing images that will please most photographers.

Whether that compromise is right for you, however, depends on your photographic needs. To help you decide, this chapter explains the Image Quality setting, along with the Image Size setting, which is also critical to the quality of images that you print. Just in case you're having quality problems related to other issues, though, the first section of the chapter provides a handy quality-defect diagnosis guide.

Diagnosing Quality Problems

When I use the term *picture quality*, I'm not talking about the composition, exposure, or other traditional characteristics of a photograph. Instead, I'm referring to how finely the image is rendered in the digital sense.

Figure 3-1 illustrates the concept: The first example is a high-quality image, with clear details and smooth color transitions. The other examples show five common digital-image defects.

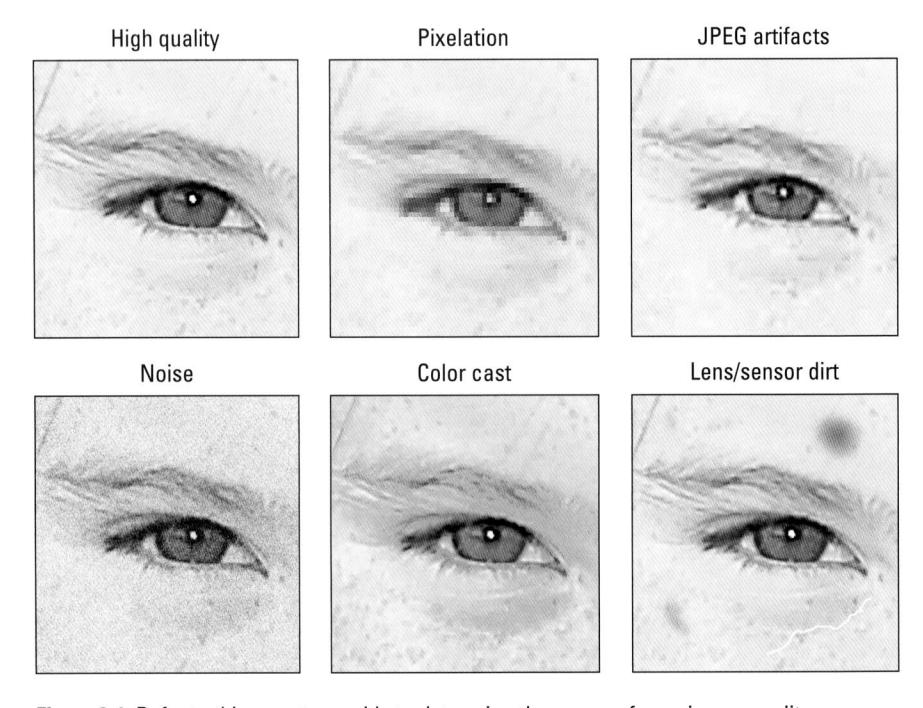

Figure 3-1: Refer to this symptom guide to determine the cause of poor image quality.

Each of these defects is related to a different issue, and only one is affected by the Image Quality setting on your D300s. So if you aren't happy with your image quality, first compare your photos to those in the figure to properly diagnose the problem. Then try these remedies:

✓ **Pixelation:** When an image doesn't have enough *pixels* (the colored tiles used to create digital images), details aren't clear, and curved and diagonal lines appear jagged. The fix is to increase image resolution, which you do via the Image Size control. See the next section, "Considering Resolution (Image Size)," for details.

- ✓ **JPEG artifacts:** The "parquet tile" texture and random color defects that mar the third image in Figure 3-1 can occur in photos captured in the JPEG (*jay-peg*) file format, which is why these flaws are referred to as *JPEG artifacts*. This is the defect related to the Image Quality setting; see "Understanding the Image Quality Options" to find out more.
- ✓ Noise: This defect gives your image a speckled look, as shown in the lower-left example in Figure 3-1. Noise can occur with very long exposure times or when you choose a high ISO Sensitivity setting on your camera. You can explore both issues in Chapter 5.
- ✓ Color cast: If your colors are seriously out of whack, as shown in the lower-middle example in the figure, try adjusting the camera's White Balance setting. Chapter 6 covers this control and other color issues.
- Lens/sensor dirt: A dirty lens is the first possible cause of the kind of defects you see in the last example in the figure. If cleaning your lens doesn't solve the problem, dust or dirt may have made its way onto the camera's image sensor. You can try running the camera's internal cleaning routine; Chapter 1 has details. If that doesn't do the trick, it's time to take your camera to a professional to have the sensor cleaned. You can do the job yourself with some special tools, but you also can easily trash a really expensive camera if you don't know what you're doing. In my area (central Indiana), sensor cleaning costs range from \$30-\$50.

One more cleaning tip: Never — and I mean *never* — try to clean any part of your camera using a can of compressed air. Doing so can not only damage the interior of your camera, blowing dust or dirt into areas where it can't be removed, but also crack the external monitor.

When diagnosing image problems, you may want to open the photos in ViewNX or some other photo software and zoom in for a close-up inspection. Some defects, especially pixelation and JPEG artifacts, have a similar appearance until you see them at a magnified view. (See Part III for information about using ViewNX.)

I should also tell you that I used a little digital enhancement to exaggerate the flaws in my example images to make the symptoms easier to see. With the exception of an unwanted color cast or a big blob of lens or sensor dirt, these defects may not even be noticeable unless you print or view your image at a very large size. And the subject matter of your image may camouflage some flaws; most people probably wouldn't detect a little JPEG artifacting in a photograph of a densely wooded forest, for example.

In other words, don't consider Figure 3-1 as an indication that your D300s is suspect in the image quality department. First, *any* digital camera can produce these defects under the right circumstances. Second, by following the guidelines in this chapter and the others mentioned in the preceding list, you can resolve any quality issues that you may encounter.

Considering Resolution (Image Size)

Like other digital devices, your D300s creates pictures out of *pixels*, which is short for *picture elements*. You can see some pixels close up in the right example of Figure 3-2, which shows a greatly magnified view of the eye area in the left image.

Figure 3-2: Pixels are the building blocks of digital photos.

You can specify the pixel count of your images, also known as the *resolution*, in two ways:

✓ Shooting menu: The Image Size option is near the bottom of the first screen of the menu, as shown in Figure 3-3.

A	SHOOTING MENU		
O	Shooting menu bank	A	
11	Reset shooting menu		
4	Active folder	100	
U	File naming	DSC	
0	Primary slot selection	Ľ]CF	
虚	Secondary slot function	"'	
	Image quality	NORM	
?	lmage size		

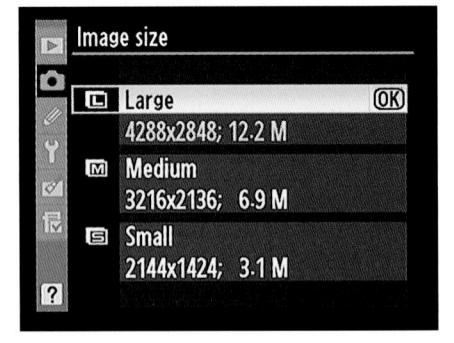

Figure 3-3: Set the Image Size through the Shooting menu.

• Qual button + sub-command dial: Hold down the button while rotating the sub-command dial to cycle through the available settings. You can monitor the setting in the Control panel and Information display, in the areas highlighted in Figure 3-4.

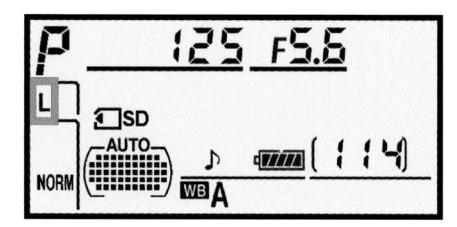

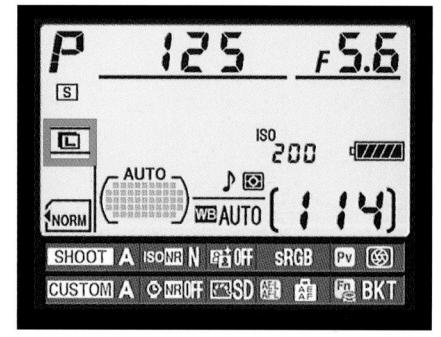

Figure 3-4: The current setting appears in the Control panel and Information display.

Either way, you can choose from three settings: Large, Medium, and Small; Table 3-1 lists the resulting resolution values for each setting.

Table 3-1	Image Size (Resolution) Options		
Setting	Resolution		
Large	4288 x 2848 pixels (12.2 MP)		
Medium	3216 x 2136 pixels (6.9 MP)		
Small	2144 x 1424 pixels (3.1 MP)		

In the table, the first pair of numbers shown for each setting represents the image *pixel dimensions* — that is, the number of horizontal pixels and the number of vertical pixels. The values in parentheses indicate the approximate total resolution. This number is usually stated in *megapixels*, abbreviated MP for short. One megapixel equals 1 million pixels.

Note, however, that if you select RAW (NEF) as your file format, all images are captured at the Large setting. The upcoming section "Understanding the Image Quality Options" explains file formats.

So how many pixels are enough? To make the call, you need to understand how resolution affects print quality, display size, and file size. The next sections explain these issues, as well as a few other resolution factoids.

Pixels and print quality

When mulling over resolution options, your first consideration is how large you want to print your photos, because pixel count determines the size at which you can produce a high-quality print. If you don't have enough pixels, your prints may exhibit the defects you see in the pixelation example in Figure 3-1, or worse, you may be able to see the individual pixels, as in the right example in Figure 3-2.

Depending on your photo printer, you typically need anywhere from 200 to 300 pixels per linear inch, or *ppi*, of the print. To produce an 8-x-10-inch print at 200 ppi, for example, you need 1600 horizontal pixels and 2000 vertical pixels (or vice versa, depending on the orientation of your print).

Table 3-2 lists the pixel counts needed to produce traditional print sizes at 200 ppi and 300 ppi. But again, the optimum ppi varies depending on the printer — some printers prefer even more than 300 ppi — so check your manual or ask the photo technician at the lab that makes your prints. (And note that ppi is *not* the same thing as *dpi*, which is a measurement of printer resolution. *Dpi* refers to how many dots of color the printer can lay down per inch; most printers use multiple dots to reproduce 1 pixel.)

Table 3-2	Pixel Requirements for Traditional Print Sizes			
Print Size	Pixels for 200 ppi	Pixels for 300 ppi		
4 x 6 inches	800 x 1200	1200 x 1800		
5 x 7 inches	1000 x 1400	1500 x 2100		
8 x 10 inches	1600 x 2000	2400 x 3000		
11 x 14 inches	2200 x 2800	3300 x 4200		

Even though many photo editing programs enable you to add pixels to an existing image, doing so isn't a good idea. For reasons I won't bore you with, adding pixels — known as *resampling* — doesn't enable you to successfully enlarge your photo. In fact, resampling typically makes matters worse. The printing discussion at the start of Chapter 9 includes some example images that illustrate this issue.

Pixels and screen display size

Resolution doesn't affect the quality of images viewed on a monitor, television, or other screen device as it does printed photos. What resolution *does* determine is the *size* at which the image appears.

This issue is one of the most misunderstood aspects of digital photography, so I explain it thoroughly in Chapter 9. For now, just know that you need *way* fewer pixels for onscreen photos than you do for printed photos.

For example, Figure 3-5 shows a 450-x-300-pixel image that I attached to an e-mail message.

For e-mail images, I recommend a maximum of 640 pixels for the picture's longest dimension. If your image is much larger, the recipient may not be able to view the entire picture without scrolling the display.

Figure 3-5: The low resolution of this image (450 x 300 pixels) ensures that it can be viewed without scrolling when shared via e-mail.

In short, even if you use the smallest Image Size setting on your D300s, you'll have more than enough pixels for onscreen use, whether you display the picture on a computer monitor, digital projector, or television set — even one of the new, supersized high-definition TVs. Again, Chapter 9 details this issue and also shows you how to prepare your pictures for online sharing.

Pixels and file size

Every additional pixel increases the amount of data required to create a digital picture file. So a higher-resolution image has a larger file size than a low-resolution image.

Large files present several problems:

- You can store fewer images on your memory card, on your computer's hard drive, and on removable storage media such as a CD-ROM.
- The camera needs more time to process and store the image data on the memory card after you press the shutter button. This extra time can hamper fast-action shooting.
- When you share photos online, larger files take longer to upload and download.
- When you edit your photos in your photo software, your computer needs more resources and time to process large files.

To sum up, the tradeoff for a high-resolution image is a large file size. But note that the Image Quality setting also affects file size. See the upcoming section "Understanding the Image Quality Options" for more on that topic. The upcoming sidebar "How many pictures fit on my memory card?" provides additional thoughts about the whole file-storage issue.

Resolution recommendations

As you can see, resolution is a bit of a sticky wicket. What if you aren't sure how large you want to print your images? What if you want to print your photos *and* share them online?

Personally, I take the "better safe than sorry" route, which leads to the following recommendations about the Image Size setting:

- ✓ **Always shoot at a resolution suitable for print.** You then can create a low-resolution copy of the image in your photo editor for use online. Chapter 9 shows you how.
 - Again, you *can't* go in the opposite direction, adding pixels to a low-resolution original in your photo editor to create a good, large print. Even with the very best software, adding pixels doesn't improve the print quality of a low-resolution image.
- ✓ For everyday images, Medium is a good choice. I find the Large setting to be overkill for most casual shooting, which means that you're creating huge files for no good reason. Keep in mind that even at the Medium setting, your pixel count (3216 x 2136) exceeds what you need to produce an 8-x-10-inch print at 200 ppi.
- ✓ Choose Large for an image that you plan to crop, print very large, or both. The benefit of maxing out resolution is that you have the flexibility to crop your photo and still generate a decent-sized print of the remaining image. Figures 3-6 and 3-7 offer an example. When I was shooting this scene, I couldn't get any closer to the bee okay, didn't want to get closer to the bee than the first picture shows. But because I had the

resolution cranked up to Large, I was able to later crop the shot to the composition you see in Figure 3-7 and still produce a great print. In fact, I could have printed the cropped image at a much larger size than fits here.

Figure 3-6: I couldn't get close enough to fill the frame with the subject, so I captured this image at the Large resolution setting.

Figure 3-7: A high-resolution original enabled me to crop the photo tightly and still have enough pixels to produce a quality print.

How many pictures fit on my memory card?

As explained in the Image Size and Image Quality discussions in this chapter, image resolution (pixel count) and file format (JPEG, RAW, or TIFF) contribute to the size of the picture file which, in turn, determines how many photos fit in a given amount of camera memory. File size also depends on a few other factors, including the level of detail and color in the subject.

On the D300s, file sizes range anywhere from 36.6MB (megabytes) to 0.4MB, depending on the combination of Image Size and Image Quality settings you select. That means the capacity

of a 4GB (gigabyte) memory card ranges from about 100 pictures to a whopping 7800 pictures, again, depending on your Size/Quality settings.

The table here shows the approximate file sizes for just some Size/Quality combinations; you can find a table that lists all the possibilities in your camera manual if you're curious. The numbers here assume the default settings for the JPEG Compression and NEF (RAW) Recording options on the Shooting menu, both of which relate to the Image Quality setting and are detailed elsewhere in this chapter.

Image Quality + Image Size = File Size						
Image Quality	Large	Medium	Small			
JPEG Fine	6.0MB	3.4MB	1.5MB			
JPEG Normal	3.0MB	1.7MB	0.8MB			
JPEG Basic	1.5MB	0.9MB	0.4MB			
NEF (RAW)	12.1MB	NA*	NA*			
TIFF	36.6MB	20.6MB	9.3MB			

^{*}NEF (RAW) images are always captured at the Large size.

Understanding the Image Quality Options

If I had my druthers, the Image Quality option would instead be called File Type, because that's what the setting controls.

Here's the deal: The file type, more commonly known as a file *format*, determines how your picture data is recorded and stored. Your choice does impact picture quality, but so do other factors, as outlined at the beginning of this chapter. In addition, your choice of file type has ramifications beyond picture quality.

At any rate, your D300s offers three file types: JPEG, TIFF, and Camera RAW, or just RAW for short, which goes by the specific moniker NEF on Nikon cameras. You also can choose to record two copies of each picture, one in the RAW format and one in the JPEG format. You can view the current format in

the Control panel and Information display, as shown in Figure 3-8. For JPEG, the displays indicate the JPEG quality level — Fine, Normal (Norm, as in the figure), or Basic. (The next section explains these three options.)

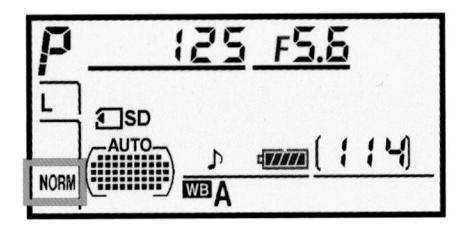

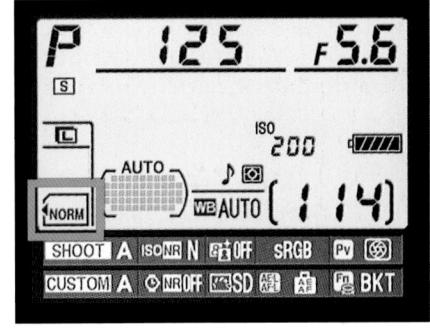

Figure 3-8: The current Image Quality setting appears here.

In the Information display, the icons used for the Quality setting depend on whether you're using a single memory card or one SD card and one CompactFlash card. In Figure 3-8, the symbol shows that a single SD card is being used. See the Chapter 1 section related to using two memory cards at the same time for information on how to decode this aspect of the display.

The rest of this chapter explains the pros and cons of each file format to help you decide which one works best for the types of pictures you take. If you already have your mind made up, you can select the format you want to use in two ways:

- Qual button + main command dial: Hold down the Qual (Quality)
 - button while rotating the main command dial to cycle through all the format options.
- ✓ **Shooting menu:** You also can set the Image Quality option via the Shooting menu, as shown in Figure 3-9.

Scroll to the second screen of the Shooting menu, and you find two additional options related to the Quality setting: JPEG Compression and NEF (RAW) Recording. Look for details about these features in the upcoming discussions of each format.

Figure 3-9: The Shooting menu enables you to select the Quality setting plus a few related options.

Don't confuse *file format* with the Format Memory Card option on the Setup menu. That option erases all data on your memory card; see Chapter 1 for details.

JPEG: The imaging (and Web) standard

Pronounced *jay-peg*, the JPEG format is the default setting on your D300s, as it is for most digital cameras. The next two sections tell you what you need to know about JPEG.

IPEG pros and cons

JPEG has become the de facto digital-camera file format for two main reasons:

- Immediate usability: All Web browsers and e-mail programs can display JPEG files, so you can share your pictures online immediately after you shoot them. The same can't be said for NEF (RAW) or TIFF files, which must be converted to JPEG for online use. (Some photo-sharing sites do accept TIFF files and then make a JPEG copy for online display.)
 - You also can print and edit JPEG files immediately, whether you want to use your own software or have pictures printed at a retail site. The same is true for TIFF files, but not for RAW images. You can view and print RAW files using Nikon ViewNX, the software that comes with your camera, but many third-party photo programs can't open RAW images and retail printing sites typically don't accept RAW files either. You can read more about the conversion process in the upcoming section "NEF (RAW): The purist's choice."
- ✓ **Small files:** JPEG files are much smaller than NEF (RAW) files and way, way, way smaller than TIFF files. And smaller files consume less room on your camera memory card and in your computer's storage tank.

The downside — you knew there had to be one — is that JPEG creates smaller files by applying *lossy compression*. This process actually throws away some image data. Too much compression leads to the defects you see in the JPEG Artifacts example in Figure 3-1.

Fortunately, your camera enables you to specify how much compression you're willing to accept, as outlined next.

Customizing your JPEG capture settings

The D300s gives you two levels of control over the quality of your JPEG images:

- ✓ Fine, Normal, or Basic: When you select the file format, whether
 through the Shooting menu or by using the Qual button with the main
 command dial, you can choose from three JPEG settings, each of which
 produces a different level of compression.
 - *JPEG Fine*: At this setting, the compression ratio is 1:4 that is, the file is four times smaller than it would otherwise be. In plain English, that means that very little compression is applied, so you shouldn't see many compression artifacts, if any.
 - *JPEG Normal:* Switch to Normal, and the compression ratio rises to 1:8. The chance of seeing some artifacting increases as well.
 - *JPEG Basic*: Shift to this setting, and the compression ratio jumps to 1:16. That's a substantial amount of compression and brings with it a lot more risk of artifacting.
- Compression Priority: The size of the file produced at any of the three quality levels varies from picture to picture depending on the subject matter. The difference occurs because a picture with lots of detail and a wide color palette can't be as easily compressed as one with large areas of flat color and a limited color spectrum.

By default, the camera applies compression with a goal of producing consistent file sizes, which means that highly detailed photos can take a larger quality hit from compression. But through the JPEG Compression option on the Shooting menu, shown in Figure 3-10, you can tell the camera to instead give priority to producing optimum picture quality when applying compression. To go that route, choose the Optimal Quality setting, as shown in the figure. For the default option, choose Size Priority. Note that the compression ratios just mentioned for the Fine, Normal, and Basic options assume that you use the Size Priority option. The ratios will vary from picture to picture, as will the picture file sizes, if you select Optimal Quality.

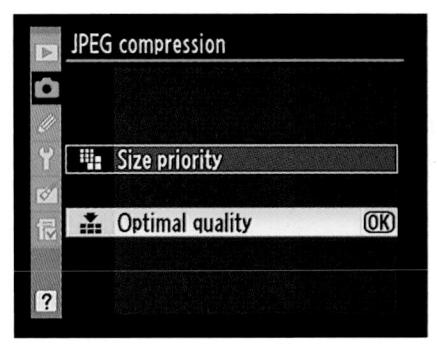

Figure 3-10: Set the JPEG Compression option to Optimal Quality to get the best-looking JPEG pictures.

Note, though, that even if you choose the Size Priority option and combine it with JPEG Basic — thereby producing the lowest-quality JPEG results — you don't get anywhere near the level of artifacting that you see in my example in Figure 3-1. Again, that example is exaggerated to help you be able to recognize artifacting defects and understand how they differ from other image-quality issues.

In fact, if you keep your image print or display size small, you aren't likely to notice a great deal of quality difference between the compression settings. It's only when you greatly enlarge a photo that the differences become apparent.

Take a look at Figures 3-11 and 3-12, for example. I captured the scene in Figure 3-11 four times, keeping the resolution the same for each shot so that the only variable was the Image Quality setting. I captured three JPEG versions, one at each compression level (Fine, Normal, and Basic) and using the default JPEG Compression option, Size Priority, which sets the camera to favor file sizes over picture quality when applying compression. For the fourth image, I used the RAW (NEF) format and selected the default RAW recording options, which result in a non-destructive type of file compression. (See the next section for details about RAW options.)

For the photo you see in Figure 3-11, I used the JPEG Fine setting. I thought about printing the three other shots along with that example, but frankly, you wouldn't be able to detect a nickel's worth of difference between the examples at the size that I could print them on this page. So Figure

Figure 3-11: This subject offered a good test for comparing the Image Quality settings.

3-12 shows just a portion of each shot at a greatly enlarged size. (During the process of converting the RAW image to a print-ready file, I tried to use settings that kept the RAW image as close as possible to its JPEG cousins in all aspects but quality. But any variations in exposure, color, and contrast are a result of the conversion process, not of the format per se.)

Even at the greatly magnified size, it takes a sharp eye to detect the quality differences between the RAW and Fine images. When you carefully inspect the Normal version, you can see some artifacting start to appear, but again,

you have to look closely — and my guess is that you wouldn't spot it at all if you weren't searching for it. Jump to the Basic example, and compression artifacting becomes more obvious.

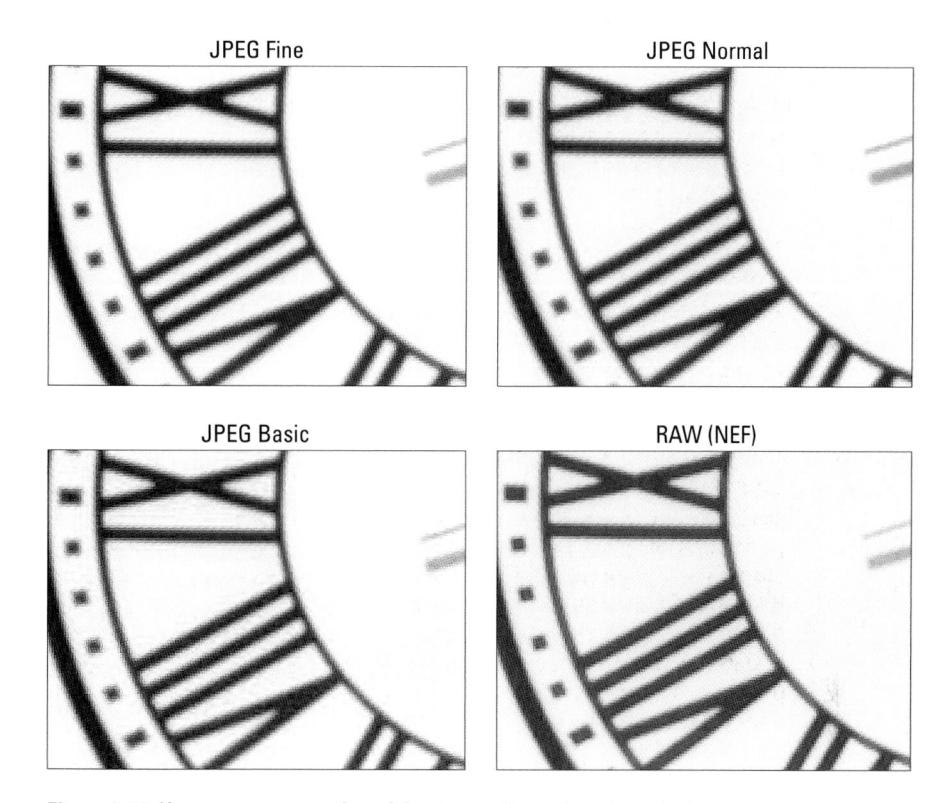

Figure 3-12: Here you see a portion of the tower at greatly enlarged views.

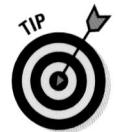

Nikon chose to use the JPEG Normal setting and the Size Priority option as the defaults on the D300s. I suppose that's okay for everyday images that you don't plan to print or display very large. And those settings do enable you to fit more photos on your memory card than the higher-quality JPEG settings.

For my money, though, the file-size benefit you gain when going from Fine to Normal and using the Size Priority option instead of Optimal Quality isn't worth even a little quality loss, especially with the price of camera memory cards getting lower every day. You never know when a casual snapshot is going to turn out to be so great that you want to print or display it large enough that even minor quality loss becomes a concern. And of all the defects that you can correct in a photo editor, artifacting is one of the hardest to remove. So if I shoot in the JPEG format, I stick with Fine and set the JPEG Compression option to Optimal Quality.

I suggest that you do your own test shots, however, carefully inspect the results in your photo editor, and make your own judgment about what level of artifacting you can accept. Artifacting is often much easier to spot when you view images onscreen. It's difficult to reproduce artifacting here in print because the print process obscures some of the tiny defects caused by compression.

If you don't want *any* risk of artifacting, bypass JPEG altogether and change the file type to NEF (RAW) or TIFF. Or consider your other option, which is to record two versions of each file, one RAW and one JPEG. The next sections offer details.

Whichever format you select, be aware of one more important rule for preserving the original image quality: If you retouch pictures in your photo software, don't save the altered images in the JPEG format. Every time you alter and save an image in the JPEG format, you apply another round of lossy compression. And with enough editing, saving, and compressing, you *can* eventually get to the level of image degradation shown in the JPEG example in Figure 3-1, at the start of this chapter. (Simply opening and closing the file does no harm.)

Always save your edited photos in a nondestructive format. You can't save photos in the RAW format, but TIFF is available in most photo editing programs. Should you want to share the edited image online, create a JPEG copy of the TIFF file when you're finished making all your changes. That way, you always retain one copy of the photo at the original quality captured by the camera. Chapter 9 explains how to create a JPEG copy of a photo for online sharing.

NEF (RAW): The purist's choice

The second picture file type you can create on your D300s is called Camera RAW, or just RAW (as in uncooked) for short.

Each manufacturer has its own flavor of RAW. Nikon's is called NEF (for Nikon Electronic Format), so you see the three-letter extension NEF at the end of RAW filenames.

RAW pros and cons

RAW is popular with advanced, very demanding photographers for these reasons:

✓ **Greater creative control:** With JPEG and TIFF, internal camera software tweaks your images, making adjustments to color, exposure, and sharpness as needed to produce the results that Nikon believes its customers prefer. With RAW, the camera simply records the original, unprocessed image data. The photographer then copies the image file to the computer

- and uses special software known as a *RAW converter* to produce the actual image, making decisions about color, exposure, and so on at that point. The upshot is that "shooting RAW" enables you, and not the camera, to have the final say on the visual characteristics of your image.
- ✓ Higher bit depth: Bit depth is a measure of how many distinct color values an image file can contain. When you choose JPEG or TIFF as the Image Quality setting, your pictures contain 8 bits each for the red, blue, and green color components, or channels, that make up a digital image, for a total of 24 bits. That translates to roughly 16.7 million possible colors.

Choosing the RAW setting delivers a higher bit count. You can set the camera to collect 12 bits per channel or 14 bits per channel. (More about that option and some other RAW-related options momentarily.)

Although jumping from 8 to 14 bits sounds like a huge difference, you may not really ever notice any impact on your photos — that 8-bit palette of 16.7 million values is more than enough for superb images. Where having the extra bits can come in handy is if you really need to adjust exposure, contrast, or color after the shot in your photo editing program. In cases where you apply extreme adjustments, having the extra original bits sometimes helps avoid a problem known as *banding* or *posterization*, which creates abrupt color breaks where you should see smooth, seamless transitions. (A higher bit depth doesn't always prevent the problem, however, so don't expect miracles.)

▶ **Better picture quality:** RAW doesn't apply the destructive, lossy compression associated with JPEG, so you don't run the risk of the artifacting that can occur with JPEG. On the D300s, you can choose to apply two alternative types of compression to reduce RAW file sizes slightly, but neither impact image quality to the extent of JPEG compression. Or you can turn off compression altogether.

As with most things in life, RAW isn't without its disadvantages, however. To wit:

- You can't do much with your pictures until you process them in a RAW converter. You can't share them online, for example, or put them into a text document or multimedia presentation. You can print them immediately if you use Nikon ViewNX, but most other photo programs require you to convert the RAW files to a standard format first. So when you shoot RAW, you add to the time you must spend in front of the computer instead of behind the camera lens.
- ✓ To get the full benefit of RAW, you need software other than Nikon ViewNX. The ViewNX software that ships free with your camera does have a command that enables you to convert RAW files to JPEG or to TIFF. However, this free tool gives you limited control over how your original data is translated in terms of color, exposure, and other characteristics which defeats one of the primary purposes of shooting RAW.

Nikon Capture NX 2 offers a sophisticated RAW converter, but it costs about \$180. (Sadly, if you already own Capture NX, you need to upgrade to version 2 to open the RAW files from your D300s.) If you own Adobe Photoshop or Photoshop Elements, however, you're set; both include the converter that most people consider one of the best in the industry. (The Elements version is more limited than the Photoshop version, of course.) Watch the sale ads, and you can pick up Elements for well under \$100. You may need to download an update from the Adobe Web site (www. adobe.com) to get the converter to work with your D300s files.

Of course, the D300s also offers an in-camera RAW converter, found on the Retouch menu. But although it's convenient, this tool isn't the easiest to use because you must rely on the small camera monitor when making judgments about color, exposure, sharpness, and so on. The incamera tool also doesn't offer the complete cadre of features available in Capture NX 2 and other converter software utilities.

Chapter 8 offers more information on the in-camera conversion process and also offers a look at the converter found in ViewNX.

RAW files are larger than JPEGs. The type of file compression that you can enable for RAW files doesn't degrade image quality to the degree you get with JPEG compression, but the tradeoff is a larger file. In addition, Nikon RAW files are always captured at the maximum resolution available on the camera, even if you don't really need all those pixels. For both reasons, RAW files are significantly larger than JPEGs, so they take up more room on your memory card and on your computer's hard drive or other picture-storage device.

Are the disadvantages worth the gain? Only you can decide. But before you make up your mind, refer to Figure 3-12 and compare the JPEG Fine example with its NEF (RAW) counterpart. You may be able to detect some subtle quality differences when you really study the two, but a casual viewer likely would not, especially if shown the entire example images at normal print sizes rather than the greatly magnified views shown in the figure. I took Figure 3-11, for example, using JPEG Fine.

That said, I do shoot in the RAW format when I'm dealing with tricky lighting because doing so gives me more control over the final image exposure. For example, if you use a capable RAW converter, you can specify how bright you want the brightest areas of your photo to appear and how dark you prefer your deepest shadows. With JPEG and TIFF, the camera makes those decisions, which can potentially limit your flexibility if you try to adjust exposure in your photo editor later. And the extra bits in a RAW file offer an additional safety net because I usually can push the exposure adjustments a little further in my photo editor if necessary without introducing banding.

I also go RAW if I know that I'm going to want huge prints of a subject. But keep in mind: I'm a photography geek, I have all the requisite software, and I don't really have much else to do with my time than process scads of RAW images.

Customizing your RAW capture settings

If you opt for RAW, you can control three aspects of how your pictures are captured:

✓ RAW only or RAW+JPEG: You can choose to capture the picture in the RAW format or create two files for each shot, one in the RAW format and another in the JPEG format, as shown in Figure 3-13. The figure shows the list of options that appears when you change the Image Quality setting through the Shooting menu; you can select from the same settings when you adjust the option by pressing the Qual button and rotating the main command dial.

For RAW+JPEG, you can specify whether you want the JPEG version captured at the Fine, Normal, or Basic quality level, and you can set the resolution of the JPEG file through the Image Size option, explained earlier in this chapter. Again, you don't have a choice of Image Size settings for the RAW file; the camera always captures the file at the maximum resolution.

I often choose the RAW+JPEG Fine option when I'm shooting pictures I want to share right away with people who don't have software for viewing RAW files. I upload the JPEGs to a photo-sharing site where everyone can view them and order prints, and then I process the RAW versions of my favorite images for my own use when I have time. Having the JPEG version also enables you to display your photos on a DVD player or TV that has a slot for an SD or Compact Flash memory card — most can't display RAW

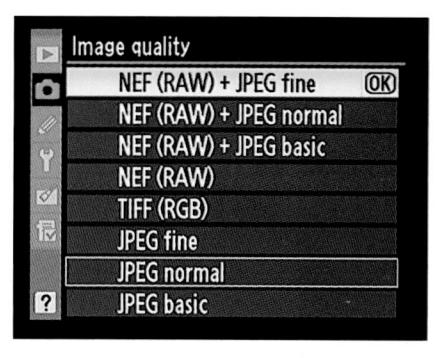

Figure 3-13: You can create two files for each picture, one in the RAW format and a second in the JPEG format.

files but can handle JPEGs. Ditto for portable media players and digital photo frames.

RAW bit depth: You can specify whether you want a 12-bit RAW file or a 14-bit RAW file. More bits means a bigger file but a larger spectrum of possible colors, as explained in the preceding section. You make the call through the NEF (RAW) Recording option on the Shooting menu, as shown in Figure 3-14. Be aware that choosing the 14-bit option reduces the maximum burst rate you can achieve when using either of the continuous Release mode settings to 2.5 frames per second. (Chapter 2 discusses the Release mode options.)

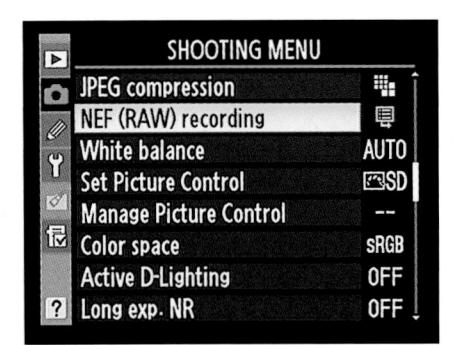

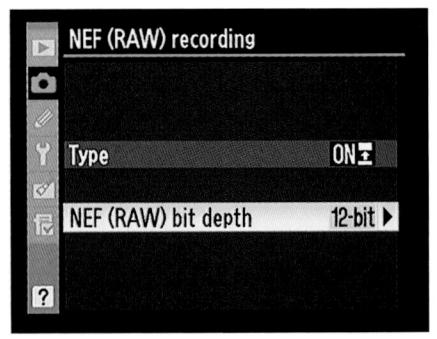

Figure 3-14: Set the file bit depth through this Shooting menu option.

✓ RAW compression: By default, the camera applies lossless compression to RAW files. As its name implies, this type of compression results in no visible loss of image quality and yet still reduces file sizes by about 20 to 40 percent. In addition, the compression is reversible, meaning that any quality loss that does occur through the compression process can be undone at the time you process your RAW images.

You can choose from two other options, again through the NEF (RAW) Recording option on the Shooting menu. After selecting that option, choose Type, as shown on the left in Figure 3-15, to display the screen shown on the right. The Compressed setting achieves a greater degree of file-size savings, shrinking files by about 40 to 55 percent. Nikon promises that this setting has "almost no effect" on image quality. But the compression in this case is not reversible, so if you do experience some quality loss, there's no going back. The third option, Uncompressed, applies no compression at all to your file, resulting in the largest files of the three settings but no chance of any compression quality loss.

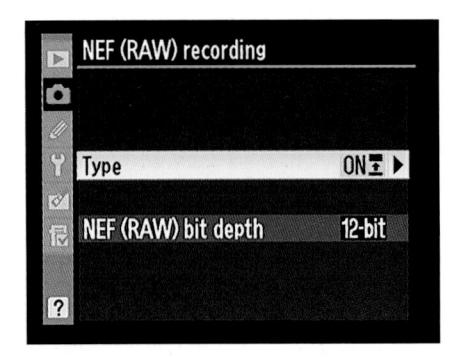

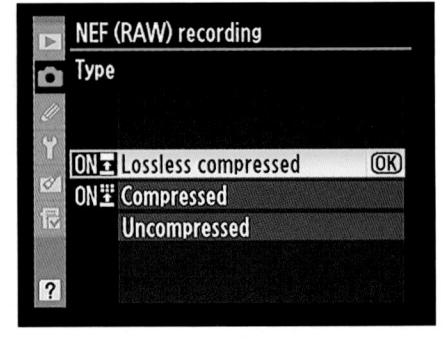

Figure 3-15: You can choose to apply one of two types of compression or leave RAW files uncompressed.

Together, the choices you make for these three settings make a big difference in the size of your picture files and, thus, your memory card capacity. If you combine the 14-bit file type with the Uncompressed setting, a single picture file consumes about 25.4MB of card space. A 12-bit file captured at the compressed setting, by contrast, is only 10.5MB — still large, but less than half that of the "ultimate RAW" 14-bit, uncompressed file. And if you choose RAW+JPEG capture, well, just add the size of the JPEG file into the equation. If you choose the 14-bit and Uncompressed settings for the RAW file and create the second file as a JPEG Fine at the highest resolution, for example, the combined size of the RAW plus JPEG files is (gulp) 31.4MB (25.4MB for the RAW file plus 6MB for the Large/Fine JPEG).

For my purposes, the default RAW settings — 12-bit RAW with Lossless Compression — serve me well. And frankly, I doubt that too many people could perceive much difference between a photo captured at that setting and a 14-bit, uncompressed picture. But if you are using your D300s for commercial photography — whether you shoot weddings, do high-end studio work, or shoot fine-art photography for sale — you may feel more comfortable knowing that you're capturing files at the absolute maximum quality and bit depth. The higher bit depth also may make sense if you're shooting in really difficult lighting because, again, it gives you the potential of capturing a broader range of colors and tones.

If you choose to create both a RAW and JPEG file, note a couple of things:

- If you're using only one memory card, you see the JPEG version of the photo during playback. However, the Image Quality data that appears with the photo reflects your capture setting (RAW+Basic, for example). To use the in-camera RAW processing option on the Retouch menu, display the JPEG image and then proceed as outlined in Chapter 8.
- ✓ If both the JPEG and RAW files are stored on the same memory card, deleting the JPEG image also deletes the RAW copy. See Chapter 1 to find out how you can send the two versions to separate memory cards instead. If you go that route, deleting one file doesn't delete the other. (Either way, after you transfer the two files to your computer, deleting one doesn't affect the other.)

Chapter 4 explains more about viewing and deleting photos.

TIFF: A mixed bag

Whereas most cameras limit you to a choice of RAW or JPEG files, the D300s gives you a third format option, TIFF, as shown in Figure 3-16. The acronym stands for *tagged image file format*, and it's pronounced *tiff*, as in tiny spat. The RGB next to the format name indicates that the file is being created using the RGB (red-green-blue) color model, explained in Chapter 6. JPEG and RAW files are also RGB files, and no, I can't tell you why the designation appears only with the TIFF option in the menus. However, I can tell you that when you

view your pictures during playback, the file type data shows RGB instead of TIFF.

As with RAW and JPEG, TIFF has its good side and bad side:

The good: Like RAW, TIFF doesn't involve the destructive compression you get with JPEG. In fact, absolutely no compression is applied to TIFF files. That translates to better image quality than JPEG. Unlike RAW files, though, TIFF files don't have to

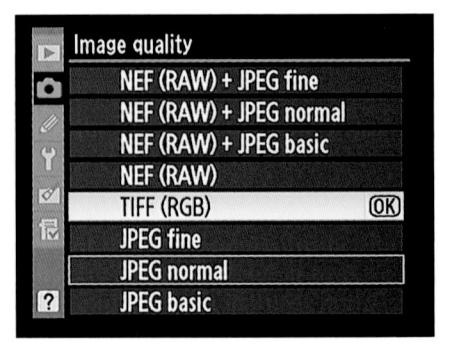

Figure 3-16: TIFF is the standard format used in print publishing.

be converted to a standard format because TIFF *is* a standard format. In fact, it's been the leading format for files destined for print for many years. So you can print, view, and edit TIFF files in most photo programs immediately after you download them from the camera. Most retail printing outlets also can print TIFF files. The only thing you can't do with a TIFF file right out of the camera is view it in an e-mail program or Web browser — for that, you need JPEG.

✓ The bad: TIFF files are huge. Wait — make that huuggggge. Captured at the highest resolution setting (Large), a TIFF file weighs in at 36.6MB! That's significantly larger than the 25.4MB required for a RAW file, even when you use the highest RAW bit depth and apply no compression to the file.

You can reduce the TIFF file size by setting the Image Size to the lowest resolution setting (Small), in which case your final file size is 9.3MB. However, you can't modify file sizes by using different compression options as you can for RAW and JPEG.

The D300s also caps out bit depth for TIFF files at 8 bits per channel, the same as for JPEG files. So not only do you get larger files than with RAW, but you don't even gain the expanded color spectrum of a 12- or 14-bit RAW for your trouble.

So who exactly is this format designed to please? Well, I can think of a couple of scenarios that would make TIFF a good choice:

- ✓ You're shooting for a publication or client that requires you to submit files in the TIFF format, and you're on a tight deadline. Instead of taking the time to download your RAW or JPEG originals and then convert them to TIFF, you can send the TIFF files directly.
- You're after the slightly better image quality provided by TIFF but you don't have the time, interest, or software required to process RAW files.

You should know, however, that any quality differences between a picture shot at the highest quality JPEG settings and a TIFF file are usually pretty difficult to detect — although again, the larger you print your files, the more even the slightest quality difference becomes important. Because I don't find the quality difference worth the substantially larger file sizes, I don't use this format unless I need that TIFF file right away, with no time to get to the computer.

Summing up: My take on which format to use when

At this point, you may find all this technical goop a bit much — I recognize that panicked look in your eyes — so allow me to simplify things for you. Until you have the time or energy to completely digest all the ramifications of JPEG versus RAW versus TIFF, here's a quick summary of my thoughts on the matter:

- ✓ If you require the absolute best image quality and have the time and interest to do the RAW conversion, shoot RAW. Set the RAW file options (bit depth and compression type) to suit your specific needs, but remember that the maximum bit depth and minimum compression mean really big files. So you'll need lots of storage space both on your memory cards and on your computer's hard drives. Again, I opt for 12-bit RAW files with the default compression setting (Lossless Compressed). See Chapter 8 for more information on the conversion process.
- If great photo quality is good enough for you, you don't have wads of spare time, or you aren't that comfortable with the computer, stick with JPEG Fine and set the JPEG Compression option on the Shooting menu to Optimal Quality.
- ✓ If you don't mind the added file-storage space requirement and want the flexibility of both formats, choose RAW+JPEG. If you need your JPEGs to exhibit the best quality, go with RAW+JPEG Fine.
- ✓ If you go with JPEG only, stay away from JPEG Normal and Basic. The tradeoff for smaller files isn't, in my opinion, worth the risk of compression artifacts. As with my recommendations on image size, this fits the "better safe than sorry" formula: You never know when you may capture a spectacular, enlargement-worthy subject, and it would be a shame to have the photo spoiled by compression defects. If you select RAW+JPEG, of course, this isn't as much of an issue because you always have the RAW version as backup if you aren't happy with the JPEG quality.
- If you want top quality but don't want to deal with RAW processing, you can opt for TIFF. But again, stock up on memory cards and extra hard drive storage space at almost 40MB per picture file, you'll run out of space quickly.

Do you need high-speed memory cards?

Memory cards are categorized not just by their storage capacity, but also by their data-transfer speed. But sorting out the numbers requires a little background:

- CompactFlash (CF) cards are rated according to the same standards used for CD-ROM recording devices, where speed is based on transferring a 150K (kilobyte) chunk of data. A rating of 1x equals 150K (kilobytes) per second. As I write this, a card with a max speed rating of 666X has just been announced, although is not yet on the market.
- SD and SDHC cards sometimes also use the "X" speed ratings but more recently are categorized according to one of three speed classes, Class 2, Class 4, and Class 6, with the number indicating the minimum number of megabytes (roughly 1,000 kilobytes) transferred per second. A Class 2 card, for example, has a minimum transfer speed of 2 megabytes, or MB, per second.

Of course, with the speed increase comes a price increase. Should you make the extra investment? It depends. Photographers who shoot action benefit most from high-speed cards — the faster data-transfer rate helps the camera record shots at its maximum speed. Users who shoot at the highest resolution or prefer the NEF (RAW) file format also gain from high-speed cards; both options increase file size and, thus, the time needed to store the picture on the card. (See Chapter 3 for details.) Finally, you typically get better movie-recording performance from high-speed cards. As for picture downloading, how long it takes for files to shuffle from card to computer depends not just on card speed, but also on the capabilities of your computer and, if you use a memory card reader to download files, on the speed of that device. (Chapter 8 covers the file-downloading process.)

Long story short, if you want to push your camera to its performance limits, a high-speed card is worth considering, assuming budget is no issue. Otherwise, just about card currently on the market you can buy today should be more than adequate for most photographers (assuming that you're buying new, as opposed to snapping up some 5-year old cards being sold in an online auction).

Monitor Matters: Picture Playback, Live View, and Movie Recording

In This Chapter

- Exploring picture playback functions
- Deciphering the picture information displays
- ▶ Deleting bad pictures and protecting great ones
- Using the monitor as viewfinder in Live View mode
- Recording and editing digital movies

ithout question, my favorite thing about digital photography is being able to view my pictures on the camera monitor the instant after I shoot them. No more guessing whether I captured the image I wanted or I need to try again, as in the film era. And no more wasting money on developing and printing pictures that stink.

Of course, with the D300s, you can use the monitor not only to review your photos, but also to *preview* them. That is, if you turn on Live View shooting, you can use the monitor instead of the viewfinder to compose your shots. And not just for still pictures: You can record short digital movies, too, complete with sound.

Because all these functions involve some of the same buttons, bells, and whistles, I cover them together in this chapter. In addition, this chapter explains how to hide or delete pictures that you don't like and protect the ones you

love from accidental erasure. (Be sure to also visit Chapter 9, which covers some additional ways to view your images, including how to create slide shows and display your photos and movies on a television screen.)

Customizing Basic Playback Options

You can control many aspects of picture playback on the D300s. Later sections show you how to choose what type of data appears with your pictures, how to display multiple images at a time, and how to magnify an image for a close-up look. But first, the next few sections explain options that affect overall playback performance, including how long your pictures appear onscreen, how they're oriented on the monitor, and what functions you can perform with the Multi Selector.

Adjusting playback timing

You can adjust the length of time the camera displays your images on the monitor as follows:

Adjust the timing of automatic playback shutoff. After you press the Playback button to begin reviewing your pictures, the monitor turns off automatically if 10 seconds go by without any further button presses. I find that playback time maddeningly brief when I'm trying to study a picture. Fortunately, you can adjust the shutoff timing through the Monitor Off Delay option, found in the Timers/AE Lock section of the Custom Setting menu and shown on the left in Figure 4-1. Choose Playback, as shown on the right, to access the timing options, which range from four seconds to 10 minutes. (If you're powering the camera with the optional AC adapter, the monitor shutdown occurs at the 10-minute mark regardless of any settings you select from the Monitor Off Delay menu.)

Figure 4-1: You can control how long pictures are displayed before automatic monitor shutdown occurs.

- Enable instant review. You can tell the camera to display each image for a quick review immediately after you shoot it. Because any monitor use is a strain on battery power, this feature is disabled by default; you enable it through the Image Review option on the Playback menu, shown in Figure 4-2.
- Adjust the length of the instantreview period. By default, the instant-review period lasts four seconds, but you can adjust this timing through the Monitor

Figure 4-2: Head for the Playback menu to enable or disable instant review.

Off Delay option shown in Figure 4-1 as well. Just choose Image Review instead of Playback when you get to the right screen in the figure. Again, settings range from four seconds to ten minutes.

Enabling automatic picture rotation

When you take a picture, the camera can record the image *orientation* — whether you held the camera normally, creating a horizontally oriented image, or turned the camera on its side to shoot a vertically oriented photo. This bit of data is simply added into the picture file.

During playback, the camera can then read the data and automatically rotate the image so that it appears in the upright position, as shown on the left in Figure 4-3. The image is also automatically rotated when you view it in Nikon ViewNX, Capture NX 2, and some other photo programs that can interpret the data.

Figure 4-3: You can display vertically oriented pictures in their upright position (left) or sideways (right).

Official photo lingo uses the term *portrait orientation* to refer to vertically oriented pictures and *landscape orientation* to refer to horizontally oriented pictures.

On the D300s, you set up your rotation wishes through the following two menu options, both shown in Figure 4-4:

- ✓ **Auto Image Rotation:** This option, on the Setup menu, determines whether the orientation data is included in the picture file. The default setting is On; select Off to leave the data out.
- ✓ Rotate Tall: Found on the Playback menu, this option controls whether the camera pays attention to the orientation data. The default setting is Off. Select On, as shown in the figure, if you want the camera to rotate the image during playback.

Note that regardless of these settings, your pictures aren't rotated during the instant review period. Also, be aware that shooting with the lens pointing directly up or down sometimes confuses the camera, causing it to record the wrong data in the file.

Customizing the Multi Selector's role during playback

At the camera's default settings, the Multi Selector performs these functions after you press the Playback button to view your pictures:

- Pressing right or left scrolls from one picture to the next.
- Pressing up or down changes the Information display mode, which controls what shooting data appears with the image.
- Pressing the center button toggles the display from showing a single image to thumbnail views of multiple photos.

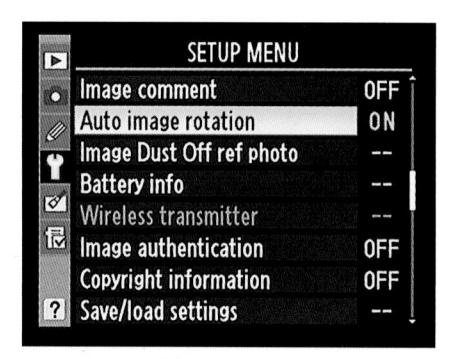

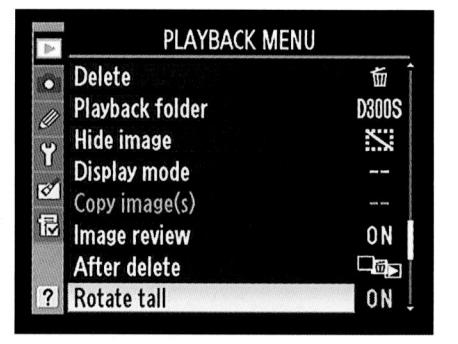

Figure 4-4: Visit the Setup and Playback menus to enable or disable image rotation.

The rest of this chapter assumes that you stick with these defaults. But you do have the option of customizing the Multi Selector's role through the Custom Setting menu. Choose Controls, as shown on the left in Figure 4-5, and then press OK to display the right screen. You can then customize the playback functions as follows:

- ✓ **Swap the right/left and up/down functions.** Want to scroll through pictures by pressing up and down instead of left and right? You can accomplish this by setting the Photo Info/Playback option, highlighted on the right in Figure 4-5, to On. You then change the Information display mode by pressing right/left.
- Change the function of the center button. To choose the role of the center button, use the Multi Selector Center Button option (the Custom Setting menu item two steps above the Photo Info/Playback option). After you choose that menu item and press OK, you see the left screen in Figure 4-6. Highlight Playback Mode and press OK to get to the right screen, where you can assign the button function.

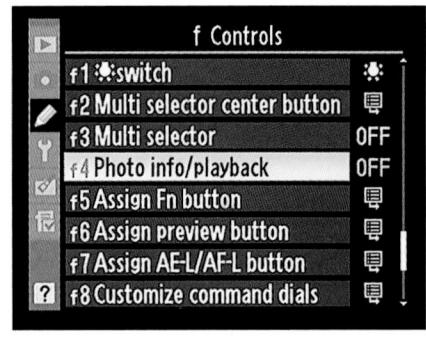

Figure 4-5: Use the Photo Info/Playback option to control the functions of the left/right and up/down buttons.

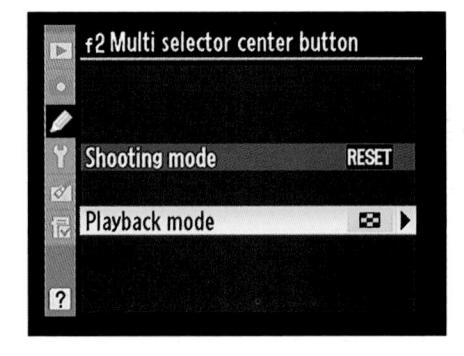

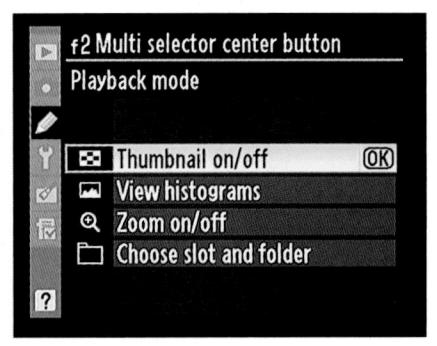

Figure 4-6: This option sets the playback purpose of the center button.

Here's what pressing the button does at each setting:

- *Thumbnail On/Off*: Toggles between thumbnails display to single-picture display (the default setting).
- *View Histograms:* Temporarily overlays a histogram over your image. See the upcoming section "RGB Histogram mode" for a look at this feature, which is my preferred use of the button.
- Zoom On/Off: Displays a magnified view of the photo that is automatically centered on the focus point you used when taking the shot. You also can magnify a photo by pressing the Zoom In button, as explained in the later section "Zooming in for a closer view." But if you want to use the Multi Selector button for this purpose, highlight Zoom On/Off and then press the Multi Selector right to display a screen where you set the magnification level (low, medium, or high) of the zoomed view.
- Choose Slot and Folder: Displays a screen where you can select a memory card and folder to view. Again, you can accomplish the same thing in other ways; see the next section as well as see "Viewing multiple images at a time" for details.

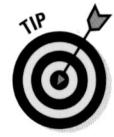

You also can change the role that the center button plays during shooting; Chapter 10 has details on those options.

Viewing Images in Playback Mode

To review your photos, take these steps:

1. Select the image folder you want to view.

Your D300s organizes pictures automatically into folders that are assigned generic names: 100D300s, 101D300s, and so on. You can see the name of the current folder by looking at the Active Folder option on the Shooting menu. (The default folder name appears as just 100 on the menu.) You also can create custom folders through a process outlined in Chapter 10.

To choose the folder you want to view, open the Playback menu and select the Playback Folder option, as shown on the left in Figure 4-7, to access these three options:

• *D300s (default setting):* Displays all pictures shot with your camera, regardless of their folder location. If you're using two memory cards, pictures on both cards are displayed.
- All: Displays all pictures in all folders, even those taken with other cameras (as long as they are in a format the camera can display — JPEG, TIFF, or NEF). Again, pictures from both memory cards are displayed.
- *Current:* Displays images contained in the active folder only. The camera looks to the Active Folder option on the Shooting menu to determine which folder's photos to display.

Figure 4-7: Specify which folder you want to view through this option.

2. Press the Playback button, labeled in Figure 4-8.

The monitor displays the last picture you took, along with some picture data, such as the frame number of the photo and the memory card that holds the photo, as shown in the figure. To find out how to interpret the picture information and specify what data you want to see, see the upcoming section "Viewing Picture Data."

3. To scroll through your pictures, press the Multi Selector right or left.

This assumes the default settings are used for the playback functions of the Multi Selector, as explained in the preceding section.

4. To return to picture-taking mode, press the Playback button again or press the shutter button halfway and then release it.

These steps assume that the camera is currently set to display a single photo at a time, as shown in Figure 4-8. You can also display multiple images at a time, as explained next.

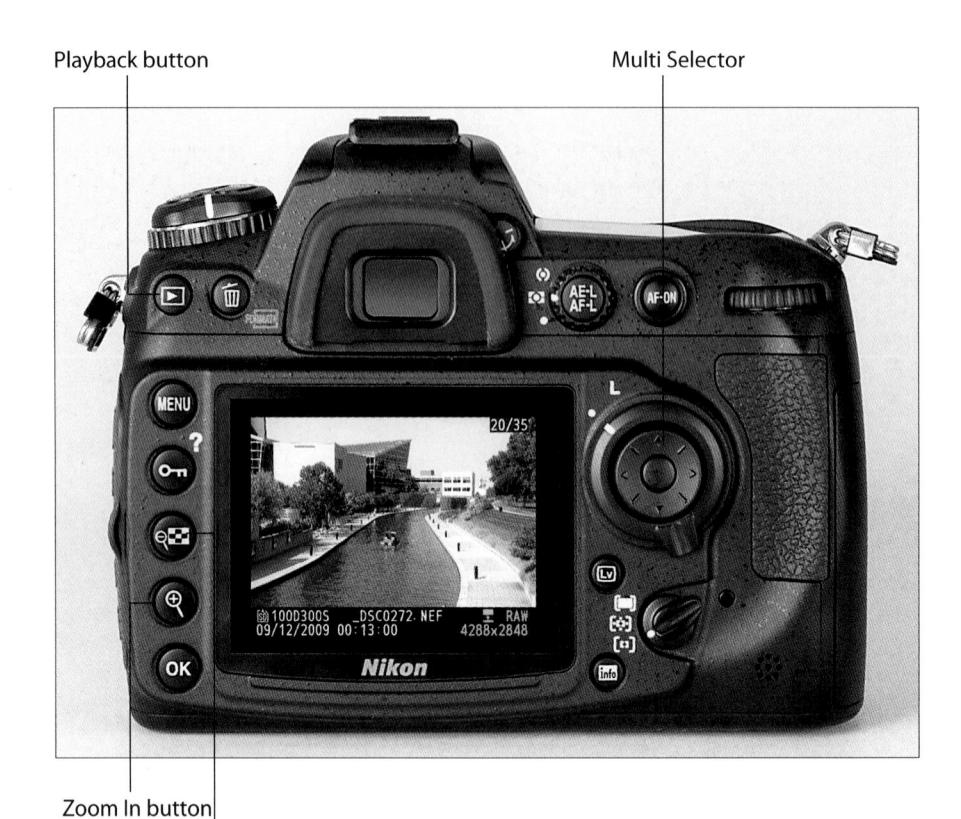

Zoom Out/Thumbnail button

Figure 4-8: Use these controls to navigate through your photos.

Viewing multiple images at a time

Along with viewing images one at a time, you can choose to display 4, 9, or 72 thumbnails, as shown in Figure 4-9. Use these techniques to change to thumbnails view and navigate your photos:

✓ Display thumbnails. Press the Zoom Out button once to cycle from single-picture view to 4-thumbnail view, press again to shift to 9-picture view, and press once more to bring up those itty-bitty thumbnails featured in 72-image view.

- ✓ **Display fewer thumbnails.** Press the Zoom In button. Again, your first press takes you from 72 thumbnails to 9, your second press to 4 thumbnails, and your third press returns you to single-image view.
- Jump from any thumbnail display to full-frame view. Press the OK button.

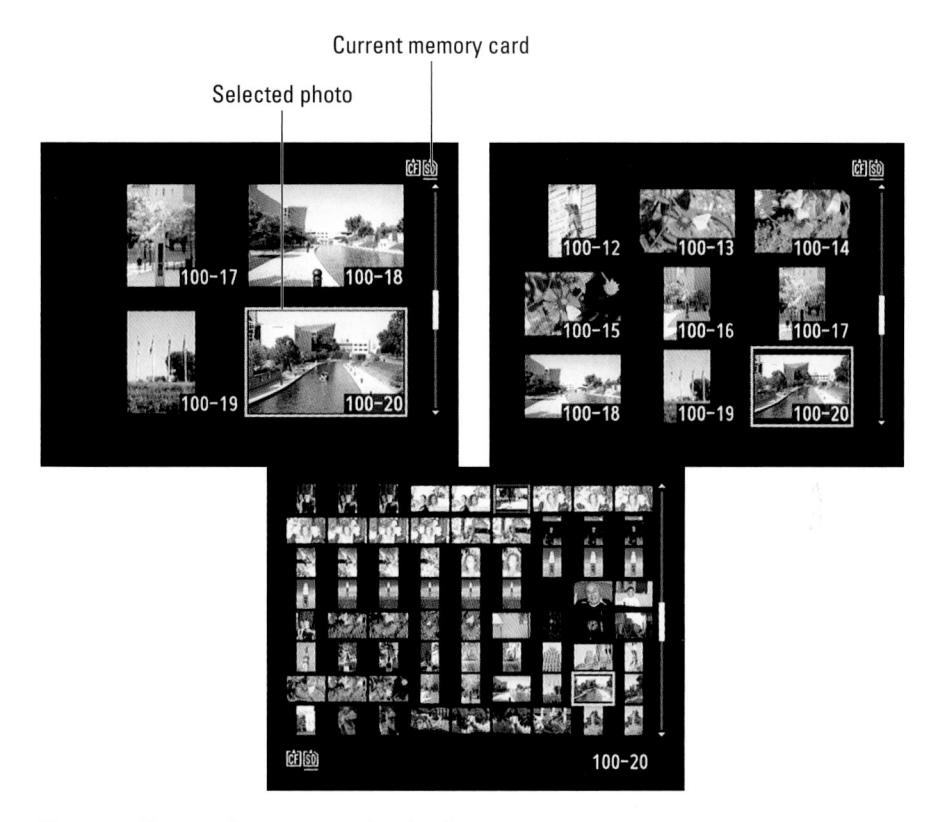

Figure 4-9: You can view 4, 9, or 72 thumbnails at once.

- ✓ Toggle between thumbnails view and full-frame view. By default, the center button of the Multi Selector performs this function. However, you can set the button to perform another function during picture playback, as explained in the earlier section "Customizing the Multi Selector's role during playback."
- ✓ **Scroll the display.** Press the Multi Selector up and down to scroll to the next or previous screen of thumbnails. Again, this assumes the default setup for the Multi Selector's playback functions.

- If you're using dual memory cards, you can tell which card contains the picture you're viewing in the thumbnails display by looking at the card icons, labeled in Figure 4-9. The icon for the current card is yellow. Note that the location of the icons depends on how many thumbnails you're viewing. In the 72-thumbnail view, they're in the lower-left corner.
- ✓ **Select an image.** To perform certain playback functions, such as deleting a photo or protecting it, you first need to select an image. A yellow box surrounds the currently selected image, as shown in Figure 4-9. To select a different image, use the Multi Selector to move the highlight box over the image.

Jump to the first picture in a folder. After you bring up the 72-thumbnail display, you can press the Zoom Out button one more time to display the screen shown in Figure 4-10. From there, you can select a memory card, press OK, and then select a specific folder. Press OK once more, and the first picture contained in that folder becomes selected automatically.

You have the option of using the center button of the Multi Selector to bring up the card/ folder selection screen if you don't want to use it to toggle

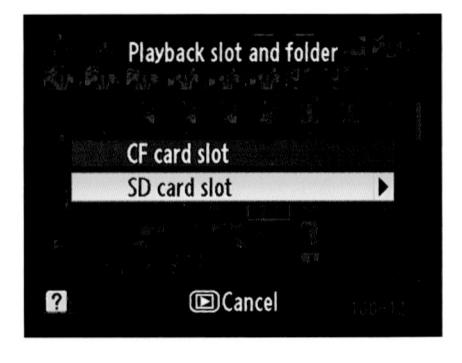

Figure 4-10: From the 72-thumbnail display, press the Zoom Out button to access this screen, which enables you to jump to a different card slot or folder.

between full frame and thumbnails view. Again, see the aforementioned section about customizing the Multi Selector for help.

Either way, the folders that appear when you display the card/folder selection screen shown in Figure 4-10 depend on the setting of the Playback Folder option on the Playback menu. See Step 1 in the preceding section for details. And check out Chapter 10 to find out how to set up custom folders.

Zooming in for a closer view

After displaying a photo in single-frame view, you can magnify it to get a close-up look at important details, such as whether someone's eyes are closed in a portrait. Here's the scoop:

Zoom in. Press the Zoom In button. You can magnify the image to a maximum of 13 to 27 times its original display size, depending on the resolution (pixel count) of the photo. Just keep pressing the button until you reach the magnification you want. Notice the symbol on the button: the magnifying glass with the plus sign, indicating zoom in.

As detailed in the section "Customizing the Multi Selector's role during playback," you can set the center button to immediately zoom your view to one of three preset magnification levels. The advantage of this option is that the display is automatically centered on the focus point you used when taking the picture, whereas pressing the Zoom In button zooms to the center of the frame. If you do use the center button to zoom, know that after you press the button to get to your selected magnification level, you can zoom in further by using the Zoom In button.

✓ **Zoom out.** To zoom out to a reduced magnification, press the Zoom Out button. This button also sports the magnifying glass symbol, but this time with a minus sign to indicate that it reduces the display size. That

little grid-like thingy next to the magnifying glass reminds you that the button also comes into play when you want to go from full-frame view to one of the thumbnail views.

✓ View another part of the mag**nified picture.** When an image is magnified, a little navigation thumbnail showing the entire image appears briefly in the lower-right corner of the monitor. For example, Figure 4-11 shows a zoomed view of the scene shown earlier, in Figure 4-8. The yellow outline in this picture-in-picture

Figure 4-11: Use the Multi Selector to move the yellow outline over the area you want to inspect.

image indicates the area that's currently consuming the rest of the monitor space. Use the Multi Selector to scroll the yellow box and display a different portion of the image. After a few seconds, the navigation thumbnail disappears; just press the Multi Selector in any direction to redisplay it.

it works correctly, this is a pretty great tool for checking for closed

eyes, red-eye, and, of course,

spinach in the teeth.

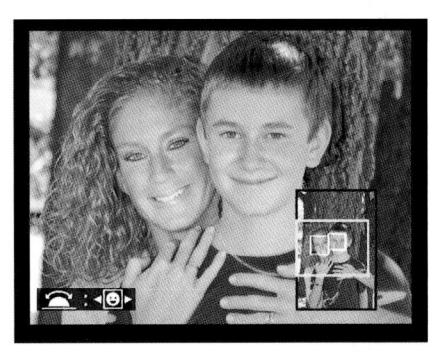

Figure 4-12: Rotate the sub-command dial to jump between faces in a portrait.

- ✓ View more images at the same magnification. Here's another neat trick: While the display is zoomed, you can rotate the main command dial to display the same area of the next photo at the same magnification. So if you shot the same subject several times, you can easily check how the same details appear in each one.
- ✓ **Return to full-frame view.** When you're ready to return to the normal magnification level, you don't need to keep pressing the Zoom Out button until you're all the way zoomed out. Instead, just press the OK button. The center button of the Multi Selector also returns you to the standard, full-frame view, regardless of what function you assign the button for playback.

Viewing Picture Data

In single-image picture view, you can choose from different photo information modes, each of which presents a different set of shooting data along with the image.

Upcoming sections provide you with a decoder ring to the details you see in each display mode. First, though, a little setup work is in order, as detailed next.

Enabling hidden data-display options

By default, three of the five picture-data display modes are disabled, as is an option that enables you to view the focus point you used when taking the picture. You can access these hidden options through the Display Mode option on the Playback menu, as shown in Figure 4-13.

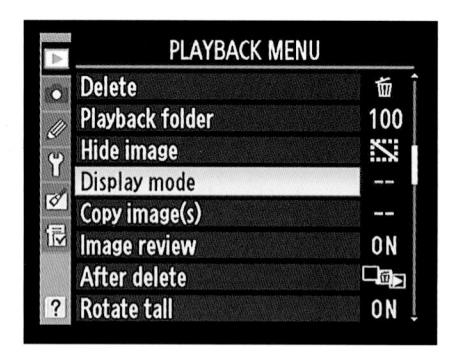

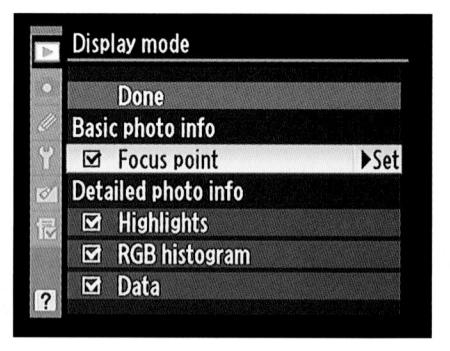

Figure 4-13: These display options are disabled by default.

The options work as follows:

Focus Point: When this option is turned on, a little red rectangle appears to mark the focus point, as shown in Figure 4-14. You also see the same brackets that represent the autofocus area in the viewfinder. These focus indicators appear only when you use the Information display mode shown in the figure — File Information mode, covered in the next section. They aren't displayed if you focused manually or used the

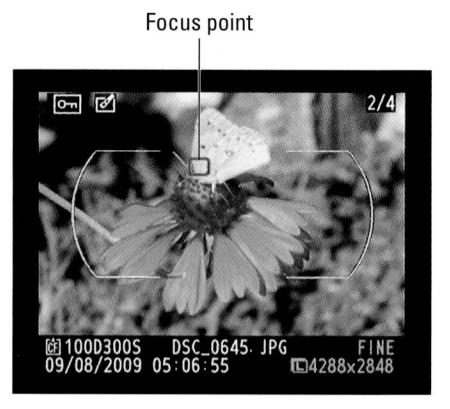

Figure 4-14: You can view the focus point you used when taking the photo.

- Auto Area AF-area mode setting. I find the focus marks distracting, but make your own call.
- Highlights/RGB Histogram/Data: These options control the three display modes that are hidden by default, all covered later in this chapter.

A check mark in the box next to the option means that the feature is turned on. In Figure 4-13, for example, all four options are enabled. To toggle the check mark on and off, highlight the option and then press the Multi Selector right.

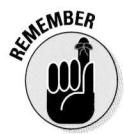

After turning on the options you want to use, be sure to highlight Done (at the top of the screen) and press OK again. Otherwise, the settings you selected don't stick.

The next sections explain exactly what details you can glean from each display mode. I present them here in the order they appear if you cycle through the modes by pressing the Multi Selector down. You can spin through the modes in the other direction by pressing the Multi Selector up.

File Information mode

In the File Information display mode, the monitor displays the data shown in Figure 4-15. Here's the key to what information appears, starting at the top of the screen and working down:

Figure 4-15: In File Information mode, you can view these bits of data.

- **Protect Status:** A little key icon indicates that you used the camera's file-protection feature to prevent the image from being erased when you use the camera's Delete function. See "Protecting Photos," later in this chapter, to find out more. (*Note:* Formatting your memory card, a topic discussed in Chapter 1, does erase even protected pictures.) This area appears empty if you didn't apply protection.
- **Retouch Indicator:** This icon appears if you used any of the Retouch menu options to alter the image. (I cover most Retouch features in Chapter 11.) Again, no icon means that you didn't retouch the photo.
- **Frame Number/Total Pictures:** The first value here indicates the frame number of the currently displayed photo; the second tells you the total number of pictures on the memory card. In Figure 4-15, for example, the image is number 2 out of 4.
- Focus point: If you enable the Focus Point feature, as outlined in the preceding section, you see the red focus-point indicator and the autofocus area brackets, as shown in Figure 4-14. But note that for pictures that you took using continuous-servo autofocus, you see the point only if you set the AF-area mode to Single Point or Dynamic Area. (Chapter 6 explains all this autofocus stuff.) And for pictures taken with manual focusing, the focus point doesn't appear during playback at all.
- ✓ Card and Folder Name: Here you can see which card and folder contains the photo. Folders are named automatically by the camera unless you create custom folders, an advanced trick you can explore in Chapter 10. The first camera-created folder is named 100D300s. Each folder can contain up to 9999 images; when you exceed that limit, the camera creates a new folder and assigns the next folder number: 101D300s, 102D300s, and so on.
- Filename: The camera also automatically names your files. Filenames end with a three-letter code that represents the file format, which is either JPG (for JPEG), TIF (for TIFF), or NEF (for Camera RAW) for still photos. Chapter 3 discusses these formats. If you record a movie (a project you can explore near the end of this chapter), the file extension is AVI, which represents a digital-movie file format. If you create a dust-off reference image file, an advanced feature designed for use with Nikon Capture NX 2, the camera instead uses the extension NDF. (Because this software must be purchased separately, I don't cover it or the dust-off function in this book.)

The first four characters of filenames also vary. Here's what the possible codes indicate:

- DSC_: This code means you captured the photo at the default Color Space setting, sRGB. You can investigate this option in Chapter 6.
- _DSC: If you change the Color Space setting to Adobe RGB, the underscore character comes first. (The exception is dust-off reference photos, which don't use the underscore.)

- Each image is also assigned a four-digit file number, starting with 0001. When you reach image 9999, the file numbering restarts at 0001, and the new images go into a new folder to prevent any possibility of overwriting the existing image files. For more information about file numbering, see the Chapter 1 section that discusses the File Number Sequence option.
- ✓ **Date and Time:** Just below the folder and filename info, you see the date and time that you took the picture. Of course, the accuracy of this data depends on whether you set the camera's date and time values correctly, which you do via the Setup menu. Chapter 1 has details.
- ✓ Image Authentication: If you enable this feature, available on the Setup menu, you see the little stamp icon shown in Figure 4-15. Because this option relates to an optional Nikon software package, I don't cover it in this book.
- ✓ Image Quality: Here you can see which Image Quality setting you used when taking the picture. Image Quality determines the file format. Again, Chapter 3 has details, but the short story is this: Fine, Normal, and Basic are the three JPEG recording options, with Fine representing the highest JPEG quality. The word RAW indicates that the picture was recorded in the Nikon Camera RAW format, NEF. And for TIFF files, you see the letters RGB (which stand for red, green, blue, the primary color components of a digital image).
- ✓ Image Size: This value tells you the image resolution, or pixel count. See Chapter 3 to find out about resolution.

Highlights display mode

One of the most difficult photo problems to correct in a photo editing program is known as *blown highlights* in some circles and *clipped highlights* in others. In plain English, both terms mean that *highlights* — the brightest areas of the image — are so overexposed that areas that should include a variety of light shades are instead totally white. For example, in a cloud image, pixels that should be light to very light gray become white due to overexposure, resulting in a loss of detail in those clouds.

In Highlights display mode, areas that the camera thinks may be overexposed blink in the camera monitor. To fully understand all the features of this mode, though, you need to know a little about digital imaging science.

As mentioned earlier, digital images are called *RGB images* because they are created out of three primary colors of light: red, green, and blue. In Highlights mode, you can display the exposure warning for all three color components — sometimes called color *channels* — combined or view the data for each individual channel.

When you look at the brightness data for a single channel, though, greatly overexposed areas don't translate to white in photos — rather, they result in a solid blob of some other color. I don't have space in this book to provide a full lesson in RGB color theory, but the short story is that when you mix together red, green, and blue light, and each component is at maximum brightness, you get white. Zero brightness in all three channels gives you black. But if you have maximum red and no blue or green, you have fully saturated red. If you mix together two channels at maximum brightness, you also get full saturation. For example, maximum red and blue produce fully saturated magenta. And wherever colors are fully saturated, you can lose picture detail. For example, a rose petal that should have a range of tones from light to dark red may instead be bright red throughout.

The moral of the story is that when you view your photo in single-channel display, large areas of blinking highlights in one or two channels indicate that you may be losing color details. Blinking highlights that appear in the same spot in all three channels indicate blown highlights — again, because when you have maximum red, green, and blue, you get white. Either way, you may want to adjust your exposure settings and try again.

Okay, with today's science lesson out of the way, Figure 4-16 shows you how the screen looks when you view a picture in Highlights display mode. Remember, if you want to use this mode, follow the instructions in the "Enabling hidden data-display options" section, earlier in this chapter, to enable it.

In the lower-left corner of the display, the letters that appear yellow tell you whether you're looking at a single channel (R, G, or B) or the three-channel, composite display (RGB). The latter is selected in the figure. To cycle between the settings, press the Zoom Out button as you press the Multi Selector right or left.

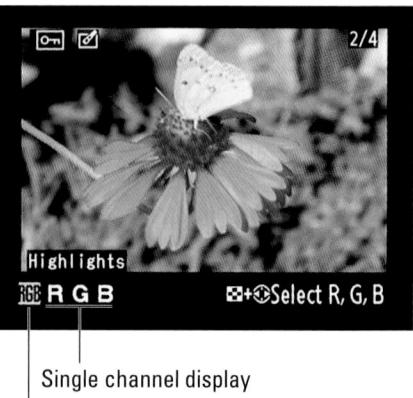

onigie chamier disp

Composite display

Figure 4-16: In Highlights mode, blinking areas indicate blown highlights.

Along with the blinking highlight warning, Highlights display mode presents the standard bits of information in this mode: the Protect Status, Retouch Indicator, and File Number/Total Pictures values, all explained in the preceding section. The label *Highlights* also appears to let you know the current display mode, as shown in Figure 4-16.

RGB Histogram mode

Press the Multi Selector down to shift from Highlights mode to this mode, which displays your image in the manner shown in Figure 4-17. (Remember: You can view your picture in this mode only if you enable it via the Display Mode option on the Playback menu.)

This mode is sort of like Highlights mode on steroids. As with Highlights mode, you can display the blinking warning in the image thumbnail and view the warning for either the composite image (RGB) or each individual channel. Again, press the Zoom Out button and press the Multi Selector right to cycle between the single-channel and multichannel views.

Underneath the image thumbnail, you see just a few pieces of data. As with File Information mode, you see the Protect Status and Retouch Indicator icons if you used those features. Beneath that, you see the White Balance settings used for the shot. (White balance is a color feature you can explore in Chapter 6.) The first value tells you the setting (Auto, in the figure), and the two number values tell you whether you fine-tuned that setting along the amber to blue axis (first value) or green to magenta axis (second value). Zeros, as in the figure, indicate no fine-tuning.

In addition, you get those chart-like thingies, called *histograms*. You actually get two types of histograms: The top one is a Brightness histogram and reflects the composite, three-channel image data. The three others represent the data for the single red, green, and blue channels. This trio is sometimes called an RGB Histogram, thus the display mode name.

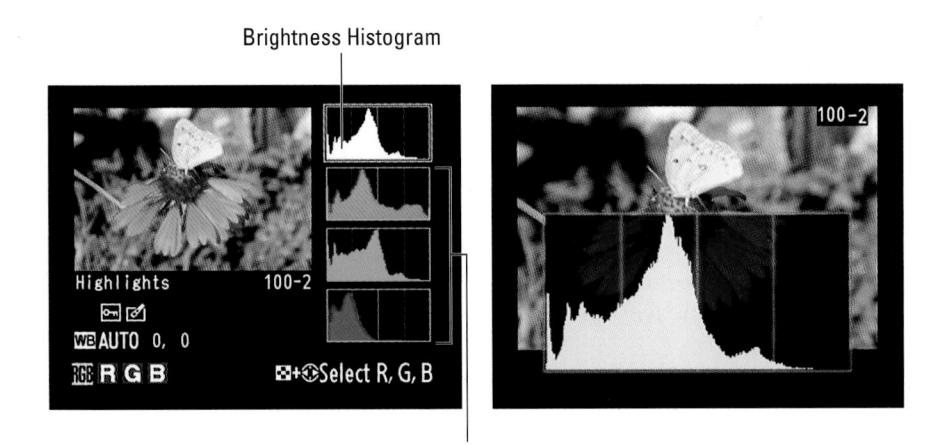

Figure 4-17: Histogram mode presents exposure and color information in chart-like fashion.

RGB Histogram

The next two sections explain what you can discern from the histograms. But first, here are two cool tricks to remember:

- If you press the Zoom In button while in this display mode, you can zoom the thumbnail to a magnified view. The histograms then update to reflect only the magnified area of the photo. To return to the regular view and once again see the whole-image histogram, press OK.
- You can set the center button of the Multi Selector to temporarily display a brightness histogram over your photo, as shown on the right in Figure 4-17. You can access this feature in any of the display modes File Information, Highlights, whatever. Additionally, you can bring up the histogram even in thumbnails playback view. When you let up on the button, you return to the normal screen for the display mode you're using. For details on setting the button to this function, check out the section "Customizing the Multi Selector's role in playback mode," earlier in this chapter.

Reading a Brightness histogram

You can get an idea of image exposure by viewing your photo on the camera monitor and by looking at the "blinkies" in Highlight mode. But the Brightness histogram provides a way to gauge exposure that's a little more detailed.

A Brightness histogram indicates the distribution of shadows, highlights, and midtones (areas of medium brightness) in your image. Figure 4-18 shows you a sample histogram.

The horizontal axis of the histogram represents the possible picture brightness values — the maximum tonal range, in photography-speak — from the darkest shadows on the left to the brightest highlights on the right. And the vertical axis shows you how many pixels fall at a particular brightness value. A spike indicates a heavy concentration of pixels. For example, in Figure 4-18, the histogram shows a large supply of pixels clustered in the range just below medium brightness, but very few at the higher end of the range.

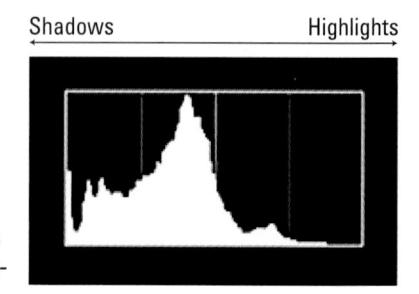

Figure 4-18: The Brightness histogram indicates tonal range, from shadows on the left to highlights on the right.

Keep in mind that there is no one "perfect" histogram that you should try to achieve. Instead, interpret the histogram with respect to the distribution of shadows, highlights, and midtones that comprise your subject. You wouldn't expect to see lots of shadows, for example, in a photo of a polar bear walking on a snowy landscape. Pay attention, however, if you see a very high concentration of pixels at the far right or left end of the histogram, which can indicate a seriously overexposed or underexposed image, respectively. To find out how to resolve exposure problems, visit Chapter 5.

Understanding RGB histograms

When you view your images in RGB Histogram display mode, you see two histograms: the Brightness histogram, covered in the preceding section, and an RGB histogram. Figure 4-19 offers a sample RGB histogram for your consideration.

As explained in the earlier section about Highlights mode, digital images are made up of red, green, and blue light. With the RGB histograms, you can view the brightness values for each of those color channels. Again, overexposure in one or two channels can produce oversaturated colors and thus a loss of picture detail. So if most of the pixels for one or two channels are clustered toward the right end of the histogram, you may have a problem. Take a look at the image thumbnail and note where the blinking highlights (indicating overexposure) occur, and then assess your subject and lighting to determine whether you need to make adjustments and retake the photo.

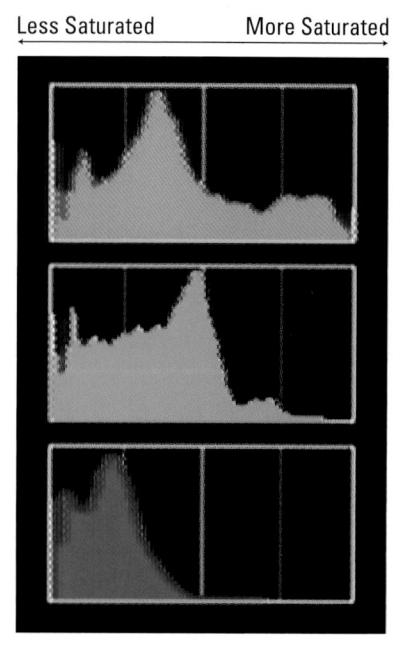

Figure 4-19: The RGB histogram can indicate problems with color saturation.

A savvy RGB histogram reader also can spot color-balance issues by looking at the pixel values. But frankly, color-balance problems are fairly easy to notice just by looking at the image itself on the camera monitor. And understanding how to translate the histogram data for this purpose requires more knowledge about RGB color theory than I have room to present in this book.

For information about manipulating color, see Chapter 6.

Shooting Data display mode

Before you can access this mode, you must enable it via the Display Mode option on the Playback menu. See the earlier section, "Enabling hidden data-display options," for details. After turning on the option, press the Multi Selector down to shift from Highlights mode to Shooting Data mode.

In this mode, you can view up to four screens of information, which you toggle between by pressing the Multi Selector up and down. Figure 4-20 shows you these screens, referred to in the Nikon manual as Shooting Data Page 1, 2, 3, and 4. The fourth screen appears only if you include copyright data with your picture, a feature you can explore in Chapter 10.

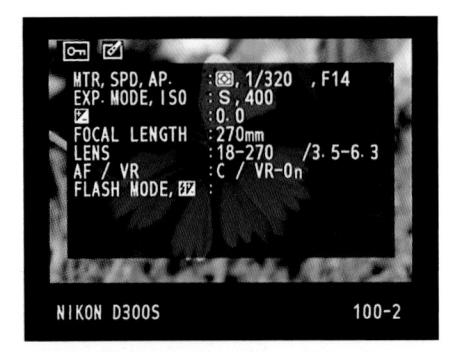

Figure 4-20: You can view the camera settings used to capture the image in Shooting Data display mode.

Most of the data here won't make any sense to you until you explore Chapters 5 and 6, which explain the exposure, color, and other advanced settings available on your camera. But I want to call your attention to a couple of factoids now:

- ✓ The top-left corner of the monitor shows the Protect Status and Retouch Indicator icons, if you used the protect or retouch features. Otherwise, the area is empty. (See the earlier section "File Information mode" for details about these particular features.)
- ✓ The current folder and frame number appear in the lower-right corner of the display.
- ✓ The Comment item, which is the final item on the third screen, contains a value if you use the Image Comment feature on the Setup menu. I cover this option in Chapter 10.
- ✓ If the ISO value on Shooting Data Page 1 (the first screen in Figure 4-18) appears in red, the camera is letting you know that it overrode the ISO Sensitivity setting that you selected in order to produce a good exposure. This shift occurs only if you enable automatic ISO adjustment; see Chapter 5 for details.

GPS Data mode

This display mode is available only if the image you're viewing was shot with the optional Nikon GPS (global positioning system) unit attached.

If you use the GPS unit, this display mode shows you the latitude, longitude, and other GPS information recorded with the image file. You also see the date and time of the shot along with the folder and frame number, the Protect Status icon, and the Retouch Indicator icon, all explained in the earlier section "File Information mode."

Overview Data mode

Overview Data mode is the second of the two default photo-information modes. (Meaning, you don't have to enable it via the Display Mode option on the Playback menu to use it.) In this mode, the playback screen contains a small image thumbnail along with scads of shooting data — although not quite as much as Shooting Data mode — plus a Brightness histogram. Figure 4-21 offers a look.

The earlier section "Reading a Brightness histogram" tells you what to make of that part of the screen. Just

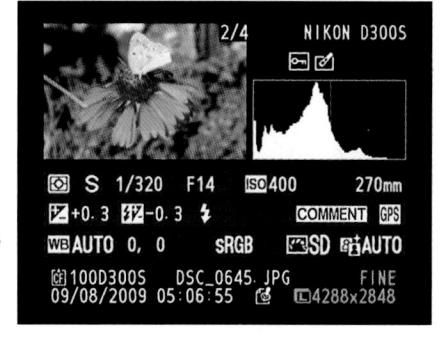

Figure 4-21: In Overview Data mode, you can view your picture along with the major camera settings you used to take the picture.

above the histogram, you see the Protect Status and Retouch Indicator, while the Frame Number/Total Pictures data appears at the upper-right corner of the image thumbnail. For details on that data, see the earlier section "File Information mode." (As always, the Protect status and Retouch Indicator icons appear only if you used those two features; otherwise, the area is empty.)

To sort out the maze of other information, the following list breaks things down into the five rows that appear under the image thumbnail and histogram. In the accompanying figures as well as in Figure 4-21, I include all pos-

sible data simply for the purpose of illustration; if any of the items don't appear on your screen, it simply means that the relevant feature wasn't enabled when you captured the shot.

✓ Row 1: This row shows the exposure-related settings labeled in Figure 4-22, along with the focal length of the lens you used to take the shot. As in Shooting Data mode, the

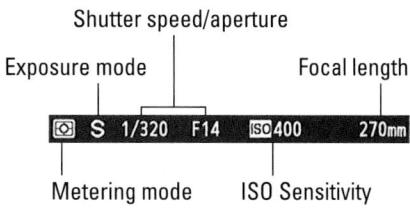

Figure 4-22: Here you can inspect major exposure settings along with the lens focal length.

ISO value appears red if you had auto ISO override enabled and the camera adjusted the ISO for you. Chapter 5 details the exposure settings; Chapter 6 introduces you to focal length.

- ✓ Row 2: This row contains a few additional exposure settings, labeled in Figure 4-23. On the right end of the row, the Comment and GPS labels appear if you took advantage of those options when recording the shot. (You must switch to the Shooting Data mode or GPS mode, respectively, to view the actual comment and GPS data.)
- **Row 3:** The first three items on this row, labeled in Figure 4-24, relate to color options explored in Chapter 6. Again, the first value shows you the White Balance setting; the second, the amount of blue-to-amber fine-tuning adjustment; and the third, the amount of green-to-magenta adjustment. The last item indicates the Active D-Lighting setting, another exposure option

discussed in Chapter 5.

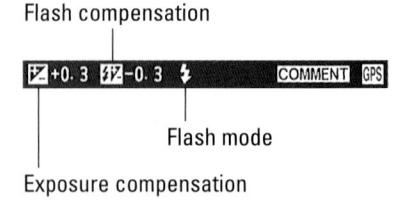

Figure 4-23: This row contains additional exposure information.

Figure 4-24: Look at this row for details about advanced color settings.

Rows 4 and 5: The final two rows of data (refer to Figure 4-21) show the same information you get in File Information mode, explained earlier in this chapter.

Deleting Photos

You can erase pictures from a memory card when it's in your camera in three ways. The next sections give you the lowdown. (Or is it the down low? I can't seem to keep up.)

Regardless of which delete technique you want to use, remember that you can't delete photos that you protected or hid by using the Protect or Hide Image features. Later sections in this chapter explain both features and show you how to unprotect and unhide images so that you can delete them.

Deleting images one at a time

The Delete button is key to erasing single images. But the process varies a little depending on which playback display mode you're using, as follows:

- In single-image view, you can erase the current image by pressing the Delete button.
- In thumbnail view (displaying 4, 9, or 72 thumbnails), use the Multi Selector to highlight the picture you want to erase and then press

After you press Delete, you see a message asking whether you really want to erase the picture. If you do, press the Delete button again. Or, to cancel out of the process, press the Playback button.

the Delete button.

If you really want to get down into your camera's customization option weeds — and I do believe this is about as weedy as it gets — you can control which picture the camera displays

Figure 4-25: You can specify which picture appears next after you delete the current one.

next after you delete the current picture. The option in question lives on the Playback menu and is called After Delete, as shown in Figure 4-25. Select the option and press OK to access your three choices: Show Next displays the picture after the one you just deleted (the default option); Show Previous displays the one that fell before the one you deleted, and Continue As Before tells the camera to keep going in the same direction you were heading before deleting. For example, if you were scrolling forward through your pictures, the camera continues playback in that direction. Wow, now *that's* control.

If you accidentally erase a picture, don't panic — you *may* be able to restore it by using data-restoration software such as MediaRecover (\$30, www.mediarecover.com) or Lexar Image Rescue (also about \$30, www.lexar.com). SanDisk also currently offers a recovery program with some of its high-performance memory cards. But in order to have a chance, you must not take any more pictures or perform any other operations on your camera while the current memory card is in it. If you do, you may overwrite the erased picture data for good and eliminate the possibility of recovering the image.

Deleting all photos

Erasing all pictures on a memory card is a five-step process:

- 1. Open the Playback menu and select Delete, as shown on the left in Figure 4-26.
- 2. Press OK.

You see the right screen in Figure 4-26.

3. Highlight All and press the Multi Selector right.

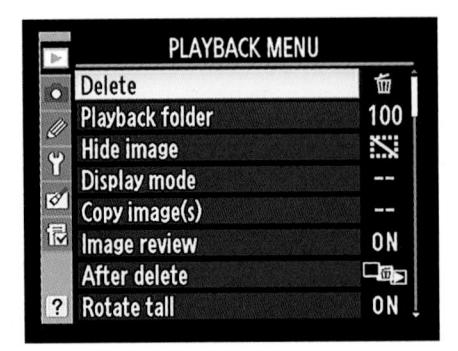

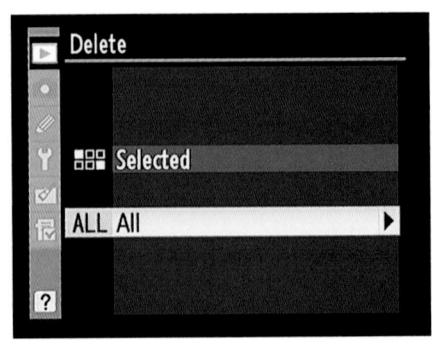

Figure 4-26: You can guickly delete all photos from a memory card.

4. On the next screen, highlight the memory card that contains the pictures you want to dump and press the Multi Selector right again.

You then see a screen that asks you to verify that you want to delete all vour images.

5. Highlight Yes and press OK.

This step deletes only pictures in the folder that is currently selected via the Playback Folder option on the Playback menu. See the section "Viewing Images in Playback Mode," earlier in this chapter, for information.

Also remember that deleting photos in this way does not erase any pictures that you protected using the Protect feature or hid from display by using the Hide Image option, both described later in this chapter.

Deleting a batch of selected photos

To erase multiple photos — but not all — display the Playback menu, highlight Delete, and press OK. You see the Delete screen shown on the left in Figure 4-27. Choose Selected and press OK to display the right screen in the figure.

Now use these techniques to navigate your thumbnails and mark the ones you want to erase:

Mark a photo for deletion. Use the Multi Selector to place the yellow highlight box over the first photo you want to delete and then press the Multi Selector's center button. A little trash can icon, the universal symbol for delete, appears in the upper-right corner of the thumbnail, as shown in the figure. If you change your mind, press the center button again to remove the Delete tag from the image.

- ✓ Temporarily magnify the selected photo. For a closer look at the selected image, press and hold the Zoom In button. When you release the button, the display returns to normal thumbnail view.
- Jump to a specific memory card or folder. If you have two memory cards installed, The card icon that appears yellow in the upper-right corner of the screen is the currently selected card. You can use the same technique available during playback to jump between cards and folders: Press the Zoom Out button to get the screen where you can select a card, highlight the card, and then press OK to display the list of folders on the card. Highlight a folder and press OK to return to the screen where you tag pictures for deletion. The first photo in your chosen folder is automatically selected. Remember that the folders that appear when you use this option depend on the setting you choose for the Playback Folder option, as covered in the earlier section "Viewing Images in Playback Mode."
- ✓ Erase all marked photos. Press OK to display a confirmation screen asking for permission to destroy the images; select Yes and press OK. The camera trashes the photos and returns you to the Playback menu.

As with the Delete All option, you can't delete protected hidden photos using this technique. For more about protecting and hiding photos, see the next two sections.

Figure 4-27: Press the center button of the Multi Selector to tag the selected photo for deletion.

Hiding Photos during Playback

Suppose that you took 100 pictures — 50 at a business meeting and 50 at the wild after-meeting party. You want to show your boss the photos where you and your co-workers look like responsible adults, but you'd rather not share the ones showing you and your assistant dancing on the conference table. You can always delete the party photos; the preceding section shows you how. But if you want to keep them — you never know when a good blackmail picture will come in handy — you can simply hide the incriminating images during playback.

The key to this trick is the Hide Image option on the Playback menu. After highlighting the option, as shown on the left in Figure 4-28, press OK to display the right screen in the figure. Choose Select/Set and press the Multi Selector right to get to the screen shown in Figure 4-29.

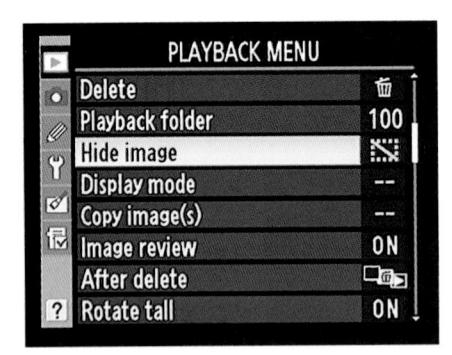

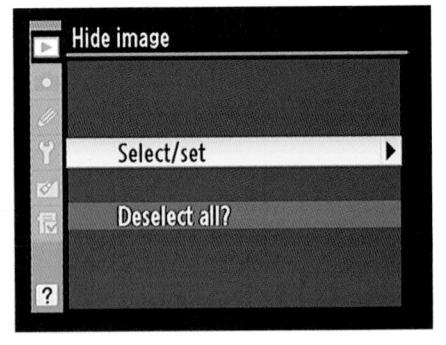

Figure 4-28: The Hide Image function lets you prevent photos from appearing during normal picture playback.

From here, things work the same as they do for marking a picture for deletion, covered in the preceding section.

Highlight the picture you want to hide and then press the center button of the Multi Selector to tag the photo with the little hide marker, labeled in Figure 4-29. Press again to remove the marker.

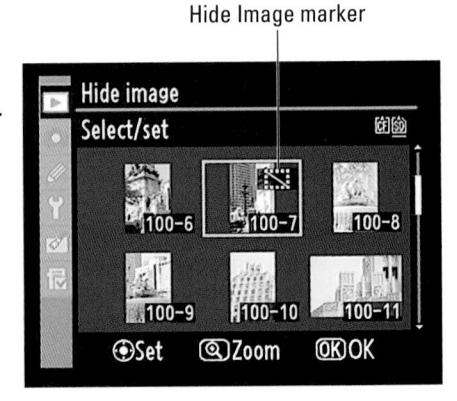

Figure 4-29: Press the center button of the Multi Selector to toggle the hide marker on and off.

You also can use the same techniques as outlined in the preceding section to jump between memory cards and folders and get a larger view of the selected photo. After you tag all the images you want to hide, press OK to return to the Playback menu. Your pictures are now hidden.

To redisplay hidden pictures, just reverse the process, removing the hide marker from photos you want to view again. Or, to redisplay all hidden pictures quickly, choose Deselect All from the first Hide Image screen (the right screen in Figure 4-28). Then press the Multi Selector right to display a screen that asks you to confirm your decision. Highlight Yes and press OK to make it so.

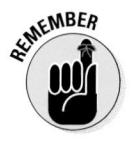

A couple of fine points about this feature: First, your hidden images remain viewable from within the Hide Image screens. (So make sure your boss doesn't have time alone with your camera.) Second, if you want to delete hidden photos, you first need to remove the Hide Image tags. Or you can format your memory card, which wipes out all photos, hidden or not. See Chapter 1 for details on card formatting.

Protecting Photos

You can safeguard pictures from accidental erasure by giving them *protected status*. After you take this step, the camera doesn't allow you to erase a picture by using either the Delete button or the Delete option on the Playback menu.

Formatting your memory card, however, *does* erase even protected pictures. In addition, when you protect a picture, it shows up as a read-only file when you transfer it to your computer. Files that have that read-only status can't be altered until you unlock them in your photo software. In Nikon ViewNX, you can do this by clicking the image thumbnail and then choosing File\$\to\$Protect Files\$\to\$Unprotect.

Protecting a picture is easy:

1. Display or select the picture you want to protect.

- In single-image view, just display the photo.
- In 4/9/72 thumbnail mode, use the Multi Selector as needed to place the yellow highlight box over the photo.

2. Press the Protect button.

See the key symbol on the button? That's your reminder that you use the button to lock a picture. The same symbol appears on protected photos during playback, as shown in Figure 4-30. (The placement of the lock symbol depends on your Information display mode, a topic you can explore earlier in this chapter.) In the figure, the symbol's in the upper-left corner.

3. To remove protection, display or select the image and press the Protect button again.

Figure 4-30: Press the Protect button to prevent accidental deletion of the selected image.

Exploring Live View Shooting

If you've used a compact, point-and-shoot digital camera, you may be used to composing your pictures on the camera monitor rather than by looking through the viewfinder. In fact, many compact cameras no longer even offer a viewfinder, which is a real shame, in my opinion. When you use the monitor to frame the image, you must hold the camera away from your body, a posture that increases the likelihood of blurry images caused by camera shake. When you use the viewfinder, you can brace the camera against your face, creating a steadier shooting stance.

Due to some design complexities that I won't bore you with, many digital SLR cameras do not enable you to preview shots on the monitor. Your D300s, however, does offer that feature, known as *Live View* in dSLR nomenclature. The D300s also uses Live View when you record movies.

You need to know a few points about Live View as it's provided on your camera:

Manual focusing is recommended. You can autofocus, assuming that you're using a lens that supports that feature when paired with the D300s. (See Chapter 1 for more about that issue.) But even if your lens does offer autofocusing, manual focusing usually offers faster, more precise results.

- Continuous autofocusing isn't possible. In normal shooting, you can set the camera to the continuous-servo autofocus mode to continually adjust focus automatically up to the moment you take the shot. (See Chapter 6 for details.) Continuous autofocusing is not available in Live View mode, unfortunately. If you need to adjust focus before taking a shot or during movie recording, you just have to set focus a second time.
- Using Live View for an extended period can harm your pictures and the camera. When you work in Live View mode, the camera's innards heat up more than usual, and that extra heat can create the right electronic conditions for *noise*, a defect that gives your pictures a speckled look. (Chapter 5 offers more information.)

- Perhaps more critically, the increased temperatures can damage the camera itself. For that reason, Live View is automatically disabled after one hour of shooting or earlier, if a critical heat level is detected. When the camera is 30 seconds or less from shutting down your Live View session, you see a little LV symbol, with a numerical value (such as 18s) to let you know how many seconds you have to wrap things up. This warning appears in the upper-left corner of the screen. In extremely warm environments, you may not be able to use Live View mode for very long before the system shuts down.
- Aiming the lens at the sun or other bright lights also can damage the camera. Of course, you can cause problems doing this even during normal shooting, but the possibilities increase when you use Live View. You not only can harm the camera's internal components but also the monitor.

Live View also presents two additional disadvantages which, in this case, are the same as for a point-and-shoot camera. First, any time you use the monitor, you put extra strain on the battery. Second, the monitor can wash out in bright sunlight, making it difficult to compose outdoor shots.

This list of caveats doesn't mean that I'm telling you not to use Live View. But for normal photography — that is, still shooting rather than movie recording — you shouldn't envision Live View as a full-time alternative to using the viewfinder. Rather, think of it as a special-purpose tool that can help in situations where framing with the viewfinder is cumbersome.

I find Live View most helpful for still-life, tabletop photography, especially in cases that require a lot of careful arrangement of the scene. For example, I have a shooting table that's about waist high. Normally, I put my camera on a tripod, come up with an initial layout of the objects I want to photograph, set

up my lights, and then check the scene through the viewfinder. Then there's a period of refining the object placement, the lighting, and so on. If I'm shooting from a high angle, requiring the camera to be positioned above the table and pointing downward, I have to stand on my tiptoes or get a stepladder to check things out through the viewfinder between each compositional or lighting change. At lower angles, where the camera is tabletop height or below, I have to either bend over or kneel to look through the viewfinder, causing no end of later aches and pains to back and knees. With Live View, I can alleviate much of that bothersome routine (and pain) because I can usually see how things look in the monitor no matter what the camera position.

With that lengthy preamble out of the way, the next several sections explain some Live View setup options. Following that, you can find stepby-step instructions for taking pictures in Live View mode and recording movies.

Choosing your Live View shooting mode

Before turning on the Live View display, pay a visit to the Shooting menu and call up the Live View Mode option, as shown in Figure 4-31. You can choose from Tripod Mode and Handheld Mode. As their names suggest, one is designed for times when you have the camera mounted on a tripod and the other is for handheld work.

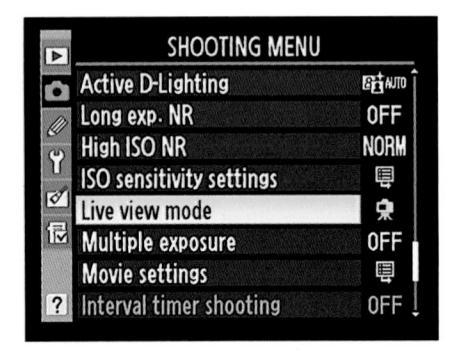

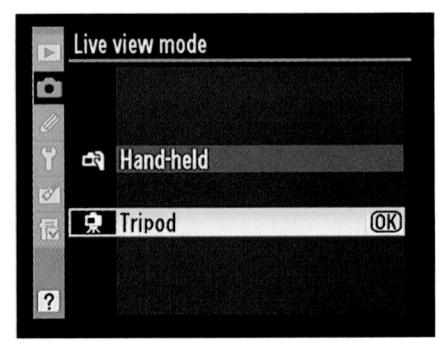

Figure 4-31: The main difference between the two Live View modes has to do with autofocusing.

The major difference between the two modes, though, has to do with autofocusing, although your choice does have some implications with regard to exposure for movie making as well. Here's the deal:

Autofocusing: In Handheld mode, the camera uses an autofocusing technology called *phase-detection autofocus*, which is the same autofocusing technology as it does for normal, non-Live View photography. In Tripod mode, a different technology, called *contrast-detection*, is used.

It's not important to understand the two technologies — although, if you're interested, you can find lots of online discussions about the two. What is important to note is how the two technologies impact Live View autofocusing operation, as follows:

- Focusing area: In Tripod mode, you can set focus on any point in the entire frame, even on points outside the normal autofocus-area brackets (those brackets that indicate the spread of the camera's 51 possible autofocus points when you look through the viewfinder). In Handheld mode, you're limited to the normal autofocus area.
- Focus adjustments during movie recording: If you opt for autofocusing, you can reset focus as needed during movie recording in Tripod mode. In Handheld mode, you can't adjust focus once recording begins.
- Monitor shut-off during focusing: In Handheld mode, the monitor turns off briefly in order to allow the camera to use the aforementioned normal autofocusing system. In Tripod mode, the monitor remains on during focusing.
- Focusing speed and accuracy: Tripod mode autofocusing can take a little longer, and low-contrast subjects can challenge the camera.
 And keep the mode name in mind: The focusing system used in Tripod mode really does not work well for handheld shots or for moving subjects.
 - On the other hand, autofocus can be a little more precise in Tripod mode because you can set the focus point anywhere in the frame. In addition, you can zoom the onscreen view up to a 13 times magnification to check focus in Tripod Mode, whereas Handheld mode limits you to a three-times magnification.
- Exposure adjustment during movie recording: In Handheld mode, the camera handles exposure automatically as you're recording a movie. In Tripod mode, you can set the camera to the M or A exposure mode and then select a specific aperture, using any setting up to f/16. The camera then uses that aperture during recording. This option comes in handy if you want to maintain a specific depth of field throughout the recording.

Confusing enough for you? Well, let me simplify things by repeating my earlier advice that if at all possible, use manual focus. Not only are you likely to get faster, more accurate focusing, but you also don't have to worry about all

the autofocusing intricacies just described. The mode decision then favors Tripod mode because of the stronger magnification that's available to check focus. As for movie recording, choose the mode that best matches your desire to control aperture and exposure.

The way you take the picture, record your movie, and check focusing depends on your selected Live View mode, so upcoming sections walk you through the details.

Whichever mode you want to use, you can customize the Live View display as outlined next.

Customizing the Live View display

When you press the Live View button, the scene in front of the lens appears on the monitor, as shown in Figure 4-32, and you no longer can see anything through the viewfinder.

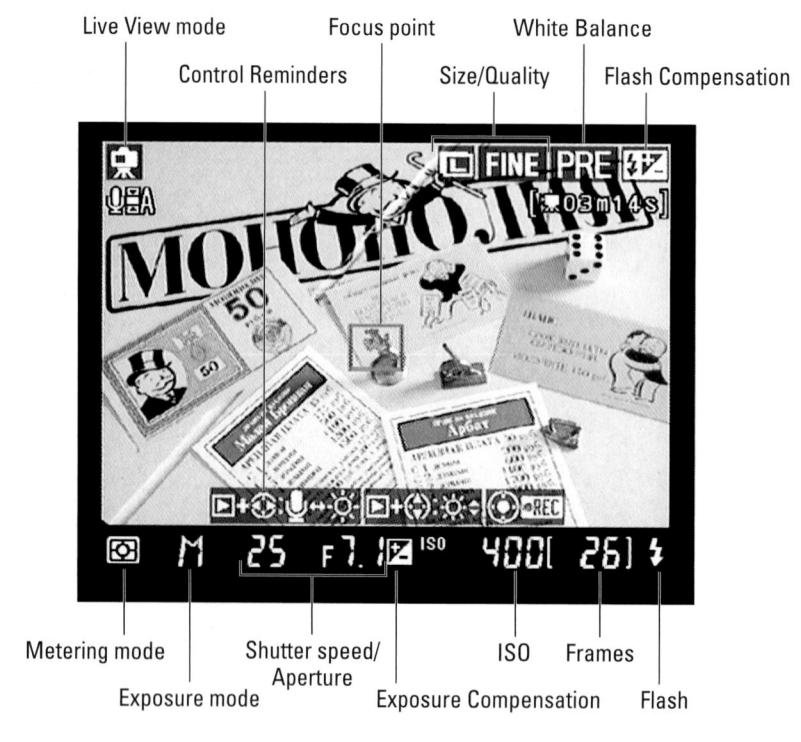

Figure 4-32: The settings labeled here relate to still photography; the rest, to movie recording.

Just as you can change what information appears onscreen during picture playback, you can change the data that shows up during Live View shooting. Press the Info button to cycle through the four styles, which are:

- ✓ **Information On:** In this mode, your screen displays the boatload of data shown in Figure 4-32. A few notes about this display:
 - Some symbols, such as those representing Exposure Compensation and Flash Compensation values, appear only if you enable those features. (Chapter 5 details these settings.)
 - In Handheld mode, you see the autofocus-area brackets as well as the focus point. (Not shown in Figure 4-32.)
 - The strip of cryptic symbols labeled Control Reminders in the figure is there to remind you what buttons to push to perform certain functions. For example, the far-right symbol represents the Multi Selector. The center button in the symbol is highlighted to show that you press it to begin recording a movie. More about what the rest of the icons mean momentarily.
- ✓ **Information Off:** Press the Info button to cycle to this display option, which hides all the indicators that are displayed over your image. You still see the settings along the bottom of the frame and the focusing frame (and autofocus area brackets, if you're shooting in Handheld mode).
- Framing Grid: This mode displays a grid over the image. In Tripod mode, the grid appears as shown on the left in Figure 4-33; in Handheld mode, the grid lines appear only around the perimeter of the autofocus area brackets (as they do when you enable the viewfinder grid, an option covered in Chapter 1). The grid is helpful when you need to precisely align objects in your photo. But note that if you zoom the display to check focusing, as outlined in the next section, the grid disappears until you return to normal magnification.

Figure 4-33: Press the Info button to change the display mode.

✓ **Virtual Horizon:** You also can display the Virtual Horizon indicator, as shown on the right in Figure 4-33. This tool works the same way as the one you can enable through the Custom Setting menu, introduced in Chapter 1. When the camera is level to the horizon, the little green triangle appears, as shown in the figure.

In addition to these options, you can adjust the monitor brightness without exiting Live View mode. Just press and hold the Playback button to display the little brightness scale on the right side of the screen, as highlighted in Figure 4-34. While holding the button, you can press the Multi Selector right and left to toggle between that brightness strip and the microphone icon in the upper-left corner of the screen. When the brightness strip is highlighted, press the Multi Selector up and down to adjust the brightness. (When the microphone is highlighted. you can adjust the sound-recording options, covered later in this chapter.)

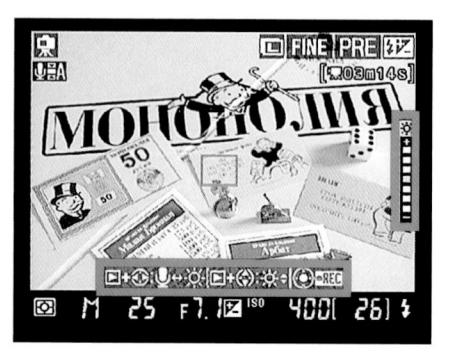

Figure 4-34: Press the Playback button, press right to activate the brightness strip, and then press up or down to adjust monitor brightness.

The strip of reminder icons along the bottom of the screen (highlighted in the figure) is there to jog your memory of what buttons accomplish this function.

If you connect your camera to an HDMI (High-Definition Multimedia Interface) device, you no longer see the live scene on your camera monitor. Instead, the view is displayed on your video device. In that scenario, the arrangement of the information on the screen may appear slightly different than in the examples in this chapter.

Taking still pictures in Tripod mode

After setting your camera to Tripod mode (through the Live View Mode option on the Shooting menu), follow these steps to take a picture:

1. To switch to the Live View display, press the Live View button.

You hear a clicking sound as the camera's internal mirror — the part that makes it possible to see your subject in the viewfinder — flips up. The viewfinder goes dark, and your subject appears on the monitor.

- 2. Frame the shot.
- 3. Set the focus mode to auto or manual focusing.

This part of the process works just as it does for normal photography: Set the Focus mode selector on the front of the camera to M for manual focusing; choose S for autofocusing. (Again, you can set the Focus mode selector to C, but doing so does no good because in Live View mode, the camera can't provide continuous autofocus.)

Also be sure to set the focus mode on your lens to auto or manual, if it offers that control.

Nikon recommends that you use an AF-S lens for best autofocusing results in Tripod mode. See Chapter 1 for more about lens types.

4. Use the Multi Selector to move the focus point (labeled in Figure 4-35) over your subject.

This step is optional for manual focusing, but it does make checking your focus through the process used in Step 6 a little easier.

5. Focus.

• To autofocus, press the AF-ON button. When the camera has established focus, you hear a beep, and the focus frame turns green. You can then release the button. You can't set focus by pressing the shutter button halfway as you do for normal, through-theviewfinder shooting.

Figure 4-35: To autofocus, position the focus frame over your subject and then press the AF-ON button.

 To focus manually, twist the focusing ring on the lens. Note that the focusing frame does not turn green even if your focus is correct.

6. Press the Zoom In button to magnify the view and check focus.

The zoomed display is centered on the focusing frame (which is why positioning the frame in Step 4 is helpful even for manual focusing). Each press of the button zooms the display further, up to 13 times magnification.

In the lower-right corner of the screen, the smaller box inside the larger rectangle indicates the area of the frame that's currently being magnified, as shown in Figure 4-36. To scroll the display and check another part of the image, press the Multi Selector.

Figure 4-36: Press the Zoom In button to magnify the area under the focusing frame.

To reduce the magnification, press the Zoom Out button. Press OK to return to full-frame view.

If you're focusing manually, you can tweak focus in the magnified view — just keep turning the focusing ring until things look good. Likewise, you can press the AF-ON button to reset focus if you're autofocusing. But if you want to reposition the focus frame before autofocusing a second time, you need to press OK to return to the normal magnification first.

7. Adjust other picture-taking settings as needed.

You adjust exposure, color, and other picture-taking settings for Live View shooting the same way as you do for through-the-viewfinder photography. For example, to adjust white balance, press the WB button and rotate the main command dial; to change the exposure mode, press the Mode button and rotate the main command dial. (Refer to Figure 4-32 to see what settings you can monitor on the screen.) However, if you want to adjust the metering mode or any settings that are available only through menus, you have to exit Live View mode. Just press the Menu button, adjust the setting, and then press the Live View button again. Your focus should be maintained, assuming that you don't move the camera while changing settings.

The aperture, shutter speed, and ISO settings displayed at the bottom of the screen represent the ones that were in force when you shifted to Live View mode. If you're using the P, A, or S exposure modes, in which the camera selects aperture, shutter speed, or both, the camera will meter the exposure again when you take the shot and adjust those settings if needed. Likewise, ISO may be adjusted if you enable auto ISO override. For help with all these exposure issues, see Chapter 5.

8. Depress the shutter button fully to take the shot.

The monitor turns off briefly and then the Live View preview returns, and you're ready to take the next shot.

9. To exit the Live View preview, press the Lv button.

You can then return to framing your images through the viewfinder.

If your Tripod mode shots appear blurry and you're sure that focus is correct, try enabling the Exposure Delay Mode option on the Custom Setting menu. At this setting, the camera waits about one second after you press and release the shutter button to record the image, which can help ensure that the slight movement of the camera's internal mirror doesn't blur the image.

One other fine-print notation regarding Tripod mode: On occasion, the autofocus frame may turn green even if focus isn't actually accurate. So always take the step of magnifying the display to double-check focusing results.

Taking pictures in Handheld mode

Shooting pictures in Handheld mode works a little differently than Tripod mode. As with Handheld mode, start by setting the camera's Focus mode selector to M for manual focusing and S for autofocusing. Also set the lens focus mode switch, if your lens offers one. Be sure to select your exposure

metering mode as well, because you can't adjust that setting after you switch to Live View mode. (Chapter 5 covers the metering mode options.) Then proceed like so:

1. Press the Live View button.

Again, the mirror flips up, the viewfinder goes dark, and your subject appears on the monitor. This time, you see the same autofocus area brackets that normally appear in the viewfinder, along with a red focus point, as shown in Figure 4-37.

- Frame the shot so that your subject appears within the autofocus area brackets.
- 3. Use the Multi Selector to move the focus point over your subject.

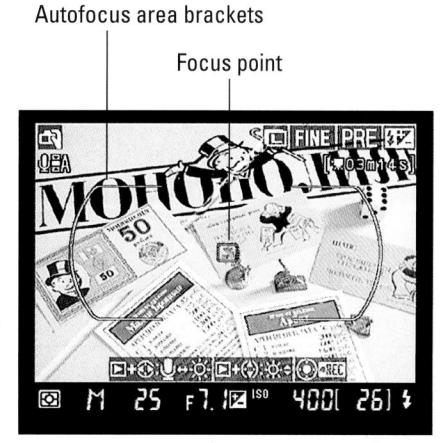

Figure 4-37: Use the Multi Selector to move the focus point over your subject.

4. Focus.

To autofocus, press the AF-ON button or use the normal autofocusing technique of pressing the shutter button halfway. Note that if you use the AF-ON button, though, vibration reduction isn't engaged. So if your lens offers vibration reduction and that feature is important, use the shutter button to set focus.

As soon as you press either button, the monitor shuts off and the camera begins focusing. When you hear a beep, focus has been achieved, and you can release the button. The monitor then turns back on. Note that the focus point remains red instead of turning green as in Tripod mode.

Focus is locked at this point, even if you set the Focus mode to C (continuous-servo autofocus). You don't need to keep the shutter button pressed halfway as you do to lock focus during normal photography.

• To focus manually, twist the focusing ring on the lens.

Press the Zoom In button to magnify the view and refine focus, if needed.

In this Live View mode, you can zoom to a three-times magnification only. Press the Multi Selector to scroll the display and check another part of the image.

To reduce the magnification, press the Zoom Out button. Press OK to return to full-frame view.

If needed, repeat Step 4 to refine focus. For autofocusing, you must return to full-frame view first if you want to select a different autofocus point.

6. Adjust exposure, color, and other picture settings in the usual way.

Remember that you must exit Live View mode if you want to change the metering mode. Press the Live View button, move the metering mode switch, and press again to return to Live View shooting. If you need to adjust a menu setting, press Menu to temporarily exit Live View mode. Adjust the setting and then return to Live View mode.

7. Depress the shutter button fully to take the shot.

At the point you take the shot, the camera meters the final exposure and may adjust exposure settings automatically, depending on what exposure mode and ISO options you're using. Chapter 5 discusses exposure. The monitor turns off briefly after you press the shutter button, and then the Live View preview reappears.

8. If you're done with Live View shooting, press the Live View button.

The monitor shuts off, and the viewfinder comes back to life.

Recording movies

Your D300s offers the ability to record digital movies. Although recording live action with a D300s involves a few limitations and difficulties that you don't experience with a real video camera, it's a fun option to have onboard nonetheless.

Before I give you the specifics, here's the broad overview of D300s movie making:

- Live View mode: You have the same two shooting mode options as for still Live View photography: Tripod mode and Handheld mode. See the earlier section "Choosing your Live View shooting mode" for details.
- Movie quality: The Movie Quality setting, which you set via the Movie Settings option on the Shooting menu, as shown in Figure 4-38, determines the frame size and aspect ratio of the movie. You can set the

quality to 320×216 pixels, for a 3:2 aspect ratio (the same aspect ratio as your D300s still images); 640×424 , also a 3:2 aspect ratio; and 1280×720 , which gives you a 16:9 aspect ratio, which is found on many new TV sets and computer monitors.

The higher the pixel count, the larger you can display the movie on a TV or monitor before you see the quality of the playback deteriorate. But a higher Quality setting also produces a larger file, eating up more of your memory card, and it reduces the maximum length of the movie you can record, as outlined next.

- ✓ Maximum movie length/file size: If you select the highest movie resolution (1280 x 720 pixels), your movie can have a maximum length of five minutes and a maximum file size of 2GB. At the two lower-resolution settings, you're still restricted to 2GB file sizes, but the movies can run as long as 20 minutes. Of course, you must have 2GB of empty memory card space to store the movie.
- ✓ Frame rate: The frame rate determines the smoothness of the playback. At all three Quality settings, the frame rate is 24 frames per second, or fps. By contrast, the standard frame rate for television-quality video is 30 frames per second, so expect your movies to play a little less smoothly than your favorite sitcoms.
- ✓ **Sound recording:** You can record sound or shoot a silent movie; make the call via the Movie Settings option on the Shooting menu (shown in Figure 4-38). See the next section for details on your choices and an explanation of how to connect an external microphone.
- ✓ Color: You can set the White Balance option as usual. Movies also use
 the currently selected Picture Control and Color Space (sRGB or Adobe
 RGB). For details about all these color options, see Chapter 6.

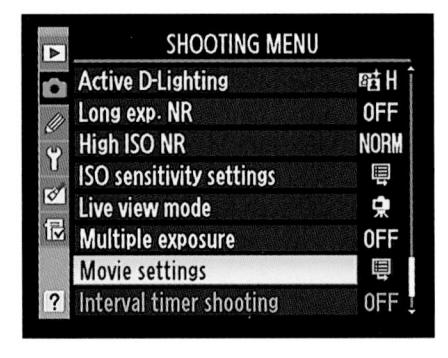

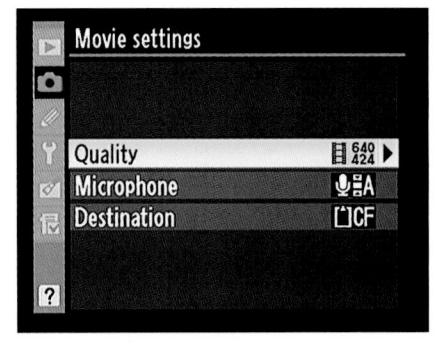

Figure 4-38: Specify movie quality and sound recording options via the Shooting menu.

File storage: If you have two memory cards installed in the camera, use the Destination option on the Movie Settings menu (refer to Figure 4-38) to select which card you want to use to store the file. After you select the option, press the Multi Selector right to see the screen shown in Figure 4-39. For each card, you see the length of the movie that will fit on each card at the current movie-quality settings. (You also can view the capacity of the current card after you switch to Live View mode.) To select the card, highlight it and press OK.

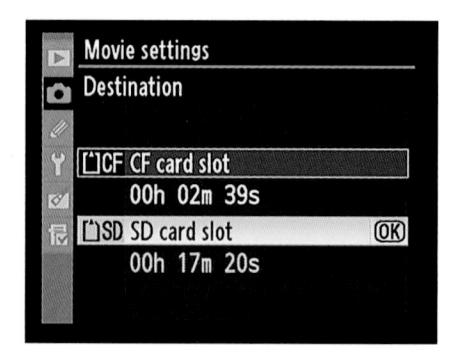

Figure 4-39: If you have two memory cards installed, use this option to select the card where the movie will be stored

Video format: Movies are created in the AVI format, which means you can play them on your computer using most movie-playback programs. If you want to view your movies on a TV, you can connect the camera to the TV, as explained in Chapter 9. Or if you have the necessary computer software, you can convert the AVI file to a format that a standard DVD player can recognize and then burn the converted file to a DVD disk. You also can edit your movie in a program that can work with AVI files.

So far, so good. None of the aforementioned details is terribly unusual or complicated. Where things get a little tricky for the would-be filmmaker are in the areas of focus and exposure:

Focusing: As with regular Live View photography, you can use autofocusing to establish initial focus on your subject before you begin recording. But after recording begins, the autofocus system lays down and plays dead if you use the Handheld Live View mode. In Tripod mode, you can reset focus, but you're likely to record at least a few frames during which focus goes in and out as the system looks for its new focusing target.

Either way, autofocusing during movie recording is problematic. So unless you're recording a static subject — say, a guitar player sitting on a stool or a speaker at a lectern — opt for manual focusing. You can then adjust focus manually any time during the recording.

If you plan to also zoom in and out, give yourself some time to practice before the big event. It's a bit of a challenge to zoom and focus at the same time, especially while holding the camera in front of you so that you can see the monitor. (A tripod makes the maneuver slightly easier.)

Exposure: The camera automatically selects Matrix metering mode, which sets exposure based on the light throughout the entire scene. You

can't use the other two metering modes. In addition, the camera adjusts ISO (light sensitivity) automatically for you.

In Handheld mode, the camera also handles the aperture and shutter speed settings automatically, In Tripod mode, however, you can set the camera to the M or A exposure modes and then dial in an aperture setting (to affect depth of field) before you begin recording. In either Tripod or Handheld mode, you can adjust exposure in the P, S, and A exposure modes by using Exposure Compensation, but only to EV +3.0 or –3.0 (rather than the usual range of –5.0 to +5.0 available for still photography). During recording, you can press the AE-L/AF-L button to lock exposure.

Customizing sound recording

The D300s improves on the movie-recording capabilities of most other still cameras that offer movie mode by enabling you to record sound either through the internal microphone or by attaching an external mike.

The advantages of an external microphone are twofold. First, you can buy a mike that offers stereo recording and better overall sound quality than the internal one. Additionally, by positioning the mike away from the camera, you avoid including sounds made by the camera in the recording.

You can attach any microphone that has a standard, 3.5mm mini-pin plug. The mike jack is located under the cover on the left side of the camera, as shown on the left in Figure 4-40.

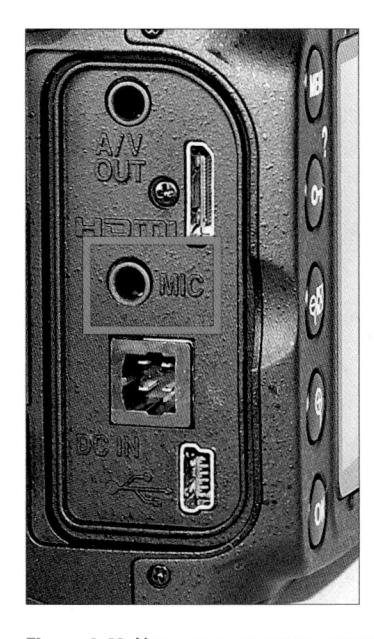

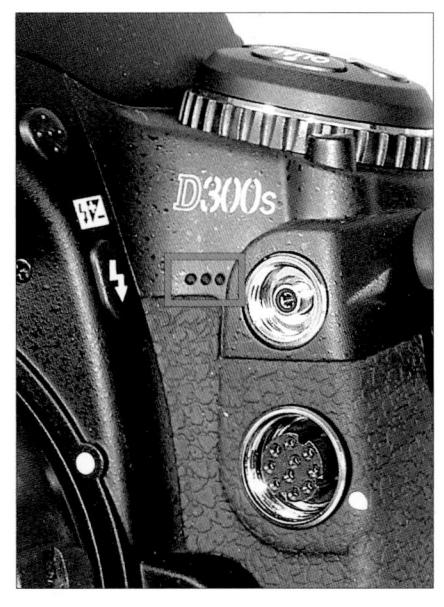

Figure 4-40: You can connect an external mike or use the built-in one.

If you instead choose to use the internal microphone, note its position: It's the little three-holed area above the D300s logo, on the front of the camera, as shown on the right in the figure. Make sure that you don't inadvertently cover up the microphone with your finger. And keep in mind that anything *you* say will be picked up by the mike along with any other audio present in the scene.

Whether you use the internal mike or attach another one, set the recording options through the Movie Settings option on the Shooting menu, as shown in Figure 4-41. Highlight Microphone and press OK to display the options shown on the second screen in the figure.

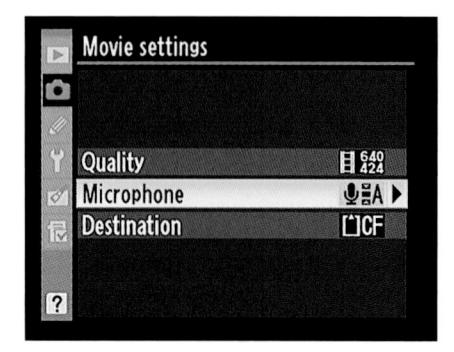

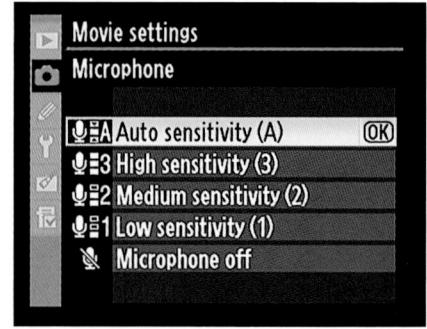

Figure 4-41: Set the microphone sensitivity or disable sound here.

You have the following options:

- ✓ To disable sound: Choose Microphone Off to record a movie without any sound at all.
- ✓ To enable sound: All the other settings enable sound. You can select a specific sensitivity setting to control how loud a sound has to be in order to be picked up by the mike. For a very quiet speaker sitting across the room, for example, you may want to increase the sensitivity. Or, if you don't want to pick up faraway noises, decrease the sensitivity so only sounds close to the mike get recorded. At the Auto level, the camera adjusts the sound level automatically.

You also can adjust the microphone sensitivity after switching to Live View mode by using the trick mentioned earlier, in the section about adjusting monitor brightness: Press and hold the Playback button and then press the Multi Selector left to highlight the little microphone symbol in the upper-right
corner of the screen. (Peek ahead at Figure 4-42, in the next section, for a look.) Then press up or down to cycle through the various sensitivity settings. Release the Playback button when you're done.

Shooting your movie

To try out movie recording, first set your camera as outlined in all the preceding sections. Then take these steps:

- 1. Press the Lv button to switch to Live View mode.
- 2. Compose your shot.
- 3. Set focus.

Which method you can use depends on whether you use Tripod mode or Handheld mode. You can find details in the preceding sections on still photography in Live View mode, but here's the quick recap:

- In either mode, manual focusing typically works best. Be sure to set your lens and the camera to manual focusing and then just twist the lens focusing ring to adjust focus.
- In Handheld mode, frame your subject so that it's under the autofocus point you can use the Multi Selector to position the point and then press the AF-ON button or press the shutter button halfway to focus. The monitor will shut off briefly; when you hear the beep signaling that focus has been set, release the button. You can't adjust autofocus after you begin recording; if you try, recording stops automatically. Also remember that Vibration Reduction, if your lens offers it, engages only if you press the shutter button to set focus.
- In Tripod mode, use the Multi Selector to position the focus point over your subject and then press the AF-ON button to set focus. The monitor remains on while focus is being set. You can press the button again during recording to adjust focusing if needed, but be aware that you may be able to hear the sound of the focusing motor in the recording and see the camera "hunt" for the new focusing target.

After focusing, you can press the Zoom In button to magnify the display and check focus, just as when you take still pictures in Live View mode. Press OK to return to the non-magnified view.

4. Adjust exposure if desired.

Depending on the Live View mode you use, you can adjust exposure through the aperture setting (f-stop), by applying exposure compensation,

AF-ON

or applying autoexposure lock. Chapter 5 details all these settings; here's how they work during movie recording:

- Select an aperture (f-stop). In Tripod mode, you can set the exposure mode to M or A and then select an aperture setting as high as f/16. (Rotate the sub-command dial to set the f-stop.) However, if the scene on the monitor appears too dark, open up the aperture by choosing a lower f-stop value. In Handheld mode, you can't select an aperture.
- Apply Exposure Compensation. In either mode, you can tweak exposure by applying Exposure Compensation within a range of +/- EV 3.0. But you must set the exposure mode to A, S, or P to use that feature; it doesn't work with manual exposure. Rotate the command dial while pressing the Exposure Compensation button to adjust the setting.
- Lock the current exposure settings. Press the AE-L/AF-L button at any time during recording to keep the current exposure settings. Otherwise, exposure is continually adjusted as needed to deal with any changes in the lighting conditions.

A red Rec symbol begins flashing at the top of the monitor. If your monitor is set to the default Live View display mode, you also see the recording symbols shown in Figure 4-42. These symbols, which are also visible before you start recording, indicate the following:

- Time remaining: This value shows you how many minutes and seconds of video will fit on your current memory card. (The length is dependent on the movie-quality settings you choose and the amount of space on your memory card.) As you record, the value updates continually.
- *Microphone setting:* This symbol shows the current microphone sensitivity setting. (The symbols match those that you see when you adjust the setting through the Movie Settings option on the Shooting menu. (Refer to Figure 4-41.) For example, the symbol shown in Figure 4-42 reflects the Auto Sensitivity setting.

Remember that you can adjust the microphone sensitivity without returning to the menu: See the tip at the end of the preceding section for how-tos.

- 6. To stop recording, press the center button of the Multi Selector.
- 7. Press the Lv button to exit Live View mode and return to normal shooting.

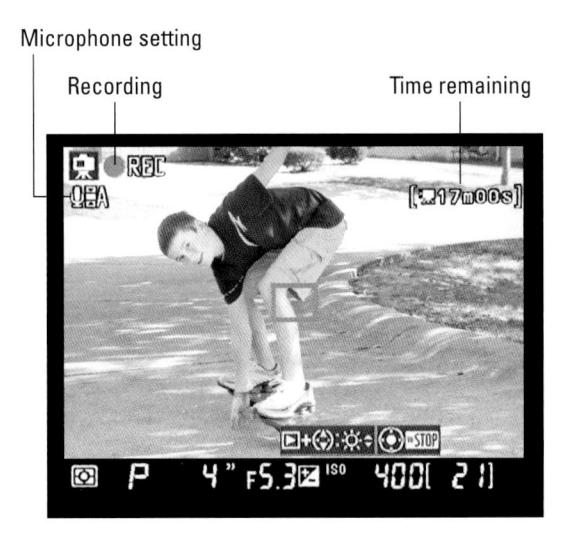

Figure 4-42: The red Rec symbol flashes while recording is in progress.

Playing a movie

To play your movie, exit Live View mode and then press the Playback button. In single-image playback mode, you can spot a movie file by looking for the little movie-camera icon in the top-left corner of the screen, as shown in Figure 4-43. Press the center button of the Multi Selector to start playback.

In thumbnails view, you see little filmstrip dots along the edges of movie files. Use the Multi Selector to highlight the movie file and then press the center button of the Multi Selector twice to start playback — once to shift to single-image view and again to start movie playback.

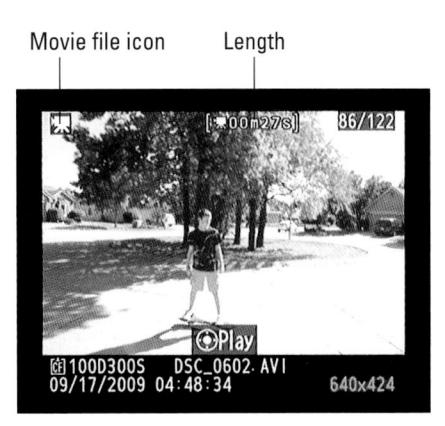

Figure 4-43: Press the center button of the Multi Selector to begin playing a movie.

You can control playback as follows:

- ✓ **Increase sound volume.** Press the Zoom In button.
- **Decrease volume.** Press the Zoom Out button.
- Pause playback. Press the Multi Selector down. While playback is paused, press the Multi Selector right or left to advance or go back one frame.
- **Resume playback.** Press the center button again.
- ✓ **Fast-forward or rewind.** While the movie is playing, press the Multi Selector right to fast-forward and left to rewind. Each press increases the speed of the playback, up to 16 times normal. Keep holding the button down to skip to the end or beginning of the movie.
- ✓ **Stop playback.** Press the Multi Selector up.

Chapter 9 explains how to connect your camera to a television so you can play your movies on the big screen.

Editing movies

You can do some limited movie editing through the camera's Retouch menu. I emphasize: *limited* editing. You can trim frames from the start of a movie and clip off frames from the end, and that's it. If that interests you, give it a go:

- 1. Display your movie in full-frame view and then press OK.
 - You see the Edit Movie option appear, as shown in Figure 4-44. This is the sole Retouch menu option related to movies.
- 2. Press the Multi Selector right to display the screen shown on the right in Figure 4-44.

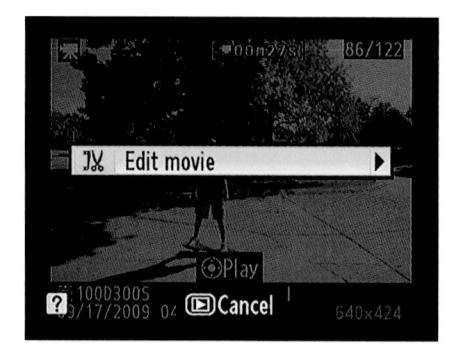

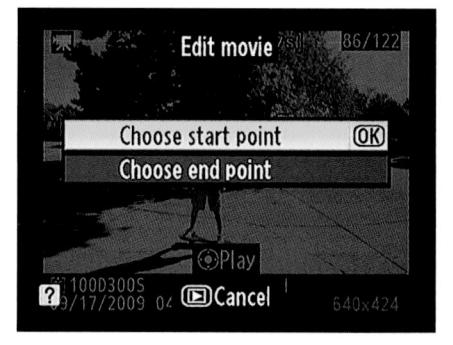

Figure 4-44: You can trim frames from the start and end of your movie through the Retouch menu.

- 3. To trim frames from the start of the movie, select the Choose Start Point option; to trim the end of the film, select the Choose End Point option.
- 4. Press OK.
- Play the movie to the first frame you want to use and then pause playback.

Use the playback techniques referenced in the preceding section to control playback.

6. With the playback paused, press the Multi Selector up.

You see a screen asking permission for the cuts to be made.

7. Highlight Yes and press OK.

All frames prior to the current one head for the cutting room floor. Don't worry, though, your frames aren't permanently lost because the edited movie is saved as a new file.

8. To trim additional footage, repeat the process but start by displaying the edited movie file in Step 1.

Edited files are indicated by a little scissors icon that appears to the right of the movie file symbol, as shown in Figure 4-45.

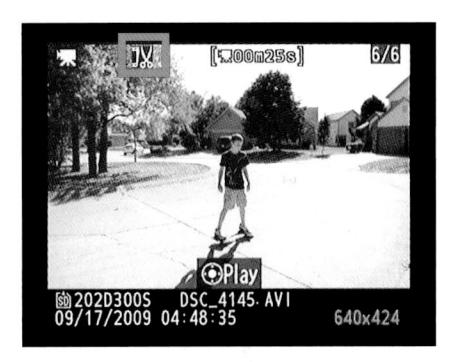

Figure 4-45: The scissors tell you that you're looking at an edited movie file.

Part II Taking Creative Control

In this part . . .

his part of the book details the myriad ways you can manipulate exposure, focus, and color to capture an image as you see it in your mind's eye. And don't think that you have to be a genius or spend years to be successful — adding just a few simple techniques to your photographic repertoire can make a huge difference in how happy you are with the pictures you take.

Chapter 5 helps you master exposure, from choosing the right exposure mode to getting better flash results. Chapter 6 delves into focus and color, covering the ins and outs of the camera's autofocusing options, white balance, color spaces, and more. Following that, Chapter 7 helps you draw together all the information presented earlier in the book, summarizing the best camera settings and other tactics to use when capturing portraits, action shots, landscapes, and close-up shots.

Getting Creative with Exposure and Lighting

In This Chapter

- Understanding the basics of exposure
- Choosing the right exposure mode: P, S, A, or M?
- Reading meters and other exposure cues
- Tweaking exposure with Exposure Compensation and Active D-Lighting
- Getting better flash results
- Creating a safety net with automatic bracketing

astering the art of exposure is one of the most challenging aspects of photography. First, you have to grapple with a seemingly endless list of technical terms — aperture, metering, shutter speed, ISO, stop, and so on. Add to that the equally large number of exposure-related options on your D300s, and, well . . . suffice it to say that if you're feeling a little intimidated, you're in good company. I know, I've been there.

From years of working with beginning photographers, though, I can promise that when you take things nice and slow, digesting just a piece of the exposure pie at a time, the topic is not nearly as complicated as it seems on the surface. And I guarantee that the payoff will be well worth your time and brain energy. You'll not only learn how to solve just about any exposure problem, but you'll also discover ways to use exposure to put your creative stamp on a scene.

To that end, this chapter provides everything you need to know to really exploit all your camera's exposure options, including a primer in exposure science. (It's not as bad as it sounds.) Explore a paragraph or two one day, a few more the next, and before long, you'll have it all down pat.

Introducing the Exposure Trio: Aperture, Shutter Speed, and ISO

Any photograph, whether taken with a film or digital camera, is created by focusing light through a lens onto a light-sensitive recording medium. In a film camera, the film negative serves as that medium; in a digital camera, it's the image sensor, which is an array of light-responsive computer chips.

Between the lens and the sensor are two barriers, known as the *aperture* and *shutter*, which together control how much light makes its way to the sensor. The actual design and arrangement of the aperture, shutter, and sensor vary depending on the camera, but Figure 5-1 offers an illustration of the basic concept.

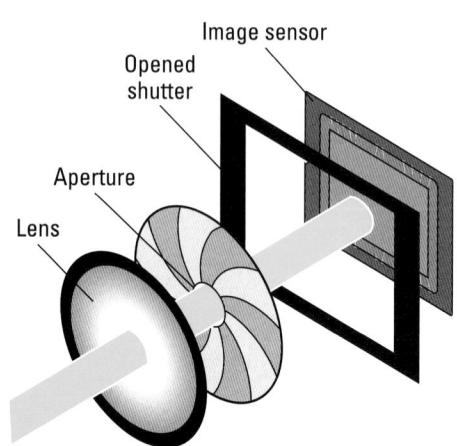

Figure 5-1: The aperture size and shutter speed determine how much light strikes the image sensor.

The aperture and shutter, along with a third feature known as *ISO*, determine *exposure* — what most of us would describe as the picture's overall brightness and contrast. This three-part exposure formula works as follows:

Aperture (controls amount of light): The *aperture* is an adjustable hole in a diaphragm set just behind the lens. By changing the size of the aperture, you control the size of the light beam that can enter the camera. Aperture settings are stated as *f-stop numbers*, or simply *f-stops*, and are expressed with the letter *f* followed by a number: f/2, f/5.6, f/16, and so on. The lower the f-stop number, the larger the aperture, and the more light is permitted into the camera, as illustrated by Figure 5-2. Each increase in f-stop value cuts the light that can enter the camera in half: For example, at f/2.8, half as much light is permitted in as at f/2.0.

The range of possible f-stops depends on your lens and, if you use a zoom lens, on the zoom position (focal length) of the lens. For example, on the 18–55mm Nikon AF-S VR lens shown with the D300s in this book, you can select apertures from f/3.5-f/22 when zoomed all the way out to the shortest focal length, 18mm. When you zoom in to the maximum focal length, 55mm, the aperture range is f/5.6-f/36. (See Chapter 6 for a discussion of focal lengths.)

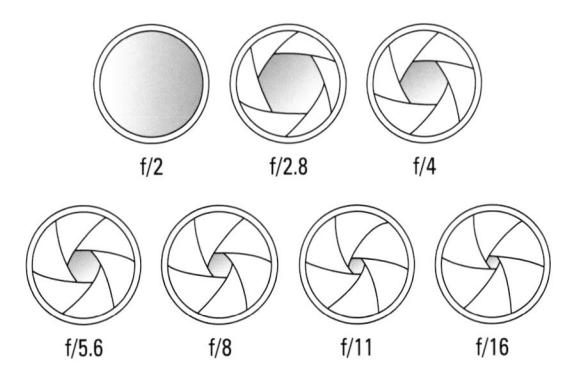

Figure 5-2: A lower f-stop number means a larger aperture, allowing more light into the camera.

✓ Shutter speed (controls duration of light): Set behind the aperture, the shutter works something like, er, the shutters on a window. When you aren't taking pictures, the camera's shutter stays closed, preventing light from striking the image sensor, just as closed window shutters prevent sunlight from entering a room. When you press the shutter button, the shutter opens briefly to allow light that passes through the aperture to hit the image sensor.

The length of time that the shutter is open is called the *shutter speed* and is measured in seconds: 1/60 second, 1/250 second, 2 seconds, and so on. Shutter speeds on the D300s range from 30 seconds to 1/8000 second when you shoot without flash. For flash photography with the built-in flash, the range is more limited; for some external flash units, you can still access the entire range of shutter speeds, although there are tradeoffs to be made for the privilege. See the section "Enabling high-speed flash (auto FP)," later in this chapter, for information.

Should you want a shutter speed longer than 30 seconds, manual (M) exposure mode also provides a feature called *bulb* exposure. At this setting, the shutter stays open indefinitely as long as you press the shutter button.

✓ **ISO** (controls light sensitivity): ISO, which is a digital function rather than a mechanical structure on the camera, enables you to adjust how responsive the image sensor is to light. The term ISO is a holdover from film days, when an international standards organization rated each film stock according to light sensitivity: ISO 200, ISO 400, ISO 800, and so on.

On a digital camera, the sensor itself doesn't actually get more or less sensitive when you change the ISO — rather, the light "signal" that hits the sensor is either amplified or dampened through electronics wizardry, sort of like how raising the volume on a radio boosts the audio signal.

But the upshot is the same as changing to a more light-reactive film stock: A higher ISO means that less light is needed to produce the image, enabling you to use a smaller aperture, faster shutter speed, or both. (In other words, from now on, don't worry about the technicalities and just remember that ISO equals light sensitivity.)

The normal ISO settings on the D300s range from ISO 200 to 3200. But if you really need to push things, you can extend that range all the way to ISO 100 at the low end and 6400 at the high end. (These "extra" settings, called Lo 1 and Hi 1, respectively, have some downsides that you can explore in the upcoming section "ISO affects image noise.")

Distilled down to its essence, the image-exposure formula is just this simple:

- Aperture and shutter speed together determine how much light strikes the image sensor.
- ✓ ISO determines how much the sensor reacts to that light and thus how much light is needed to expose the picture.

The tricky part of the equation is that aperture, shutter speed, and ISO settings affect your pictures in ways that go *beyond* exposure. You need to be aware of these side effects, explained in the next section, to determine which combination of the three exposure settings will work best for your picture.

Understanding exposure-setting side effects

You can create the same exposure with multiple combinations of aperture, shutter speed, and ISO. You're limited only by the aperture range allowed by the lens and the shutter speeds and ISO range offered by the camera.

But as I hinted in the preceding section, the settings you select impact your image beyond mere exposure, as explained in the following three sections.

Aperture affects depth of field

The aperture setting, or f-stop, affects *depth of field*, which is the range of sharp focus in your image. I introduce this concept in Chapter 2, but here's a quick recap: With a shallow depth of field, your subject appears more sharply focused than faraway objects; with a large depth of field, the sharp-focus zone spreads over a greater distance.

As you reduce the aperture size — or *stop down the aperture*, in photo lingo — by choosing a higher f-stop number, you increase depth of field. As an example, take a look at the two images in Figure 5-3. For both shots, I established focus on the female statue atop the fountain. Notice that the background in the first

image, taken at an aperture setting of f/14, is softer than in the right example, taken at f/29. Aperture is just one contributor to depth of field, however; focal length and your camera-to-subject distance are also involved. See Chapter 6 for the complete story.

Shutter speed affects motion blur

At a slow shutter speed, moving objects appear blurry, whereas a fast shutter speed captures motion cleanly. Compare the fountain spray in the photos in Figure 5-3, for example. At a shutter speed of 1/20 second (right photo), the water blurs, giving it a misty look. At 1/80 second (left photo), the droplets appear more sharply focused. How high a shutter speed you need to freeze action depends on the speed of your subject.

f/14, 1/80 second, ISO 100

f/29, 1/20 second, ISO 100

Figure 5-3: Stopping down the aperture (by choosing a higher f-stop number) increases depth of field, or the zone of sharp focus.

Assuming that your lens is focusing correctly, a picture that suffers from overall blur, where even stationary objects appear out of focus, indicates that the camera itself moved during the exposure, which is always a danger when you handhold the camera. The slower the shutter speed. the longer the exposure time and the longer you have to hold the camera still to avoid the blur that is caused by camera shake. For example, I was able to successfully handhold the 1/80 second exposure you see on the left in Figure 5-3, but at 1/20 second, there was enough camera movement to result in the blurry shot shown in Figure 5-4. So I mounted the camera on the tripod to get the shake-free version shown on the right in Figure 5-3.

How slow is too slow? It depends on your physical capabilities and your lens — a longer, heavier lens adds to the challenge. For reasons that are too technical to get into, camera shake also affects your picture more when you shoot with a lens that has a long

Figure 5-4: Allover blur usually indicates that the camera moved during the exposure.

focal length. So you may be able to use a much slower shutter speed when you shoot with a 28mm wide-angle lens, for example, than a 200mm telephoto lens. (Chapter 6 explains focal length, if the term is new to you.)

The best idea is to do your own tests to see where your handholding limit lies. Start with a slow shutter speed — say, in the 1/40 second neighborhood, and then click off multiple shots, increasing the shutter speed for each picture. If you have a zoom lens, run the test first at the minimum focal length (widest angle) and then zoom to the maximum focal length for another series of shots. Then it's simply a matter of comparing the images in your photo editing program. (You may not be able to accurately judge the amount of blur on the camera monitor.) See Chapter 8 to find out how to see the shutter speed you used for each picture when you view your images.

Some Nikon lenses, including the one featured in this book, offer *vibration reduction*, which is designed to help compensate for small amounts of camera shake. If you're using a lens from another manufacturer, the feature may go by the name *image stabilization* or something similar. Whatever you call it,

this option can enable you to capture sharp images at slightly slower shutter speeds than normal when handholding the camera. (Again, your mileage may vary, but most people can expect to go at least two or three notches down the shutter-speed ramp.)

See Chapter 1 for details about using a vibration reduction lens. Chapter 6 has tips on solving other focus problems, and Chapter 7 offers more help with action photography.

150 affects image noise

As ISO increases, making the image sensor more reactive to light, you increase the risk of producing a defect called *noise*. This defect looks like sprinkles of sand and is similar in appearance to film *grain*, a defect that often mars pictures taken with high ISO film. Noise can also be caused by very long exposure times.

Ideally, then, you should always use the lowest ISO setting on your camera to ensure top image quality. But in dim lighting, you simply may not be able to use the aperture and shutter speed you need without raising ISO. Fortunately, the D300s produces remarkably little noise even at fairly high ISO settings, as evidenced by the examples in Figure 5-5, which shows you close-up views of the candle scene shot at six different settings along the ISO range.

Putting the f (stop) in focus

One way to remember the relationship between f-stop and depth of field, or the range of distance over which objects remain in sharp focus, is simply to think of the f as standing for focus. A higher f-stop number produces a larger depth of field, so if you want to extend the zone of sharp focus to cover a greater distance from your subject, you set the aperture to a higher f-stop. Higher f-stop number, greater zone of sharp focus.

Please *don't* share this tip with photography elites, who will roll their eyes and inform you that the *f*in *f-stop* most certainly does *not* stand

for focus but for the ratio between the aperture size and lens focal length — as if *that's* helpful to know if you're not an optical engineer. (Chapter 6 explains focal length, which *is* helpful to know.)

As for the fact that you *increase* the f-stop number when you want a *smaller* aperture, well, I'm still working on the ideal mnemonic tip for that one. But try this in the meantime: Lower f-stop, larger aperture. Or maybe the opposite: Raise the f-stop to reduce the aperture size and restrict the light. (As I said, I'm working on it.)

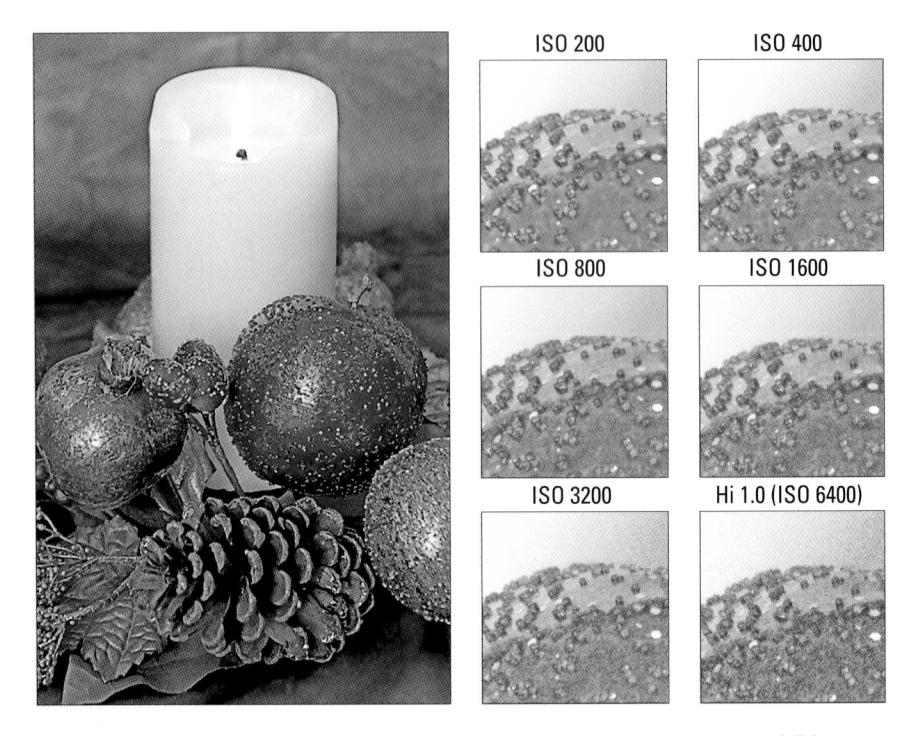

Figure 5-5: Each step up the ISO ladder adds more noise, which becomes more visible as you enlarge the image.

Although you can definitely spot the noise in the close-ups starting at about ISO 800, you may be able to get away with even the maximum ISO if you keep your print or display size small. The candle image printed with the ISO close-ups, for example, was taken at ISO 800, as most people couldn't detect any appreciable noise. As with other image defects, noise becomes more apparent as you enlarge the photo. Noise is also easier to spot in shadow areas of your picture and in large areas of solid color.

At the low end of the ISO range, it's important to know that the three Lo settings — Lo 3.0, Lo 0.7, and Lo 1.0, which are roughly equivalent to ISO 160, 125, and 100, respectively — produce images with higher contrast than normal, which is why Nikon suggests that you use them only if you have no other choice. For example, in really bright light, you may need to drop down below ISO 200 in order to use a large aperture or slow shutter speed. A better solution, though, is to put a neutral density filter over your lens. This filter works like sunglasses for your lens, darkening the scene without affecting colors (thus, the *neutral* part of the filter name).

Doing the exposure balancing act

As you change any of the three exposure settings — aperture, shutter speed, and ISO — one or both of the others must also shift in order to maintain the same image brightness. Say that you're shooting a soccer game, for example, and you notice that although the overall exposure looks great, the players appear slightly blurry at your current shutter speed. If you raise the shutter speed, you have to compensate with either a larger aperture, to allow in more light during the shorter exposure, or a higher ISO setting, to make the camera more sensitive to the light — or both.

As the preceding section explains, changing these settings impacts your image in ways beyond exposure. As a quick reminder:

- Aperture affects depth of field, with a higher f-stop number producing a greater zone of sharp focus.
- Shutter speed affects whether motion of the subject or camera results in a blurry photo. A faster shutter "freezes" action and also helps safeguard against allover blur that can result from camera shake when you're handholding the camera.
- ✓ ISO affects the camera's sensitivity to light. A higher ISO makes the camera more responsive to light but also increases the chance of image noise.

So when you boost that shutter speed to capture your soccer subjects, you have to decide whether you prefer the shorter depth of field that comes with a larger aperture or the increased risk of noise that accompanies a higher ISO.

Everyone has their own approach to finding the right combination of aperture, shutter speed, and ISO, and you'll no doubt develop your own system as you become more practiced at using your camera. In the meantime, here's how I handle things:

- ✓ I always use ISO 200 unless the lighting conditions are such that I can't use the aperture and shutter speed I want without adjusting ISO.
- ✓ If my subject is moving (or might move, as with a squiggly toddler or antsy pet), I give shutter speed the next highest priority in my exposure decision. I might choose a fast shutter speed to ensure a blur-free photo or, on the flip side, select a slow shutter to intentionally blur that moving object, an effect that can create a heightened sense of motion. (The waterfall photo in Chapter 7 offers an example of the latter technique.)
- For images of non-moving subjects, I make aperture a priority over shutter speed, setting the aperture according to the depth of field I have in mind. For portraits, for example, I use the largest aperture (the lowest f-stop number, known as shooting wide open, in photographer speak) so that I get a short depth of field, creating a nice, soft background for my

subject. For landscapes, I usually go the opposite direction, stopping down the aperture as much as possible to capture the subject at the greatest depth of field.

I know that keeping all this straight is a little overwhelming at first, but the more you work with your camera, the more the whole exposure equation will make sense to you. You can find tips for choosing exposure settings for specific types of pictures in Chapter 7; keep moving through this chapter for details on how to actually monitor and adjust aperture, shutter speed, and ISO settings on the D300s.

Meet the Exposure Modes: P, S, A, and M

Chapter 2 offers a brief introduction to your camera's four *exposure modes*. You set the mode by pressing the Mode button as you rotate the main command dial. The Mode setting appears in the areas highlighted in Figure 5-6.

The exposure mode determines how much control you have over aperture and shutter speed, as follows:

- ✓ P (programmed autoexposure): In this mode, the camera selects both aperture and shutter speed. But you can choose from different combinations of the two. This mode offers the most stress-free shooting available, which is why it's the star of the "almost automatic" photography techniques outlined in Chapter 2.
- ✓ **S** (shutter-priority autoexposure): In this mode, you select a shutter speed, and the camera chooses the aperture setting that produces a good exposure at your selected ISO setting.

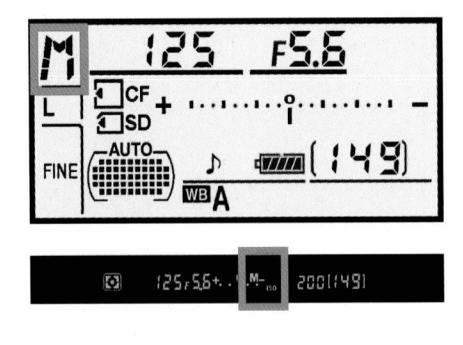

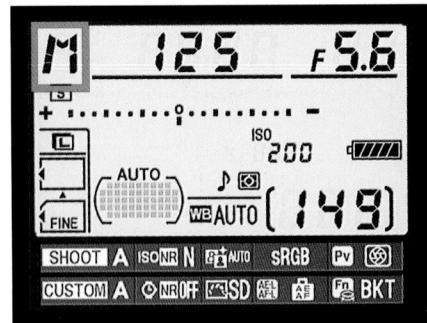

Figure 5-6: The exposure mode determines how much control you have over aperture and shutter speed.

- ✓ A (aperture-priority autoexposure): The opposite of shutter-priority autoexposure, this mode asks you to select the aperture setting. The camera then selects the appropriate shutter speed to properly expose the picture.
- M (manual exposure): In this mode, you specify both shutter speed and aperture.

To sum up, the first three modes are semi-automatic exposure modes that are designed to help you get a good exposure by handling part of the work for you. You do still have some control over the ultimate exposure, though: If you think your picture is under- or overexposed, for example, you can ask for a brighter or darker result on your next shot by using Exposure Compensation, a feature outlined later in this chapter. You can tweak the results in other ways as well. It's important to understand, though, that in extreme lighting conditions, the camera may not be able to select settings that will produce a good exposure no matter what you do. The camera will warn you about the potential problem but doesn't prevent you from capturing the shot.

Manual mode puts all exposure control in your hands. If you're a longtime photographer who comes from the days when manual exposure was the only game in town, you may prefer to stick with this mode. If it ain't broke, don't fix it, as they say. And in some ways, manual mode is simpler than the semi-auto modes because if you're not happy with the exposure, you just change the aperture, shutter speed, or ISO setting (or all three) and shoot again. You don't have to apply Exposure Compensation or fiddle with other features that enable you to modify your autoexposure results.

My own personal choice is to use aperture-priority autoexposure when I'm shooting still subjects and want to control depth of field — aperture is my *priority* — and to switch to shutter-priority autoexposure when I'm shooting a moving subject and so am most concerned with controlling shutter speed. Frankly, my brain is taxed enough by all the other issues involved in taking pictures — what my white balance setting is, what resolution I need, where I'm going for lunch as soon as I make this shot work — that I just appreciate having the camera do some of the exposure lifting.

However, when I know exactly what aperture and shutter speed I want to use, or I'm after an out-of-the-ordinary exposure, I use manual exposure. For example, sometimes when I'm doing a still life in my studio, I want to create a certain mood by underexposing a subject or even shooting it in silhouette. The camera is always going to fight you on that result in the P, S, and A modes because it so dearly wants to provide a good exposure. Rather than dialing in all the autoexposure tweaks that could eventually force the result I want, I simply set the mode to M, adjust the shutter speed and aperture directly, and give the autoexposure system the afternoon off.

But even in manual mode, you're never really flying without a net — the camera assists you by displaying the exposure meter, explained next.

Reading (And Adjusting) the Meter

To help you determine whether your exposure settings are on cue in M (manual) exposure mode, the camera provides an *exposure meter* in the displays. The meter is the little linear graphic highlighted in Figure 5-7. You can see a close-up look at how the meter looks in the viewfinder in Figure 5-8. To activate the meter displays, just press the shutter button halfway and then release it.

The minus-sign end of the meter represents underexposure; the plus sign, overexposure. So if the little notches on the meter fall to the right of 0, as shown in the first example in Figure 5-8, the image will be underexposed. If the indicator moves to the left of 0, as shown in the second example, the image will be overexposed. The farther the indicator moves toward the plus or minus sign, the greater the potential problem. When the meter shows a balanced exposure, as in the third example, you're good to go.

In the P, S, and A exposure modes, the meter appears in the displays only if the camera anticipates an exposure problem. The word Lo at the end of the meter tells you that the photo may be seriously underexposed; the word Hi indicates severe overexposure. The meter flashes if your exposure settings are so far off the chart that the amount of under- or overexposure exceeds the limits of the meter.

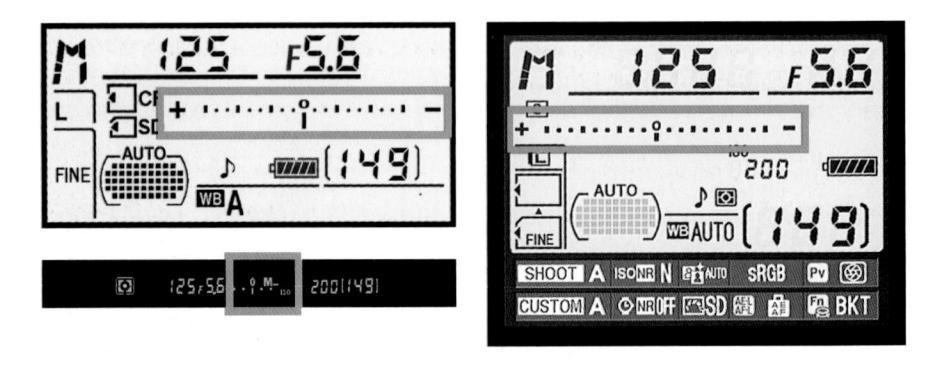

Figure 5-7: You can view the exposure meter in the Information display and Control panel.

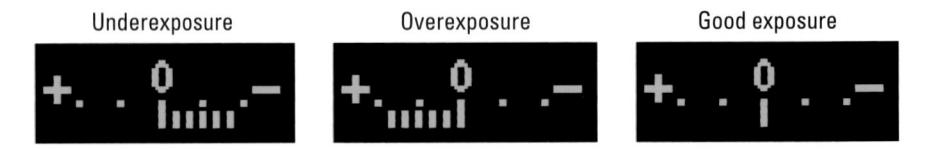

Figure 5-8: The exposure meter indicates whether your exposure settings are on target.

Exposure stops: How many do you want to see?

In photography, the term *stop* refers to an increment of exposure. To increase exposure by one stop means to adjust the aperture or shutter speed to allow twice as much light into the camera as the current settings permit. To reduce exposure a stop, you use settings that allow half as much light.

By default, all the major exposure-related settings on the D300s are based on one-third stop adjustments. For example, when you adjust the Exposure Compensation value, a feature that enables you to request a brighter or darker picture than the camera's autoexposure system thinks is correct, you can choose settings of EV 0.0 (no adjustment), +0.3, +0.7, and +1.0 (a full stop of adjustment).

If you prefer, you can tell the camera to present exposure settings in half-stop or whole-stop increments. You can even request different increments for different exposure options. Make your preferences known through the three options highlighted in the left figure here, found

in the Metering/Exposure section of the Custom Setting menu. All three options offer the same three settings, shown on the right in the figure. (The menu uses the term *step* instead of *stop*, but the results are the same.) But each option affects specific exposure components:

- ISO Sensitivity Step Value: Affects ISO settings only.
- EV Steps for Exposure Control: Affects shutter speed, aperture, and exposure bracketing settings. Also determines the increment used to indicate the amount of under- or overexposure in the meter.
- Exposure Comp/Fine Tune: Determines the increments available for Exposure Compensation and Flash Compensation.

Obviously, the default setting provides the greatest degree of exposure fine-tuning, so I stick with that option. In this book, all instructions also assume that you're using the defaults.

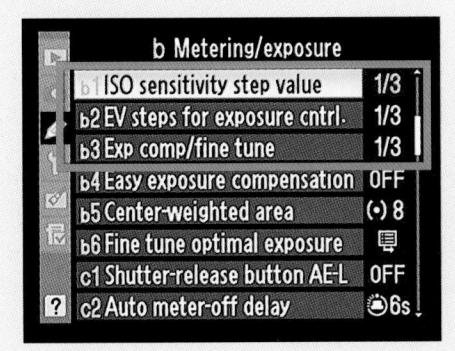

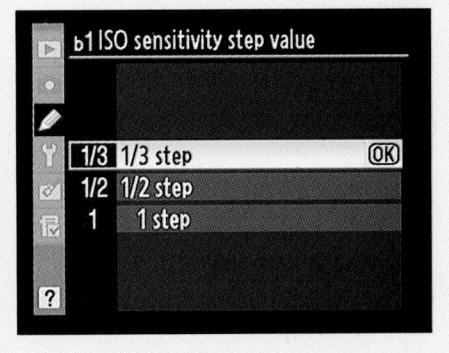

Keep in mind that the meter's suggestion on exposure may not always be the one you want to follow. For example, you may want to shoot a backlit subject in silhouette, in which case you *want* that subject to be underexposed. In other words, the meter is a guide, not a dictator. In addition, the exposure information the meter reports is based on the *exposure metering mode*, which determines which part of the frame the camera considers when calculating exposure. See the upcoming section "Choosing an Exposure Metering Mode" for details

If you're so inclined, you can customize the meter in the following ways:

- ✓ **Adjust the meter shutoff timing.** The meter turns on anytime you press the shutter button halfway. But then it turns off automatically if you don't press the button again for a period of time 6 seconds, by default. You can adjust the shut-off timing through the Auto Meter-Off Delay option, found on the Timers/AE Lock submenu of the Custom Setting menu, as shown on the left in Figure 5-9. Shorter delay times conserve battery power.
- Reverse the meter orientation. You can flip the meter so that the positive (overexposure) side appears on the right and the negative (underexposure) side falls on the left. This option also lies on the Custom Setting menu, but on the Controls submenu. Look for the Reverse Indicators option, as shown on the right in the figure.
- ✓ Use the Multi Selector to activate the meters. In addition to using the shutter button to jumpstart the meters, you can set the Multi Selector directional buttons (up, down, left, right) to do the job. To take advantage of this option, head for the Controls section of the Custom Setting menu and choose the Multi Selector option, as shown on the left in Figure 5-10. Then select the Reset Meter-Off Delay option. (Despite the name, this setting has no effect on the Auto Meter-Off Delay option.) Just be careful that you don't inadvertently wake up the meters with an errant press of the Multi Selector and thereby unknowingly waste battery power.

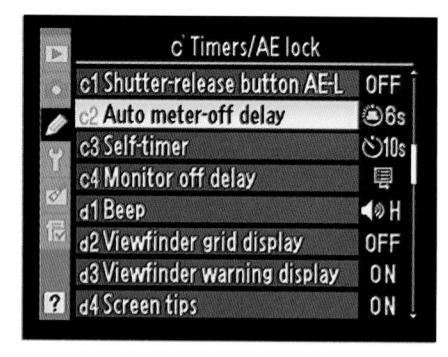

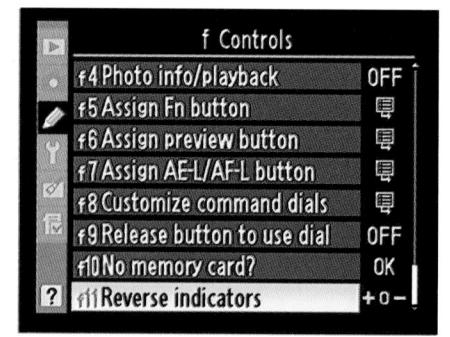

Figure 5-9: You can customize the behavior of the exposure meter.

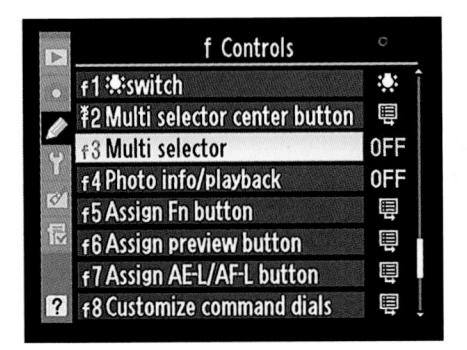

Figure 5-10: You can set the Multi Selector directional buttons to activate the meter.

Setting 150, Aperture, and Shutter Speed

The next sections detail how to view and adjust these three critical exposure settings. For a review of how each setting affects your pictures, check out the first part of this chapter.

Adjusting aperture and shutter speed

You can view the current aperture (f-stop) and shutter speed in the Control panel, viewfinder, and Information display, as shown in Figure 5-11. If you don't see the values, the exposure meter isn't awake; press the shutter button halfway to bring it out of its slumber.

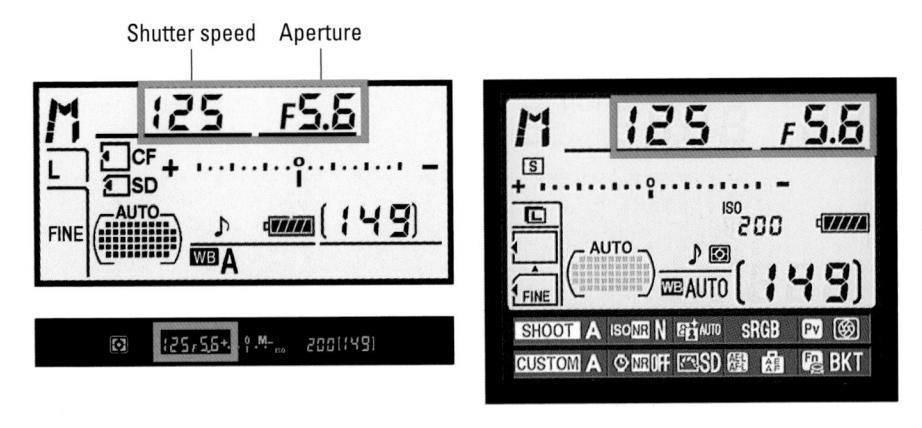

Figure 5-11: You can view the f-stop and shutter speed setting in all three displays.

Before I explain how to select the f-stop and shutter speed, I need to share a few notes about the latter setting:

- ✓ Shutter speeds are presented as whole numbers, even if the shutter speed is set to a fraction of a second. For example, the number 125 indicates a shutter speed of 1/125 second. When the shutter speed slows to 1 second or more, quote marks appear after the number 1" indicates a shutter speed of 1 second, 4" means 4 seconds, and so on.
- When you set the exposure mode to M (manual) or S (shutter-priority auto), you have access to two shutter speeds not displayed in the other modes:
 - Bulb: At this setting, the shutter remains open as long as you hold down the shutter button. You can shoot bulb exposures only in the M (manual) exposure mode. If you select the bulb setting in M mode and then change to the S (shutter-priority auto) mode, the word "Bulb" flashes in the display to remind you to change to manual exposure. Well, to remind you that something's amiss, anyway.
 - *x250:* In addition, you also see a setting that has an *x* before the value *x250,* by default. The x, when used with shutter speeds, indicates the *flash sync speed,* which is the fastest shutter speed that works with flash. On the D300s, the default sync speed is 1/250 second, but you can set another speed through a Custom Setting option. (See the later section "Exploring Flash Photography with D300s" for details.) If you do change the speed, the x value that appears as a shutter speed reflects the new setting. For example, if you set the maximum speed to 1/320 second, you see x320. If you want to use 1/320 second as your shutter speed, you can select either the x320 setting or the plain ol' 1/320 setting. In other words, the x-value number is pretty much there just to remind you of the maximum flash sync speed.

With that enormously long introduction out of the way, the following list tells you how to actually select the aperture and shutter speed settings in each exposure mode:

✓ P (programmed auto): In this mode, the camera shows you its recommended f-stop and shutter speed when you press the shutter button halfway. But you can rotate the main command dial to select a different combination of settings. The number of possible combinations depends upon the aperture settings and shutter speeds the camera can select, which in turn depend on the lighting conditions, your lens, and the ISO setting.

An asterisk (*) appears next to the P exposure mode symbol in the displays after you rotate the main command dial. The asterisk indicates that you adjusted the aperture/shutter speed settings from those the camera initially suggested. To get back to the initial combo of shutter speed and aperture, rotate the main command dial until the asterisk disappears.

For a more thorough look at using this mode, see Chapter 2.

✓ **S (shutter-priority autoexposure):** In this mode, you select the shutter speed. Just rotate the main command dial to get the job done. Again, you can't use the Bulb shutter speed in this mode.

As you change the shutter speed, the camera automatically adjusts the aperture as needed to maintain what it considers the proper exposure. Remember that as the aperture shifts, so does depth of field — so even though you're working in shutter-priority mode, keep an eye on the f-stop, too, if depth of field is important to your photo. Also note that in extreme lighting conditions, the camera may not be able to adjust the aperture enough to produce a good exposure at your current shutter speed — again, possible aperture settings depend on your lens. So you may need to compromise on shutter speed or ISO.

✓ A (aperture-priority autoexposure): In this mode, you control aperture, and the camera adjusts shutter speed automatically. To set the aperture (f-stop), rotate the sub-command dial.

When you stop down the aperture (raise the f-stop value), be careful that the shutter speed doesn't drop so low that you run the risk of camera shake if you handhold the camera — unless you have a tripod handy, of course. And if your scene contains moving objects, make sure that when you dial in your preferred f-stop, the shutter speed that the camera selects is fast enough to stop action (or slow enough to blur it, if that's your creative goal). These same warnings apply when you use P mode, by the way.

- M (manual exposure): In this mode, you select both aperture and shutter speed, like so:
 - To adjust shutter speed: Rotate the main command dial.
 - To adjust aperture: Rotate the sub-command dial.

Keep in mind that when you use P, S, or A modes, the settings that the camera handles are selected based on what the exposure meter thinks is the proper exposure. If you don't agree with the camera, you have two options: You can switch to manual exposure mode and simply dial in the aperture and shutter speed that deliver the exposure you want; or if you want to stay in P, S, or A mode, you can tweak exposure using the Exposure Compensation feature, explained later in this chapter. Adjusting the metering mode, ISO setting, and Active D-Lighting setting can also get you closer to the exposure result you're after.

Controlling 150

The ISO setting, introduced at the start of this chapter, adjusts the camera's sensitivity to light. At a higher ISO, you can use a faster shutter speed or a smaller aperture (higher f-stop number) because less light is needed to expose the image. But remember that a higher ISO also increases the possibility of noise, as illustrated in Figure 5-5. (Be sure to check out the upcoming sidebar "Dampening noise" for features that may help calm noise somewhat.)

On the D300s, you can choose ISO values ranging from 200 to 3200, plus three more settings in each direction: Hi 0.3, Hi 0.7, and Hi 1.0; and Lo 0.3, Lo 0.7, and Lo 1.0. These settings, in order, translate to ISO values of about 160, 125, and 100 at the low end and 4000, 5000, and 6400 at the high end. See the earlier section "ISO affects image noise" for advice on selecting the right ISO value.

The number of settings available between the top and bottom of the ISO range depend on a Custom Setting menu option called ISO Sensitivity Step Value, covered in the sidebar "Exposure stops: How many do you want to see?" By default, you can make adjustments in one-third stop increments.

Your current ISO setting appears in the Information display and viewfinder in the areas highlighted in Figure 5-12. To view the ISO setting in the Control panel, as shown in the figure, press the ISO button. To adjust the setting, press the button while rotating the main command dial.

You also can adjust ISO through the ISO Sensitivity Settings option on the Shooting menu, as shown in Figure 5-13. Going this route gives you access to an additional ISO option, ISO Sensitivity Auto Control. If you enable this feature, you still select an ISO value. But any time the camera thinks that your selected ISO will result in an over- or underexposed picture at your current f-stop and shutter speed settings, it automatically adjusts ISO to solve the problem.

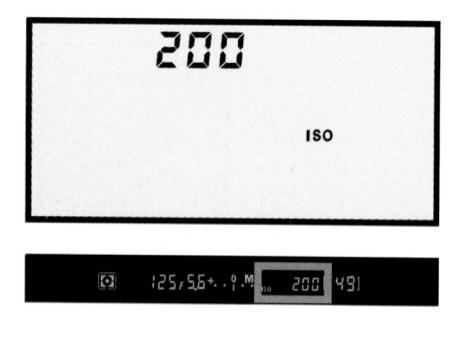

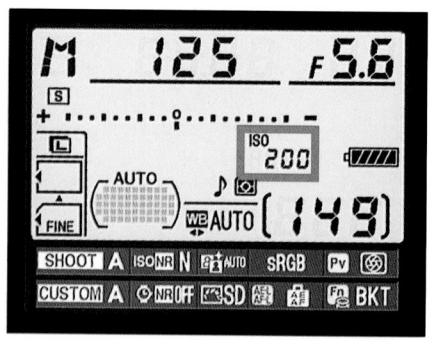

Figure 5-12: Press the ISO button while rotating the main command dial to adjust ISO.

A	SHOOTING MENU	
	Active D-Lighting	EZANTO
111	Long exp. NR	0FF
5	High ISO NR	NORM
	ISO sensitivity settings	自
0	Live view mode	桌
V	Multiple exposure	OFF
	Movie settings	目
?	Interval timer shooting	0FF

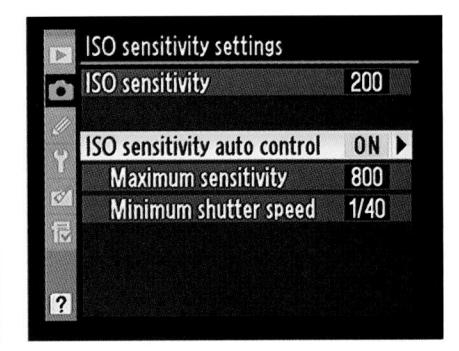

Figure 5-13: You can set limits for Auto ISO override.

If you enable Auto ISO Sensitivity, use the Maximum Sensitivity and Minimum Shutter Speed options, also shown in Figure 5-13, to tell the camera exactly when it should step in and offer ISO assistance. With the first option, you specify the highest ISO setting the camera may select when it overrides your ISO decision. The second option sets the minimum shutter speed at which the ISO override engages when you shoot in the P and A exposure modes. For example, you can specify that you want the camera to amp up ISO if the shutter speed drops to 1/40 second or below. (However, the camera will override your wishes and use a slower shutter speed if it can't produce a good exposure at your maximum ISO setting.)

When automatic ISO adjustment is turned on, you see an ISO Auto label in the displays, as shown in Figure 5-14. If the camera is about to override your ISO setting, the label blinks. And in playback mode, the ISO value appears in red if you view your photos in the Shooting Data and Overview Data display modes. (Chapter 4 has details.)

Figure 5-14: If Auto ISO blinks, the camera is planning on overriding your current ISO setting.

Dampening noise

A high ISO setting or a long exposure time — or both — can result in *noise*, the digital defect that gives your pictures a speckled look. (Refer to Figure 5-5.) To help solve the problem, the D300s offers two noise-removal filters: High ISO Noise Reduction, designed to reduce the appearance of ISO-related noise; and Long Exposure Noise Reduction, which dampens the type of noise that occurs during long exposures.

You can enable both filters through the Shooting menu, as shown in the left figure below, or through the control strip along the bottom of the Information display. To activate the strip, press the Info button twice. Then use the Multi Selector to highlight a filter. In the figure here, the Long Exposure Noise Reduction filter is active; the High ISO filter is directly above on the control strip. Press OK to access the available settings.

If you turn on Long Exposure Noise Reduction, the camera applies the filter to pictures taken at shutter speeds of longer than 8 seconds. For High ISO Noise Reduction, you can choose from four settings. The High, Normal, and Low settings apply the filter at ISO settings of 800 or higher; the setting you choose determines the

strength of the filter. At the fourth setting, Off, the camera actually still applies a tiny amount of noise removal, but only when you shift into the Hi ISO settings (Hi 0.3 or greater).

Before you enable noise reduction, be aware that doing so has a few disadvantages. First, the filters are applied after you take the picture, as the camera processes the image data. (While the Long Exposure Noise Reduction filter is being applied, the message "Job nr" appears in the viewfinder and Control panel, in the area normally reserved for the shutter speed and aperture.) The time needed to apply the filter can slow down your shooting speed.

Second, noise-reduction filters work primarily by applying a slight blur to the image. Don't expect this process to totally eliminate noise, and do expect some resulting image softness. You may be able to get better results by using the blur tools or noise-removal filters found in many photo editors, because you can blur just the parts of the image where noise is most noticeable — usually in areas of flat color or little detail, such as skies.

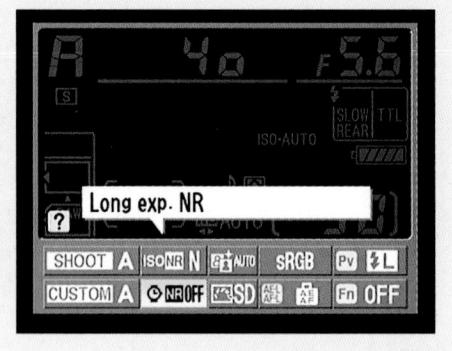

Choosing an Exposure Metering Mode

To fully interpret what your exposure meter tells you, you need to know which *metering mode* is active. The metering mode determines which part of the frame the camera analyzes to calculate the proper exposure. The metering mode affects more than the meter, however: It also determines the exposure settings that the camera selects for you when you shoot in the P, S, and A exposure modes.

Your camera offers three metering modes, which you select via the Metering selector switch, labeled in Figure 5-15. You can view an icon representing the selected mode in the viewfinder and Info display as well, as shown on the right in the figure.

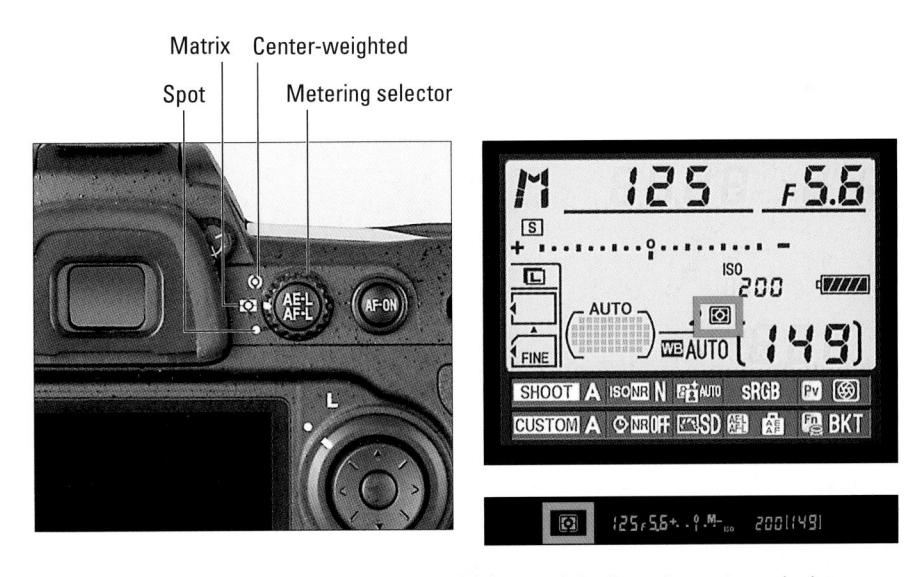

Figure 5-15: The Metering mode determines which part of the frame is used to calculate exposure.

Here's how each mode calculates exposure:

Matrix: The camera bases exposure on the entire frame. Your camera manual refers to this mode as 3D Color Matrix II, which is simply the label that Nikon created to describe the specific technology used in this mode.

✓ **Spot:** In this mode, the camera bases exposure on a single, circular area that's about 3.5mm in diameter and surrounds a specific focus point, as illustrated on the left in Figure 5-16.

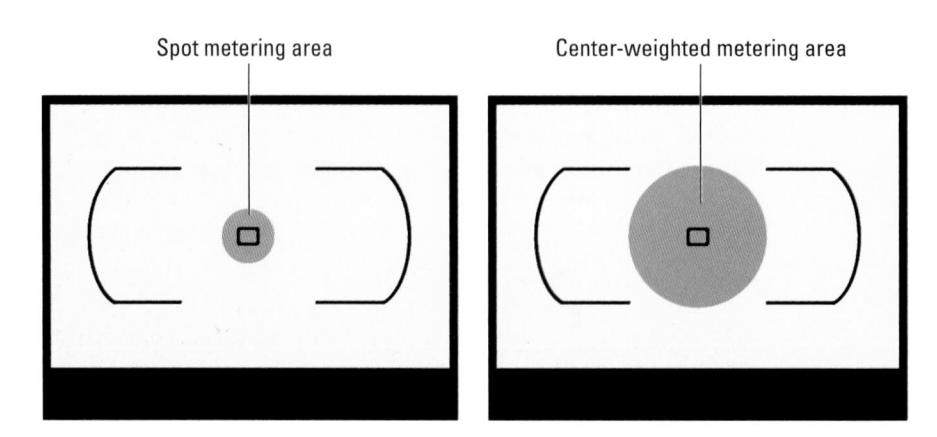

Figure 5-16: Spot metering bases exposure on a single focus point; center-weighted metering gives priority to a larger area at the center of the frame.

Spot-metering performance is tied to some focusing options detailed in Chapter 6, as follows:

- If you use autofocusing and set the AF-area mode to Auto Area, in which the camera chooses the focus point for you, exposure is based on the center focus point.
- When you use the other AF-area mode settings (Dynamic Area or Single Point) or manual focusing, you use the Multi Selector to select a focus point, and the camera bases exposure on that point.

Center-weighted: A blend of matrix and spot metering, the camera bases exposure on the entire frame but puts extra emphasis — or weight — on the center of the frame.

Normally, the area that's given priority in this mode is about 8mm in diameter, as illustrated on the right in Figure 5-16. But you can alter the critical metering area through the Center-Weighted Area option, found in the Metering/Exposure section of the Custom setting menu and shown in Figure 5-17. You can change the size of the metering circle to 6mm, 10mm, or 13mm.

The Center-Weighted Area option also offers a setting called Avg, which tells the camera to take a reading of the entire frame and then base exposure on the average brightness values it sees. The difference between this option and the Matrix setting is that Matrix is based on a newer, more capable technology, while Avg is based on a system

used in earlier Nikon cameras. Long-time Nikon shooters who are familiar with this metering option may appreciate its inclusion on the D300s, but the Matrix system typically delivers a better exposure if you're concerned about objects throughout the frame, so I suggest that you stick with that when you want to expose the photo with the entire frame in mind.

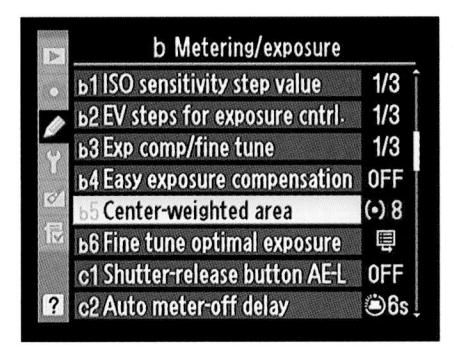

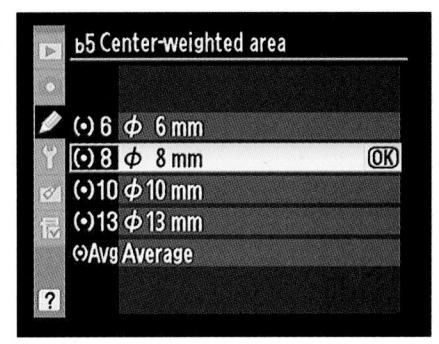

Figure 5-17: You can customize the center-weighted metering area.

As an example of how metering mode affects exposure, Figure 5-18 shows the same image captured at each mode. In the Matrix example, the bright background caused the camera to select an exposure that left the statue quite dark. Switching to center-weighted metering helped somewhat, but didn't quite bring the statue out of the shadows. Spot metering produced the best result as far as the statue goes, although the resulting increase in exposure left the sky and background monument a little washed out.

In theory, the best practice is to check the metering mode before you shoot and choose the one that best matches your exposure goals. But in practice, that's a bit of a pain, not just in terms of having to adjust yet one more capture setting but in terms of having to remember to adjust one more capture setting. So here's my advice: Until you're really comfortable with all the other controls on your camera, just stick with the default setting, which is matrix metering. That mode produces good results in most situations, and, after all, you can see in the monitor whether you disagree with how the camera metered or exposed the image and simply reshoot after adjusting the exposure settings to your liking. This option, in my mind, makes the whole metering mode issue a lot less critical than it is when you shoot with film. Just remember that if you're shooting a series of photos like the one in the figure, where your subject is significantly darker or lighter than the background, switching to spot or center-weighted metering is one way to make sure that the subject is properly exposed.

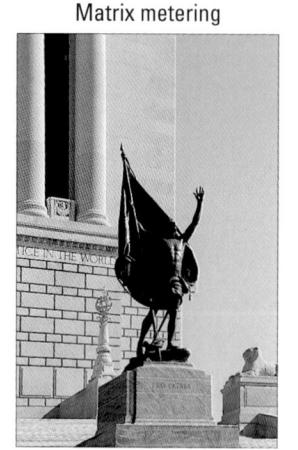

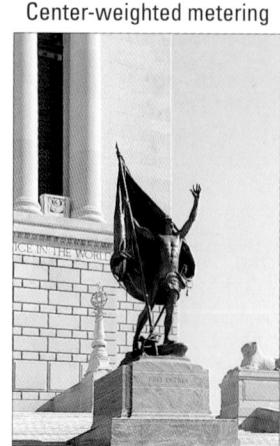

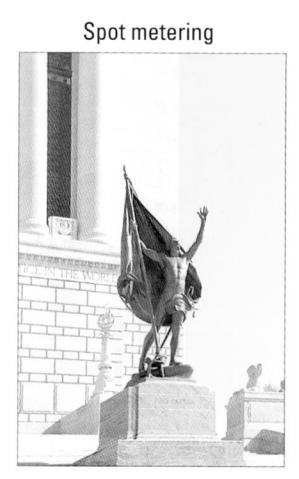

Figure 5-18: Spot and center-weighted metering can produce a better exposure of backlit subjects.

One final point about metering: An option called Fine-Tune Optimal Exposure, found on the Metering/Exposure submenu of the Custom Setting menu, enables you to fiddle with the metering system beyond just specifying the size of the center-weighted metering area. For each metering mode, you can specify that you always want a brighter or darker exposure than what Nikon's engineers determined to be optimal when developing the camera. In essence, you're recalibrating the meter. Although it's nice to have this level of control, I really discourage you from making this adjustment unless you really know what you're doing, both in terms of using the camera and calculating exposure. It's sort of like re-engineering your oven so that it heats to 300 degrees when the dial is set to 325 degrees — it's easy to forget that you made the shift and not be able to figure out why your exposure settings aren't delivering the results you expected.

If your camera consistently under- or overexposes your pictures when you use the semi-automatic exposure modes (P, S, or A), it may be time for a service check at your local camera-repair shop, assuming that the problems occur even in normal lighting situations. For intermittent exposure issues, tweak picture brightness by using Exposure Compensation, explained next, when you use the semi-auto exposure modes (P, S, and A), or just adjust the aperture, shutter speed, or ISO in manual exposure mode (M). Also investigate the upcoming section about Active D-Lighting, which gives you yet another way to manipulate exposure.

Applying Exposure Compensation

When you set your camera to the P, S, or A modes, you can enjoy autoexposure support but still retain some control over the final exposure. If you think that the image the camera produced is too dark or too light, you can use a feature known as *Exposure Compensation*.

This feature enables you to tell the camera to produce a darker or lighter exposure than what its autoexposure mechanism thinks is appropriate. Best of all, this feature is probably one of the easiest on the whole camera to understand. Here's all there is to it:

✓ Exposure Compensation settings are stated in terms of EV values, as in +2.0 EV. Possible values range from +5.0 EV to -5.0 EV. (The EV stands for exposure value.)

Each full number on the EV scale represents an exposure shift of one *stop*. If you're new to this terminology, see the sidebar "Exposure stops: How many do you want to see?" elsewhere in this chapter. That sidebar also explains how you can tweak the increments of EV adjustment the camera offers.

- ✓ A setting of EV 0.0 results in no exposure adjustment.
- ✓ For a brighter image, raise the EV value. The higher you go, the brighter the image becomes.
- For a darker image, lower the EV value.

As an example, take a look at the first image in Figure 5-19. The initial exposure selected by the camera left the balloon a tad too dark for my taste. So I just amped the Exposure Compensation setting to EV +1.0, which produced the brighter exposure on the right.

To apply Exposure Compensation, hold down the Exposure Compensation button, found near the shutter button. All data except the Exposure Compensation value then disappears from the Control panel and is dimmed in the Information display. In the viewfinder, the frames-remaining value is replaced by the Exposure Compensation value. While holding the button, rotate the main command dial to adjust the EV value. The exposure meter reflects your change as you adjust the value.

After you release the button, the 0 on the meter in the viewfinder blinks to remind you that Exposure Compensation is active. You also see a little plus/minus symbol (the same one that decorates the button itself) in the Control panel and Information display, and the meter readout indicates the amount

of compensation you applied. For example, in Figure 5-20, the meter indicates an adjustment of EV \pm 1.0. (If you have difficulty making out the meter reading, just press the Exposure Compensation button again to display the numerical value in the Control panel.)

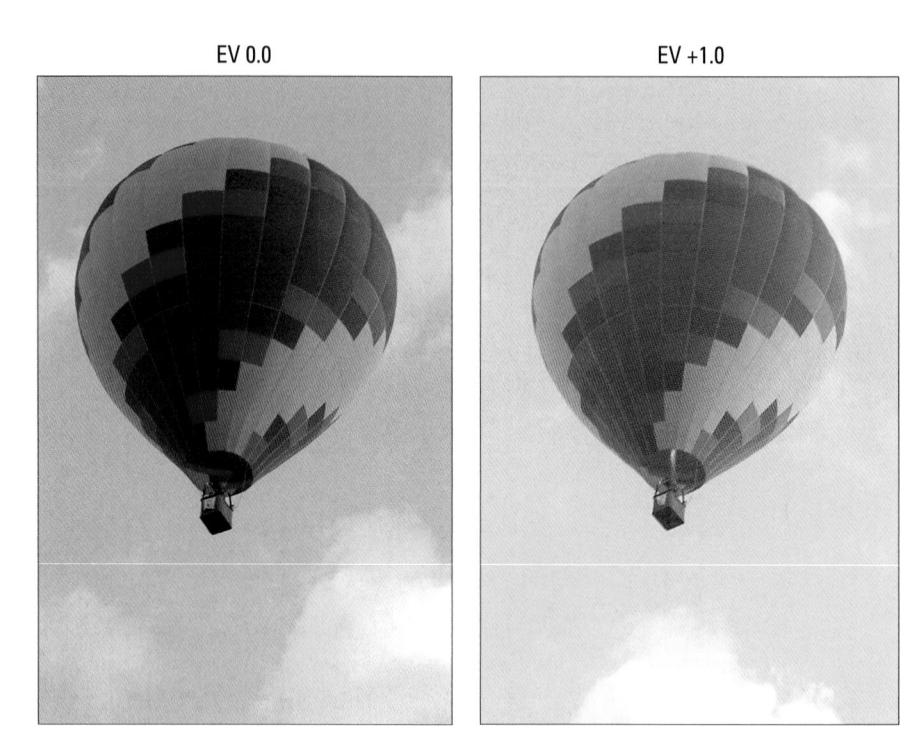

Figure 5-19: For a brighter exposure, raise the EV value.

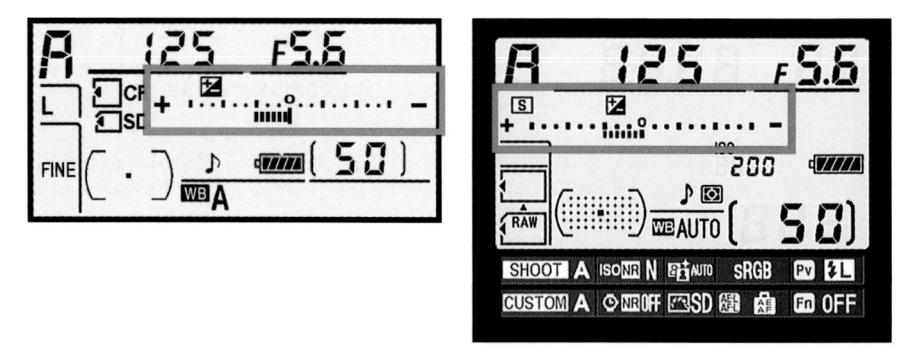

Figure 5-20: The plus/minus symbol tells you that Exposure Compensation is being applied.

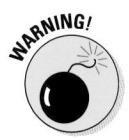

Your Exposure Compensation setting remains in force until you change it, even if you power off the camera. So you may want to make a habit of checking the setting before each shoot or always setting the value back to EV 0.0 after taking the last shot for which you want to apply compensation.

Here are a few other tips about Exposure Compensation:

- How the camera arrives at the brighter or darker image you request through your Exposure Compensation setting depends on the exposure mode:
 - In A (aperture-priority autoexposure) mode, the camera adjusts the shutter speed but leaves your selected f-stop in force. Be sure to check the resulting shutter speed to make sure that it isn't so slow that camera shake or blur from moving objects is problematic.
 - In S (shutter-priority autoexposure) mode, the opposite occurs: The camera opens or stops down the aperture, leaving your selected shutter speed alone.
 - In P (programmed autoexposure) mode, the camera decides whether to adjust aperture, shutter speed, or both.
 - In all three modes, the camera may also adjust ISO if you have ISO Sensitivity Auto Control enabled.

Keep in mind that the camera can adjust f-stop only so much, according to the aperture range of your lens. And the range of shutter speeds, too, is limited by the camera itself, although you're not likely to reach those limits on the D300s, which offers speeds from 30 seconds to 1/8000 second. If you do hit the aperture or shutter speed wall, you either have to compromise on shutter speed or aperture or adjust ISO. Remember that the exposure meter blinks if the camera can't adjust the settings enough to produce a good exposure.

- ✓ When you use flash, the Exposure Compensation setting affects both background brightness and flash power. But you can further modify the flash power through a related option, Flash Compensation. You can find out more about that feature later in this chapter.
- ✓ The Metering/Exposure section of the Custom Setting menu contains an option called Easy Exposure Compensation. If you enable this feature, you can adjust the Exposure Compensation setting in the P and S exposure modes simply by rotating the sub-command dial. In A exposure mode, you use the main command dial instead of the sub-command dial (because you use the sub-command dial in A mode to adjust the f-stop). I advise against enabling this feature: You can easily rotate the dial by mistake and not realize that you adjusted the setting.

✓ Finally, if you don't want to fiddle with Exposure Compensation, just switch to manual exposure mode and select whatever aperture and shutter speed settings produce the exposure you're after. Start with the settings selected by the camera in the autoexposure mode you were using and then just go from there. Exposure Compensation has no effect on manual exposures; again, that adjustment is made only in the P, S, and A modes.

Although the camera doesn't change your selected exposure settings in manual mode even if Exposure Compensation is enabled, the exposure *meter is* affected by the current setting, which can lead to some confusion. The meter indicates whether your shot will be properly exposed based on the Exposure Compensation setting. So if you don't realize that Exposure Compensation is enabled, you may mistakenly adjust your exposure settings when they're actually on target for your subject. This is yet another reason why it's best to always reset the Exposure Compensation setting back to EV 0.0 after you're done using that feature.

Using Autoexposure Lock

To help ensure a proper exposure, your camera continually meters the light in a scene until the moment you depress the shutter button fully and capture the image. In autoexposure modes — that is, any mode but M — it also keeps adjusting exposure settings as needed to maintain a good exposure.

For most situations, this approach works great, resulting in the right settings for the light that's striking your subject at the moment you capture the image. But on occasion, you may want to lock in a certain combination of exposure settings. For example, perhaps you want your subject to appear at the far edge of the frame. If you were to use the normal shooting technique, you would place the subject under a focus point, press the shutter button halfway to lock focus and set the initial exposure, and then reframe to your desired composition to take the shot. The problem is that exposure is then recalculated based on the new framing, which can leave your subject under-or overexposed.

The easiest way to lock in exposure settings is to switch to M (manual) exposure mode and use the f-stop, shutter speed, and ISO settings that work best for your subject. But if you prefer to stay in P, S, or A mode, you can press the AE-L/AF-L button to lock exposure and focus before you reframe. By keeping the button pressed between shots, you can even keep using the same exposure and focus for a series of photographs. Here's the technique I recommend:
1. Set the metering mode to spot metering.

Just move the Metering mode selector switch to the setting shown in the top red box in Figure 5-21.

2. Set the camera to manual or autofocusing.

For autofocusing, set the focusmode selector switch on the front of the camera to S. For manual focusing, set the switch to M. (Continuous autofocusing, represented by the C setting, isn't possible with this exposure lock technique; C mode operates just like S in this scenario.)

If your lens offers a focus-mode switch, set it to manual focusing or autofocusing as well.

3. For autofocusing, set the AF-area mode selector to the Single Point setting.

Focus-point selector lock switch

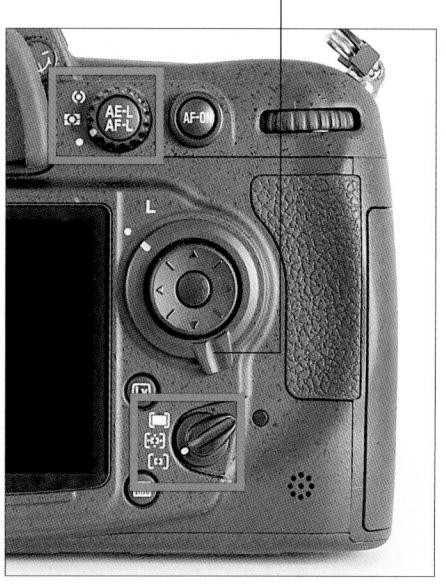

Figure 5-21: These settings work best when you want to use autoexposure lock and autofocusing.

The AF-area mode selector is the switch surrounded by the lower red box in Figure 5-21. Set the switch to the position shown in the figure. (Chapter 6 discusses this option.) When you select this setting, which tells the camera to base focus on a single focus point, a rectangle representing the focus point appears in the viewfinder (as it does when you set the focus mode to manual).

4. Use the Multi Selector to move the focus point over your subject.

You sometimes need to press the shutter button halfway and release it to activate the exposure meters before you can do so. Also, be sure that the Focus-point selector lock switch, labeled in Figure 5-21, is set to the little white dot, as shown in the figure. Otherwise, you can't adjust the focus point.

In spot metering mode, the focus point determines the area used to calculate exposure, so this step is critical whether you use autofocusing or manual focusing.

5. Press the shutter button halfway.

The camera sets the initial exposure settings. If you're using autofocusing, focus is also set at this point. For manual focusing, twist the focusing ring on the lens to bring the subject into focus. The green focus indicator dot in the viewfinder lights when focus is achieved.

6. Press and hold the AE-L/AF-L button.

This button's just to the right of the viewfinder.

While the button is pressed, the letters AE-L appear at the left end of the viewfinder to remind you that exposure lock is applied.

By default, focus is locked at the same time if you're using autofocusing. You can change this behavior by customizing the AE-L/AF-L button function, as outlined in Chapter 11.

7. Reframe the shot if desired and take the photo.

Be sure to keep holding the AE-L/AF-L button until you release the shutter button! And if you want to use the same focus and exposure settings for your next shot, just keep the AE-L/AF-L button pressed.

Even though AE Lock is in effect, you can still adjust the aperture (in A exposure mode) or shutter speed (S mode). Just rotate the sub-command dial (for A mode) or main command dial (for S mode). As you do, the camera automatically shifts the other setting as needed to maintain the exposure at the level it was locked. In P mode, you can rotate the main command dial to select a different combination of aperture and f-stop without affecting the final exposure as well.

Expanding Tonal Range with Active D-Lighting

A scene like the one in Figure 5-22 presents the classic photographer's challenge: Choosing exposure settings that capture the darkest parts of the subject appropriately causes the brightest areas to be overexposed. And if you instead "expose for the highlights" — that is, set the exposure settings to capture the brightest regions properly — the darker areas are underexposed.

In the past, you had to choose between favoring the highlights or the shadows. But thanks to a feature than Nikon calls Active D-Lighting, you have a better chance of keeping your highlights intact while better exposing the darkest areas. In my seal scene, turning on Active D-Lighting produced a brighter rendition of the darkest parts of the rocks and the seals, for example, and yet the color in the sky didn't get blown out as it did when I captured the image with Active D-Lighting turned off. The highlights in the seal and in the rocks on the lower-right corner of the image also are toned down a tad in the Active D-Lighting version.

Active D-Lighting Off

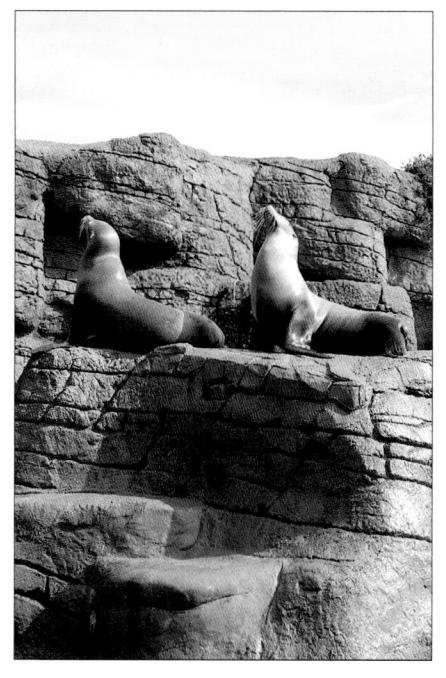

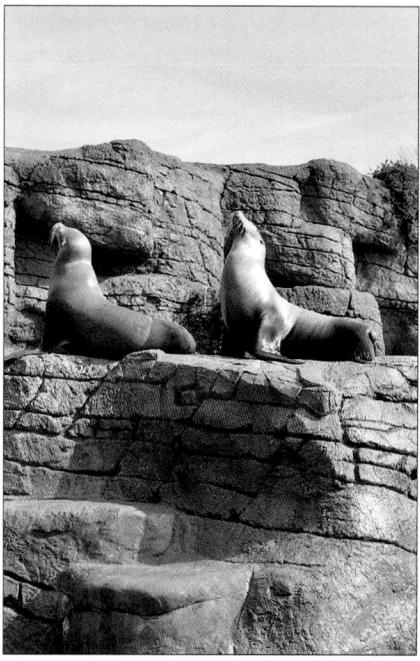

Figure 5-22: Active D-Lighting enabled me to capture the shadows without blowing out the highlights.

Active D-Lighting actually does its thing in two stages. First, it selects exposure settings that result in a slightly darker exposure than normal. This half of the equation guarantees that you retain details in your highlights. Without that adjustment, the brightest areas of the image might be overexposed, leaving you with a batch of all-white pixels that really should contain a range of tones from light to lighter to white. So a cloud, for example, would appear as a big white blob, with no subtle tonal details to give it form. After you snap the photo, the second part of the process occurs. During this phase, the camera applies an internal software filter to brighten only the darkest areas of the image. This adjustment rescues shadow detail, so that you wind up with a range of dark tones instead of a big black blob.

You can turn Active D-Lighting on and off in two ways:

Select Active D-Lighting from the Shooting menu, as shown on the left in Figure 5-23. Press OK to display the second screen in the figure, where you can specify the amount of Active D-Lighting adjustment. At the Auto setting, the camera determines how much adjustment is needed. I used this setting for the seal photo in Figure 5-22. If you prefer to take control, you can select from one of the other four settings (Extra High, High, Normal, and Low). Press OK to enable the adjustment for your next shot.

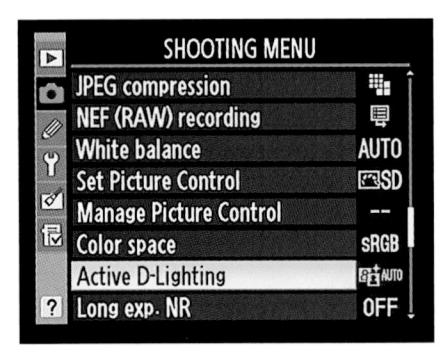

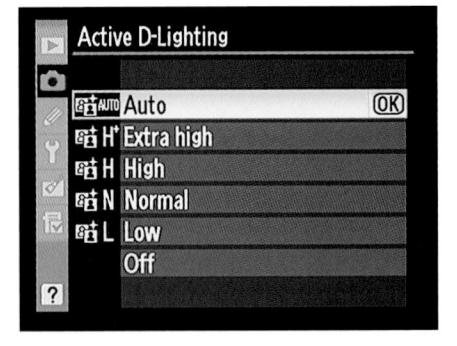

Figure 5-23: At the Auto setting, the camera automatically applies the amount of Active D-Lighting adjustment as it sees fit.

✓ Press the Info button twice to activate the control strip at the bottom of the Information display. Then use the Multi Selector to highlight the Active D-Lighting icon, as shown in Figure 5-24, and press OK. You're then taken to the menu screen where you can choose the level of adjustment you want to use.

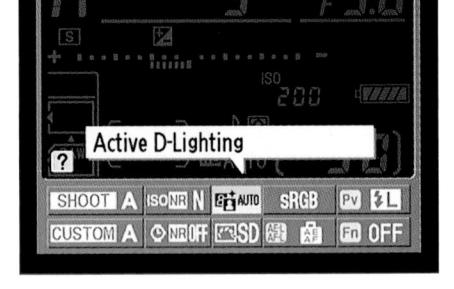

A couple of pointers about using this feature:

Figure 5-24: You can also access the D-Lighting options from the Information display control strip.

- Nikon says that you'll get the best Active D-Lighting results in matrix metering mode.
- ✓ If you're not sure how much adjustment to apply, try out the Active D-Lighting bracketing feature. With this option, you take multiple shots of the subject, and the camera automatically selects a different Active D-Lighting adjustment for each shot. You then can decide which image you prefer. See the last section in this chapter for details.
- Active D-Lighting does have one drawback: The camera needs a moment or two to do its shadow-recovery work, which can sometimes be a hindrance when you need to fire off shots in rapid succession.
- ✓ The Retouch menu offers a D-Lighting filter that applies a similar adjustment to existing pictures. (See Chapter 11 for help.) Some photo editing programs, such as Adobe Photoshop Elements and Photoshop, also have good shadow and highlight recovery filters. In either case, when you

shoot with Active D-Lighting disabled, you're better off setting the initial exposure settings to record the highlights as you want them. It's very difficult to bring back lost highlight detail after the fact, but you typically can unearth at least a little bit of detail from the darkest areas of the image.

Exploring Flash Photography with the D300s

Sometimes, no amount of fiddling with aperture, shutter speed, and ISO produces a bright enough exposure — in which case, you simply have to add more light. The built-in flash on your D300s offers the most convenient solution, but you can also attach an external flash. You can connect the flash to the camera's *hot shoe*, the connector on top of the camera, or via a flash sync cable attached to the connection hidden under the little rubber cover on the front of the camera. Figure 5-25 labels both connection points.

To raise the built-in flash, press the Flash button on the side of the camera, also labeled in Figure 5-25.

To go flash-free, just press the top of the flash unit gently down to close it.

Like everything else on the D300s, flash options range from fairly simple to fairly not. Unfortunately, to keep this book from being exorbitantly large (and expensive), I can cover only the basics here. So I point you

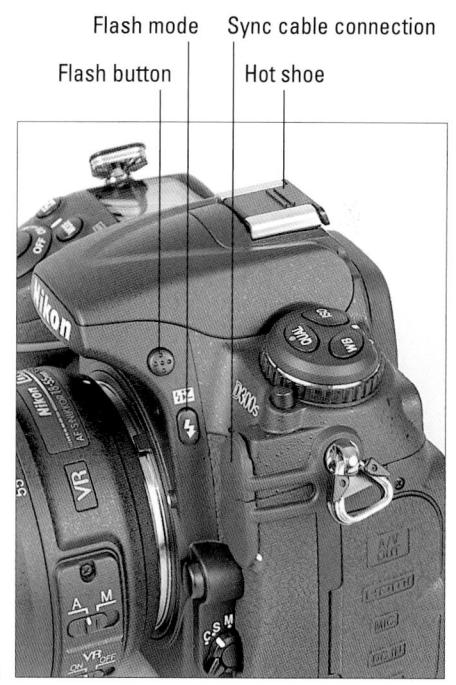

Figure 5-25: Press the Flash button to pop up the built-in flash.

toward a couple of my favorite resources for delving more deeply into flash photography:

- Nikon's Web site (www.nikon.com) offers some great tutorials on flash photography (as well as other subjects). Start in the Learn and Explore section of the site.
- ✓ A Web site completely dedicated to flash photography, www.strobist. com, enables you to learn from and share with other photographers.

- You also can find several good books detailing the entire Nikon flash system, which it calls the Creative Lighting System (CLS, for short).
- Be sure to also visit Chapter 7, where you can find additional flash and lighting tips related to portraits and other specific types of photographs.

Before moving on, though, here's one preliminary tip: Pay careful attention to your results when you use the built-in flash with a telephoto lens that is very long. You may find that the flash casts an unwanted shadow when it strikes the lens. For best results, try switching to an external flash head, as discussed near the end of this chapter.

Setting the flash mode

Whether you're using the built-in flash or an external flash, you can choose from several *flash modes*. This setting determines the timing of the flash and also affects how much of the picture is exposed by ambient light and how much is lit by the flash.

To set the mode, press the Flash Mode button on the front-left side of the camera while rotating the main command dial. As soon as you press the button, the Control panel and Information display change to show only an icon representing the flash mode and the current Flash Compensation value, as shown in Figure 5-26. (Flash Compensation enables you to adjust flash power; look for details later in this chapter.) In the viewfinder, you see only the Flash Compensation value plus a little lightning bolt icon indicating that flash is enabled, charged, and ready to fire. The viewfinder doesn't present any information about the flash mode, so this is one setting you need to adjust while looking at the other displays.

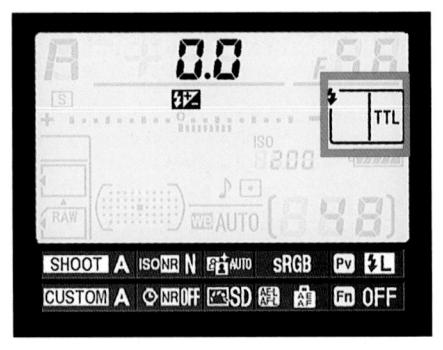

Figure 5-26: Press the Flash Mode button while rotating the main command dial to change the flash mode.

Your flash mode choices break down into three basic categories, described in the next sections: normal flash; red-eye reduction flash; and slow-sync and rear-sync flash, which are special-purpose flash options.

The flash mode icon in the Information display reflects the current setting for a Custom Setting menu option called Flash Cntrl for Built-in Flash, shown in Figure 5-27. For normal flash, stick with the default setting, TTL, as shown in the figure. (TTL stands for through the lens and refers to the fact that the camera bases the necessary flash power on the amount of light actually coming through the lens.) For a look at what the other options do, see the section "Changing to manual, repeating, or commander flash mode," later in this chapter.

Figure 5-27: For normal flash operation, set this menu item to TTL.

Front-curtain sync (normal flash)

For normal flash, select the setting represented in the Information display and Control panel by the symbol you see in the margin here. (Again, the information display symbol includes the letters TTL, as shown in Figure 5-26.)

This mode is officially named *front-curtain sync*, which refers to how the flash is synchronized with the opening of the shutter. Here's the deal: The D300s uses a type of shutter that involves two curtains moving across the frame each time you press and release the shutter button. When you press the shutter button, the first curtain opens, allowing light through to the sensor. At the end of the exposure, the second curtain draws across the frame to once again shield the sensor from light. With front-curtain sync, the flash fires at the moment the front curtain opens. This arrangement produces normal flash exposures. Rear-curtain sync, in which the flash fires at the end of the exposure, is a special-effects flash mode, as illustrated a little later in this chapter.

You may also hear this mode called *fill* or *force* flash on cameras that have an Auto flash setting, in which the camera decides when flash is needed. (Your D300s doesn't have this option.) On these cameras, fill or force flash mode causes the flash to fire even in the brightest daylight — which, by the way, is often an excellent idea.

Yep, you read me correctly: Adding a flash can really improve outdoor photos, especially portraits, as shown in Figure 5-28. The small pop of light provided by the built-in flash is perfect for filling in shadows that can occur when your light source — the sun — is coming from above. Flash can also help bring out the details in flowers and other outdoor subjects.

No flash

Fill flash

Figure 5-28: The built-in flash is perfect for filling in shadows in outdoor portraits.

When you combine multiple light sources, such as flash with daylight, you may also notice that colors appear slightly warmer or cooler than neutral. To find out how to address this issue, see the Chapter 6 section related to the White Balance control.

Note, too, that when you use the built-in flash, you're restricted to a top shutter speed of 1/250 second by default. That means that in very bright sun, you may need to stop down the aperture significantly or lower ISO, if possible, to avoid overexposing the image. As another option, you can place a neutral density filter over your lens; this accessory simply reduces the light that comes through the lens, enabling you to use a larger aperture in bright sun.

You also can bump up the maximum shutter speed for flash slightly for the built-in flash and access all shutter speeds when you use certain Nikon external flash heads; see the section "Enabling high-speed flash (auto FP)," later in this chapter, for the pros and cons of doing so.

Built-in or external flash, you can also get into trouble as a result of a too-slow shutter when you shoot in the P (programmed auto) or A (aperture-priority auto) exposure modes. Remember, in these two modes, the camera controls shutter speed. And in dim lighting, the camera may drop the shutter speed quite low to ensure a good exposure, even if you use flash. But there's a safety net you can employ: Through the Flash Shutter Speed option, shown in Figure 5-29. you can give the camera a slow-shutter limit to use for flash photography. You can set the minimum shutter speed between 1/60 second and 30

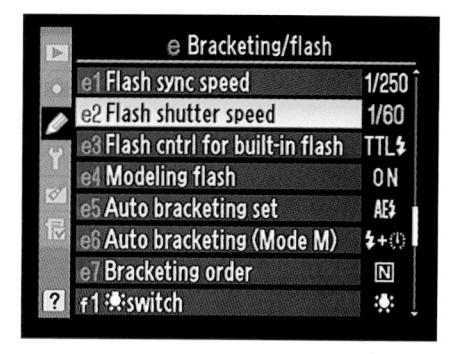

Figure 5-29: You can specify the slowest shutter speed the camera can use when you use flash in the P and A exposure modes.

seconds. You'll find this option in the Flash/Bracketing section of the Custom Setting menu.

This setting applies only to the normal, front-curtain sync flash mode as well as to the red-eye reduction mode and rear-sync mode, both discussed in upcoming sections. The camera completely ignores your limit if you choose slow-sync flash, slow-sync with red eye, or slow rear-curtain sync, also discussed later. So use a tripod in any of those modes to avoid the potential for blur due to camera shake.

Red-eye reduction flash

Red-eye is caused when flash light bounces off a subject's retinas and is reflected back to the camera lens. Red-eye is a human phenomena, though; with animals, the reflected light usually glows yellow, white, or green.

Man or beast, this issue isn't nearly the problem with the type of pop-up flash found on your D300s as it is on non-SLR cameras. Your camera's flash is positioned in such a way that the flash light usually doesn't hit a subject's eyes straight on, which lessens the chances of red-eye. However, red-eye may still be an issue when you use a lens with a long focal length (a telephoto lens) or you shoot subjects from a distance.

💽 If you do notice red-eye, you can try the red-eye reduction mode, represented by the icon shown in the margin here. In this mode, the AF-assist lamp on the front of the camera lights up briefly before the flash fires. The subject's pupils constrict in response to the light, allowing less flash light to enter the eye and cause that glowing red reflection. Be sure to warn your subjects to wait for the flash, or they may step out of the frame or stop posing after they see the light from the AF-assist lamp.

For an even better solution, try the flash-free portrait tips covered in Chapter 7. If you do a lot of portrait work that requires flash, you may also want to consider an external flash unit that offers a rotating head. You then can aim the flash toward the ceiling and "bounce" the light off the ceiling instead of aiming it directly at your subject. That technique produces softer lighting and also virtually eliminates the possibility of red-eye.

If all else fails, check out Chapter 11, which shows you how to use the built-in red-eye removal tool on your camera's Retouch menu. Sadly, though, this feature removes only red-eye, not the yellow/green/white eye that you get with animal portraits.

Slow-sync and rear-curtain sync flash

In front-curtain sync (normal flash) and red-eye reduction flash modes, the flash and shutter are synchronized so that the flash fires at the exact moment the shutter opens. As mentioned earlier, technical types refer to this flash arrangement as front-curtain sync.

Your D300s also offers some special-sync modes, which work as follows:

✓ Slow-sync flash: This mode, available only in the P and A exposure modes, also uses front-curtain sync but allows a shutter speed slower than the 1/60 second minimum that is in force when you use fill flash and red-eve reduction flash. Remember, in these two exposure modes, you can't directly control shutter speed, so the camera automatically drops down the shutter speed for you.

The benefit of this longer exposure is that the camera has time to absorb more ambient light, which in turn has two effects: Background areas that are beyond the reach of the flash appear brighter, and less flash power is needed, resulting in softer lighting.

The downside of the slow shutter speed is, well, the slow shutter speed. As discussed earlier in this chapter, the longer the exposure time, the more you have to worry about blur caused by movement of your subject or your camera. A tripod is essential to a good outcome, as are subjects that can hold very, very still. I find that the best practical use for this mode is shooting nighttime still-life subjects such as the one you see in

> Figure 5-30. But if you have an adult portrait subject, slow-sync can also produce good results; Chapter 7 has an example.

Figure 5-30: Slow-sync flash produces softer, more even lighting than normal flash in nighttime pictures.

Some photographers, though, turn the downside of slow-sync flash to an upside, using it to purposely blur their subjects, thereby emphasizing motion.

Whatever your creative goals, if you want to use flash with a slow shutter in the S or M exposure mode, just choose the normal flash mode (front-curtain sync) and then select the shutter speed you want to use. The flash will fire at the beginning of the exposure. Or as an alternative choice, choose rear-curtain sync, explained next.

Rear-curtain sync: In this mode, available in all four exposure modes, the flash fires at the very end of the exposure, just before the shutter's second curtain draws across the frame to prevent any more light from hitting the image sensor.

The classic use of this mode is to combine the flash with a slow shutter speed to create trailing-light effects like the one you see in Figure 5-31. With rear-curtain sync, the light trails extend behind the moving object (my hand, and the match, in this case), which makes visual sense. If instead you use slow-sync flash (or front-curtain sync with a slow shutter), the light trails appear in front of the moving object.

When you shoot in the P and A exposure modes, the camera actually combines slow-sync flash with rear-curtain sync when vou select this flash mode. You see the words Slow Rear in the flash mode display area of the Control panel and Information display. (Insert junior-high potty joke here.) Shutter speeds automatically drop below normal because the camera assumes that when vou use rear-curtain flash, vou're after the longer exposure time needed to produce the "trailing ghost" effect. (In the M and S modes, you dial in that slow shutter speed yourself.)

Slow-sync with red-eye reduction: In P and A exposure modes. you can also combine a slow-sync Figure 5-31: I used rear-curtain flash and a flash with the red-eye reduction feature. Given the potential for blur that comes with a slow shutter, plus the potential for

shutter speed of about 1.5 seconds to create this candle-lighting image.

subjects to mistake the prelight from the AF-assist lamp for the real flash and walk out of the frame before the image is actually recorded, I vote this flash mode as the most difficult to pull off successfully.

Note that all of these modes are somewhat tricky to use successfully, however. So have fun playing around, but at the same time, don't feel too badly if you don't have time right now to master these modes plus all the other exposure options presented to you in this chapter. In the meantime, do a Web search for slow-sync and rear-sync image examples if you want to get a better idea of the effects that other photographers create with these flash modes.

Adjusting flash output

On the D300s, the way the camera calculates the necessary flash output varies depending on your exposure metering mode:

✓ In matrix and center-weighted modes, flash power is adjusted to expose the picture using a balance of ambient light and flash light. Nikon uses the term i-TTL Balanced Fill Flash for this technology. The i stands for intelligent; again, the TTL means that the camera calculates exposure by reading the light that's coming through the lens. The balanced fill part refers to the fact that the flash is used to fill in shadow areas, while

- brighter areas are exposed by the available light, resulting (usually) in a pleasing balance of the two light sources.
- In spot metering mode, the camera assumes that you are primarily interested in a single area of the frame. So it calculates flash power on the same single area it uses to calculate overall exposure, without much regard for the background. This mode is called *Standard i-TTL Flash*. (See the earlier discussion of metering modes to find out how the specific metering spot, which is based on a single autofocus point, is chosen.)

Regardless of your metering mode, if you want a little more or less flash light than the camera thinks is appropriate, you can adjust the flash output by using a feature called *Flash Compensation*.

This feature works just like Exposure Compensation, discussed earlier in the chapter, except that it enables you to tweak flash power instead of the overall exposure. As with Exposure Compensation, the Flash Compensation settings are stated in terms of EV ($exposure\ value$) numbers. A setting of 0.0 indicates no flash adjustment; you can increase the flash power to EV +1.0 or decrease it to EV -3.0.

As an example of the benefit of this feature, look at the carousel images in Figure 5-32. The first image shows you a flash-free shot. Clearly, I needed a flash to compensate for the fact that the horses were shadowed by the roof of the carousel. But at normal flash power, as shown in the same image, the flash was too strong, creating glare in some spots and blowing out the highlights in the white mane, as shown in the middle image. By dialing the flash power down to EV –0.7, I got a softer flash that straddled the line perfectly between no flash and too much flash.

As for boosting the flash output, well, you may find it necessary on some occasions, but don't expect the built-in flash to work miracles even at a Flash Compensation of +1.0. Any built-in flash has a limited range, and you simply can't expect the flash light to reach faraway objects. In other words, don't even try taking flash pictures of a darkened recital hall from your seat in the balcony — all you'll wind up doing is annoying everyone.

4

With that preface in mind, you adjust flash power by pressing the Flash Exposure button while rotating the sub-command dial. (Rotating the main dial adjusts the flash mode.) As long as you hold the button, the Flash Compensation setting appears in the Control panel and Information display, as shown in Figure 5-33. In the viewfinder, the current setting takes the place of the usual frames-remaining value, and a plus or minus sign also appears to indicate whether you're dialing in a positive or negative value.

After you release the Flash button, you see just the Flash Compensation icon in all three displays. To check the specific compensation value, press and hold the Flash button.

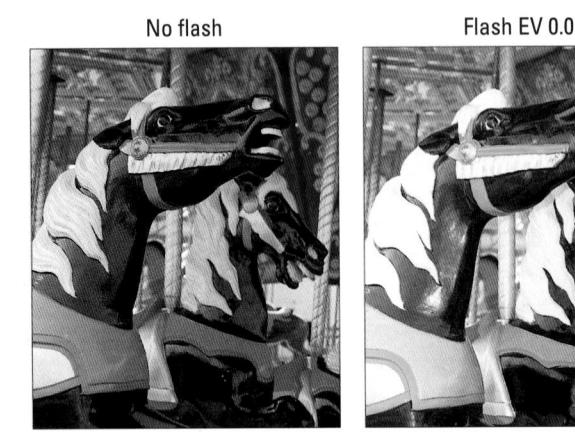

Flash EV -0.7

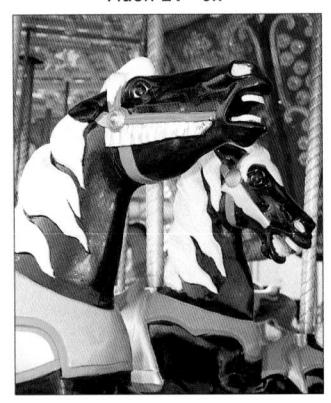

Figure 5-32: When normal flash output is too strong, dial in a lower Flash Compensation setting.

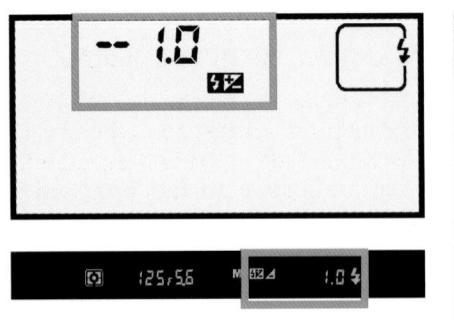

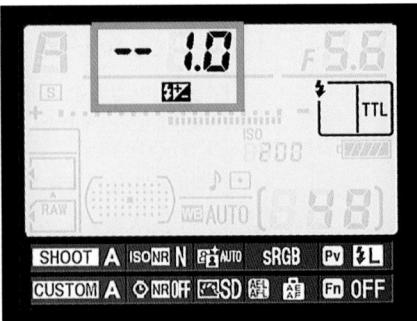

Figure 5-33: Rotate the sub-command dial while pressing the Flash button to adjust flash power.

As with Exposure Compensation, any flash-power adjustment you make remains in force, even if you turn off the camera, until you reset the control. So be sure to check the setting before you next use your flash.

Locking flash exposure on your subject

With a feature called *FV Lock*, or *flash value lock*, you can lock flash power similar to the way you can use the AE-L/AF-L button to lock autoexposure. (Note that not all external flash units support this function; the camera manual and your flash manual provide a list of supported flash models.) This option can come in handy when you want to compose your photo so that your subject is located at the edge of the frame, for example. You frame the scene initially so the subject is at the center of the frame, lock the flash power, and then reframe. If you didn't lock the flash value, the camera would calculate flash power on your final framing, which could be inappropriate for your subject. You also can use FV Lock to maintain a consistent flash power for a series of shots.

In order to use this feature, however, you first need to program a button to do the job. You can assign this task to the AE-L/AF-L button, on the back of the camera, or to the Fn button or the Depth-of-Field Preview button, both found on the front-right side of the camera, to do the job. Chapter 10 provides specifics. The rub is that if you assign this task to a button, you lose whatever function is normally accomplished by pressing the button as well as the function that's performed by pressing the button and rotating a command dial. Again, Chapter 10 has details to help you make your decision.

If you do assign a button to perform Fv Lock, here's how to use it:

- Frame the shot so that your subject is in the center of the viewfinder.
 You can adjust composition after locking the flash power if you want.
- 2. Press and hold the shutter button halfway to engage the exposure meter and, in autofocus mode, set focus.
- 3. Press the button that was assigned the Fv Lock function.

The flash fires a little preflash to determine the correct flash power. When flash power is locked, you see a little flash symbol with the letter L at the left end of the viewfinder, next to the metering mode icon. The same symbol appears in the Control panel and Information display.

4. Recompose the picture if desired and then take the shot.

To release the flash value lock, just press the assigned button again.

Exploring a few additional flash options

For most people, the flash options covered to this point in the chapter are the most useful on a regular basis. But your D300s does offer a few other flash options that some photographers may appreciate on occasion, so the next several sections provide a quick look-see. Again, keep in mind that I am only touching on the most prominent highlights — be sure to dive into the camera manual or your flash manual, if you use an external flash unit, for all the nitty-gritty.

Enabling high-speed flash (auto FP)

In order to properly expose flash pictures, the camera has to synchronize the timing of the flash output with the opening and closing of the shutter. For technical reasons that are too gnarly to get into in this book, this synchronization normally dictates a maximum shutter speed of 1/250 second when you use the built-in flash on the D300s.

Through a Custom Setting menu option, you can bump the maximum sync speed up to 1/320 second for the built-in flash, however. Furthermore, if you attach some specific Nikon flash units, you can take advantage of a Nikon feature called Auto FP flash, which enables you to access the full range of shutter speeds, all the way up to 1/8000 second.

It's important to note, though, that when Auto FP flash is used, the flash fires a little differently than normal. Instead of a single pop of light, it emits a continuous, rapid-fire burst for the entire time that the shutter is open. This rapid firing of the flash, while it sounds like a good thing, actually forces a reduction of the flash power, thereby shortening the distance over which subjects remain illuminated. The faster your shutter speed, the greater the impact on the flash power. So at very high speeds, your subject needs to be pretty close to the camera in order to be properly exposed by the flash. You also lose a little flash effectiveness when you set the built-in flash to sync at 1/320 second.

Because of this limitation, high-speed flash is mostly useful for shooting portraits or other close-up subjects. In fact, it's very useful when you're shooting portraits outside in the daytime because it permits you to use a wide-open aperture to blur the background. At a shutter speed of 1/250 second, that shutter speed and aperture combination would normally overexpose the picture. With high-speed flash, you can increase the shutter speed enough to compensate for the large aperture.

To access the high-speed flash option, open the Flash/Bracketing section of the Custom Setting menu and select the Flash Sync Speed option, as shown in Figure 5-34. You can choose from the following settings:

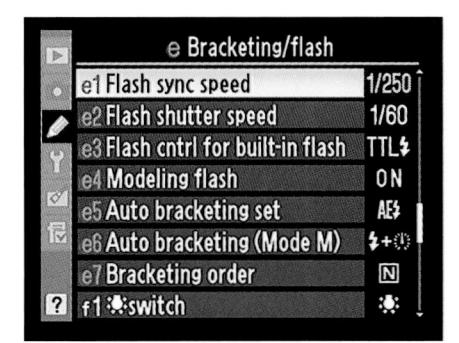

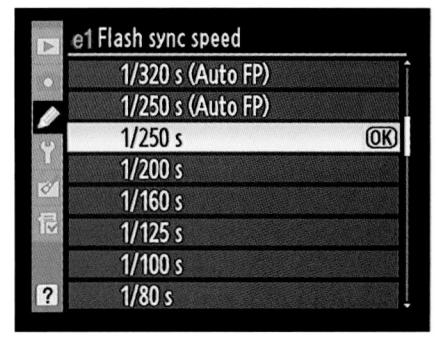

Figure 5-34: Through this option, you can enable high-speed flash, permitting a faster maximum shutter speed for flash photos.

- ✓ 1/320 s (Auto FP): At this setting, you can use the built-in flash with speeds up to 1/320 second, but remember that using speeds over 1/250 second reduces flash power slightly. For select Nikon flash units (models SB-900, SB-800, SB-600, and SB-R200), you can use shutter speeds up to 1/8000 second. At speeds between 1/250 and 1/320, flash power is less affected than when you use the other Auto FP setting, explained next.
- ✓ 1/250 s (Auto FP): This setting has no effect on the built-in flash. For compatible external flash units, the high-speed flash behavior kicks in at shutter speeds over 1/250 second. As shutter speed goes up, flash power is reduced.
- ✓ 1/250 s to 1/60 s: The other settings on the menu (see the right image in Figure 5-34) establish a fixed maximum sync speed. By default, it's set to 1/250 second. High-speed flash operation is disabled.

Using manual, repeating, or commander flash mode

The Bracketing/Flash submenu of the Custom Setting menu also offers a setting called Flash Cntrl (Control) for Built-In Flash, as shown in Figure 5-35. Normally, your flash operates in the TTL, or *through-the-lens*, mode, in which the camera automatically determines the right flash output for you, as discussed earlier in this chapter.

However, if you're an advanced flash user, you may want to explore the other options:

✓ **Manual:** In this mode, you can select a specific flash power, with settings ranging from full power to 1/128 power. (If you're hip to rating flash power by Guide Numbers, the manual spells out the ratings for the built-in flash.)

	e Bracketing/flash	
	e1 Flash sync speed	1/250
	e2 Flash shutter speed	1/60
U	e3 Flash cntrl for built-in flash	TTL\$
	e4 Modeling flash	ON
0	e5 Auto bracketing set	AE\$
侵	e6 Auto bracketing (Mode M)	\$+(1)
	e7 Bracketing order	N
?	f1 # switch	:

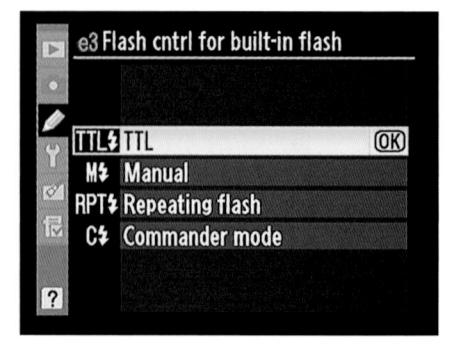

Figure 5-35: The Commander Mode option enables you to trigger off-camera flash units with your built-in flash.

- ✓ Repeating Flash: If you select this mode, the camera fires the flash repeatedly as long as the shutter is open. The resulting picture looks as though it was shot with a strobe light. In other words, this is a special-effects function. You can modify certain aspects of the flash output, including how often the flash fires per second.
- Commander Mode: This mode enables the camera's built-in flash as a master to trigger (command) off-camera flash units, which are called slaves. (I know, but don't write me any nasty letters I'm here to tell you what the terminology is, no matter how politically incorrect those words may be.) You can even set the power of the external units through the Commander Mode options and specify whether you want the built-in flash to simply trigger the other flash heads or add its own flash power to the scene.

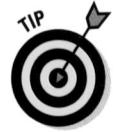

In order to use this feature, your external flash heads must support something called the Nikon *Creative Lighting System*. Visit the Nikon Web site to get a better idea of how the system works. It's pretty cool, and it can provide you with some great added lighting flexibility without having to spend lots of money (although you certainly can) or rely on lots of bulky, traditional lighting equipment.

Firing a modeling flash

Chapter 6 introduces you to your D300s's Depth-of-Field Preview button, which enables you to preview through the viewfinder how your selected aperture setting will affect depth of field. You can set up the button to also emit a *modeling flash* when you press the button. The feature works both with the built-in flash and an external flash head.

When you enable this feature, the flash emits a repeating, strobe-like series of flash light while you press the button. The idea is to enable you to preview how the light will fall on your subject. However, living subjects aren't likely to appreciate the feature — it's a bit blinding to have the flash going off repeatedly in your face. And obviously, using the feature drains the camera battery or, if you're using an external flash, its battery.

If you do want to enable it, you can do so through the Modeling Flash option, found on the Bracketing/Flash submenu of the Custom Setting menu, as shown in Figure 5-36.

Figure 5-36: After enabling this feature, you can press the Depth of Field Preview button to fire a modeling flash.

Bracketing Exposures

Many professional photographers use a strategy called *bracketing* to ensure that at least one shot of a subject is properly exposed. They shoot the same subject multiple times, slightly varying the exposure settings for each image.

To make bracketing easy, your D300s offers *automatic bracketing*. When you enable this feature, your only job is to press the shutter button to record the shots; the camera automatically adjusts the exposure settings between each image.

The D300s, however, takes things one step further than most cameras that offer automatic bracketing, enabling you to bracket not just basic exposure, but also flash power, Active D-Lighting, and white balance. Furthermore, when bracketing exposure, flash, or white balance, you can capture a whopping nine frames for each series of bracketed shots — most cameras limit you to three frames per series. Active D-Lighting bracketed series are limited to five frames because there are only five available Active D-Lighting settings (Off, Low, Normal, High, and Very High).

For ordinary, cover-your, uh, "bases" shooting, three frames per series should be plenty. But the mega-frames option is useful for *HDR imaging*. HDR stands for *high dynamic range*, with dynamic range referring to the spectrum of brightness values in a photograph. The idea behind HDR is to capture the

same shot multiple times, using different exposure settings for each image. You then use special imaging software, called *tone mapping software*, to combine the exposures in a way that uses specific brightness values from each shot. By using this process, you get a shot that contains more detail in both the highlights and shadows that a camera could ever record in a single image.

Figure 5-37 shows an example. I captured this riverside scene five times; the first two images show you the brightest and darkest exposures. The bottom image shows the HDR composite.

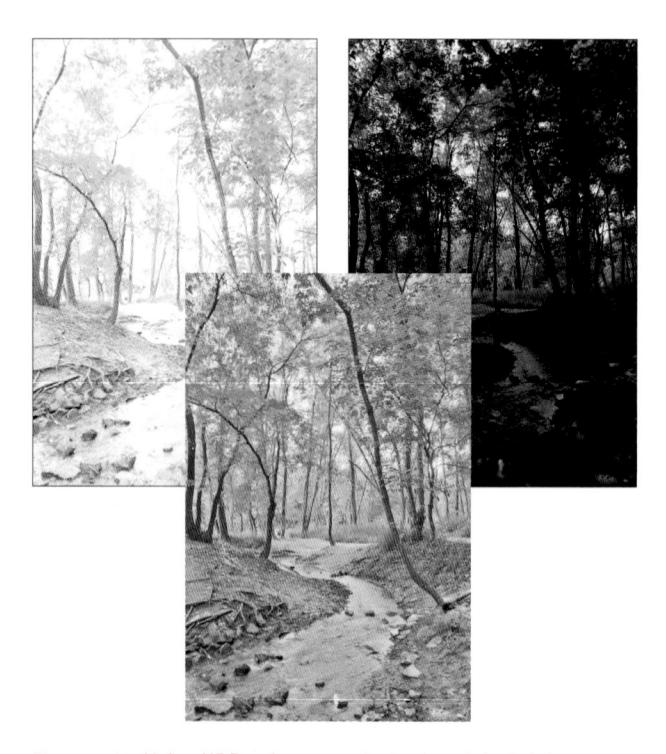

Figure 5-37: Using HDR software tools, I merged the brightest and darkest exposures (top) along with several intermediate exposures, to produce the composite image (bottom).

When applied to its extreme limits, HDR produces images that have something of a graphic-novel look. My example is pretty tame; some people might not even realize that any digital trickery has been involved. To me, it has the look of a hand-tinted photo.

HDR is all the rage right now in digital imaging circles, so if you want to explore more, you can find plenty of online examples and tone-mapping software recommendations. Or pick up a copy of *High Dynamic Range*

Digital Photography For Dummies by Robert Correll (Wiley). In the meantime, whether you're interested in HDR or just want to give yourself an exposure safety net, the next section explains how to bracket exposure and flash. Following that, you can find details about bracketing Active D-Lighting. Chapter 6 walks you through the process of bracketing white balance.

Bracketing exposure and flash

Follow these steps to bracket exposure only, flash only, or both together. (Don't be put off by the length of these steps; although describing the features takes quite a few words, actually using them isn't all that complicated.)

 Specify what you want to bracket through the Auto Bracketing Set option, located in the Bracketing/Flash section of the Custom Setting menu.

Shown in Figure 5-38, this option determines what aspect of your picture you want to vary between shots. For exposure and flash bracketing, you have three choices:

- AE & Flash: Brackets exposure settings and flash power between shots.
- AE only: Brackets exposure settings only.

In P mode, the camera varies shutter speed and f-stop between shots to produce the different exposures. In S mode, it adjusts aperture only; in A and M modes, it changes shutter speed only. In all modes, ISO is also adjusted between shots if you enable ISO Sensitivity Auto Control, as outlined earlier in this chapter.

• Flash only: Brackets flash power only.

If you select one of the first two options and plan to shoot in the manual exposure mode (M), move on to Step 2. Otherwise, skip to Step 3.

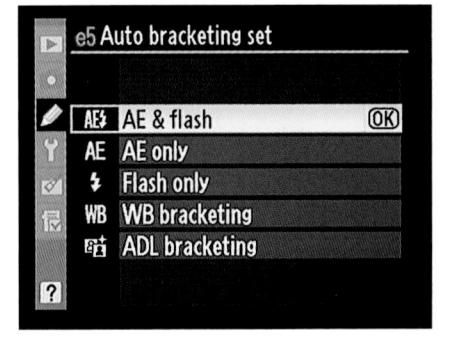

Figure 5-38: Use this option to select the setting you want the camera to adjust between shots.

2. If you're shooting in the manual exposure mode (M), modify the way the camera achieves the exposure variation (optional).

Again, this option applies only if you set the Auto Bracketing Set to the AE or AE & Flash option. Normally, the camera adjusts shutter speed between shots to achieve the different exposures. But you can request a different setup if you prefer.

To do so, select the Auto Bracketing (Mode M) option, found directly below the Auto Bracketing Set option on the Custom Setting menu. You have four choices, as shown in Figure 5-39.

- Flash/Speed: This setting results in the default bracketing behavior. If you choose AE Only for the Auto Bracketing Set, the camera varies shutter speed between shots. If you choose AE & Flash, the camera varies shutter speed and flash power.
- Flash/Speed/Aperture: With this setting, the camera varies shutter speed and aperture if you set the Auto Bracketing Set to the AE Only option. Flash is also varied if you select the AE & Flash Auto Bracketing Set option.
- Flash/Aperture: This one works just like the Flash/Speed option, but the camera adjusts aperture between shots instead of shutter speed.
- *Flash Only:* This one limits the camera to adjusting flash only between shots if you set the Auto Bracketing Set to the AE & Flash option.

3. Choose the order in which you want the bracketed shots recorded.

Make the call via the Bracket Order option, found with the other bracketing options on the Custom Setting menu. As shown in Figure 5-40, you have two options:

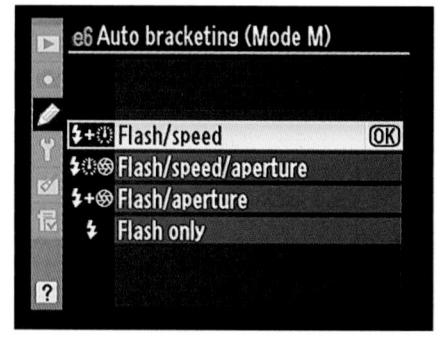

Figure 5-39: You can control which settings the camera adjusts between shots when you bracket exposure in manual exposure mode.

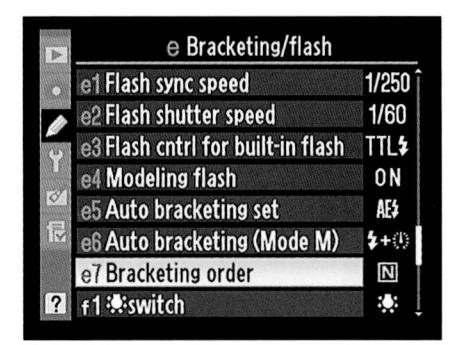

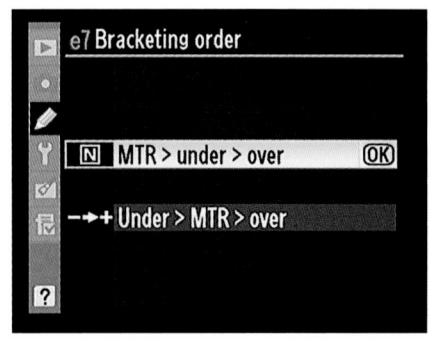

Figure 5-40: You can choose the order in which you want the bracketed shots to be captured.

• *MTR>Under>Over*: This setting is the default. For a three-shot exposure bracketing series, your first shot is captured at your original settings. (MTR stands for *metered* and designates the initial settings suggested by the camera's exposure meter.) The second image is captured at settings that produce a darker image, and the third, at settings that produce a brighter image.

This sequence can vary slightly depending on how many frames you include in your bracketed series; if you're a detail nut, you can find out the specific order used in every scenario in the camera manual.

- *Under>MTR>Over*: The darkest image is captured first, then the metered image, and then the brightest image.
- 4. Select the number of frames in each series by pressing the Fn button while rotating the main command dial.

This step assumes that you haven't altered the default behavior of the Function (Fn) button, a topic you can explore in Chapter 11. (The Fn button is the bottom button on the right-front side of the camera, under the AF-assist lamp and Depth-of-Field Preview button. There's a little Fn label on the side of the button closest to the lens.)

As soon as you press the button, you see the current bracketing settings in the Control panel and Information display, as shown in Figure 5-41. You also see an exposure meter with some symbols related to bracketing; more on how to interpret the bracketing information a little later.

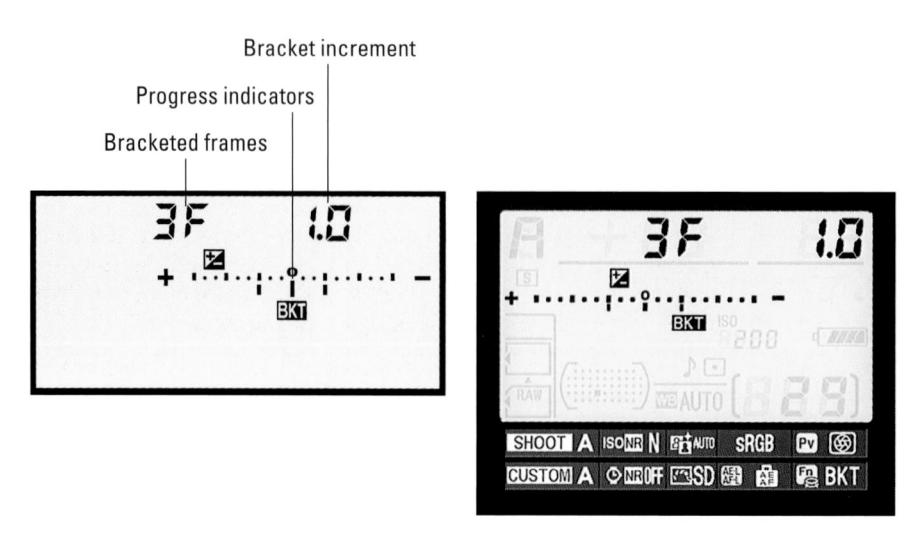

Figure 5-41: Rotate the main command dial while pressing the Fn button to turn auto bracketing on and off.

With the Fn button pressed, rotate the main command dial to cycle to through the available settings. Here's what you can accomplish at each of the frame-count settings:

- Disable bracketing: Set the frame count to 0.
- Capture your original plus both darker and lighter frames: Choose 3, 5, 7, or 9 frames. The camera records one image at your original exposure or flash settings and the others at settings that produce both brighter and darker exposures. For example, if you select 5, you get one original, one that's a bit darker, another that's darker still, and then two that shift to the brighter side of the exposure scale.
- Capture your original plus brighter frames only: Choose +2 or +3: Choose +2 to record just two frames: one at your original settings plus one brighter exposure. Choose +3 to get a third image that's even brighter than the second.
- Capture your original plus darker frames only: Select –2 or –3. These settings work just like the preceding option, except that the bracketed frames are darker than your original.

5. Set the level of adjustment between frames by pressing the Fn button while rotating the sub-command dial.

By default, you can adjust exposures by one-third stop (0.3), two-thirds stop (0.7), or a whole stop (1.0). If you vary the setting of the EV Steps for Exposure Control, found on the Metering/Exposure section of the

Custom Setting menu, you have fewer options. If that menu option is set to 1/2 step, you can set the bracketing increment to a half-stop (0.5) or one stop. And if the menu option is set to 1 step, you can bracket in whole stops only. See the earlier sidebar "Exposure stops: How many do you want to see?" for details on this menu option and an explanation of stops.

Now for the promised decoder guide to the bracketing information displayed with the meter: In the Control panel and Information display, the meter appears as shown in Figure 5-41 when you enable the three-frame bracketing option. The markings near the meter indicate the following:

- The little plus/minus symbol indicates that you set the bracketing set to vary an exposure setting (flash or overall exposure).
- The BKT symbol tells you bracketing is enabled.
- The notches under the meter show you how many frames are enabled and the amount of adjustment between frames. For example, in the figure, the notch at the zero point represents the neutral shot — the one that will be recorded with no adjustment. The notches to the left and right show that the other two shots will be recorded at settings that produce a one-stop increase and a onestop decrease in exposure.

All this assumes that you use the default setting for the Bracketing Order option on the Bracketing/Flash submenu, however. If you prefer, you can reverse the order in which the positive- and negative-value shots are recorded by choosing the second of the two Bracketing Order settings.

6. Release the Fn button to return to shooting mode.

The bracketing frame and increment settings then disappear from the Control panel and Shooting Information display; the bracketing indicators and the meter remain, along with the BKT icon.

7. Take your first shot.

After you take the picture, the indicator representing the shot you just took disappears from under the meter. For example, if you are bracketing three frames, the notch at the 0 position disappears after your first shot.

8. Take the remaining shots in the series.

When the series is done, the indicator scale returns to its original appearance, and you can then begin shooting the next series of bracketed shots

9. To disable bracketing, press the Fn button and rotate the main command dial until the number of frames returns to 0.

Bracketing Active-D Lighting

Active D-Lighting, as explained earlier in this chapter, adjusts exposure in a way that brightens shadows without blowing out highlights in the process. You can set up a bracketed series that applies different levels of the adjustment to each shot.

The process varies slightly from the steps in the preceding section, so instead of repeating it all here, I'll just hit the highlights:

1. Set the Auto Bracketing Set option to Active D-Lighting, as shown in Figure 5-42.

This option is located in the Bracketing/Flash section of the Custom Setting menu.

The other two bracketing setup options on the menu don't matter for Active D-Lighting bracketing. The camera always uses the default setting for Bracketing

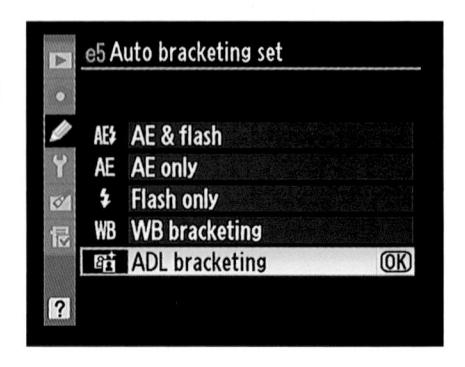

Figure 5-42: You can capture a series of up to 5 shots, each with a different amount of Active D-Lighting applied.

Order. And because aperture, shutter, and flash aren't varied — just the amount of D-Lighting — the Auto Bracketing (Mode M) option is irrelevant as well, even if you use manual exposure.

2. Press the Function (Fn) button while rotating the main command dial to set the number of frames.

With Active D-Lighting bracketing, you don't set the frame count and level of shot-to-shot adjustment as you do for exposure and flash bracketing. Instead, the number of frames you select determines what Active D-Lighting setting is used for each frame.

When you press the Fn button, the letters "ADL" appear in the area normally reserved for the frame count, as shown in Figure 5-43, and spinning the main command dial adjusts the other value, which determines the number of frames and the Active-D-Lighting amount that's applied to each frame. Here are your options:

- 2A: Records one image with Active D-Lighting turned off and another at the Auto setting, in which the camera analyzes the shot and determines how much adjustment to apply.
- 3: Records one shot with Active D-Lighting off, one at the Low level, and one at Normal.

- 4: Adds one more frame captured at the High setting.
- 5: Adds yet a fifth frame, this one shot with an Extra High level of Active D-Lighting.

Notice that in the Information display, the labels under the meter offer an indication of the settings that you get with each choice. For example, in Figure 5-43, the labels display the settings associated with recording three frames: Off, L (Low), and N (Normal).

3. Release the button and take your shots.

As with exposure and flash bracketing, each little bar under the meter represents one frame in the series. After you capture a shot, the bar representing that frame disappears. When you've captured all shots in the series, the meter indicators return to their "starting position."

Note that in the Information display (right image in Figure 5-43), you also see an "ADL-BKT" label to remind you exactly what setting you're bracketing.

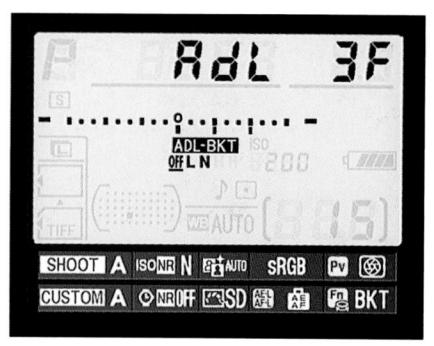

Figure 5-43: With Active D-Lighting, a single value controls both the frame count and the level of Active D-Lighting adjustment.

Manipulating Focus and Color

In This Chapter

- Controlling the camera's autofocusing performance
- ▶ Understanding focal lengths, depth of field, and other focus factors
- Exploring white balance and its affect on color
- Investigating other advanced color options

o many people, the word *focus* has just one interpretation when applied to a photograph: Either the subject is in focus or it's blurry. And it's true — this characteristic of your photographs is an important one. There's not much to appreciate about an image that's so blurry that you can't make out whether you're looking at Peru or Peoria.

.

But an artful photographer knows that there's more to focus than simply getting a sharp image of a subject. You also need to consider *depth of field*, or the distance over which objects remain sharply focused. This chapter explains all the ways to control depth of field as well as how to take best advantage of the myriad focusing options on your camera.

In addition, this chapter dives into the topic of color, explaining your camera's White Balance control, which compensates for the varying color casts created by different light sources. You also can get my take on the other color features, including the Color Space option and Picture Controls, in this chapter.

Understanding Focusing Basics

One of the most important advantages you gain from stepping up to a powerhouse camera like the D300s is access to an amazing array of autofocusing features, all designed to help you achieve tack-sharp focus with just the press of a button.

Although I cover all the focusing options in this chapter, the two most critical to understand — and, coincidentally, the only two adjusted via external camera switches rather than through the Custom Setting menu — are the following:

- Focus mode: You use this setting to specify whether you want to focus manually or take advantage of one of two autofocusing options, one designed for still subjects and the other for moving subjects. (Keep in mind that whether you can take advantage of autofocusing depends on your lens. See Chapter 1 for a primer on lenses.)
- ✓ **AF-area mode:** If you go with autofocusing, you use this setting to tell the camera what area of the frame to analyze when establishing focus. You can ask the camera to consider all 51 of its autofocusing points, a single point, or something in between.

Together, these two options set the foundation for focusing with the D300s, so make learning them your priority. The next several sections detail each option individually. Within each section, you can read about the Custom Setting options that enable you to fine-tune the autofocus system, but if you start to feel overwhelmed, leave those options on the back burner and stick with the defaults until you get the basics nailed down. Wrapping up the focusing discussion, you can find a review of the steps you take to use different combinations of the Focus mode/AF-area mode tag team.

One note before you dig in: Information in this chapter assumes that you haven't changed the default functions of camera buttons (such as the center button of the Multi Selector and the shutter button). I detail those customization options in Chapter 10, but it's a good idea to leave the buttons at their default settings until you're fully acquainted with the camera — otherwise, instructions here (and those you find in the camera manual) aren't going to work.

Choosing a Focus mode: M, S, or C?

The first step in controlling focus with the D300s is to select a Focus mode, which sets the camera to either manual focusing or autofocusing. Depending on your lens, you may also need to set a focus-mode switch on it as well. Here's the drill:

✓ **Autofocusing:** Set the camera's Focus mode selector switch, shown in Figure 6-1, to one of the two autofocus settings, S or C. If your lens, like the one in the figure, has a focus mode switch, move that switch to the A position (or AF, depending on the lens) as well.

The camera's S and C autofocus settings work like so:

• *S* (*single-servo autofocus*): With this option, the camera locks focus when you depress the shutter button halfway. It's designed for shooting stationary subjects. (Think *S* for *still*, *stationary*.)

• *C (continuous-servo autofocus)*. In this mode, which is designed

for moving subjects, the camera sets focus initially at the time you press the shutter button halfway but then continually adjusts focus as necessary up to the time you take the picture. (Think *C* for *continuous motion*.)

You can also press and hold the AF-ON button instead of the shutter button to initiate autofocusing. However, if your lens offers vibration reduction, be aware that the feature doesn't work if you use the AF-ON button to focus; vibration reduction engages only when you focus using the shutter button. See the later section "Putting the AF-ON button to work" for more details on the AF-ON button.

Manual focusing: Again, if your lens has an auto/manual switch, set it to the M (or MF) position. Set the camera's Focus mode switch to M. With manual focusing, you simply twist the focusing ring on the lens barrel to focus.

However you focus, you see the focus indicator light in the viewfinder when focus is achieved, as shown in Figure 6-2. But in continuous-servo mode, the light may blink on and off while the camera adjusts focus in response to motion. When you use manual focusing or pair the S or C autofocus modes with the Dynamic Area or Single Point AF-area mode (both explained later in this chapter), the indicator lights when the object under the selected focus point comes into focus. You can see what a focus point looks

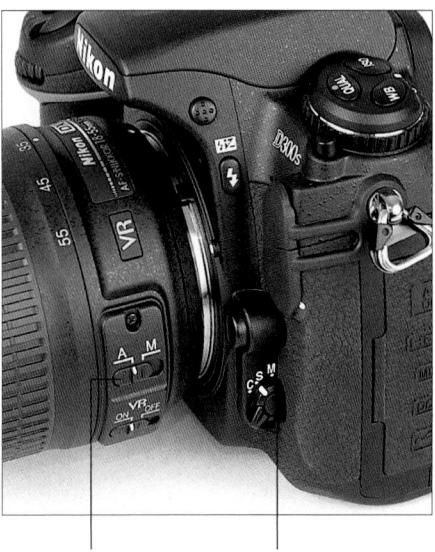

Lens focus mode Focus mode

Figure 6-1: Set the camera to manual or autofocus through the Focus mode selector switch.

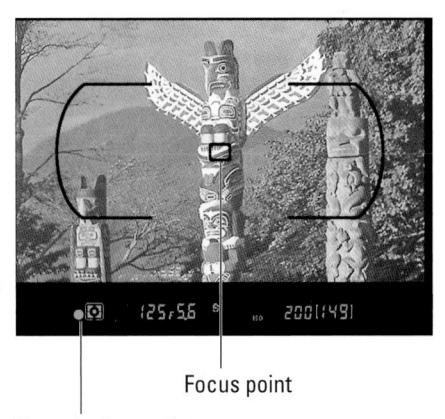

Focus indicator light

Figure 6-2: In all three Focus modes, the focus indicator light appears when focus is achieved.

like in Figure 6-2; see the upcoming section "Selecting (and locking) a focus point" to find out more about selecting the point you want to use. If you set

AF-ON

the AF-area mode to Auto Area, the camera selects the focus point for you; one or more focus points appear in the viewfinder after you press the shutter button halfway to let you know what points were used.

One other critical thing to note about the single-servo and continuous-servo modes: By default, the camera refuses to take a picture in single-servo (S) mode if it can't achieve focus. No way, no how, it's not going to take an out-of-focus picture no matter how hard you press the shutter button. With continuous-servo (C) autofocus, the opposite occurs: The camera assumes that because this mode is designed for shooting action, you want to capture the shot at the instant you press the shutter button, regardless of whether it had time to set focus.

Because Nikon figures you didn't buy a camera as advanced as the D300s to be limited to only one way of doing things, though, you can adjust this behavior through the Custom Setting menu. The relevant options are the two AF Priority options at the top of the Autofocus section of the menu, shown in Figure 6-3. (The AF stands for *autofocus*.)

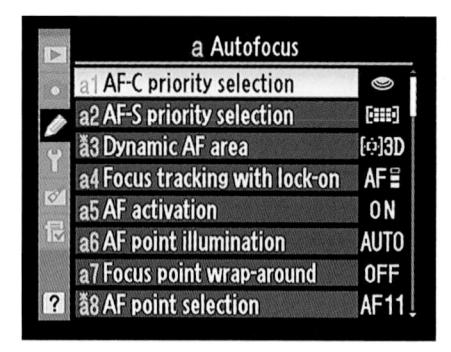

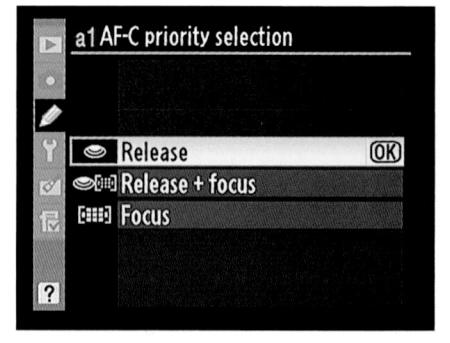

Figure 6-3: You can tell the camera whether to go ahead and take the picture even if focus hasn't been achieved.

Here are your choices for each option:

- ✓ **AF-C Priority Selection:** For this option, which controls continuousservo focusing behavior, you have three possible settings, as shown on the right in Figure 6-3:
 - Release: This setting is the default and enables you to take the picture regardless of whether focus is achieved.
 - Release+Focus: In this mode, you can snap the pic before focus
 is set, but if you're shooting a continuous burst of pictures by
 using the Continuous release modes covered in Chapter 2 the
 camera automatically slows the frame rate a little to give itself just

- a hair more time to focus between shots. This adjustment occurs only when the lighting on the subject is poor or little contrast exists in the scene.
- *Focus*: You can't take the picture until focus is achieved and that little focus lamp lights in the viewfinder.
- ✓ **AF-S Priority Selection:** This option, shown in Figure 6-4, controls the shutter release for the single-servo (S) autofocus mode. You get only two choices: Release, which lets you take the picture regardless of whether focus is set; and Focus, which prevents you from taking the picture until the little focus lamp signals to you that focus is good.

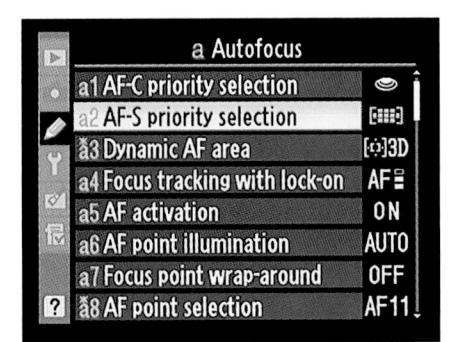

Figure 6-4: At this (default) setting, the camera won't take a picture until the focus indicator lamp lights.

To decide which option is right for you, you have to consider whether you'd rather have any shot, even if it's out of focus, or capture only those that are in focus. I prefer the latter, so I set the AF-C option to Focus and the AF-S option to Locked. Why waste battery power, memory card space, and inevitable time deleting out-of-focus pictures, after all? Yes, if you're shooting rapid action, you may miss a few shots waiting for the focus to occur, but if they're going to be lousy shots, who cares?

Sports shooters who regularly fire off hundreds of shots while covering an event, though, may want to "unlock" the shutter release for continuous-servo mode or at least shift to Release+Focus. Again, you may wind up with lots of wasted shots, but you increase the odds that you'll capture that split-second "highlight reel" moment. If it's slightly out of focus, you can probably retouch it enough to make it passable, especially if the picture content is truly special. And by using camera settings that produce a large *depth of field* (zone of sharp focus), your subject may appear in focus even if the actual focusing point the camera used wasn't dead on. Later sections in this chapter discuss depth of field.

Choosing an AF-area mode: One focus point or many?

When you look through the viewfinder, you see brackets on either side of the frame, as illustrated in Figure 6-5. These brackets indicate the overall *autofocus area*. Within those brackets are 51 possible *autofocus points* that the camera can analyze to establish focus. The figure shows the locations of the points; in real life, you see either a single point or no points at all, depending on which focus settings you use.

The AF-area mode setting, which you select via the switch shown in Figure 6-6, determines how the camera decides which point to use as the focusing target. You have three choices:

- [[:]]
- Single Point: This mode is designed to help you quickly and easily lock focus on a still subject. You select a single focus point, and the camera bases focus on that point only. This option is best paired with the single-servo (S) Focus mode, which is also geared to still subjects.
- [•္
- Dynamic Area: With this option, designed for focusing on a moving subject, you select an initial focus point. But if your subject moves out of that point before you snap the picture, the camera looks to surrounding points for focusing information. In order for this focus tracking to occur, though, you must pair this AF-area mode with the continuous-servo (C) Focus mode.

Auto Area: At this setting, the camera automatically chooses which of the 51 focus points to use. Focus priority is typically

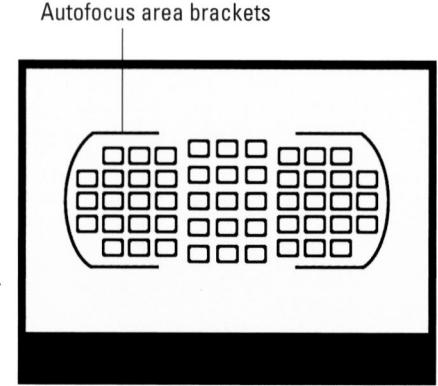

Figure 6-5: The AF-area mode determines which of the camera's 51 autofocus points are used to establish focus.

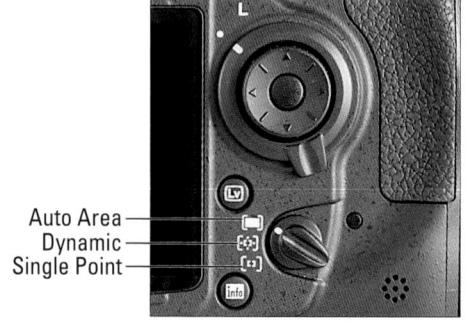

Figure 6-6: Use this switch to select the AF-area mode.

assigned to the object closest to the camera. Auto Area mode is best combined with single-servo autofocus — if you need continuous autofocusing for a moving subject, you're much better off using Dynamic Area mode, which is specially engineered to accomplish that task.

Although Auto Area mode requires the least input from you, it's also typically the slowest option because of the technology it must use to set focus. First, the camera analyzes all 51 focus points. Then it consults an internal database to try to match the information reported by those 51 points to a huge collection of reference photographs. From that analysis, it makes an educated guess about which focus points are most appropriate for your scene. Although it's still amazingly fast considering what's happening in the camera's brain, it's sometimes slower than either of the other two AF-area options.

Frankly, I don't use Auto Area mode very often unless I'm handing the camera over to someone who's inexperienced and wouldn't know how to use the other two modes. And with a camera that costs nearly two grand, I can think of only a few people who I'd even trust to hand it over to. ("Oh, I'm sorry, but I'm borrowing this from my boss and I swore I wouldn't let anyone else use it.") So I keep things nice and simple and stick with two AF-area/Focus mode combos:

- ✓ For still subjects: Single Point AF-area mode and single-servo Focus mode.
- For moving subjects: Dynamic Area mode and continuous-servo Focus mode.

Upcoming sections spell out the exact steps you use to set focus with both of these autofocus pairings. Just in case you have a family member who would get all snippy if you refused to let them try your camera, I also include the steps for using Auto Area mode with single-servo autofocus.

First, though, I need to take a slight detour to explain how you select a specific focus point when you use Single Point or Dynamic Area modes or focus manually.

Selecting (and locking) a focus point

As soon as you set the AF-area mode to Dynamic Area or Single Point, you see a single focus point in the viewfinder. (Refer to Figure 6-2.)

You also see a focus point in the viewfinder when you use manual focusing. It's not absolutely critical to select a focus point if you trust your eyes to tell you when the scene is in focus. But if you want some backup from the camera, go ahead and set the focus point. When you twist the focusing ring, the green focus lamp in the viewfinder lights when the object under the selected point is in focus. (Note that this focus-feedback system works only with lenses that offer a maximum aperture of at least f/5.6.)

To select a focus point, first make sure that the focus-point selector lock switch is set to the position shown in Figure 6-7. Then just press the Multi Selector right, left, up, or down to cycle through the available focus points.

If nothing happens, press the shutter button halfway to activate the metering system. Then release the button and try again.

A couple of additional tips:

✓ By default, 51 autofocus points are available. But through the AF Point Selection option, discussed in the next section, you can limit the number of points available for selection to 11.

- On the D300s, some focus points are more capable than others. The 15 center points use *cross-type sensors*, which evaluate focus by analyzing both horizontal and vertical lines in the scene. The other points assess only horizontal lines. Cross-type sensors typically work better, especially in dim lighting, so if you're having trouble getting the camera to focus, select one of these focus points and try again.
- By default, you hit a "wall" when you reach the top, bottom, left, or right focus point in the group. So if the leftmost point is selected, for example, pressing left again gets you nowhere. But if you turn on the Focus Point Wrap-Around option, found with the other autofocus options on the Custom Setting menu and shown in Figure 6-8, you instead jump to the rightmost point. I like this option, but it's totally a personal preference.

✓ If you want to use a certain focus point for a while, you can "lock in" that point by moving the focus-point selector lock to the L position. This feature ensures that an errant press of the Multi Selector doesn't accidentally change your selected point.

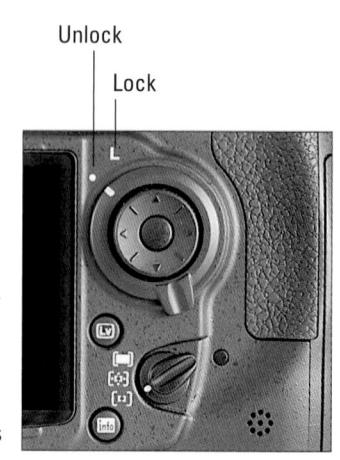

Figure 6-7: Set the focus-point selector switch to the unlocked position and then use the Multi Selector to choose a focus point.

Figure 6-8: This option controls whether you

©

Your selected focus point also determines which part of the frame the camera uses to calculate exposure and flash power when you use the spot metering mode setting. See Chapter 5 for details.

Autofocusing with still subjects: Single Point+Single-servo AF

For stationary subjects, the fastest, most precise autofocus option is to pair the single-servo (S) Focus mode with the Single Point AF-area mode. With this combination, the autofocus system can quickly home in on your subject.

The approach is the same one spelled out in the "almost automatic" shooting section of Chapter 2. Here's a quick recap, just to save you the trouble of flipping back:

[[]

1. Set the AF-area mode switch to the Single Point position.

It's the one represented by the margin icon you see here and shown in Figure 6-7.

2. Set the Focus mode selector switch to S.

Again, the switch for choosing that setting is on the left-front side of the camera. Don't forget to also set your lens switch to autofocus mode.

3. Looking through the viewfinder, use the Multi Selector to position the focus point over your subject.

If the focus point doesn't respond, press the shutter button halfway and release it to jog the camera awake. Then try again.

4. Press the shutter button halfway to set focus.

The camera displays a green focus lamp in the viewfinder and emits a beep to let you know that focus was achieved. (The beep doesn't sound, however, if you set the AF-S Priority option, discussed earlier, to Release. You also can disable the beep through the Custom Setting menu, as covered in Chapter 1, or by setting the Release mode to Quiet.) Focus remains locked as long as you keep the shutter button pressed halfway. If you're using autoexposure (P, S, or A modes), the initial exposure settings are also chosen at the moment you press the shutter button halfway, but they're adjusted as needed up to the time you take the shot.

5. Press the shutter button the rest of the way to take the shot.

Don't forget that by default, the camera doesn't let you take the picture when focus isn't set. To modify that behavior, see the earlier section "Choosing a Focus mode: M, S, or C?"

Now for a few nuances that I didn't get into in Chapter 2:

Setting the number of available focus points: By default, you can select any of the camera's 51 focus points. But through the AF Point Selection option on the Custom Setting menu, shown on the left in Figure 6-9, you can limit the number of points to the 11 shown on the right.

Figure 6-9: You can choose to limit the number of available focus points to the 11 shown here.

Why would you do this? Because it enables you to choose a focus point more quickly — you don't have to keep pressing the Multi Selector zillions of times to get to the one you want to use. For that reason, I usually keep this option set to 11. Or, in the words of rock genius Nigel Tufnel of the band Spinal Tap, "This one goes to 11!"

- Positioning your subject outside a focus point: You can frame your subject so that it doesn't fall under one of the focus points, if necessary. Just compose the scene initially so that your subject is under a point, press the shutter button halfway to lock focus, and then reframe. However, note that if you're using autoexposure, you may want to lock focus and exposure together using the AE-L/AF-L button, as covered in Chapter 5. Otherwise, exposure is adjusted to match your new framing, which may not work well for your subject. In fact, the Chapter 5 technique for locking exposure is designed to work when teamed up with the single-servo/Single Point autofocus settings.
- ✓ **Reading the Info screen and Control panel icons:** An icon representing the current AF-area mode appears in the highlighted spots shown in Figure 6-10. In the Information display, the icons changes to show you how many points are active (51 or 11) as well as the location of the selected focus point. For example, in the figure, 11 points are active, and the center point is selected. In the Control panel, you just see the location of the selected point.

Focusing on moving subjects: Dynamic Area+continuous-servo AF

When you need to autofocus on a moving target, whether it's a fast-paced subject or just a child playing, set the Focus mode switch to C (continuous-servo autofocus) and the AF-area mode switch to Dynamic Area, as shown in Figure 6-11.

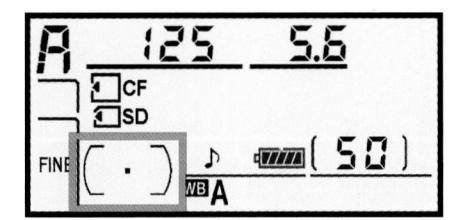

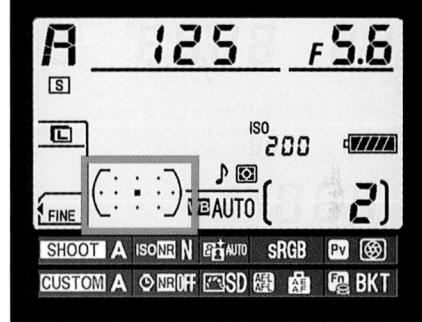

Figure 6-10: The display icons show you which focus point is selected.

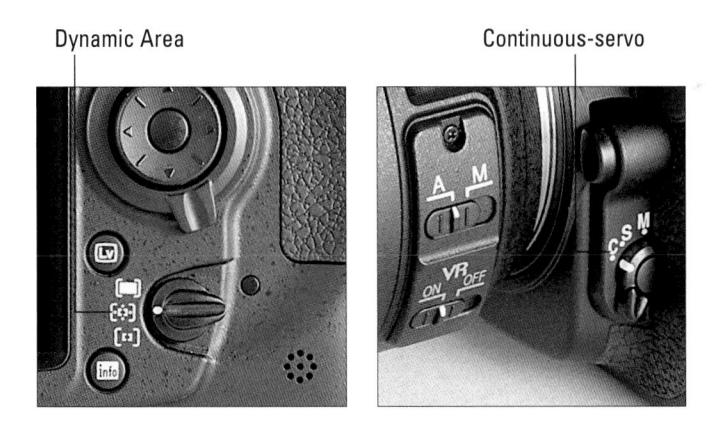

Figure 6-11: For moving subjects, combine continuous-servo Focus mode with Dynamic Area mode.

With those preliminary setup steps down, use this technique to set focus:

1. Use the Multi Selector to choose an initial focus point.

First, make sure that the focus-point selector switch is set to the unlocked position. (Refer to Figure 6-7.) Then press the directional buttons on the Multi Selector to move the focus point around the frame.

(Again, you may need to press the shutter button halfway and release it before you can move the point.)

The number of focus points available is either 51 or 11, depending on the setting you choose for the AF Point Selection option, discussed in the preceding section and shown in Figure 6-9. The default setting is 51.

In the Dynamic Area mode, the camera looks for focus information first from your selected focus point but then checks surrounding points for focus infor-

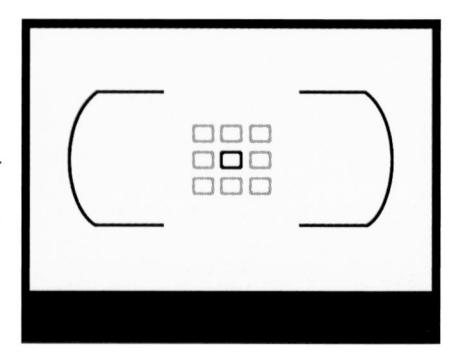

Figure 6-12: By default, the Dynamic Area mode considers nine focus points: your selected point plus the eight surrounding points.

mation if your subject moves from the selected point. By default, the eight points surrounding your selected point are the secondary focus targets. So a total of nine points actually are active, although only your selected point appears in the viewfinder. Figure 6-12 offers an illustration. If you select the center focus point, shown in black in the figure, the eight points shown in gray are the secondary focus targets.

You can expand the number of available secondary focus points if you wish; more on that topic in the next section.

2. Frame your subject so that it falls under the selected focus point.

3. Press and hold the shutter button halfway to establish the initial focusing distance.

Your button press also triggers exposure metering. If you're using auto-exposure, the camera sets the initial exposure settings.

Because you're using the continuous-servo Focus mode, you don't hear a beep when focus is achieved. But the focus indicator lamp in the view-finder lights when the object under the selected focus point comes into focus.

4. If your subject moves, keep reframing as needed to keep the subject within the 9-point area.

Try to keep the subject under the selected focus point to increase the odds of good focus. But as long as the subject falls within one of the nine points, focus should be adjusted accordingly. Note that you don't see the focus point actually move in the viewfinder, but the focus tweak is happening just the same. (You can hear the focus motor doing its thing.)

Should you want to "freeze" the focus adjustment at any time so that focus remains set at a specific distance, you can press and hold the AE-L/AF-L button. Remember, though, that the default setup for this

button freezes both focus and exposure. If you use this option a lot, you may want to decouple the two functions by the button customization options covered in Chapter 10. You can use the button to lock focus only, for example, and select another button to lock exposure only.

5. Press the shutter button the rest of the way to take the picture.

At the default settings, the camera takes the picture when you press the shutter button regardless of whether focus has been achieved. To change this behavior, head for the AF-C Priority option on the Custom Setting menu; see the earlier section "Choosing a Focus mode: M, S, or C?" for details.

After you get comfortable with this basic technique, you may want to explore a couple of tweaks you can make to this motion-capture autofocus duo. You can adjust the number of points the camera considers in Dynamic Area AF-area mode, and you can tell it what to do if someone unexpectedly walks between you and your subject after you focus. The next two sections explain.

First, though, I want to make one comment about focusing on moving subjects: You can pair continuous-servo autofocus with the Single Point AF-area mode if you want. But if you go this route, you have to be *sure* you keep your subject underneath that one selected focus point up to the time you take the picture — the camera won't look to any of the surrounding points for focus information. Although the Single Point method can sometimes make for a little faster focusing because the camera considers only that single point, it's pretty tricky to do unless you're working with a subject that's moving in a very predictable pattern or within a very confined area — maybe a drummer sitting behind a drum kit, for example, or a conductor leading an orchestra.

Customizing the Dynamic Area focusing operation

Through the Dynamic AF-area option, found on the Custom Setting menu and shown in Figure 6-13, you can specify the exact number of points the camera evaluates in the Dynamic Area mode. You can set the point count to 9, 21, or 51. Through the fourth option on the menu, you can modify the way the camera does its subject tracking as well.

The details:

This setting also provides the fastest Dynamic Area autofocusing because the camera has to analyze the fewest number of autofocusing points.

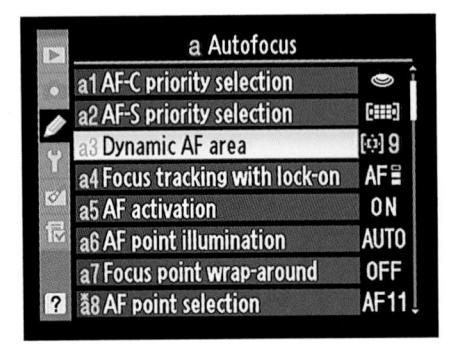

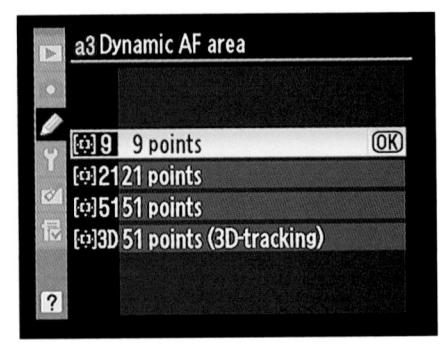

Figure 6-13: You can modify the number of Dynamic Area points and also choose from two 51-point options.

ers your selected point plus 20 surrounding points. Figure 6-14 shows you the 21-point grid that's used if you select the center focus point, for example. Obviously, this setting enables your subject to move a little farther afield from your selected focus point and still remain in the target zone. So it works better than 9-point mode when you can't quite predict the path your subject is going to take.

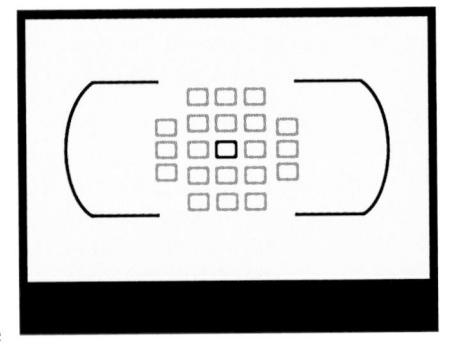

Figure 6-14: The 21-point setting references these autofocus points.

√ 51 points: Although you still can specify a single point for establishing initial focus in this mode, the camera may then select any other point in the entire 51-point group if it thinks it's warranted. It's designed for subjects that are moving so rapidly that it's hard to keep them within the framing area of the 21-point or 9-point setting — a flock of birds, for example.

The drawback to this setting is focusing time: With all 51 points on deck, the camera has to work a little harder to find a focus target. To help compensate, set the Release mode to Continuous so that you can capture multiple frames with one press of the shutter button. In Single release mode, the camera will try to reset focus for each frame.

✓ 51 points with 3D Tracking: This mode works slightly differently than the other three. When you set focus initially, the camera analyzes the colors of the area under the focus point and tries to distinguish between the subject and the background. Then, if the subject moves, the camera

attempts to follow that color and contrast pattern across the screen, adjusting focus as needed. When this happens, you can see the focus point jump around the viewfinder, letting you know what the camera is following. Nikon suggests that this mode is ideal for subjects moving from one side of the frame to the other at a fast pace.

This technology can work pretty well when a lot of contrast exists between subject and background. So for best results, try to establish focus on a point that helps the camera distinguish the subject from the background. For example, if you're photographing a soccer player who's dressed in a green uniform and running on a green playing field, you make it tough for the camera if you set focus on the uniform. Instead, try to set focus on the player's face or another area of contrast, such as lettering on the shirt.

Additionally, if your subject moves completely out of the frame, you must release the shutter button and reset focus again. So while 3D Tracking can be really effective under the right conditions, it also requires a little more input from you.

As with the Single Point AF-area, you can get a reminder of how many points are currently in use by looking at the icons in the Control panel and Info display, as shown in Figure 6-15. In the figure, the icon shows that the 51-point area is selected. Notice, though, the Information display icon. This icon reflects two Custom Settings options: your Dynamic AF Area setting plus the AF Point Selection setting, which enables you to limit the number of points you can select as your initial focus point from the default 51 to 11. If you change that setting to 11, the 11 available points appear darker than the others, with your selected point appearing both darker and larger. (In the figure, the center point is selected.) The camera still analyzes all the surrounding points called for by your Dynamic AF Area setting — you're just limited to choosing one of the 11 darker points as your starting focus target.

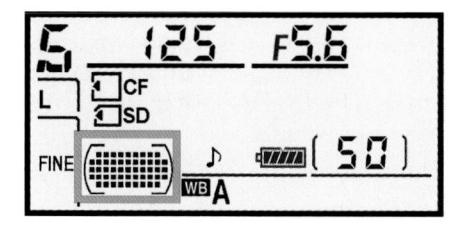

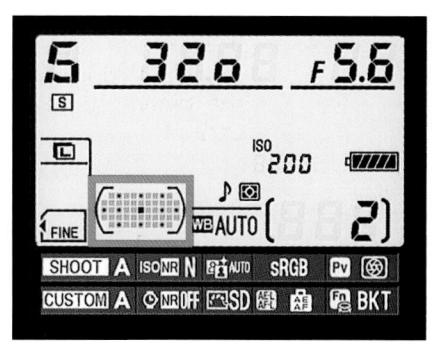

Figure 6-15: The AF-area mode icon tells you which of the four Dynamic Area point setups is in use.

Obviously, choosing which focus-point scheme you want to use is something you should decide and select ahead of time - you don't want to be monkeying around with menu settings while the action is in progress. And getting a feel for which types of subjects work best with which settings is a matter of practice and experience — don't expect to get it right in the first couple of tries. (Or if you do, don't tell me, because it sure took me a while!)

Unfortunately, you can't tell which setting you used when you review your pictures because that value doesn't appear in the picture metadata. So the best way to teach yourself is to stick with one setting for an entire outing and then try a different one the next time. Or you can just jot down the frame number where you switched settings if you try different options with the same subject.

Preventing focusing miscues with tracking lock-on

So you're shooting your friend's volleyball game, practicing your actionautofocusing skills. You've got your shot all set up, have the camera set to continuous-servo autofocus and Dynamic Area AF-area mode, and you're just waiting for the moment your friend serves the ball. You've set the initial focus, and the camera's doing its part by adjusting focus to accommodate her pre-serve moves. Then all of a sudden, some clueless interloper walks in front of the camera. Okay, it was the referee, who probably did have a right to be there, but still.

The good news is that as long as the ref gets out of the way before the action happens, you're probably okay. A feature called focus tracking with lock-on, designed for just this scenario, tells the camera to ignore objects that appear temporarily in the scene after you begin focusing. Instead of resetting focus on the newcomer, the camera continues focusing on the original subject.

You can vary the length of time the camera waits before starting to refocus through the Focus Tracking with Lock-On option, found on the Custom Setting menu and shown in Figure 6-16. Normal is the default setting. You can choose a longer or shorter delay or turn off the lock-on altogether. If you do turn off the lock-on, the camera starts refocusing on any object that appears in the frame between you and your original subject.

Shutter speed and blurry photos

A poorly focused photo isn't always related to the issues discussed in this chapter. Any movement of the camera or subject can also cause blur. Both of these problems are related to shutter speed, an exposure control that I cover in Chapter 5. Be sure to also visit Chapter 7, which provides some additional tips for capturing moving objects without blur.

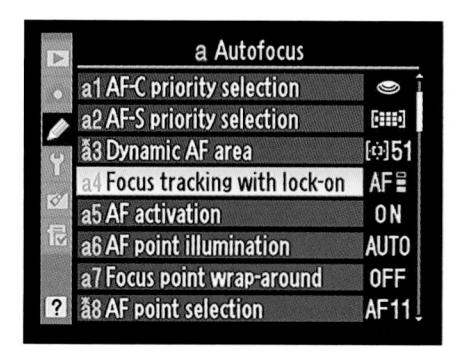

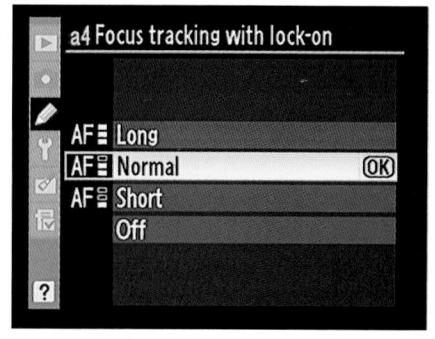

Figure 6-16: This option controls how the autofocus system deals with objects that come between it and the subject after you initiate focusing.

Basic autofocus with Auto Area+Single Point AF

For reasons covered in the introduction to the AF-area mode setting, I recommend that you make the other two modes (Single Point and Dynamic Area) your go-to options. With Auto Area, you're asking the camera to figure out what part of the scene you want to be in sharpest focus.

If you do want to try Auto Area mode, follow these steps to take the picture:

1. Set the Focus mode selector switch to S (single-servo).

Although you *can* use continuous-servo autofocus with the Auto Area mode, you'll give the camera a better chance of locking onto a specific target if you use the Dynamic Area AF-area mode, explained in the preceding section. Single-servo mode is really a better teammate for the Auto Area mode.

2. Set the AF-area mode switch to Auto Area.

It's represented on the switch by the icon you see in the margin here. In the Information display and Control panel, the Auto Area setting is represented by the symbols you see in Figure 6-17. Notice the 51 little boxes inside the brackets, reminding you that all 51 autofocus points are active. (You can't limit the number of available focus points as you can in the other two AF-Area modes.)

3. Frame your subject so that it appears within the autofocus area brackets, as shown on the left in Figure 6-18.

In Auto Area mode, you don't see any focus points, and you can't select a point for the camera to use.

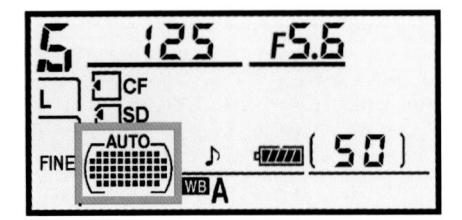

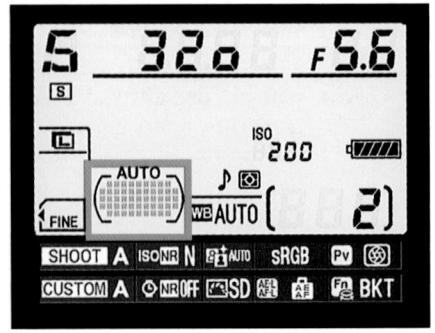

Figure 6-17: These symbols represent that Auto Area mode.

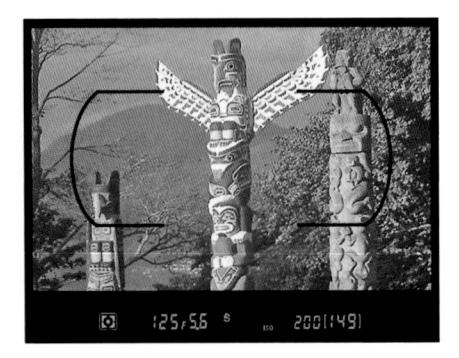

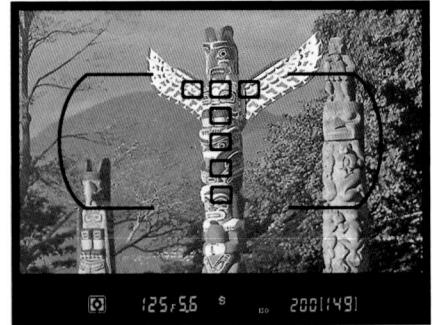

Figure 6-18: The camera analyzes all 51 points and then lights up the ones it used to set focus.

4. To set focus, press the shutter button halfway.

By default, pressing the shutter button kick-starts the exposure meter as well as sets focus.

When focus is set, the focus lamp lights in the viewfinder and the camera beeps at you. In addition, one or more focus points light up, as shown on the right in Figure 6-18. Anything under those focus points is now in focus. Focus remains locked on those points as long as you keep the shutter button pressed halfway down.

5. Press the shutter button the rest of the way to take the picture.

By default, the camera won't let you take a picture until focus is achieved when you use single-servo autofocus. For details, see the earlier section "Choosing a Focus mode: M, S, or C?"

Putting the AF-ON button to work

If you came to this chapter after exploring Chapter 4, you may be aware that you can use either the AF-ON button or the shutter button to focus during Live View shooting in Handheld mode. You can make the same choice for regular shooting. By default, pressing the AF-ON button has the same result on focusing as pressing the shutter button halfway.

However, there's one big difference between the two options: Vibration Reduction does not engage when you use the AF-ON button to focus, either for Live View shooting or normal photography. That feature activates only when you use the shutter button to focus. That's not a problem if you're shooting with a tripod, in which case most lens manufacturers recommend that you turn off Vibration Reduction anyway. But it's a pretty big uh-oh if you're handholding the camera.

If vibration reduction isn't an issue — whether because you're a steady enough shooter that you can get away without it or you're using a tripod — you may be interested to know that you can use the AF-ON button exclusively to initiate autofocus, removing that function from the shutter button. You make this adjustment through the AF Activation option, found with the other autofocus options on the Custom Setting menu and shown in Figure 6-19. At the default setting, Shutter/AF-ON, both buttons can be used to focus. The AF-ON Only setting removes the focusing function from the shutter button, which then takes responsibility only for exposure metering.

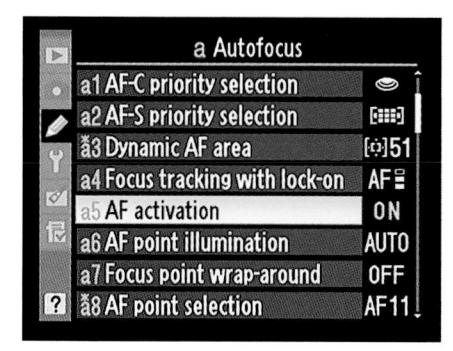

Figure 6-19: You can choose to focus only with the AF-ON button.

Some sports photographers prefer to make this change so they can use the AF-ON button to continually track focus and then press the shutter button to snap off frames. The advantage is that focus continues to track as long as you keep the AF-ON button down, even between frames, so you don't have to keep resetting focus after each shot. Of course, you have to set the Focus mode to continuous-servo for the focus tracking to occur.

Exploring a few last autofocus tweaks

You can adjust three final focus options through the autofocus section of the Custom Setting menu. Figure 6-20 shows these menu options. (If your eyes are crossing from reading about all the options already discussed, don't worry: These are the no-brainer types of options. Well, easy-brainer types, at least.)

Figure 6-20: The remaining autofocus customization options await here.

- ✓ **AF Point Illumination:** It happens so fast that you might not notice it unless you pay close attention, but when the camera establishes focus, the selected focus point in the viewfinder sometime flashes red and then goes back to black. At the default setting for this option (Auto), the red highlights are displayed only when the background is dark, which would make the black focus points difficult to see. You can choose the On setting to force the highlights no matter whether the background is dark. Or you can choose Off to disable the highlights altogether.
- ✓ Built-in AF-Assist Illuminator: In dim lighting, the camera may emit a beam of light from the little lamp just below the Control panel, on the front of the camera. If you're in a situation where that light could be distracting to others in the room, you can disable it by setting this option to Off. You may need to focus manually, though, because without the light to help it find its target, the autofocus system may have trouble.
- ✓ **AF-ON for MB-D10:** This option applies only if you attach the optional MB-D10 battery pack to the camera. That unit sports an AF-ON button just like the one on the camera back. Normally, the button serves the same purpose as the one on the camera. But through this option, you can assign it several other functions, such as locking both exposure and focus together.

Finally, you can use options on the Controls section of the Custom Setting menu to set the Function (Fn) button, AE-L/AF-L button, and Depth of Field Preview button to lock focus or lock focus and exposure together. You also can use the Fn button together with the main command dial to adjust the number of focus points used in the Dynamic Area mode. But what say we leave that discussion for Chapter 10, okay? It's time to move on from the technical talk about autofocusing and explore the fun side of focus: Depth of field and its creative impact on your photographs.

Manipulating Depth of Field

Getting familiar with the concept of *depth of field* is one of the biggest steps you can take to becoming a more artful photographer. I introduce you to depth of field in Chapters 2 and 5, but here's a quick recap just to hammer home the lesson:

- Depth of field refers to the distance over which objects in a photograph appear sharply focused.
- With a shallow, or small, depth of field, distant objects appear more softly focused than the main subject (assuming that you set focus on the main subject, of course).
- With a large depth of field, the zone of sharp focus extends to include objects at a distance from your subject.

Which arrangement works best depends entirely on your creative vision and your subject. In portraits, for example, a classic technique is to

Figure 6-21: A shallow depth of field blurs the background and draws added attention to the subject.

use a short depth of field, as I did for the photo in Figure 6-21. This approach increases emphasis on the subject while diminishing the impact of the background. But for the photo shown in Figure 6-22, I wanted to emphasize that

the foreground figures were in St. Peter's Square, at the Vatican. so I used a large depth of field. which kept the background buildings sharply focused and gave them equal weight in the scene.

So exactly how do you adjust depth of field? You have three points of control: aperture, focal length, and camera-to-subject distance, as spelled out in the following list:

Aperture setting (f-stop):

The aperture is one of three exposure settings, all explained fully in Chapter 5. Depth of field increases as you stop down the aperture (by choosing a higher f-stop number). For shallow depth of field, open the aperture (by choosing a lower f-stop number). Figure 6-23 offers an example; in the f/22 version, focus is sharp all the way through the frame; in the f/13 version, focus softens as the distance from the center lure increases. I

Aperture, f/14; Focal length, 42mm

Figure 6-22: A large depth of field keeps both foreground and background subjects in focus.

snapped both images using the same focal length and camera-to-subject distance, setting focus on the center lure.

Lens focal length: In lay terms, focal length determines what the lens "sees." As you increase focal length, measured in millimeters, the angle of view narrows, objects appear larger in the frame, and — the important point for this discussion — depth of field decreases. Additionally, the spatial relationship of objects changes as you adjust focal length. As an example, Figure 6-24 compares the same scene shot at a focal length of 127mm and 183mm. I used the same aperture, f/5.6, for both examples.

Whether you have any focal length flexibility depends on your lens: If you have a zoom lens, you can adjust the focal length — just zoom in or out.

(The Nikon lens shown with the camera in this book, for example, offers a focal range of 18-55mm.) If you don't have a zoom lens, the focal length is fixed, so scratch this means of manipulating depth of field.

For more technical details about focal length and your camera, flip to Chapter 1 and explore the section related to choosing lenses.

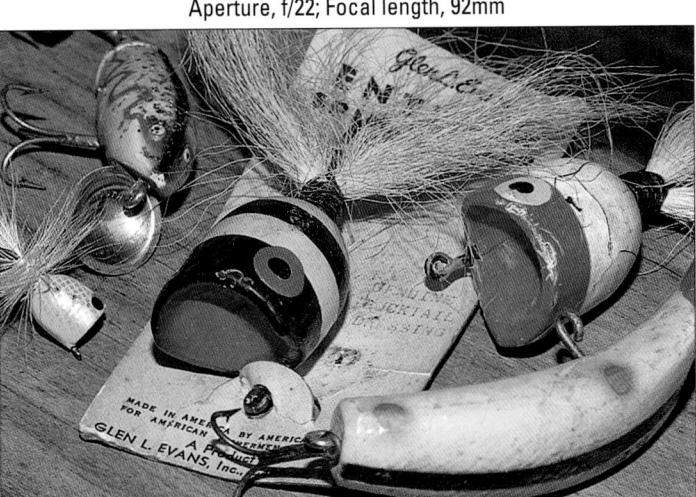

Aperture, f/22; Focal length, 92mm

Figure 6-23: A lower f-stop number (wider aperture) decreases depth of field.

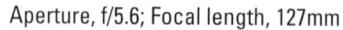

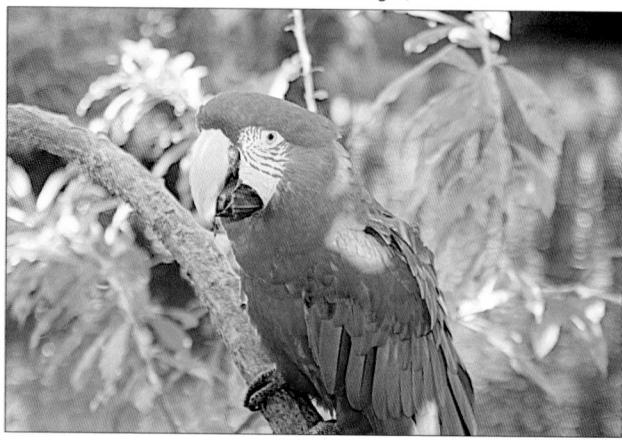

Aperture, f/5.6; Focal length, 183mm

Figure 6-24: Zooming to a longer focal length also reduces depth of field.

Camera-to-subject distance: As you move the lens closer to your subject, depth of field decreases. This assumes that you don't zoom in or out to reframe the picture, thereby changing the focal length. If you do, depth of field is affected by both the camera position and focal length.

Together, these three factors determine the maximum and minimum depth of field that you can achieve, as illustrated by my clever artwork in Figure 6-25 and summed up in the following list:

Greater depth of field:

Select higher f-stop Decrease focal length (zoom out) Move farther from subject

Shorter depth of field:

Select lower f-stop Increase focal length (zoom in) Move closer to subject

Figure 6-25: Your f-stop, focal length, and shooting distance determine depth of field.

- ✓ To produce the shallowest depth of field: Open the aperture as wide as possible (the lowest f-stop number), zoom in to the maximum focal length of your lens, and get as close as possible to your subject.
- ✓ To produce maximum depth of field: Stop down the aperture to the highest possible f-stop number, zoom out to the shortest focal length your lens offers, and move farther from your subject.

Here are a few additional tips and tricks related to depth of field:

Aperture-priority autoexposure mode (A) enables you to easily control depth of field while enjoying exposure assistance from the camera. In this mode, detailed fully in Chapter 5, you set the f-stop, and the camera selects the appropriate shutter speed to produce a good exposure. The range of aperture settings you can access depends on your lens.

Even in aperture-priority mode, keep an eye on shutter speed as well. To maintain the same exposure, shutter speed must change in tandem with aperture, and you may encounter a situation where the shutter speed is too slow to permit hand-holding of the camera.

Press the Depth-of-Field Preview button to get an idea of how your f-stop will affect depth of field. When you look through your viewfinder and press the shutter button halfway, you can get only a partial

indication of the depth of field that your current camera settings will produce. You can see the effect of focal length and the camera-to-subject distance, but because the aperture is always fully open until you actually take the picture, the viewfinder doesn't show you how your selected f-stop will affect depth of field.

By using the Depth-of-Field Preview button on your camera, however, you can preview the f-stop's impact. Almost hidden away on the front of your camera, the button is highlighted in Figure 6-26. When you press the button, the camera temporarily sets the aperture to your selected f-stop so that you can preview depth of field. At small apertures (high f-stop settings), the viewfinder display may become quite dark, but this doesn't indicate a problem with exposure - it's just a function of how the preview works.

You also can tell the camera to emit a modeling flash when you preview depth-of-field and have flash enabled. By default, the modeling flash is turned off; if you want to experiment with this feature, visit the flash discussion in Chapter 5 for details.

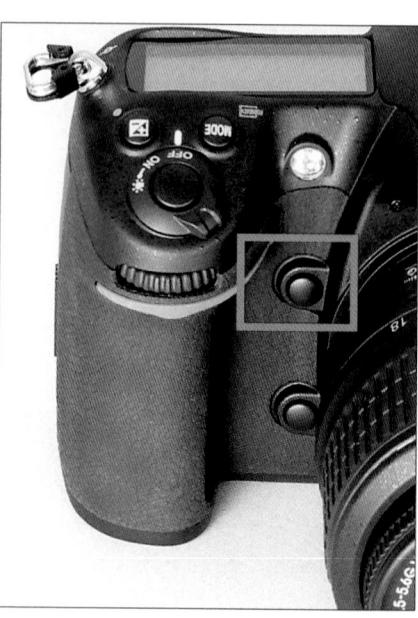

Figure 6-26: Press this button to get a preview of the effect of aperture on depth of field.

For greater background blurring, move the subject farther from the background. The extent to which background focus shifts as you adjust depth of field also is affected by the distance between the subject and the background. For increased background blurring, move the subject farther in front of the background.

Controlling Color

Compared with understanding some aspects of digital photography — resolution, aperture and shutter speed, depth of field, and so on — making sense of your camera's color options is easy-breezy. First, color problems aren't all that common, and when they are, they're usually simple to fix with a quick shift of your camera's White Balance control. And getting a

grip on color requires learning only a couple of new terms, an unusual state of affairs for an endeavor that often seems more like high-tech science than art.

The rest of this chapter explains the aforementioned White Balance control, plus a couple of menu options that enable you to fine-tune the way your camera renders colors. For information on how to use the Retouch menu's color options to alter colors of existing pictures, see Chapter 11.

Correcting colors with white balance

Every light source emits a particular color cast. The old-fashioned fluorescent lights found in most public restrooms, for example, put out a bluishgreenish light, which is why our reflections in the mirrors in those restrooms always look so sickly. And if you think that your beloved looks especially attractive by candlelight, you aren't imagining things: Candlelight casts a warm, yellow-red glow that is flattering to the skin.

Science-y types measure the color of light, officially known as *color temperature*, on the Kelvin scale, which is named after its creator. You can see the Kelvin scale in Figure 6-27.

When photographers talk about "warm light" and "cool light," though, they aren't referring to the position on the Kelvin scale — or at least not in the way we usually think of temperatures, with a higher number meaning hotter. Instead, the terms describe the visual appearance of the light. Warm light, produced by candles and incandescent lights, falls in the red-yellow spectrum you see at the bottom of the Kelvin scale in Figure 6-27; cool light, in the blue-green spectrum, appears at the top of the Kelvin scale.

At any rate, most of us don't notice these fluctuating colors of light because our eyes automatically compensate for them. Except in very extreme lighting conditions, a white tablecloth

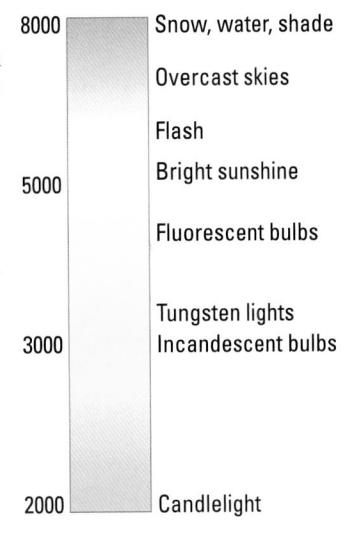

Figure 6-27: Each light source emits a specific color.

appears white to us no matter whether we view it by candlelight, fluorescent light, or regular houselights.

Similarly, a digital camera compensates for different colors of light through a feature known as *white balancing*. Simply put, white balancing neutralizes light so that whites are always white, which in turn ensures that other colors are rendered accurately. If the camera senses warm light, it shifts colors slightly to the cool side of the color spectrum; in cool light, the camera shifts colors the opposite direction.

The good news is that, as with your eyes, your camera's Auto White Balance setting tackles this process remarkably well in most situations, which means that you can usually ignore it and concentrate on other aspects of your picture. But if your scene is lit by two or more light sources that cast different colors, the white balance sensor can get confused, producing an unwanted color cast like the one you see in the left image in Figure 6-28.

Figure 6-28: Multiple light sources resulted in a yellow color cast in Auto White Balance mode (left); switching to the Incandescent setting solved the problem (right).

I shot this product image in my home studio, which I light primarily with a couple of high-powered photo lights that use tungsten bulbs, which produce light with a color temperature similar to regular household incandescent bulbs. The problem is that the windows in that room also permit some pretty strong daylight to filter through. In Auto White Balance mode, the camera reacted to that daylight — which has a cool color cast — and applied too much warming, giving my original image a yellow tint. No problem: I just switched the White Balance mode from Auto to the Incandescent setting. The right image in Figure 6-28 shows the corrected colors.

The next section explains precisely how to make a simple white balance correction; following that, you can explore some advanced white balance options.

Changing the White Balance setting

The current White Balance setting appears in the Control panel and Information display, as shown in Figure 6-29. The settings are represented by the icons you see in Table 6-1.

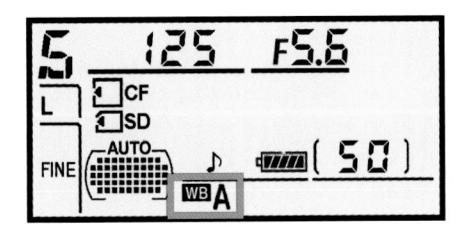

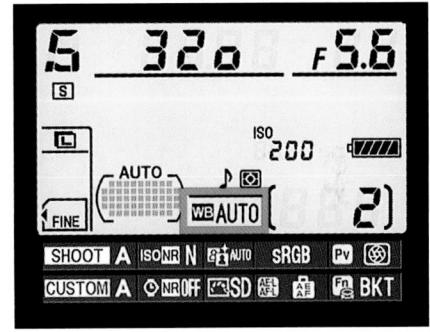

Figure 6-29: These icons represent the current White Balance setting.

Table 6-1	Manual White Balance Settings
Symbol	Light Source
*	Incandescent
\\\\\\\\\\\\\\\\\\\\\\\\\\\\\\\\\\\\\\	Fluorescent
*	Direct sunlight
4	Flash
2	Cloudy
_ /	Shade
K	Choose color temperature
PRE	Custom preset

The quickest way to change the setting is to press and hold the WB button as you rotate the main command dial. But note these factoids:

- Adjusting white balance through the Shooting menu: You also can change the White Balance setting from the Shooting menu. After highlighting the White Balance setting, press OK to display the list of options. Highlight the one you want to use and press OK. For all settings except PRE (Preset Manual), K, and Fluorescent, you're taken to a screen where you can fine-tune the amount of adjustment the camera applies to colors. See the next section for details. If you don't want to make any adjustment, just press OK.
- If you know the exact color temperature of your light source perhaps you're using some special studio bulbs, for example you can tell the camera to balance colors for that precise temperature. (Well, technically, you have to choose from a preset list of temperatures, but you should be able to get close to the temperature you have in mind.) First, select the K White Balance setting. (K for Kelvin, get it?) Then, while pressing the WB button, rotate the sub-command dial to set the color temperature, which appears at the top of the Control panel and Information display, as shown in Figure 6-30.

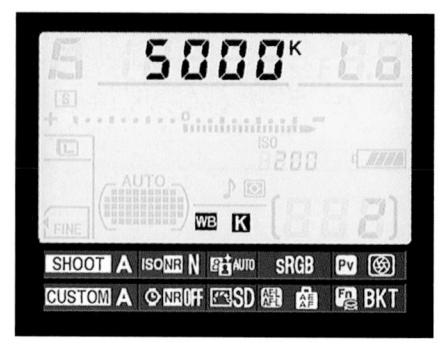

Figure 6-30: Set the White Balance option to K to select a specific color temperature.

You also can set the temperature through the White Balance option on the Shooting menu. If you do, you see the fine-tuning screen after you select the temperature and press OK. Again, just press OK to exit the screen without making any adjustment.

✓ **Specifying a fluorescent bulb type:** For the Fluorescent setting, you can select from seven types of bulbs. To do so, you must go through the Shooting menu. Select Fluorescent as the White Balance setting and then press OK to display the list of bulbs, as shown in Figure 6-31. Select the

After you select a fluorescent bulb type, that option is always used when you use the WB button to select the Fluorescent White Balance setting. Again, you can change the bulb type only through the Shooting menu.

✓ Creating a custom White Balance preset: The PRE (Preset Manual) option enables you to create and store a precise, customized White Balance setting, as explained in the upcoming "Creating White Balance presets" section. This setting is the fastest way to achieve accurate colors when your scene is lit by multiple light sources that have differing color temperatures.

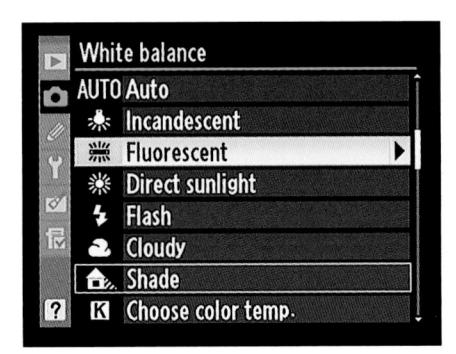

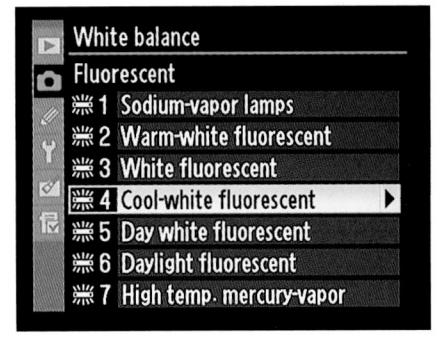

Figure 6-31: You can select a specific type of fluorescent bulb.

Your selected White Balance setting remains in force until you change it. So you may want to get in the habit of resetting the option to the Auto setting after you finish shooting whatever subject it was that caused you to switch to manual White Balance mode.

Fine-tuning White Balance settings

You can fine-tune any White Balance setting (Daylight, Cloudy, and so on). For the greatest amount of control, make the adjustment as spelled out in these steps:

- 1. Display the Shooting menu, highlight White Balance, and press OK.
- 2. Highlight the White Balance setting you want to adjust, as shown on the left in Figure 6-32, and press the Multi Selector right.

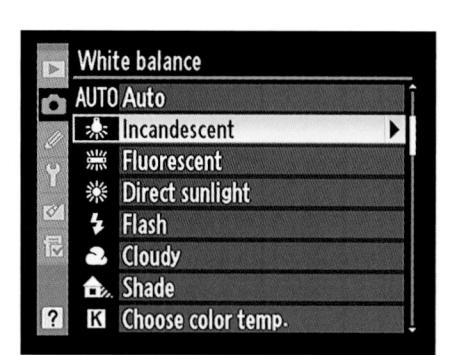

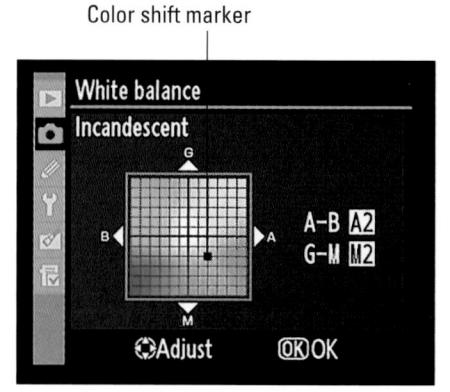

Figure 6-32: You can fine-tune the White Balance settings via the Shooting menu.

Now you're taken to a screen where you can do your fine-tuning, as shown on the right in Figure 6-32.

If you select Fluorescent or K (Choose Color Temperature), you first go to a screen where you select a specific type of bulb or Kelvin color temperature, as covered in the preceding section. After you highlight your choice, press OK to get to the fine-tuning screen. For custom presets that you create, you must select the preset you want to use and press OK. (See the next section for an explanation of presets.)

3. Fine-tune the setting by using the Multi Selector to move the white balance shift marker in the color grid.

The grid is set up around two color pairs: Green and Magenta, represented by G and M; and Blue and Amber, represented by B and A. By pressing the Multi Selector, you can move the adjustment marker around the grid.

As you move the marker, the A–B and G–M boxes on the right side of the screen show you the current amount of color shift. A value of 0 indicates the default amount of color compensation applied by the selected White Balance setting. In Figure 6-32, for example, I moved the marker two levels toward amber and two levels toward magenta to specify that I wanted colors to be a tad warmer.

If you're familiar with traditional colored lens filters, you may know that the density of a filter, which determines the degree of color correction it provides, is measured in *mireds* (pronounced *my-redds*). The

white balance grid is designed around this system: Moving the marker one level is the equivalent of adding a filter with a density of 5 mireds.

4. Press OK to complete the adjustment.

After you adjust a White Balance setting, an asterisk appears next to that setting in the White Balance menu. In the Control panel and Information display, you instead see a pair of triangles under the WB icon to indicate the adjustment. (See Figure 6-33.)

If you want to apply a white balance shift on only the blue-to-amber axis, you don't have to go through the Shooting menu. Instead, press and hold the WB button and then rotate the sub-command dial. You see the amount of adjustment in the Control panel and Information display, as shown in Figure 6-33, while the button is pressed. An a value indicates a shift toward the amber direction; a b value, toward blue. For example, in the figure, the b5 value shows that I shifted the setting five steps toward blue (b). The two-triangle symbol reminding you of the adjustment also appears. Note that this trick isn't available for the K (choose color temperature) or PRE (preset manual) White Balance settings.

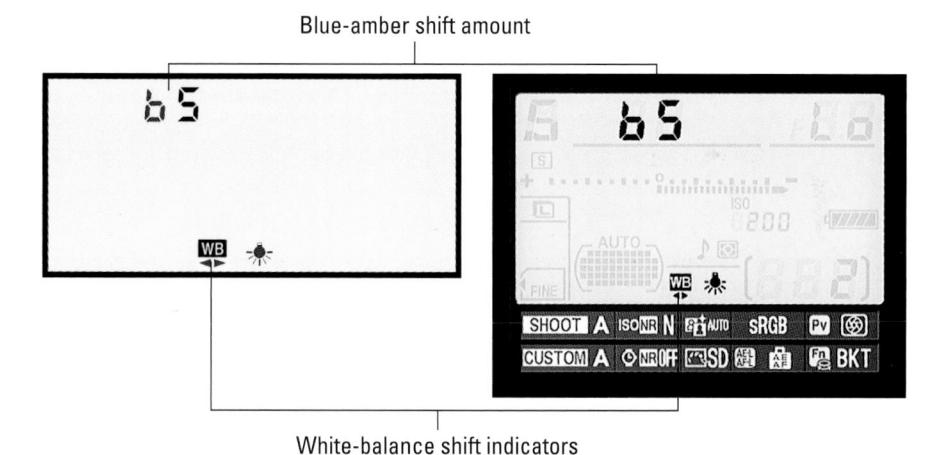

Figure 6-33: You can apply a shift along the blue/amber axis just by rotating the sub-command dial while pressing the WB button.

Here's one other tip specifically related to shifting white balance along the blue-to-amber axis: By using a feature called *white balance bracketing,* you can automatically record your picture with and without that shift. You can even record one picture with no shift, one with an amber shift, and one with a blue shift. See the later section "Bracketing white balance" for details.

6

Creating White Balance presets

If none of the standard White Balance settings do the trick and you don't want to fool with fine-tuning them, take advantage of the PRE (Preset Manual) feature. This option enables you to do two things:

- Base white balance on a direct measurement of the actual lighting conditions.
- Match white balance to an existing photo.

You can create and store up to five custom White Balance presets, which are assigned the names d-0 through d-4. The next two sections provide you with the step-by-step instructions; following that, you can find out how to select and manage your presets.

Be aware that any changes you make to a preset affect all Shooting menu banks. Chapter 10 explains Shooting menu and Custom Setting menu banks. If you create a direct-measurement preset in bank A, for example, and then try to create another one for bank B, you just wipe out the one for bank A. You don't get a separate set of 5 presets for each bank, in other words.

Setting white balance with direct measurement

To use this technique, you need a piece of card stock that's either neutral gray or absolute white — not eggshell white, sand white, or any other close-but-not-perfect white. (You can buy reference cards made just for this purpose in many camera stores for under \$20.)

Position the reference card so that it receives the same lighting you'll use for your photo. Then take these steps:

- 1. Frame your shot so that the reference card completely fills the viewfinder.
- 2. Check exposure and adjust settings if needed.

This process doesn't work if the picture will be over- or underexposed.

3. Press the WB button while rotating the main command dial to choose the PRE (Preset Manual) White Balance setting.

You see the letters PRE in the white balance area of the Control panel as well as in the Information display.

- 4. Release the button and then immediately press and hold it again until the letters PRE begin flashing in the Control panel and viewfinder.
- 5. Release the WB button and take a picture of the gray card before the PRE warning stops flashing.

You've got about six seconds to snap the picture.

If the camera is successful at recording the white balance data, the letters "Gd" flash in the viewfinder. In the Control panel, the word "Good" flashes. If you instead see the message "No Gd," adjust your lighting and then try again.

When you create a preset this way, the camera automatically stores your setting as Preset d-0. (The other presets are named d-1 through d-4.) So any time

you want to select and use the preset, press the WB button and rotate the main command dial to select PRE, as in Step 3. Then rotate the sub-command dial while pressing the button to select d-0, as shown in Figure 6-34. (The Information display shows the same data when you press the WB button.) You also can select the preset through the White Balance option on the Shooting menu; see the upcoming section "Selecting a preset" for a few critical details on that method.

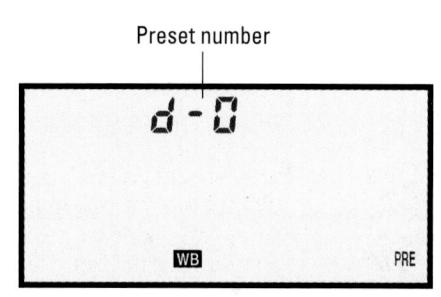

Figure 6-34: Preset d-0 is always used for the most recent direct-measurement preset.

Each time you go through these steps, your d-0 preset is replaced by the new white balance data you record. However, you can preserve your original preset by copying it to one of the other preset slots. See the upcoming section "Managing presets" for details on how to copy your preset as well as how to select it when you're ready to shoot.

Matching white balance to an existing photo

Suppose that you're the marketing manager for a small business, and one of your jobs is to shoot portraits of the company big-wigs for the annual report. You build a small studio just for that purpose, complete with a couple of photography lights and a nice, conservative, beige backdrop.

Of course, the big-wigs can't all come to get their pictures taken in the same month, let alone on the same day. But you have to make sure that the colors in that beige backdrop remain consistent for each shot, no matter how much

time passes between photo sessions. This scenario is one possible use for an advanced white balance feature that enables you to base white balance on an existing photo.

Basing white balance on an existing photo works well only in strictly controlled lighting situations, where the color temperature of your lights is consistent from day to day. Otherwise, the White Balance setting that produces color accuracy when you shoot Big Boss Number One may add an ugly color cast to the one you snap of Big Boss Number Two.

To give this option a try, follow these steps:

1. Copy the picture that you want to use as the reference photo to your camera memory card, if it isn't already stored there.

You can copy the picture to the card using a card reader and whatever method you usually use to transfer files from one drive to another. Copy the file to the folder named DCIM, inside the main folder, named 100D300s by default. (See Chapter 8 for help with working with files and folders.)

If you're using dual memory cards, you can put the reference photo on either card.

- 2. Open the Shooting menu, highlight White Balance, and press OK.
- 3. Select PRE (Preset Manual) and press the Multi Selector right.

After you press the Multi Selector right, the screen shown on the left in Figure 6-35 appears. The five thumbnails represent the five preset slots, d-0 through d-4.

4. Use the Multi Selector to highlight any preset except d-0.

The d-0 preset is always used for White Balance settings you create by taking a picture of a reference card, as described in the preceding section.

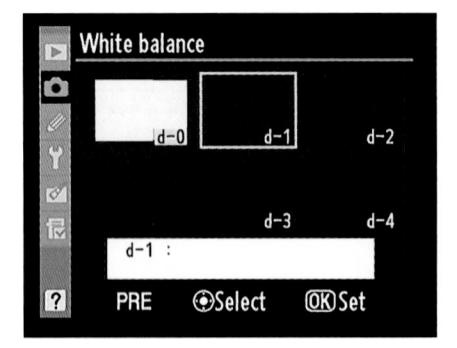

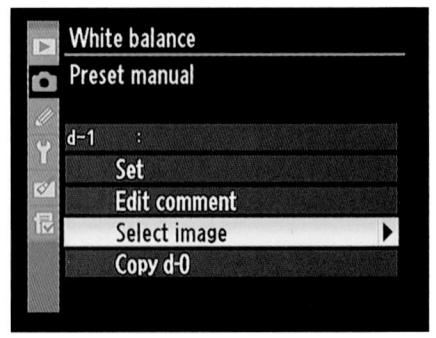

Figure 6-35: Select Preset d-1 through d-4; d-0 is reserved for direct-measurement presets.

5. Press the Multi Selector center button.

Now you see the menu shown on the right in Figure 6-35.

6. Highlight Select Image and press the Multi Selector right.

You see thumbnails of your photos.

To access a screen that enables you to switch to a different memory card or folder, press the Zoom Out button. Select your card and folder and press OK to display the thumbnails from that location.

- 7. Use the Multi Selector to move the yellow highlight box over the picture you want to use as your white balance photo.
- 8. Press the Multi Selector center button.

You're returned to the screen showing your White Balance preset thumbnails. The thumbnail for the photo you selected in Step 7 appears as the thumbnail for the preset slot you chose in Step 4.

9. Press OK to travel to the white-balance fine-tuning screen.

Make any adjustments to the setting that you see fit, as described in the earlier section "Fine-tuning White Balance settings."

10. Press OK to return to the Shooting menu.

The White Balance setting you just created is now selected.

Selecting a preset

After creating White Balance presets, select the one you want to use in two ways:

- ✓ Use the WB button together with the command dials. First, select PRE as the White Balance setting by pressing the WB button as you rotate the main command dial. Keep holding the button and rotate the subcommand dial to cycle through the available presets (d-0 through d-4). The number of the selected preset appears in the Control panel and Information display while the button is pressed.
- ✓ Use the White Balance option on the Shooting menu. Open the Shooting menu, select White Balance, press OK, highlight PRE (Preset Manual) and press the Multi Selector right. You then see the screen that contains thumbnails for all your presets. (Refer to the left screen in Figure 6-35.) Use the Multi Selector to place the yellow highlight box over the preset you want to use and then press OK. You're taken to the fine-tuning screen that appears any time you select a White Balance setting from the menu; press OK to exit the screen without adjusting the setting.

Managing presets

Just to recap this whole White Balance preset deal:

- You can create up to five presets, which take the names d-0 through d-4.
- Preset d-0 is always used for the most recent preset you created through the direct measurement method (where you take a photo of a reference card).
- Presets d-1 through d-4 can be assigned to presets based on photos.

- If you want to create more than one preset through direct measurement, you can copy the existing d-0 setting to one of the other four preset slots before doing another direct measurement. This feature is very handy if you regularly use different studio or lighting setups, by the way. You can create one direct-measurement preset for a home studio, for example, and another for a work studio.
- All five presets apply to all Shooting menu banks. And any changes that you make to a preset you created while working in one bank affect all other banks as well. Again, Chapter 10 discusses banks.

To copy Preset d-0 to another slot, take these steps:

- 1. Select the White Balance option on the Shooting menu and press OK.
- 2. Select PRE (Preset Manual) and press the Multi Selector right.

You see the thumbnails representing the five presets. For example, the left image in Figure 6-36 shows the d-0 position held by an existing direct-measurement preset and d-1 held by a preset based on a photo.

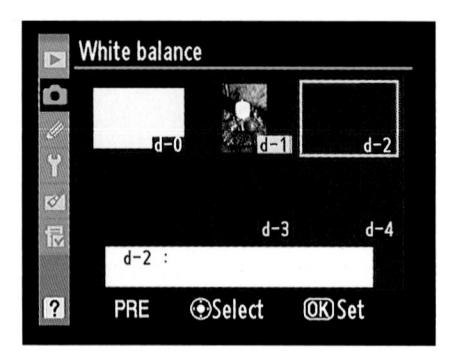

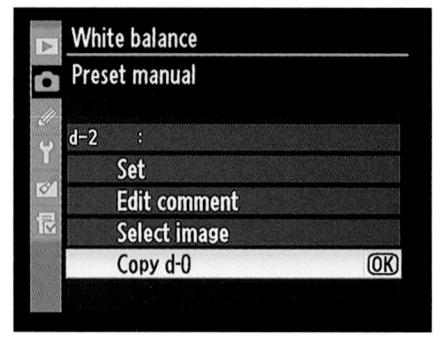

Figure 6-36: To create an additional direct-measurement preset, first copy the existing one from d-0 to another slot (d1-d4).

3. Highlight the slot where you want to copy your d-0 preset.

Use the Multi Selector to place the yellow highlight box around the slot. In the figure, I selected an empty slot (d-2), but you can also copy over an existing preset. (The preset that has the yellow label — d-1 in the figure — represents your current White Balance setting.)

4. Press the Multi Selector center button to display the menu shown on the right in the figure.

5. Highlight Copy d-0 and press OK.

You're returned to the preset thumbnails screen, and your original d-0 preset now occupies both d-0 and the slot you selected in Step 3. You can now create your second direct-measurement preset, which will take over the d-0 position.

Finally, you also can add a brief text comment to describe each preset. For example, you might add the label "Studio A" to one preset and "Studio B" to another to help you remember which is which. The label then appears with the preset thumbnail, as shown in Figure 6-37.

To enter a comment, take the exact same steps as you do to copy a preset, but instead of choosing Copy d-0 in Step 5, select Edit Comment and press the Multi Selector right. You then see a screen where you can

Figure 6-37: Enter text labels that describe each preset.

enter your text. The specific text-entry steps are the same as you use for entering image comments, which I detail in Chapter 10, so I won't repeat them here.

Bracketing white balance

Chapter 5 introduces you to your camera's automatic bracketing feature, which enables you to easily record the same image at several different exposure settings. In addition to being able to bracket autoexposure, flash, and Active D-Lighting settings, you can use the feature to bracket white balance.

Note a couple of things about this feature:

- ✓ You can bracket JPEG and TIFF shots only. You can't use white balance bracketing if you set the camera's Image Quality setting to either RAW (NEF) or any of the RAW+JPEG options. And frankly, there isn't any need to do so because you can precisely tune colors of RAW files when you process them in your RAW converter. Chapter 8 has details on RAW processing.
- ✓ You take just one picture to record each bracketed series. Each time you press the shutter button, the camera records a single image and then makes the bracketed copies, each at a different White Balance setting. One frame is always captured with no white-balance adjustment.
- You can apply white balance bracketing only along the blue-to-amber axis of the fine-tuning color grid. You can't shift colors along the green-to-magenta axis, as you can when tweaking a specific White Balance setting. (For a reminder of this feature, refer to the earlier section "Fine-tuning White Balance settings.")
- You can shift colors a maximum of three steps between frames. For those familiar with traditional lens filters, each step on the axis is equivalent to a filter density of five mireds.

However, by recording the maximum number of bracketed frames (nine), you can achieve a total adjustment of 12 steps from neutral. For example, if you set the frame count to 9 and set the amount of adjustment to 3, you get your neutral, unadjusted shot plus four amber shots: one with a +3 amber bias, one with a +6 bias, one with a +9 bias, and one with a +12 bias. You also get four blue variations, each progressively more blue. (You can tell how much adjustment has been applied by looking at the White Balance data during playback or in Nikon ViewNX. For a +12 amber bias, for example, the readout will say A12. Chapter 4 explains how to view shooting data during playback.)

When you use white balance bracketing, you can request that the camera record the bracketed images so that they are progressively more blue or more amber. Or you can record one image that's pushed toward blue and another that leans toward amber. Regardless, you also get one shot that's "neutral" — that is, recorded at the current White Balance setting, without any adjustment.

I used white balance bracketing to record the three candle photos in Figure 6-38. For the blue and amber versions, I set the bracketing to shift colors the full nine steps.

To apply white balance bracketing, you first need to take these steps:

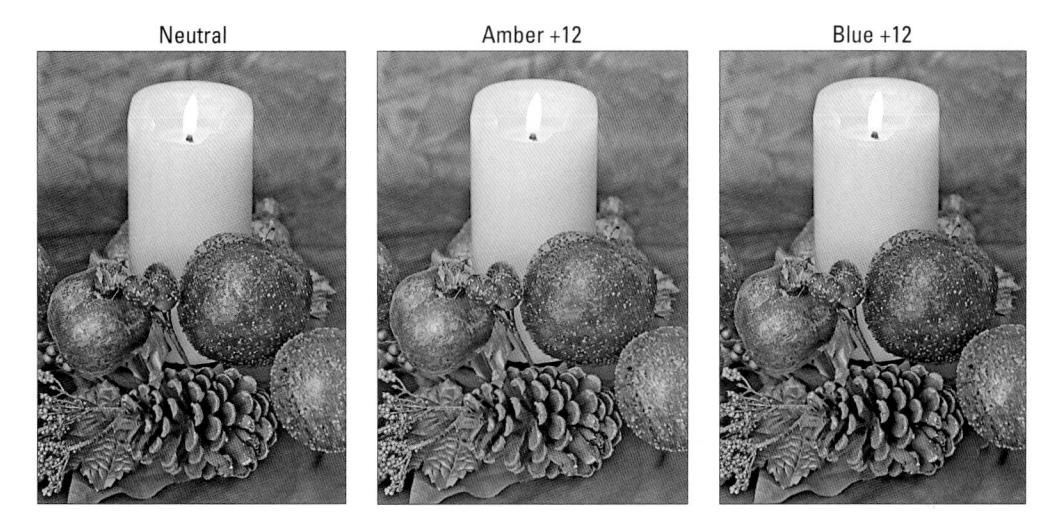

Figure 6-38: I used white balance bracketing to record three variations on the subject.

1. Set the Image Quality setting to one of the JPEG options (Fine, Normal, or Basic) or TIFF.

Chapter 3 explains all these options. To adjust the setting quickly, press the Qual button while rotating the main command dial.

- 2. Display the Custom Setting menu, select the Bracketing/Flash submenu, and press OK.
- 3. Select Auto Bracketing Set, as shown on the left in Figure 6-39, and press OK.

You see the screen shown on the right in the figure.

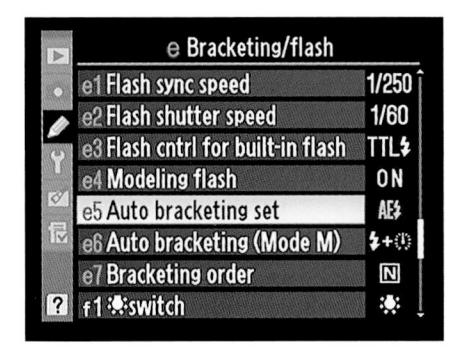

Figure 6-39: Your first step is to set the Auto Bracketing Set option to WB Bracketing.

4. Select WB Bracketing and press OK.

The bracketing feature is now set up to adjust white balance between your bracketed shots.

From here on, bracketing works pretty much as detailed in the steps at the end of Chapter 5. Rather than repeating everything here, I'll save some page space and provide just a quick summary of how to establish the bracketing settings.

- ✓ To set the number of frames and direction of the bracketing adjustment: Press and hold the Fn (Function) button (right-front side of the camera) while rotating the main command dial. For white balance bracketing, the options are as follows:
 - b3F: Records three frames: one neutral, one shifted one increment toward blue, and a third shifted one additional increment toward blue.
 - a3F: The same as b3F, but with the color adjustment toward the amber side of the scale.
 - b2F: Records two frames, one without any adjustment and one shifted toward blue.
 - a2F: Again, you get two frames, but the second is shifted toward amber.
 - 3F: This setting records three frames, with one neutral, one pushed toward amber, and one shifted toward blue.
 - 5F: You get five frames: One neutral, two shifted toward amber. and two shifted toward blue.
 - 7F: Along with one neutral shot, you get three amber variations and three blue variations.
 - 9F: This setting gives you nine shots, one neutral, four amber, and four blue.

Again, for the 5, 7, and 9 frame options, the increment of shift for the blue and amber variations is increased between shots.

- *0F*: Select this setting to turn off bracketing.
- ✓ To set the amount of white-balance adjustment: Press the Fn button and rotate the sub-command dial. Again, you can set the bracketing amount to 1, 2, or 3.

While the Fn button is pressed, you can view both settings in the Control panel and Info display. When you release the button, you see the same BKT symbol and progress indicator that appears when you bracket exposure settings. (Again, check out Chapter 5 for details.)

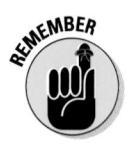

After establishing the bracketing parameters, just shoot your bracketed frames. Remember, you press the shutter button just once, and the camera records the entire bracketed series. Bracketing remains in force until you disable it (by setting the frame number to 0F).

Choosing a Color Space: sRGB versus Adobe RGB

By default, your camera captures images using the *sRGB color mode*, which simply refers to an industry-standard spectrum of colors. (The *s* is for *standard*, and the RGB is for red-green-blue, which are the primary colors in the digital color world.) The sRGB color mode was created to help ensure color consistency as an image moves from camera (or scanner) to monitor and printer; the idea was to create a spectrum of colors that all of these devices can reproduce.

However, the sRGB color spectrum leaves out some colors that *can* be reproduced in print and onscreen, at least by some devices. So as an alternative, your camera also enables you to shoot in the Adobe RGB color mode, which includes a larger spectrum (or *gamut*) of colors. Figure 6-40 offers an illustration of the two spectrums.

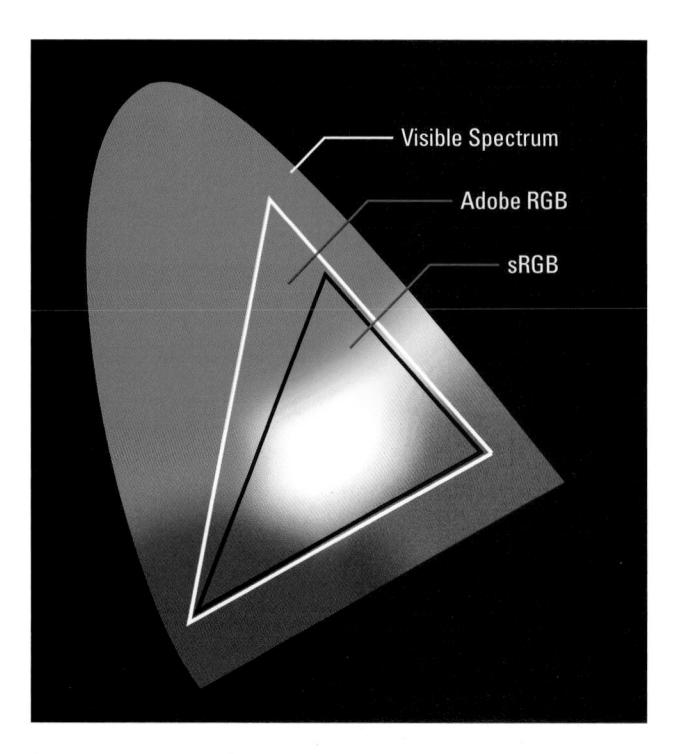

Figure 6-40: Adobe RGB includes some colors not found in the sRGB spectrum.

Some colors in the Adobe RGB spectrum cannot be reproduced in print. (The printer just substitutes the closest printable color, if necessary.) Still, I usually shoot in Adobe RGB mode because I see no reason to limit myself to a smaller spectrum from the get-go.

However, just because I use Adobe RGB doesn't mean that it's right for you. First, if you plan to print and share your photos without making any adjustments in your photo editor, you're usually better off sticking with sRGB, because most printers and Web browsers are designed around that color space. Second, know that in order to retain all your original Adobe RGB colors when you work with your photos, your editing software must support that color space — not all programs do. You also must be willing to study the whole topic of digital color a little bit because you need to use some specific settings to avoid really mucking up the color works.

If you want to go with Adobe RGB instead of sRGB, you can make the change either via the Shooting menu, as shown on the left in Figure 6-41, or via the control strip at the bottom of the Info display, as shown on the right. To use the control strip, press the Info button twice and then use the Multi Selector to highlight the color-space option. Then press OK to access the screen where you can change the setting.

Figure 6-41: Choose Adobe RGB for a broader color spectrum.

You can tell whether you captured an image in the Adobe RGB format by looking at its filename: Adobe RGB images start with an underscore, as in _DSC0627.jpg. For pictures captured in the sRGB color space, the underscore appears in the middle of the filename, as in DSC_0627.jpg.
Taking a Quick Look at Picture Controls

A Nikon feature called Picture Controls offers one more way to tweak image sharpening, color, and contrast when you shoot in the JPEG or TIFF picture formats. You can select the Picture Control setting through the Shooting menu, as shown on the left in Figure 6-42, or through the control strip option shown on the right. (Remember, press Info twice to activate the strip, use the Multi Selector to highlight the option, and press OK to display the relevant menu screen.)

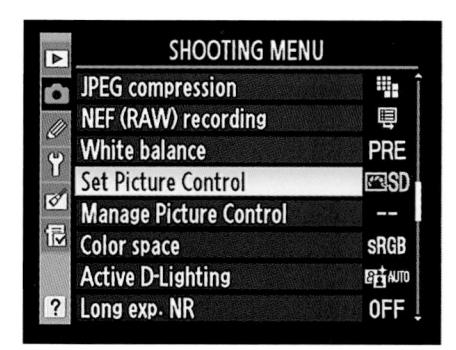

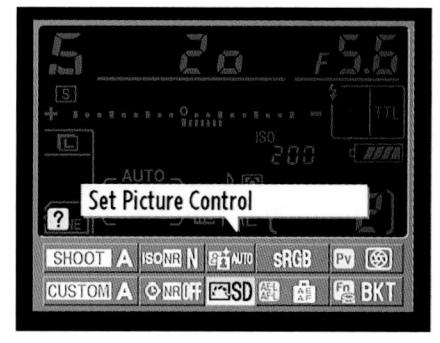

Figure 6-42: Picture Controls apply preset adjustments to color, sharpening, and other photo characteristics to images you shoot in the JPEG or TIFF file formats.

Sharpening, in case you're new to the digital meaning of the term, refers to a software process that adjusts contrast in a way that creates the illusion of slightly sharper focus. I emphasize, "slightly sharper focus." Sharpening produces a subtle *tweak*, and it's not a fix for poor focus.

On the D300s, you can choose from four Picture Controls, which produce the following results:

- Standard: The default setting, this option captures the image normally that is, using the characteristics that Nikon offers up as suitable for the majority of subjects.
- ✓ **Neutral:** At this setting, the camera doesn't enhance color, contrast, and sharpening as much as in the other modes. The setting is designed for people who want to precisely manipulate these picture characteristics in a photo editor. By not overworking colors, sharpening, and so on when producing your original file, the camera delivers an original that gives you more latitude in the digital darkroom.

- Vivid: In this mode, the camera amps up color saturation, contrast, and sharpening.
- Monochrome: This setting produces black-and-white photos. Only in the digital world, they're called *grayscale images* because a true black-and-white image contains only black and white, with no shades of gray.

I'm not keen on creating grayscale images this way. I prefer to shoot in full color and then do my own grayscale conversion in my photo editor. That technique just gives you more control over the look of your black-and-white photos. Assuming that you work with a decent photo editor, you can control what original tones are emphasized in your grayscale version, for example. Additionally, keep in mind that you can always convert a color image to grayscale, but you can't go the other direction. You can create a black-and-white copy of your color image right in the camera, in fact; Chapter 11 shows you how.

The extent to which Picture Controls affect your image depends on the subject as well as the exposure settings you choose and the lighting conditions. But Figure 6-43 gives you a general idea of what to expect. As you can see, the differences between the three color Picture Controls are pretty subtle.

Personally, I think that the Standard Picture Control works just fine, and I rarely use the others. And frankly, I suggest that you do the same. First off, you've got way more important camera settings to worry about — aperture, shutter speed, autofocus, and all the rest. Why add one more setting to your list, especially when the impact of changing it is minimal?

Second, if you really want to mess with the characteristics that the Picture Control options affect, you're much better off shooting in the RAW (NEF) format and then making those adjustments on a picture-by-picture basis in your RAW converter. In Nikon ViewNX, you can even assign any of the existing Picture Controls to your RAW files and then compare how each one affects the image. The camera does tag your RAW file with whatever Picture Control is active at the time you take the shot, but the image adjustments are in no way set in stone, or even in sand — you can tweak your photo at will. (The selected Picture Control does affect the JPEG preview that's used to display the RAW image thumbnails in ViewNX and other browsers.)

For these reasons, I'm opting in this book to present you with just this brief introduction to Picture Controls so that I can go into more detail about functions that I see as more useful (such as the white balance customization options presented earlier). But if you're intrigued, know that you also can create your very own, customized Picture Controls and even save them to a

memory card and share them with other photographers or install them on other compatible Nikon cameras. The camera manual walks you step by step through the process.

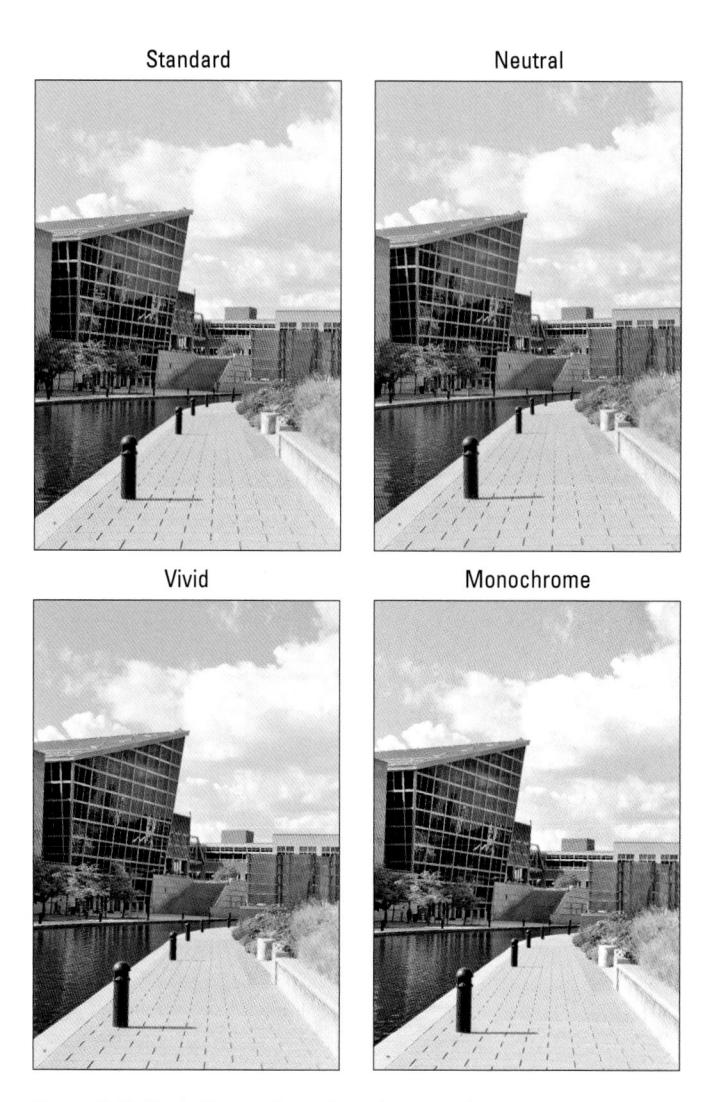

Figure 6-43: Each Picture Control produces a slightly different take on the scene.

Putting It All Together

In This Chapter

- ▶ Reviewing the best all-around picture-taking settings
- Adjusting the camera for portrait photography
- Discovering the keys to super action shots
- Dialing in the right settings to capture landscapes and other scenic vistas
- Capturing close-up views of your subject

arlier chapters of this book break down each and every picture-taking feature on your D300s, describing in detail how the various controls affect exposure, picture quality, focus, color, and the like. This chapter pulls all that information together to help you set up your camera for specific types of photography.

The first section offers a quick summary of critical picturetaking settings that should serve you well no matter what your subject. Following that, I offer my advice on which settings to use for portraits, action shots, landscapes, and close-ups.

Keep in mind that although I present specific recommendations here, there are no hard and fast rules as to the "right way" to shoot a portrait, a landscape, or whatever. So feel free to wander off on your own, tweaking this exposure setting or adjusting that focus control, to discover your own creative vision. Experimentation is part of the fun of photography, after all — and thanks to your camera monitor and the Delete button, it's an easy, completely free proposition.

necapping Basic Picture Settings

Your subject, creative goals, and lighting conditions determine which settings you should use for some picture-taking options, such as aperture and shutter speed. I offer my take on those options throughout this chapter. But for many basic options, I recommend the same settings for almost every shooting scenario. Table 7-1 shows you those recommendations and also lists the chapter where you can find details about each setting.

Table 7-1 Option	All-Purpose Picture-Taking Settings	
	Recommended Setting	Chapter
Image Quality	JPEG Fine or NEF (RAW)	3
Image Size	Large or medium	3
White Balance	Auto	6
ISO Sensitivity	200	5
Focus mode	For autofocus: S (single servo) for still subjects; C (continuous servo) for action; M for manual focus	6
AF-area mode	Still subjects, Single Point; action photos, Dynamic area	6
Release mode	Action photos: Continuous Lo or Continuous Hi; all others: Single	2
Metering	Matrix	5
Active D-Lighting	Off	5

Setting Up for Specific Scenes

For the most part, the settings detailed in the preceding section fall into the "set 'em and forget 'em" category. That leaves you free to concentrate on a handful of other camera options, such as aperture and shutter speed, that you can manipulate to achieve a specific photographic goal.

The next four sections explain which of these additional options typically produce the best results when you're shooting portraits, action shots, landscapes, and close-ups. I offer a few compositional and creative tips along the way — but again, remember that beauty is in the eye of the beholder, and for every so-called rule, there are plenty of great images that prove the exception.

Shooting still portraits

By *still portrait*, I mean that your subject isn't moving. For subjects who aren't keen on sitting still long enough to have their picture taken — children, pets, and even some teenagers I know — skip ahead to the next section and use the techniques given for action photography instead.

Assuming that you do have a subject willing to pose, the classic portraiture approach is to keep the subject sharply focused while throwing the background into soft focus. This artistic choice emphasizes the subject and helps diminish the impact of any distracting background objects in cases where you can't control the setting. The following steps show you how to achieve this look:

1. Set the Mode dial to A (aperture-priority autoexposure) and select the lowest f-stop value possible.

As Chapter 5 explains, a low f-stop setting opens the aperture, which not only allows more light to enter the camera but also shortens depth of field, or the range of sharp focus. So dialing in a low f-stop value is the first step in softening your portrait background. (The f-stop range available to you depends on your lens.) Also keep in mind that the farther your subject is from the background, the more blurring you can achieve.

I recommend aperture-priority mode when depth of field is a primary concern because you can control the f-stop while relying on the camera to select the shutter speed that will properly expose the image. Just rotate the sub-command dial to select your desired f-stop. (You do need to pay attention to shutter speed also, however, to make sure that it's not so slow that any movement of the subject or camera will blur the image.)

Of course, if you're more comfortable with manual exposure, you can use that mode and set both your aperture and shutter speed. Use the main command dial to set shutter speed.

Whichever mode you choose, you can monitor the current f-stop and shutter speed on the Information display, Control panel, and in the view-finder, as shown in Figure 7-1.

2. To further soften the background, zoom in, get closer, or both.

As covered in Chapter 6, zooming in to a longer focal length also reduces depth of field, as does moving physically closer to your subject.

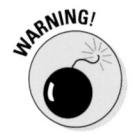

A lens with a focal length of 85–120mm is ideal for a classic head and shoulders portrait. Avoid using a very short focal length (a wide-angle lens) for portraits. They can cause features to appear distorted — sort of like how people look when you view them through a security peephole in a door.

Figure 7-1: You can monitor aperture and shutter speed settings in three places.

3. For indoor portraits, shoot flash-free if possible.

Shooting by available light rather than flash produces softer illumination and avoids the problem of red-eye. To get enough light to go flash-free, turn on room lights or, during daylight, pose your subject next to a sunny window, as I did for the image in Figure 7-2.

If flash is unavoidable, see my list of flash tips at the end of the steps to get better results.

4. For outdoor portraits, use a flash if possible.

Even in daylight, a flash adds a beneficial pop of light to subjects' faces. (The flash section of Chapter 5 has an example.)

Just press the Flash button on the side of the camera to enable the built-in flash. For daytime portraits, use the Front-Curtain sync flash mode setting. (That's

Figure 7-2: For more pleasing indoor portraits, shoot by available light instead of using flash.

the regular, basic flash mode.) Remember that by default, the top shutter speed for flash photography on the D300s is 1/250 second, so in bright light, you may need to stop down the aperture a little to avoid overexposing the photo. Doing so, of course, brings the background into sharper focus. So try to move the subject into a shaded area instead. You can also use the Flash Sync Speed option on the Custom Setting menu to increase the maximum shutter speed for flash photography; see Chapter 5 for details.

For nighttime images, try red-eye reduction or slow-sync mode; again, see the flash tips at the end of these steps to use either mode most effectively.

5. For autofocusing, combine the Single Point AF-area mode with the S (single-servo) Focus mode.

These autofocus settings are ideal for shooting still subjects. Chapter 6 explains the exact focusing steps you need to take.

Again, these steps just give you a starting point for taking better portraits. A few other tips can also improve your people pics:

- ✓ Pay attention to the background. Scan the entire frame looking for intrusive objects that may distract the eye from the subject. If necessary, reposition the subject against a more flattering backdrop. Inside, a softly textured wall works well; outdoors, trees and shrubs can provide nice backdrops as long as they aren't so ornate or colorful that they diminish the subject (for example, a magnolia tree laden with blooms).
- ▶ Pay attention to white balance if your subject is lit by both flash and ambient light. Multiple light sources can confuse the camera when you use automatic white balancing. As a result, your colors may appear slightly warmer or cooler than they should. A slight warming effect typically looks nice in portraits, giving the skin a subtle glow. But if you need to eliminate a color cast, whether it's toward the warm or cool side, see Chapter 6 to find out how to fine-tune white balance.
- When flash is unavoidable, try these tricks to produce better results. The following techniques can help solve flash-related issues:
 - Indoors, turn on as many room lights as possible. With more ambient light, you reduce the flash power that's needed to expose the picture. This step also causes the pupils to constrict, further reducing the chances of red-eye. (Pay heed to my white balance warning, however.) As an added benefit, the smaller pupil allows more of the subject's iris to be visible in the portrait, so you see more eye color.

• Try setting the flash to red-eye reduction or slow-sync mode. If you choose the first option, warn your subject to expect both a preliminary pop of light from the AF-assist lamp, which constricts pupils, and the actual flash. And remember that slow-sync flash uses a slower-than-normal shutter speed, which produces softer lighting and brighter backgrounds than normal flash. You can set the flash mode to slow-sync in A and P modes. In the other modes, just use the normal (front-curtain sync) flash mode but select a slow shutter speed to produce the same results.

Take a look at Figure 7-3 for an example of how slow-sync flash can really improve an indoor portrait. When I used regular flash, the shutter speed was 1/60 second. At that speed, the camera has little time to soak up any ambient light. As a result, the scene is lit primarily by the flash. That caused two problems: The strong flash created some "hot spots" on the subject's skin, and the window frame is much more prominent because of the contrast between it and the darker bushes outside the window. Although it was daylight when I took the picture, the skies were overcast, so at 1/60 second, the exteriors appear dark.

Regular fill flash, 1/60 second

Slow-sync flash, 1/4 second

Figure 7-3: Slow-sync flash results in softer, more even lighting and brighter backgrounds.

In the slow-sync example, shot at 1/4 second, the exposure time was long enough to permit the ambient light to brighten the exteriors to the point that the window frame almost blends into the background. And because much less flash power was needed to expose the subject, the lighting is much more flattering. In this case, the bright background also helps to set the subject apart because of her dark hair and shirt. If the subject had been a pale blonde, this setup wouldn't have worked as well, of course. And note the color shift that occurred due to the different mixes of flash and ambient lighting — in this case, the slow-sync example exhibited much warmer tones than the regular-flash example. Again, you can adjust white balance if the colors aren't to your liking.

Any time you use slow-sync flash, don't forget that a slower-than-normal shutter speed means an increased risk of blur due to camera shake. So always use a tripod or otherwise steady the camera. And remind your subject to stay absolutely still, too, because they will appear blurry if they move during the exposure. I was fortunate to have both my tripod and a cooperative subject for my examples, but I probably wouldn't try slow-sync for portraits of young children or pets.

• For professional results, use an external flash with a rotating flash head. Then aim the flash head upward so that the flash light bounces off the ceiling and falls softly down onto the subject. An external flash isn't cheap, but the results make the purchase worthwhile if you shoot lots of portraits. Compare the two portraits in Figure 7-4 for an illustration. In the first example, the built-in flash resulted in strong shadowing behind the subject and harsh, concentrated light. To produce the better result on the right, I used a Nikon Speedlight and bounced the light off the ceiling.

Make sure that the ceiling or other surface you use to bounce the light is white. Otherwise, the flash light will pick up the color of the surface and influence the color of your subject.

• To reduce shadowing from the flash, move your subject farther from the background. I took this extra step for the right image in Figure 7-4. The increased distance not only reduced shadowing but also softened the focus of the wall a bit (because of the short depth of field resulting from my f-stop and focal length).

A good general rule is to position your subjects far enough from the background that they can't touch it. If that isn't possible, though, try going the other direction: If the person's head is smack up against the background, any shadow will be smaller and less noticeable. For example, you get less shadowing when a subject's head is resting against a sofa cushion than if that person is sitting upright, with the head a foot or so away from the cushion.

Figure 7-4: To eliminate harsh lighting and strong shadows (left), I used bounce flash and moved the subject farther from the background (right).

- Invest in a flash diffuser to further soften the light. Whether you use
 the built-in flash or an external flash, attaching a diffuser is also a
 good idea. A diffuser is simply a piece of translucent plastic or fabric
 that you place over the flash to soften and spread the light much
 like sheer curtains diffuse window light. Diffusers come in lots of
 different designs, including small, fold-flat models that fit over the
 built-in flash.
- Frame the subject loosely to allow for later cropping to a variety of frame sizes. Your D300s produces images that have an aspect ratio of 3:2. That means that your portrait perfectly fits a 4-x-6-inch print size but will require cropping to print at any other proportions, such as 5 x 7 or 8 x 10. Chapter 9 talks more about this issue.

Capturing action

A fast shutter speed is the key to capturing a blur-free shot of any moving subject, whether it's a flower in the breeze, a spinning Ferris wheel, or, as in the case of Figure 7-5, a racing cyclist.

Along with the basic capture settings outlined in Table 7-1, try the techniques in the following steps to photograph a subject in motion:

1. Set the Mode dial to S (shutter-priority autoexposure).

In this mode, you control the shutter speed, and the camera takes care of choosing an aperture setting that will produce a good exposure. If you're comfortable with handling both the shutter speed and f-stop duties, you may prefer to work in manual mode instead, however.

2. Rotate the main command dial to select the shutter speed.

(Refer to Figure 7-1 to locate shutter speed in the viewfinder and Information display.) In shutter-priority autoexposure mode, the camera selects an aperture (f-stop) to match.

What shutter speed do you need exactly? Well, it depends on the speed at which your subject is moving, so some experi-

Figure 7-5: Use a high shutter speed to freeze motion.

mentation is needed. But generally speaking, 1/320 second should be plenty for all but the fastest subjects (race cars, boats, and so on). For very slow subjects, you can even go as low as 1/250 or 1/125 second. My subject in Figure 7-5 was zipping along at a pretty fast pace, so I set the shutter speed to 1/500 second just to be on the safe side.

3. Raise the ISO setting to produce a brighter exposure if needed.

In dim lighting, you may not be able to get a good exposure without taking this step; the camera simply may not be able to open the aperture wide enough to accommodate a fast shutter speed. Raising the ISO does increase the possibility of noise, but a noisy shot is better than a blurry shot.

4. For rapid-fire shooting, set the Release mode to one of the Continuous settings.

By default, the Continuous Low setting enables you to capture as many as three frames per second with a single press of the shutter button. Continuous High bumps the frame rate up to seven frames per second. Chapter 2 provides a bit more detail on these options.

5. For autofocusing, set the AF-area mode to Dynamic Area and the Focus mode to C (continuous-servo autofocus).

Chapter 6 provides details on how to set focus when using this pair of settings, which are geared to capturing action.

6. For fastest shooting, switch to manual focusing.

Manual focusing eliminates the time the camera needs to lock focus in autofocus mode. Chapter 1 shows you how to focus manually, if you need help.

7. Compose the subject to allow for movement across the frame.

Frame your shot a little wider than you normally might so that you lessen the risk that your subject will move out of the frame before you record the image. You can always crop to a tighter composition later. (I used this approach for my cyclist image — the original shot includes a lot of background that I later cropped away.) It's also a good idea to leave more room in front of the subject than behind it. This makes it obvious that your subject is going somewhere.

Using these techniques should give you a better chance of capturing any fast-moving subject. But action-shooting strategies also are helpful for shooting candid portraits of kids and pets. Even if they aren't currently running, leaping, or otherwise cavorting, snapping a shot before they do move or change positions is often tough. So if an interaction or scene catches your eye, set your camera into action mode and then just fire off a series of shots as fast as you can.

Capturing scenic vistas

Providing specific capture settings for landscape photography is tricky because there's no single best approach to capturing a beautiful stretch of countryside, a city skyline, or other vast subject. Take depth of field, for example: One person's idea of a super cityscape might be to keep all buildings in the scene sharply focused. But another photographer might prefer to shoot the same scene so that a foreground building is sharply focused while the others are less so, thus drawing the eye to that first building.

That said, I can offer a few tips to help you photograph a landscape the way *you* see it:

✓ Shoot in M (manual) or aperture-priority autoexposure mode (A) so that you can control depth of field. In A mode, you control the f-stop and the camera sets the shutter speed. (Rotate the sub-command dial to set the f-stop.)

If you want extreme depth of field, so that both near and distant objects are sharply focused, as in Figure 7-6, select a high f-stop value. I used an aperture of f/18 for this shot. For short depth of field, use a low value.

Figure 7-6: Use a high f-stop value to keep foreground and background sharply focused.

If the exposure requires a slow shutter, use a tripod to avoid blurring. The downside to a high f-stop is that you need a slower shutter speed to produce a good exposure. If the shutter speed drops below what you can comfortably hand-hold, use a tripod to avoid picture-blurring camera shake. Remember that when you use a tripod, you may need to disable Vibration Reduction, if your lens offers it; check your lens manual to be sure.

No tripod handy? Look for any solid surface on which you can steady the camera. Of course, you can always increase the ISO Sensitivity setting to allow a faster shutter, too, but that option brings with it the chances of increased image noise. See Chapter 5 for details.

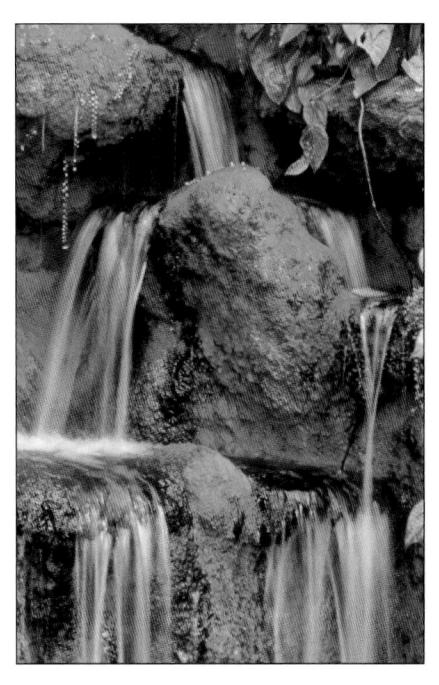

Figure 7-7: For misty waterfalls, use a slow shutter speed and a tripod.

For dramatic waterfall shots, consider using a slow shutter to create that "misty" look. The slow shutter blurs the water, giving it a soft, romantic appearance, as shown in Figure 7-7. Again, use a tripod to ensure that the rest of the scene doesn't also blur due to camera shake. You can also use a slow shutter speed to capture dramatic photographs of waves coming ashore.

In very bright light, you may need to place a neutral density filter over the lens; the filter reduces the light that can enter the lens, enabling you to use a slow shutter without overexposing the photo. Most camera stores carry these filters.

Lat sunrise or sunset, base exposure on the sky. The foreground will be dark, but you can usually brighten it in a photo editor if needed. If you base exposure on the foreground, on the other hand, the sky will become so bright that all the color will be washed out — a problem you usually can't fix after the fact.

Also experiment with different levels of Active D-Lighting adjustment. Chapter 5 explains this feature, which brightens dark areas in a way that doesn't blow out highlights, leaving your sky colors intact.

- For cool nighttime city pics, experiment with slow shutter. Assuming that cars or other vehicles are moving through the scene, the result is neon trails of light like those you see in the foreground of the image in Figure 7-10. Shutter speed for this image was about 10 seconds.
- ✓ In tricky light, bracket exposures.

 Bracketing simply means to take the same picture at several different exposures to increase the odds that at least one of them will capture the scene the way you envision. Bracketing is especially a good idea in difficult lighting situations such as sunrise and sunset. See the end of Chapter 5 to find out how to use your camera's automatic bracketing feature.

Figure 7-8: A slow shutter also creates neon light trails in city-street scenes.

Capturing dynamic close-ups

For great close-up shots, try these techniques:

- Check your owner's manual to find out the minimum closefocusing distance of your lens. How "up close and personal" you can get to your subject depends on your lens, not the camera body itself.
- Take control over depth of field by setting the camera mode to M (manual exposure) or A (aperture-priority auto-exposure) mode. Whether you want a shallow, medium, or extreme depth of field depends on the point of your photo. In classic nature photography, for example, the artistic tradition is a very shallow depth of field, as shown in Figure 7-9, and requires an open aperture (low f-stop value). But if you want the

Figure 7-9: Shallow depth of field is a classic technique for close-up floral images.

viewer to be able to clearly see all details throughout the frame — for example, if you're shooting a product shot for your company's sales catalog — you need to go the other direction, stopping down the aperture as far as possible.

- Remember that zooming in and getting close to your subject both decrease depth of field. So back to that product shot: If you need depth of field beyond what you can achieve with the aperture setting, you may need to back away, zoom out, or both. (You can always crop your image to show just the parts of the subject that you want to feature.)
- When shooting flowers and other nature scenes outdoors, pay attention to shutter speed, too. Even a slight breeze may cause your subject to move, causing blurring at slow shutter speeds.

- ✓ **Use flash for better outdoor lighting.** Just as with portraits, a tiny bit of flash typically improves close-ups when the sun is your primary light source. Again, though, keep in mind that the default maximum shutter speed possible when you use the built-in flash is 1/250 second, which may mean that you have to use a small aperture in bright light. See the flash section of Chapter 5 for details about this issue.
- When shooting indoors, try not to use flash as your primary light source. Because you'll be shooting at close range, the light from your flash may be too harsh even at a low Flash Compensation setting. If flash is inevitable, turn on as many room lights as possible to reduce the flash power that's needed even a hardware-store shop light can do in a pinch as a lighting source. (Remember that if you have multiple light sources, though, you may need to tweak the white balance setting.)
- ✓ To really get close to your subject, invest in a macro lens or a set of diopters. A true macro lens, which enables you to get really, really close to your subjects, is an expensive proposition; expect to pay around \$200 or more. But if you enjoy capturing the tiny details in life, it's worth the investment.

For a less expensive way to go, you can spend about \$40 for a set of diopters, which are sort of like reading glasses that you screw onto your existing lens. Diopters come in several strengths -+1, +2, +4, and so on — with a higher number indicating a greater magnifying power. I took this approach to capture the extreme close-up in Figure 7-10, attaching a +2 diopter to my lens. The downfall of diopters, sadly, is that they typically produce images that are very soft around the edges, a problem that doesn't occur with a good macro lens.

Figure 7-10: To extend your lens' close-focus ability, you can add magnifying diopters.

Part III Working with Picture Files

"I've got some new image editing software, so I took the liberty of erasing some of the smudges that kept showing up around the clouds. No need to thank me."

In this part . . .

ou've got a memory card full of pictures and movie files. Now what? Turn to the first chapter in this part, which explains how to get those files out of your camera and onto your computer. The same chapter also talks about processing photos that you capture in the NEF (RAW) file format.

After downloading your files, head for Chapter 9, which offers step-by-step guidance on printing your pictures, sharing them online, and viewing both photos and movies on your television.

Downloading, Organizing, and Archiving Your Picture Files

In This Chapter

- Transferring pictures to your computer
- Using Nikon Transfer and ViewNX to download and organize photos
- Processing NEF (RAW) files
- Copying pictures between memory cards
- Keeping your picture files safe from harm

or many novice digital photographers (and even some experienced ones), the task of moving pictures to the computer and then keeping track of all of those image files is one of the more confusing aspects of the art form. And frankly, writing about the downloading and organizing process isn't all that easy, either. I know, I know — would I like some whine with that cheese? But the truth is, providing you with detailed instructions is pretty much impossible because the steps vary widely depending on what software you have installed on your computer and which computer operating system you use.

To give you as much help as I can, however, this chapter shows you how to transfer and organize pictures using the free Nikon software that came in your camera box. After exploring these discussions, you should be able to adapt the steps to any other photo program you may prefer. This chapter also covers a few other aspects of handling your picture files, including converting pictures taken in the NEF (RAW) format to a standard image format.

One note before you dig in: Most figures in this chapter and elsewhere feature the Windows Vista operating system. If you use some other version of Windows or another operating system, what you see on your screen may look slightly different but should contain the same basic options unless I specify otherwise.

Sending Pictures to the Computer

You can take two approaches to moving pictures from your camera memory card to your computer:

- Connect the camera directly to the computer. For this option, you need to dig out the USB cable that came in your camera box. Your computer must also have an open USB slot, or *port*, in techie talk. If you're not sure what these gadgets look like, Figure 8-1 gives you a look. The little three-pronged icon, labeled in Figure 8-1, is the universal symbol for USB.
- ✓ Transfer images using a memory card reader. Many computers now also have slots that accept common types of memory cards. If so, you can simply pop the card out of your camera and into the card slot instead of hooking the camera up to the computer.

Figure 8-1: You can connect the camera to the computer using the supplied USB cable.

As another option, you can buy stand-alone card readers such as the SanDisk model shown in Figure 8-2. This particular model accepts a variety of memory cards, including those used by your D300s. Check your printer, too; many printers now have card slots that serve the purpose of a card reader. If not, you don't have to spend much to buy a reader — they cost anywhere from about \$10 to \$35, depending on how many different types of cards they accept.

Figure 8-2: A card reader offers a more convenient method of image transfer.

I prefer to use a card reader because to transfer via the camera, the camera must be turned on during the process, wasting battery power. If you want to transfer directly from the camera, however, the next section explains some important steps you need to take to make that option work. For help using a card reader, skip ahead to "Starting the transfer process" to get an overview of what happens after you insert the card into the reader.

Connecting the camera and computer

You need to follow a specific set of steps when connecting the camera to your computer. Otherwise, you can damage the camera or the memory card.

Also note that in order for your camera to communicate with the computer, Nikon suggests that your computer be running Windows Vista, Windows XP, or the Mac operating system. Check the Nikon Web site (www.nikon.com) for a complete list of the compatible versions of each OS (operating systems). For example, Nikon recommends that Vista users have Service Pack 1 installed.

Also check the Nikon support pages if you use another OS for the latest news about any updates to system compatibility. You can always simply transfer images with a card reader, too.

With that preamble out of the way, here are the steps to link your computer and camera:

1. Check the level of the camera battery.

If the battery is low, charge it before continuing. Running out of battery power during the transfer process can cause problems, including lost picture data. Alternatively, if you purchased the optional AC adapter, use that to power the camera during picture transfers.

- 2. Turn on the computer and give it time to finish its normal startup routine.
- 3. Turn the camera off.
- Insert the smaller of the two plugs on the USB cable into the USB port on the side of the camera.

Look under the little rubber door on the left side of the camera, as shown in Figure 8-3, for this port.

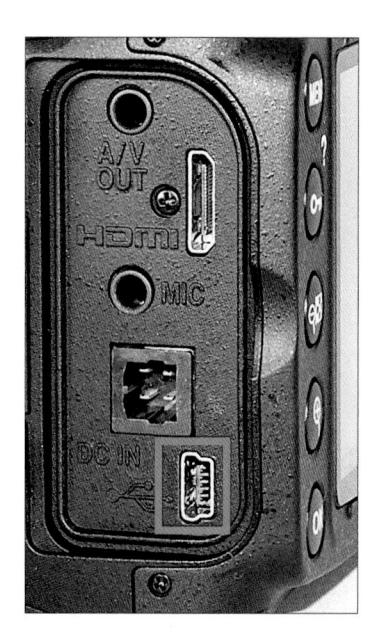

Figure 8-3: The USB slot is hidden under the rubber door on the left side of the camera.

5. Plug the other end of the cable into the computer's USB port.

If possible, plug the cable into a port that's built in to the computer, as opposed to one that's on your keyboard or part of an external USB hub. Those accessory-type connections can sometimes foul up the transfer process.

6. Turn the camera on.

What happens now depends on your computer operating system and what photo software you have installed on that system. The next section explains the possibilities and how to proceed with the image transfer process.

7. When the download is complete, turn off the camera and then disconnect it from the computer.

I repeat: Turn off the camera before severing its ties with the computer. Otherwise, you can damage the camera.

Starting the transfer process

After you connect the camera to the computer (be sure to carefully follow the steps in the preceding section) or insert a memory card into your card reader, your next step depends, again, on the software installed on your computer and the computer operating system.

Here are the most common possibilities and how to move forward:

On a Windows-based computer, a Windows message box similar to the one in Figure 8-4 appears. The dialog box suggests differ-

ent programs that you can use to download your picture files. Which programs appear depend on what you have installed on your system; if you installed Nikon Transfer, for example, it should appear in the program list, as in the figure. In Windows Vista, just click the transfer program that you want to use. In other versions of Windows, the dialog box may sport an OK button; if so, click that button to proceed.

An installed photo program automatically displays a photo-down**load wizard.** For example, the Nikon Transfer downloader or a downloader associated with some other

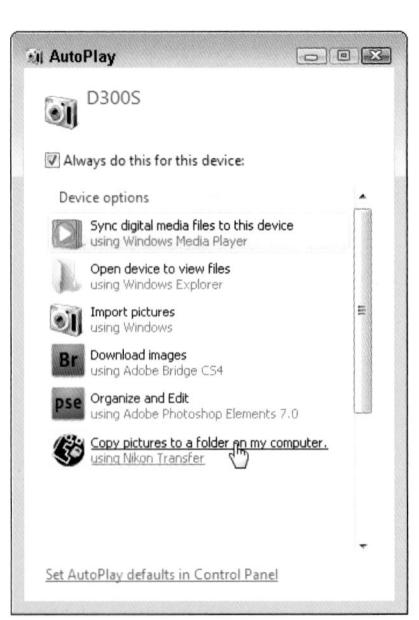

Figure 8-4: Windows may display this initial boxful of transfer options.

photo software may leap to the forefront. Usually, the downloader that appears is associated with the software that you most recently installed. Each new program that you add to your system tries to wrestle control over your image downloads away from the previous program.

If you don't want a program's auto downloader to launch whenever you insert a memory card or connect your camera, you should be able to turn that feature off. Check the software manual to find out how to disable the auto launch.

✓ **Nothing happens.** Don't panic; assuming that your card reader or camera is properly connected, all is probably well. Someone simply may have disabled all the automatic downloaders on your system. Just launch your photo software and then transfer your pictures using whatever command starts that process. (I show you how to do it with Nikon Transfer later in the chapter; for other programs, consult the software manual.)

As another option, if you work on a PC, you can use Windows Explorer to drag and drop files from your memory card to your computer's hard drive. Whether you connect the card through a card reader or attach the camera directly, the computer sees the card or camera as just another removable storage drive on the system. So the process of transferring files is exactly the same as when you move any other file from a CD, DVD, or other storage device onto your hard drive. If you have two memory cards in the camera, each will show up as a separate removable drive under the main camera drive (which should be named D300s). Mac users also can drag and drop picture files through the Finder, but only when downloading via a card reader.

In the next sections, I provide details on using Nikon Transfer to download your files and Nikon ViewNX to view and organize your pictures. Remember, if you use some other software, the concepts are the same, but check your program manual to get the small details. In most programs, you also can find lots of information by simply clicking open the Help menu.

Downloading and Organizing Photos with the Nikon Software

Remember unpacking your camera box when you first brought home your D300s? Did you notice a CD-ROM called Nikon Software Suite? If you haven't already done so, dig out that CD and pop it into your computer's CD drive. Then install the following two programs:

- ✓ **Nikon Transfer:** This program assists you with the process of transferring pictures from your camera or memory card to the computer.
- Nikon ViewNX: After downloading your files, you can view and organize your picture files using this program. You also can print and e-mail your photos from ViewNX.

Note that this book features Nikon Transfer version 1.5.1 and Nikon ViewNX version 1.5, which were the most current at the time of publication. If you own an earlier version of these programs, visit the Nikon Web site to install the updates. (To find out what version you have installed, open the program. Then, in Windows, choose Help⇔About. On a Mac, choose the About command from the Nikon Transfer or Nikon ViewNX menu.)

The next several sections give you the most basic of introductions to using Nikon Transfer and ViewNX. If you want more details, just look in the Help system built in to the programs. (Click the Help menu to access the system.)

Before you move on, though, I want to clear up one common point of confusion: You can use the Nikon software to download and organize your photos and still use any photo editing software you prefer. And to do your editing, you don't need to re-download photos — after you transfer photos to your computer, you can access them from any program, just as you can any file that you put on your system. In fact, for most photo editing programs, you can set things up so that you can select a photo in ViewNX and then open that picture in your chosen photo editor with a click or two. (With some programs, you must first take the step of *importing* the photo files, which enables the program to build thumbnails and, in some cases, working copies of your pictures.) You can find details in the ViewNX Help system (open the program and then choose Help\$\tilde{\top}\tilde{\top

Downloading with Nikon Transfer

The following steps explain how to download new pictures to your computer using Nikon Transfer:

1. Attach your camera or insert a memory card into your card reader, as outlined in the first part of this chapter.

Depending on what software you have installed on your system, you may see the initial Nikon Transfer window, as shown in Figure 8-5. Or, in Windows, you may see a dialog box similar to the one shown in Figure 8-4. In that case, click the item that has the Nikon Transfer logo, as shown in Figure 8-4.

If nothing happens, start Nikon Transfer by using the same process you use to launch any program on your computer. (If some other photo software pops up, close it first.)

2. Display the Source tab to view thumbnails of your pictures, as shown in the figure.

Don't see any tabs? Click the little Options triangle, located near the top-left corner of the window and labeled in Figure 8-5, to display them. Then click the Source tab. The icon representing your camera should be selected, as shown in the figure. If not, click the icon. The dialog box then

displays thumbnails of your images. If you don't see the thumbnails, click the arrow labeled in Figure 8-5 to expand the dialog box and open the thumbnails area.

If you have two memory cards in the camera, click the little black triangle at the bottom-right corner of the camera icon, as shown in Figure 8-5. You can then choose which card you want the downloader to access.

3. Select the images that you want to download.

A check mark in the little box under a thumbnail tells the program that you want to download the image. Click the box to toggle the check mark on and off.

If you used the in-camera functions to protect pictures (see Chapter 4), you can select just those images by clicking the Select Protected icon, labeled in Figure 8-5. To select all images on the card, click the Select All icon instead.

Click to display/hide thumbnails Select Protected Options Select memory card Select All Mikon Transfer Edit View Window Help Source: D300S Options Source Embedded Info Primary Destination Backup Destination my Picturetown Preferences Search For D300S Slot 1 Slot 2 Deselect Thumbnails 0 of 35 photo(s) selected Select: Se as as as as as as Group: None _DSC0306.NEF _DSC0309.NEF DSC0373.NEF DSC0305.NEF C Transfer Queue 35 photo(s) in the queue Process: Start Transfer

Figure 8-5: Select the check boxes of the images that you want to download.

4. Click the Primary Destination tab at the top of the window.

When you click the tab, the top of the transfer window offers options that enable you to specify where and how you want the images to be stored on your computer. Figure 8-6 offers a look.

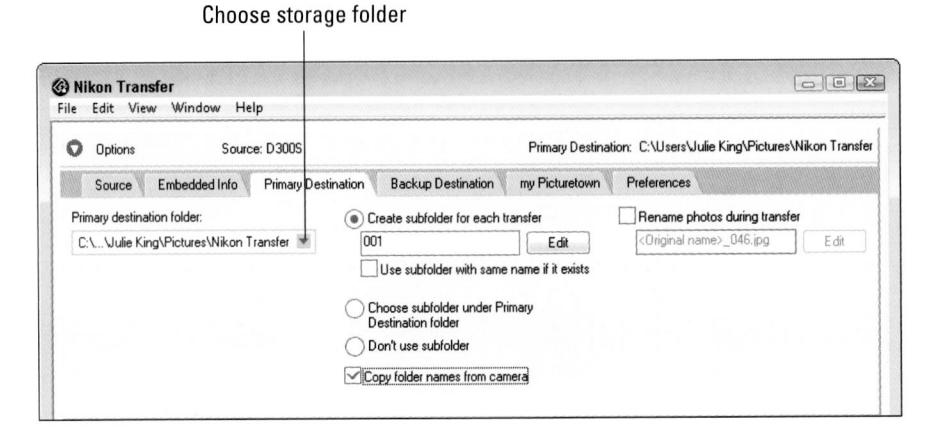

Figure 8-6: Specify the folder where you want to put the downloaded images.

5. Choose the folder where you want to store the images from the Primary Destination Folder drop-down list.

The list is labeled in Figure 8-6. If the folder you want to use isn't in the list, open the drop-down list, choose Browse from the bottom of the list, and then track down the folder and select it.

By default, the program puts images in a folder titled Nikon Transfer, which is housed inside a folder named My Pictures in Windows XP and Pictures in Windows Vista and on a Mac. That My Pictures or Pictures folder is housed inside a folder that your system creates automatically for each registered user of the computer.

You don't have to stick with this default location — you can put your pictures anywhere you please. But because most photo programs automatically look for pictures in these standard folders, putting your pictures there just simplifies things a little down the road. *Note:* You can always move your pictures into other folders after you download them if needed, too. The upcoming section "Organizing pictures" explains how to do so in Nikon ViewNX.

Specify whether you want the pictures to be placed inside a new subfolder.

If you select the Create Subfolder for Each Transfer option, the program creates a new folder inside the storage folder you selected in Step 5. Then it puts all the pictures from the current download session into that new

subfolder. You can either use the numerical subfolder name the program suggests or click the Edit button to set up your own naming system.

7. Tell the program whether you want to rename the picture files during the download process.

If you do, select the Rename Photos During Transfer check box. Then click the Edit button to display a dialog box where you can set up your new filenaming scheme. Click OK after you do so to close the dialog box.

8. Click the Preferences tab to set the rest of the transfer options.

Now the tab shown in Figure 8-7 takes over the top of the program window. Here you find a number of options that enable you to control how the program operates. Most of the options are self-explanatory, but a couple warrant a few words of advice:

 Launch Automatically When Device Is Attached. Deselect this check box if you don't want Nikon Transfer to start every time you connect your camera to your computer or insert a memory card into your card reader.

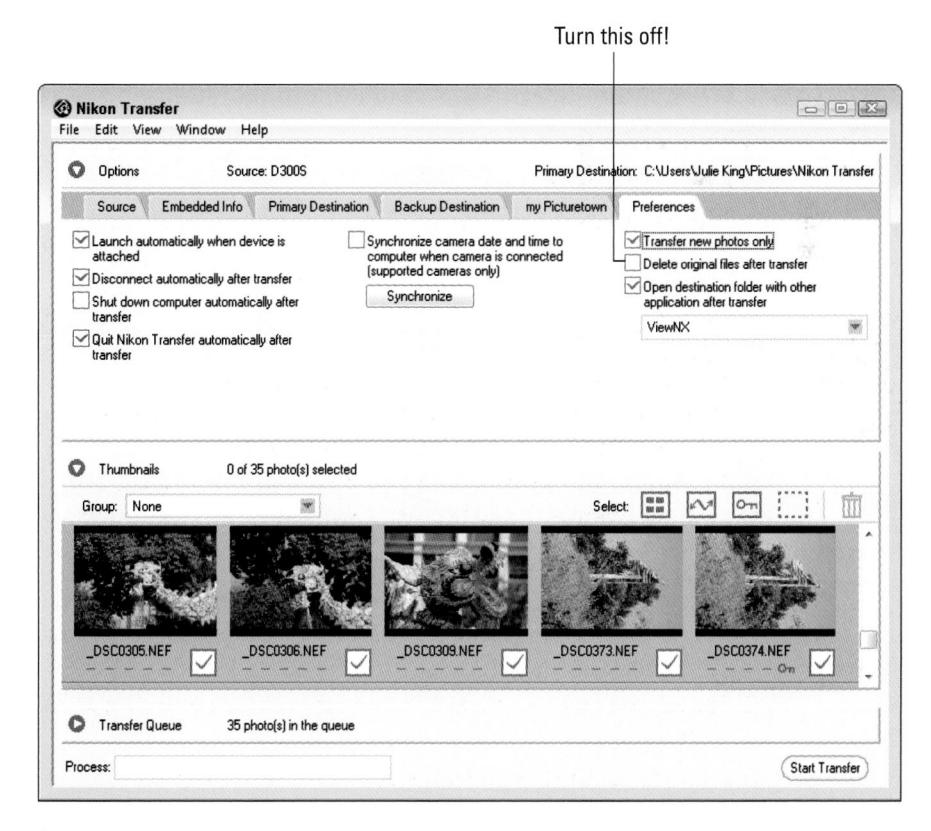

Figure 8-7: Control other aspects of the program's behavior via the Preferences tab.

- Transfer New Photos Only. This option, when selected, ensures
 that you don't waste time downloading images that you've already
 transferred but are still on the memory card.
- Delete Original Files After Transfer. Turn this option off, as shown in Figure 8-7. Otherwise, your pictures are automatically erased from your memory card when the transfer is complete. You should always check to make sure the pictures really made it to the computer before you delete them from your memory card. (See Chapter 4 to find out how to use the Delete function on your camera.)
- Open Destination Folder with Other Application After Transfer. By default, Nikon Transfer shuts itself down when the file download is complete, and Nikon ViewNX then starts automatically so that you can view and organize your images. (That's assuming that you installed ViewNX, of course.) If you want to use a program other than ViewNX for that task, open the drop-down list, click Browse, and select the program from the dialog box that appears. Click OK after doing so. And if you don't want Nikon Transfer to close after downloading, uncheck the Quit Nikon Transfer Automatically After Transfer option.

Your choices remain in force for any subsequent download sessions, so you don't have to revisit this tab unless you want the program to behave differently.

9. When you're ready to start the download, click the Start Transfer button.

It's located in the lower-right corner of the program window. (Refer to Figure 8-5.) After you click the button, the Process bar in the lower-left corner indicates how the transfer is progressing. Again, what happens when the transfer completely depends on the choices you made in Step 8; by default, Nikon Transfer closes, and ViewNX opens, automatically displaying the folder that contains your just-downloaded images.

Browsing images in Nikon ViewNX

Nikon ViewNX is designed to do exactly what its name suggests: enable you to view and organize the pictures that you shoot with your D300s. You also can view other photos — pictures you scanned, received from friends via e-mail, or took with a different camera, for example. The only requirement is that the file format is one that ViewNX can read; for still photos, that means JPEG, TIFF, or NEF, which is the Nikon flavor of Camera Raw. (Chapter 3 explains file formats.) For a complete rundown of supported file formats, check the Appendix section of the built-in program Help system.

Figure 8-8 offers a look at the ViewNX window as it appears by default in Windows Vista. The Mac version is nearly identical, although it features the usual Mac look and feel instead of the Microsoft Windows design.

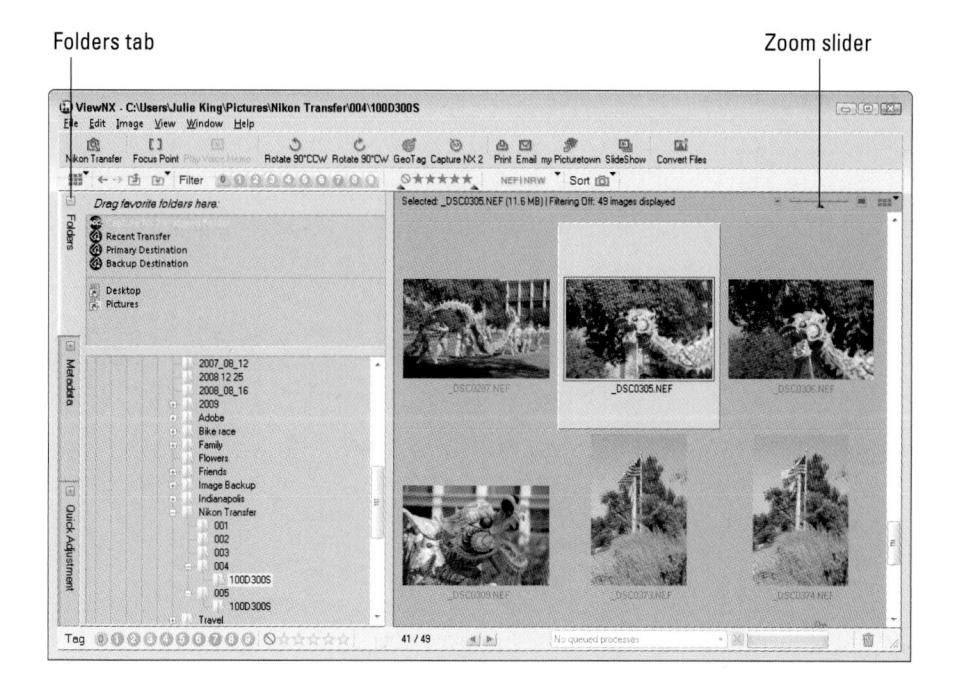

Figure 8-8: You can browse and organize your photos using Nikon ViewNX.

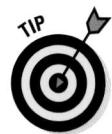

On either type of system, you can customize a variety of aspects of the window layout by using the options on the View and Window menus.

To start viewing your pictures, first display the Folders tab along the left side of the program window, as shown in Figure 8-8. (Just click the tab, labeled in the figure.) Now open the folder that holds the photos you want to view. If you came to ViewNX directly after downloading pictures via Nikon Transfer, the folder that holds the new images may already be selected for you. Thumbnails of those images then appear on the right side of the program window.

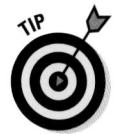

By opening the View menu, you can choose from the following viewing options:

Thumbnail View: This is the default layout. For this view, you can choose from two thumbnail display styles. If you select Thumbnail Grid from the View menu, your screen appears as shown in Figure 8-8. You can adjust the size of the thumbnails by dragging the Zoom slider, labeled in the figure. If you prefer, you can instead select Thumbnail List, in which case you see thumbnails with information such as the filenames, the dates the images were taken, file sizes, and so on.

- ✓ **Image Viewer:** Select this option from the View menu to display your files as shown in Figure 8-9. Small thumbnails appear along the top of the pane; the selected thumbnail appears in the larger preview area underneath. Use these maneuvers to inspect your images:
 - To select an image file, click its thumbnail.
 - Magnify or reduce the size of photo thumbnails and the preview by using the Zoom sliders labeled in Figure 8-9.
 - Drag in the large preview to scroll the display as needed to view hidden parts of a photo.
 - To scroll through your files, click the little arrows under the large preview, labeled Previous Photo and Next Photo in the figure.

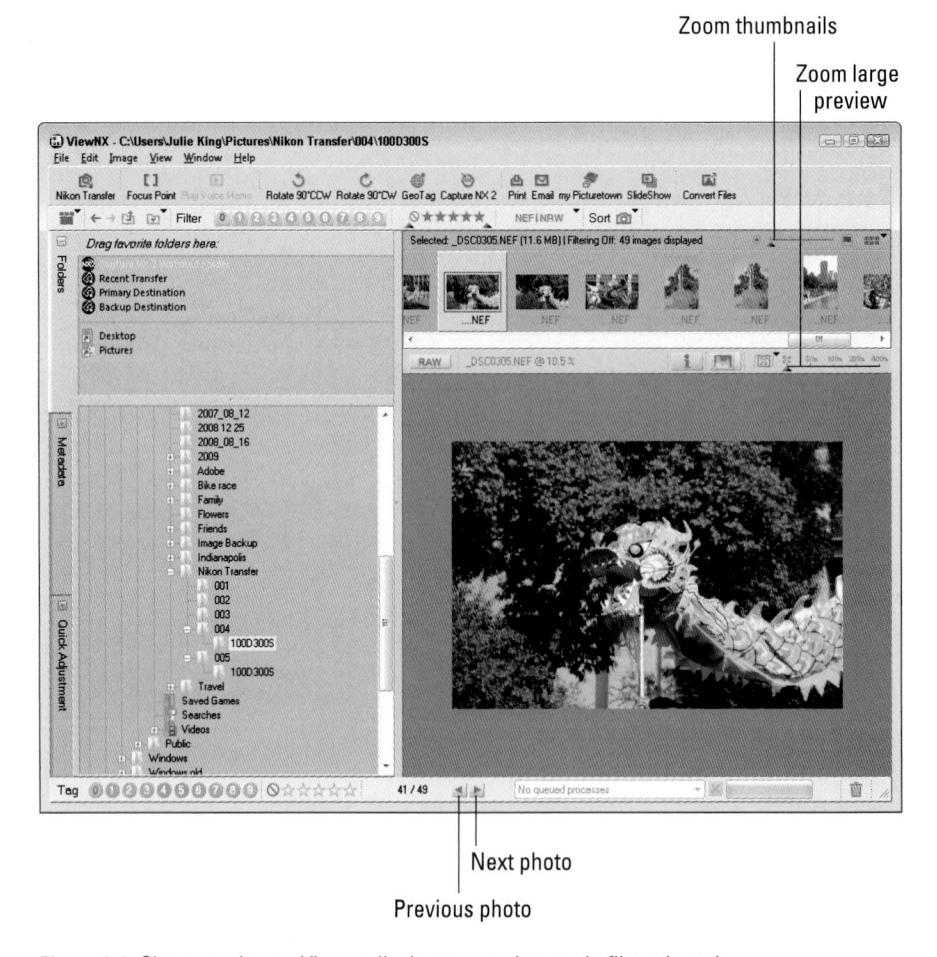

Figure 8-9: Change to Image Viewer display to see pictures in filmstrip style.

Full Screen: Want to fill the entire screen with a photo? If you're working in Thumbnail view (with or without all the data displayed), just double-click the picture thumbnail. In Image Viewer view, first click the thumbnail to display it in the large preview. Then double-click the large preview. Or, in either view, click the thumbnail and then press the letter F. Whichever way you go, your picture opens in a new viewer window, as shown in Figure 8-10.

In Full Screen view, as in the other views, you can magnify still photos by dragging the Zoom slider, as shown in the figure. To view additional photos at full-screen size, click the Previous and Next arrows under the image display. To return to the main browser window, just click the window's close button or choose a display option from the Display Options drop-down list, labeled in Figure 8-10.

Figure 8-10: Click the arrows to scroll through your photos in Full Screen view.

Viewing picture metadata

When you snap a photo with your D300s, the camera includes in the picture file some extra data that records all the critical camera settings that were in force. This data, known as *metadata*, also includes the capture date and

time. And, if you take advantage of the Image Comment feature that I cover in Chapter 10, you can even store a brief bit of custom text, such as the shooting location or subject.

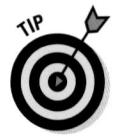

Reviewing this data is a great way to better understand what settings work best for different types of pictures, especially when you're just getting up to speed with aperture, shutter speed, white balance, and all the other digital photography basics. To get the full story on how each setting affects your pictures, see Chapters 5 and 6.

To view the metadata in ViewNX, first select an image by clicking its thumbnail in the ViewNX browser window. Then click the Metadata tab on the left side of the window or choose Window Metadata. The metadata information then comes to the forefront, as shown in Figure 8-11.

Metadata tab

Figure 8-11: Inspecting metadata is a great way to see what settings work best for different subjects and lighting conditions.

The metadata is divided into several sections of related capture settings: File Info 1, File Info 2, Camera Info, Exposure, and so on. To hide or display a section, click the triangle next to it. You may need to use the scroll bar along the right side of the panel to view all the available information. Note that Nikon supplies ViewNX with cameras other than the D300s, and some categories of data apply only to those other models.

The XMP/IPTC Information part of the Metadata panel gives you access to the ViewNX keywords, tags, and rating functions. These functions, along with the program's search feature, provide you with various tools that make locating specific pictures easier, including the option to search for pictures based on the shooting date.

In case you're curious, IPTC refers to text data that press photographers are often required to tag onto their picture files, such as captions and copyright information. XMP refers to a data format developed by Adobe to enable that kind of data to be added to the file. IPTC stands for International Press Telecommunication Council; XMP stands for Extensible Metadata Platform.

Organizing pictures

When you download files from your camera using Nikon Transfer, you can specify where on your computer's hard drive you want to store them. After you get the files on your system, you can further organize them in ViewNX. You can create new folders and subfolders, move images from one folder to another, rename and delete files, and more.

To begin organizing your files, first display the Folders tab on the left side of the program window, as shown in Figure 8-12. In this tab, you can see and manage the contents of all the drives and folders on your computer. From here, you can set up and rearrange your storage closet as follows:

- ✓ Hide/display the contents of a drive or folder. See a little plus sign (Windows) or right-pointing triangle (Mac) next to a drive or folder? Click it to display the contents of that storage bin. A minus sign (Windows) or a down-pointing triangle (Mac) means that the drive or folder is open; click that minus sign or triangle to close the drive or folder.
- ✓ Create a new folder. First, click the drive or folder where you want to house the new folder. For example, if you want to create it inside your Pictures or My Pictures folder, click it. Icons representing all the folders and files currently found within that folder then appear in the thumbnail area.

Next, choose File⇔New Folder. An icon representing the new folder should then appear, with the name box activated. Type the folder name and press Enter.

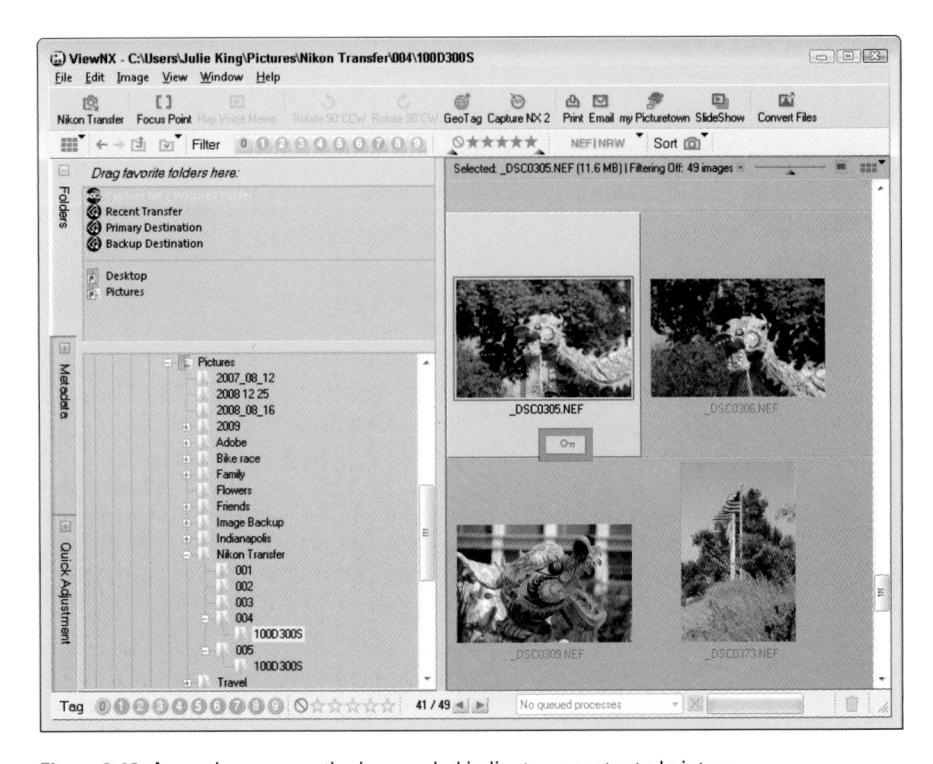

Figure 8-12: As on the camera, the key symbol indicates a protected picture.

- ✓ Move a file from one folder to another. First, display that file's thumbnail in the browser. Then drag the thumbnail to the destination folder in the Folder pane.
- Delete a file. In Windows, click the thumbnail and then choose Edit Delete or press the Delete key. On a Mac, choose Edit Move to Trash or press ℜ+Delete. You then see a message asking you to confirm that you really want to trash the file. Click Yes to move forward.
- ✓ Protect or unlock photos. If you used the Protect feature on your camera to "lock" a file, a process you can explore in Chapter 4, you need to remove the protection if you want to edit the image in your photo software. To do so, choose File Protect Files Unprotect.
 - You also can protect files in ViewNX; just choose Protect from the File Protect Files submenu. A little key icon then appears on the thumbnail to remind you that the file is now protected from editing or erasing, as shown in Figure 8-12. If you later want to delete the file, you must first unprotect it.
- ✓ Select multiple files for moving, deleting, or other actions. Click the thumbnail of the first image and then Ctrl+click (Windows) or ૠ+click (Mac) the rest. To select all images in the current folder, press Ctrl+A (Windows) or ૠ+A (Mac.)
Processing RAW (NEF) Files

When you shoot in the RAW (NEF) format, introduced in Chapter 3, you must process and convert your picture files to a standard file format before you can share them online or print them from most programs other than Nikon ViewNX. You also can't get prints from RAW files at most retail outlets or open the files in many photo editing programs.

To process your D300s NEF files, you have a couple of options:

- ✓ **Use the in-camera processing feature.** Through the Retouch menu, you can process your RAW images right in the camera. You can specify only limited image attributes (color, sharpness, and so on), and you can save the processed files only in the JPEG format, but still, having this option is a nice feature. See the next section for details.
- ✓ Process and convert in ViewNX. ViewNX also offers a RAW processing feature. Again, the controls for setting picture characteristics are a little limited, but you can save the adjusted files in either the JPEG or TIFF format. The last section of this chapter walks you through this option.
- ✓ **Use Nikon Capture NX 2 or a third-party RAW conversion tool.** For the most control over your RAW images, you need to open up your wallet and invest in a program that offers a truly capable converter. Nikon offers such a program, called Nikon Capture NX 2, which as of this writing sells for about \$180. Figure 8-13 gives you a look at the Capture NX 2 RAW converter window.

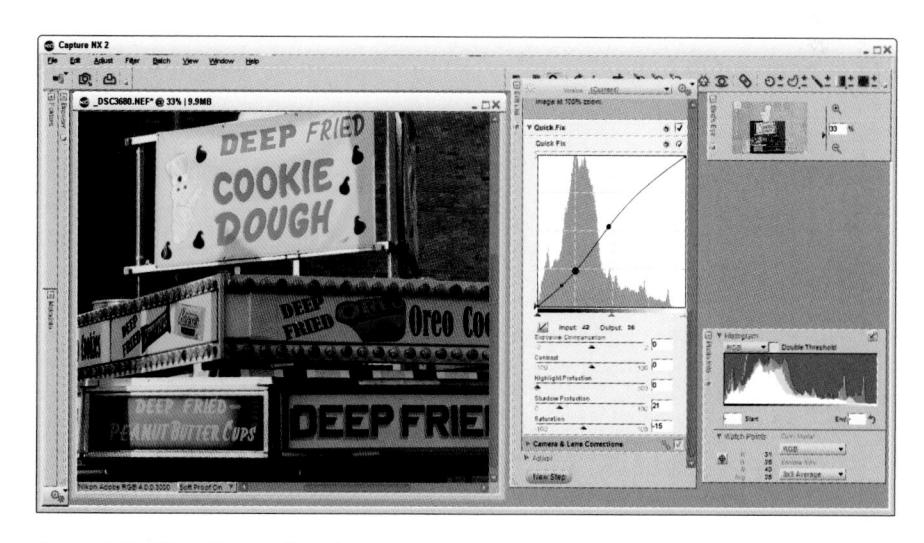

Figure 8-13: Nikon Capture NX 2 is one option for gaining more control over your RAW conversions.

Another (and less costly option) that I frequently recommend is Adobe Photoshop Elements, which sells for about \$90 (www.adobe.com). It includes the Adobe Camera Raw converter, known in the industry as ACR, which is widely considered one of the best available. (*Note:* The converter in Elements doesn't offer all the bells and whistles of the version of ACR provided with Photoshop, however.) In addition, Elements is designed for the novice photo editing enthusiast, so it includes lots of helpful onscreen guides, whereas Capture NX 2 is geared more to the advanced digital photographer.

If you do opt for a third-party conversion tool, check the program's Help system for details on how to use the various controls, which vary from program to program.

Processing RAW images in the camera

Through the NEF (RAW) Processing option on the Retouch menu, you can process RAW files right in the camera — no computer or other software required. This feature is a great convenience, but I want to share a couple of reservations:

First, you can save your processed files only in the JPEG format. As discussed in Chapter 3, that format results in some quality loss because of the file compression that JPEG applies. You can choose the level of JPEG compression you want to apply during RAW processing; you can create a JPEG Fine, Normal, or Basic file. Each of those settings produces the same quality that you get when you shoot new photos in the JPEG format and select Fine, Normal, or Basic from the Image Quality menu.

Chapter 3 details the JPEG options, but, long story short, choose Fine for the best JPEG quality. And if you want to produce the absolute best quality from your RAW images, use a software solution and save your processed file in the TIFF format instead.

You can make adjustments to exposure, color, and a few other options as part of the in-camera RAW conversion process. Evaluating the effects of your adjustments on the camera monitor can be difficult because of the size of the display compared to your computer monitor. So for really tricky images, you may want to forgo in-camera conversion and do the job on your computer, where you can get a better — and bigger — view of things. If you do go the in-camera route, make sure that the monitor brightness is set to its default position so that you aren't misled by the display. (Chapter 1 shows you how to adjust monitor brightness.)

With those preliminaries out of the way, follow these steps to convert a RAW file:

- 1. Press the Playback button to switch to playback mode.
- 2. Display the picture you want to process in the single-image (full-frame) view.

If necessary, you can shift from thumbnails view to single-image view by just pressing the OK button. Chapter 4 has more playback details.

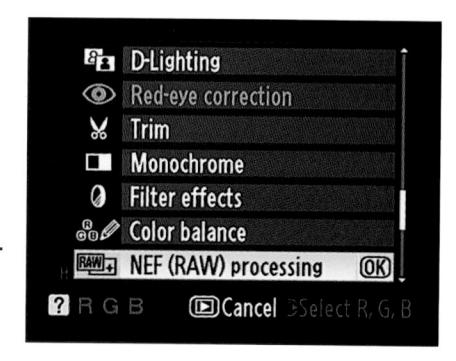

Figure 8-14: In single-image playback mode, press OK to display the Retouch menu over your photo.

3. Press the OK button.

The Retouch menu then appears atop your photo, as shown in Figure 8-14.

4. Choose NEF (RAW) Processing and press OK to display your processing options, as shown in Figure 8-15.

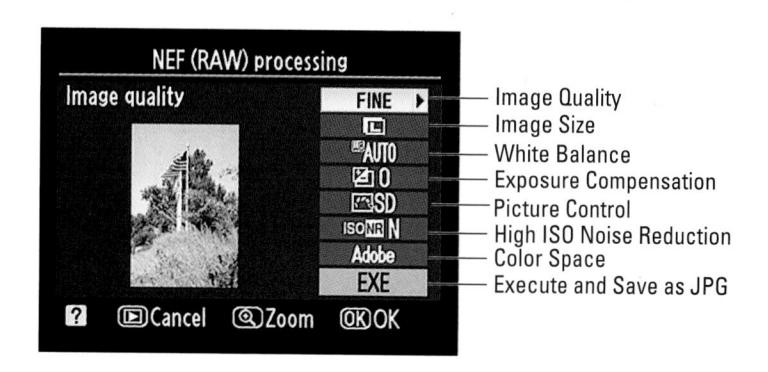

Figure 8-15: Specify the conversion settings here.

This screen is command central for specifying what settings you want the camera to use when creating the JPEG version of your RAW image.

5. Set the conversion options.

Along the right side of the screen, you see a vertical column offering seven conversion options, which I labeled in Figure 8-15. To establish the setting for an option, use the Multi Selector to highlight it and then press the Multi Selector right. You then see the available settings for the option. Use the Multi Selector to highlight the setting you want to use and press OK to return to the main RAW conversion screen.

Rather than detailing all the options here, the following list points you to the chapter where you can explore the settings available for each:

- Image Quality: See the Chapter 3 section related to the JPEG quality settings for details on this option.
- Image Size: The first part of Chapter 3 explains this one.
- White Balance: Check out Chapter 6 for details about White Balance options. After you select your main White Balance setting (Cloudy, Auto, and so on), you can press the Multi Selector right to fine-tune colors.
- Exposure Compensation: With this option, you can adjust image brightness by applying Exposure Compensation, a feature that I cover in Chapter 5.
- Picture Control: This option enables you to adjust color, contrast, and image sharpness. For a review of the available settings, see the last part of Chapter 6. As with White Balance, press the Multi Selector right after choosing a Picture Control to tweak its results. You can adjust sharpening, contrast, brightness, saturation, and hue.
- High ISO Noise Reduction: This filter attempts to soften the appearance of noise that occurs when you use a very high ISO Sensitivity setting. Chapter 5 covers this filter as well as its companion, Long Exposure Noise Reduction.
- Color Space: See Chapter 6 for details on this option, which enables you to select one of two color spectrums, Adobe RGB or sRGB.
- 6. When you finish setting all the conversion options, highlight EXE on the main conversion screen. (Refer to Figure 8-15.) Then press OK.

The camera records a JPEG copy of your RAW file and displays the copy in the monitor.

Note that the filename of your JPEG copy doesn't use the same numbering as the RAW original — the camera gives the file a new number that depends on the numbers of the existing JPEG files on your memory card.

Processing RAW files in ViewNX

In ViewNX, you can convert your RAW files to either the JPEG format or, for top picture quality, to the TIFF format. (See Chapter 3 if you're unsure about the whole concept of file format and how it relates to picture quality.)

Although the ViewNX converter isn't as full-featured as the ones in Nikon Capture NX 2, Adobe Photoshop, and some other photo editing programs, it does enable you to make some adjustments to your RAW images. Follow these steps to try it out.

1. Click the thumbnail of the NEF (RAW) image to select it.

You may want to set the program to Image Viewer mode, as shown in Figure 8-16, so that you can see a larger preview of your image. Just choose View⇔Image Viewer to switch to this display mode.

2. Display the Quick Adjustment tab by clicking its tab on the left side of the program window.

I labeled the tab in Figure 8-16. The tab provides access to a few controls for fine-tuning your image. You can adjust exposure compensation, white balance, and assign a Picture Control, for example. Each time you adjust a setting, the preview updates to show you the results.

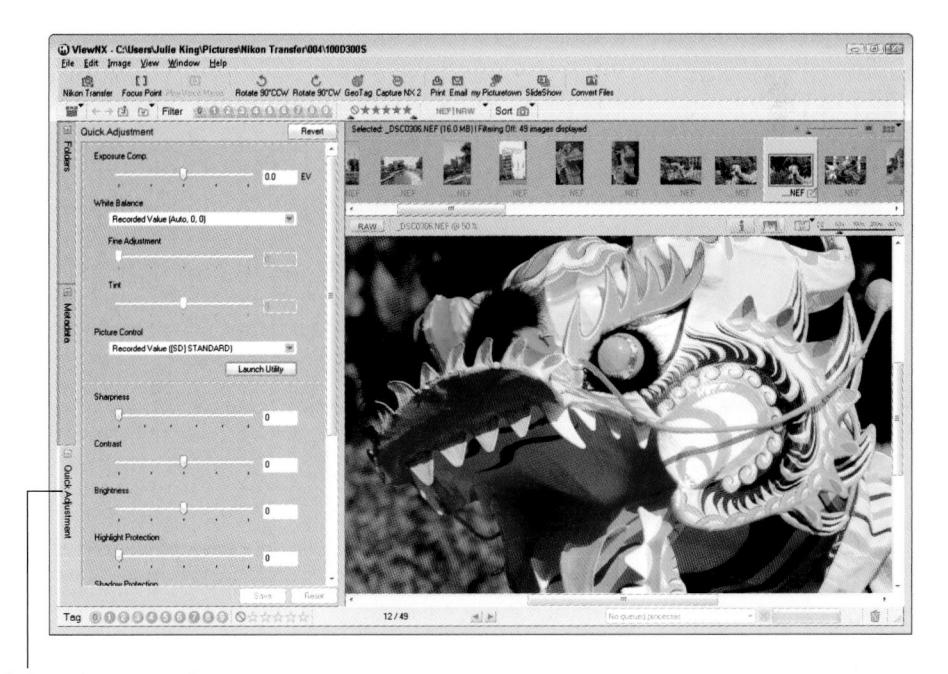

Quick Adjustment tab

Figure 8-16: Display the Quick Adjustment tab to tweak RAW images before conversion.

A couple of options may require some explanation:

- Launch Utility button: This button, located under the Picture Control option, opens the Picture Control Utility, where you can define your own Picture Controls. I don't get into this advanced function in this book, but if you're curious, open the utility and then click the Help button at the bottom of the window.
- Highlight Protection/Shadow Protection/D-Lighting HS: Try using these options to recover hidden shadow and highlight detail.

- *Color Booster:* This slider (at the bottom of the panel, not visible in Figure 8-16) enables you to increase saturation. But if you select the People button under the slider, skin tones are left alone. Choose Nature to adjust the saturation of all colors in the photo.
- Axial Color Aberration: Due to an optical phenomenon that's too complex to fully explore here, some lenses can produce a defect known as axial color aberration or, in some circles, color fringing. This defect results in weird color halos along the edges of an object, typically on the side away from the center of the photo. To check your photo, zoom the display to a magnification of 200 percent or greater the halos usually aren't visible when the display size is small and pay special attention to the corners of the photo, where the problem tends to be greatest. If you spot haloing, check the Auto box for the Axial Color Aberration setting and let the program try to apply the proper correction. You then can drag the slider to tweak the strength of the correction, if needed. (The program may need a few seconds to update the preview after each change, so be patient.)

If you want more details about these or any other of the options, choose Help⇔ViewNX Help to open the Help system, and then display the Help pages related to the Quick Adjustment tab.

3. Click the Save button at the bottom of the Quick Adjustment area.

Or to revert to the original adjustment settings, click Reset.

4. To save the processed file, choose File⇔Convert Files.

Or just click the Convert Files button on the toolbar at the top of the program window. Either way, you see the Convert Files dialog box, shown in Figure 8-17.

5. Select TIFF (8 Bit) from the File Format drop-down list.

You also can opt for TIFF (16 Bit) or JPEG, but I don't recommend it. TIFF (16 Bit) can cause problems when you try to open the file in certain photo editing and organizing programs. (Most pro-level programs, such as Photoshop, do support 16-bit files, however.) And saving in the JPEG format applies *lossy compression*, thereby sacrificing some image quality. If you need a JPEG copy of your processed RAW image for online sharing, you can easily create one from your TIFF version by following the steps laid out in Chapter 9.

6. Deselect the Use LZW Compression option, as shown in the figure.

Although LZW Compression reduces the file size somewhat and does not cause any quality loss, some programs can't open files that were saved with this option enabled. So turn it off.

7. Deselect the Change the Image Size check box.

This step ensures that you retain all the original pixels in your image, which gives you the most flexibility in terms of generating quality prints at large sizes. For details on this issue, check out Chapter 3.

Convert Files					W 712717451		23
File Format: TIFF(8 Bit) ▼							
Original Image Size: 4288 x 2848 pixels							
Use LZW Compression							
Change the image size							
Long	Edge:	640	pixels	П			
Short	Edge:	425	pixels	┙			
Remove camera setting information	1						
Remove XMP/IPTC information							
Remove ICC color profile							
Save in							
The same folder as the original image	ige						
Specified Folder	-						
C:\Users\Julie King\Pictures					[Browse	
Create a new subfolder for each file	convers	sion			Namir	ng Options	
Change file names					Namir	ng Options	
Total Number of Files: 1	Conve	rt	1	0.000	Cancel	55,55,955,5	

Figure 8-17: You can specify where you want to store the processed file.

8. Deselect each of the three Remove check boxes.

If you select the check boxes, you strip image metadata — the extra text data that's stored by the camera — from the file. Unless you have some specific reason to do so, clear all three check boxes so that you can continue to access the metadata when you view your processed image in programs that know how to display metadata.

The first two check boxes relate to data that you can view on the Metadata tab in ViewNX; earlier sections of this chapter give you the low-down. The ICC profile item refers to the image *color space*, which is either sRGB or Adobe RGB on your D300s. Chapter 6 explains the difference.

9. Select a storage location for the processed TIFF file.

You do this in the Save In area of the dialog box, highlighted in Figure 8-17. Select the top option to save your processed file in the same folder as the original RAW file. Or, to put the file in a different folder, click the Specified Folder button. The name of the currently selected alternative folder appears below the button, as shown in Figure 8-17. You can change the storage destination by clicking the Browse button (on the right side of the dialog box) and then selecting the drive and folder where you want to put the file.

By selecting the Create a New Subfolder for Each File Conversion check box, you can put your TIFF file into a separate folder within the destination folder. If you select the box, click the Naming Options button and then specify how you want to name the subfolder.

Specify whether you want to give the processed TIFF a different filename from the original RAW image.

To do so, select the Change File Names check box and then click the Naming Options button and enter the name you want to use. If you don't change the filename, ViewNX gives the file the same name as the original RAW file.

11. Click the Convert button.

A window appears to show you the progress of the conversion process. When the window disappears, your TIFF image appears in the storage location you selected in Step 10.

One neat thing about working with RAW images is that you can easily create as many variations of your photo as you want. For example, you might choose one set of options when processing your RAW file the first time, and then use an entirely different set to create another version of the photo. You could create one image in full color, perhaps, and then open the RAW file again — and this time select the Monochrome Picture Control to create a black-and-white version of the image.

Copying Pictures Between Memory Cards

In addition to being able to process RAW files right in the camera, you can perform another neat file-management trick without downloading to a computer: When you have two memory cards installed, you can copy pictures from one card to the other. Follow these steps:

1. On the Playback menu, choose Copy Images, as shown on the left in Figure 8-18, and press OK.

You see the right screen in the figure.

2. Highlight Select Source and press OK.

You see a screen listing both memory cards (CF and SD).

3. Highlight the memory card that contains the pictures you want to copy and press OK.

You're returned to the main Copy Images screen.

4. Highlight Select Images, as shown on the left in Figure 8-19, and press OK.

You then see a screen listing all folders on the selected card, as shown on the right in Figure 8-19. If you haven't created any custom folders, a topic covered in Chapter 10, you see just one folder, as in the figure.

Figure 8-18: You can copy cards from one installed memory card to another.

Figure 8-19: Select the folder that contains the pictures you want to copy.

5. Highlight the folder that contains your pictures and press OK.

The camera now displays the screen shown on the left in Figure 8-20.

6. Choose an initial picture-selection option.

Two of the options are pretty clear-cut: Choose Select All Images if you want to copy every picture on the card; choose Select Protected Images to copy just photos that you tagged with the Protect feature, covered in Chapter 4.

Figure 8-20: Press the Multi Selector center button to add or remove the checkmark that tags a picture for copying.

The third option, Deselect All, is a little counterintuitive. Here's the deal: The camera initially assumes that you want to copy every picture on the card, so it tries to help by automatically preselecting all of them in the background. You can later deselect the ones you don't want to copy, but if you're copying just a few pictures out of a large group, it's faster to choose Deselect All so that you start out with no pictures selected. Then you don't have to waste time "untagging" all the ones you don't want to copy.

7. Press OK to display thumbnails of your photos, as shown on the right in Figure 8-20.

Checkmarks appear with any photos currently selected for copying, as shown in the figure.

8. Press the center button of the Multi Selector to add or remove a photo from the selection.

Pressing the button toggles the checkmark on and off.

9. After selecting the photos you want to copy, press OK.

You're returned to the main Copy Images screen once more.

10. Choose Select Destination Folder and press OK.

You see a screen offering two options: The first, Select Folder by Number, enables you to specify a three-digit folder number. (Press the Multi Selector left or right to highlight a value and press up or down to change the number.) The second option, Select Folder from List, displays all available folders. After choosing a folder number or folder, press OK.

- 11. Choose Copy Image(s)? and press OK.
- 12. Highlight Yes and press OK to copy the photos.

Printing and Sharing Your Pictures

In This Chapter

- Setting the stage for great prints
- Preparing a picture for the Web
- Creating a slide show
- Viewing images on a TV

hen my first digital photography book was published, way back in the 1990s, consumer digital cameras didn't offer the resolution needed to produce good prints at anything more than postage-stamp size — and even then, the operative word was "good," not "great." And if you did want a print, it was pretty much a do-it-yourself proposition unless you paid sky-high prices at a professional imaging lab. In those days, retail photo labs didn't offer digital printing, and online printing services hadn't arrived yet, either.

Well, time and technology march on, and, at least in the case of digital photo printing, to a very good outcome. Your D300s can produce dynamic prints even at large sizes, and getting those prints made is easy and economical, thanks to an abundance of digital printing services now in stores and online.

That said, getting the best output from your camera still requires a little bit of knowledge and prep work on your part. To that end, this chapter tells you exactly how to ensure that your picture files will look as good on paper as they do in your camera monitor.

In addition, this chapter explores ways to share your pictures electronically. First, I show you how to prepare your picture for e-mail — an important step if you don't want to annoy friends and family by cluttering their inboxes with ginormous, too-large-to-view photos. Following that, you can find out how to create digital slide shows and view your pictures on a television.

Preventing Potential Printing Problems

Boy, I love a good alliteration, don't you? Oh, just me, then. Anyway, as I say in the introduction to this chapter, a few issues can cause hiccups in the printing process. So before you print your photos, whether you want to do it on your own printer or send them to a retail lab, read through the next three sections, which show you how to avoid the most common trouble spots.

For times when you do want to print your photos on your own printer, you can do so through Nikon ViewNX. However, I find the ViewNX printing options both more complex and more limited than those in other programs, which is why I opted not to cover them in this book. I suggest that you instead print from whatever photo editing program you use or from the software provided by your printer manufacturer.

Match resolution to print size

Resolution, or the number of pixels in your digital image, plays a huge role in how large you can print your photos and still maintain good picture quality. You can get the complete story on resolution in Chapter 3, but here's a quick recap as it relates to printing:

- On the D300s, you set picture resolution (Large, Medium, or Small) via the Image Size option. (Again, see Chapter 3 for specifics.) You must select this option *before* you capture an image, which means that you need some idea of your ultimate print size before you shoot. And if you crop your image, you eliminate some pixels, so take that factor into account when you do the resolution math.
- For good print quality, the *minimum* pixel count (in my experience, anyway) is 200 pixels per linear inch, or 200 ppi. That means that if you want a 4-x-6-inch print, you need at least 800 x 1200 pixels.
- Depending on your printer, you may get even better results at 200+ ppi. Some printers do their best work when fed 300 ppi, and a few (notably, some from Epson) request 360 ppi as the optimum resolution. However, going higher than that typically doesn't produce any better prints.
 - Unfortunately, because most printer manuals don't bother to tell you what image resolution produces the best results, finding the right resolution is a matter of experimentation. (Don't confuse the manual's statements related to the printer's *dpi* with *ppi*. DPI refers to how many dots of color the printer can lay down per inch; many printers use multiple dots to reproduce one image pixel.)

So what do you do if you find that you don't have enough pixels for the print size you have in mind? You just have to decide what's more important, print size or print quality.

If your print size does exceed your pixel supply, one of two things happens:

- ✓ The pixel count remains constant, and pixels simply grow in size to fill
 the requested print size. And if pixels get too large, you get a defect
 known as pixelation. The picture starts to appear jagged, or stairstepped, along curved or digital lines. Or at worst, your eye can actually
 make out the individual pixels, and your photo begins to look more like
 a mosaic than, well, a photograph.
- The pixel size remains constant, and the printer software adds pixels to fill in the gaps. You can also add pixels, or *resample the image*, in your photo software. Wherever it's done, resampling doesn't solve the low resolution problem. You're asking the software to make up photo information out of thin air, and the result is usually an image that looks worse than it did before resampling. You don't get pixelation, but details turn muddy, giving the image a blurry, poorly rendered appearance.

Just to hammer home the point and remind you one more time of the impact of resolution picture quality, Figures 9-1 through 9-3 show you the same image as it appears at 300 ppi (the resolution required by the publisher of this book), at 50 ppi, and resampled from 50 ppi to 300 ppi. As you can see, there's just no way around the rule: If you want the best quality prints, you need the right pixel count.

300 ppi

Figure 9-1: A high-quality print depends on a high-resolution original.

50 ppi

Figure 9-2: At 50 ppi, the image has a jagged, pixelated look.

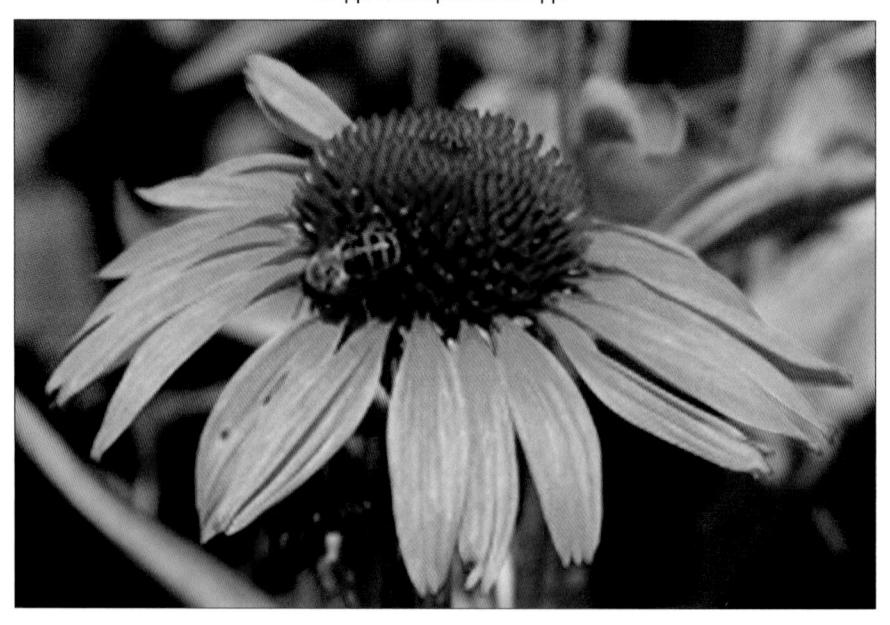

Figure 9-3: Adding pixels in a photo editor doesn't rescue a low-resolution original.

Allow for different print proportions

Unlike many digital cameras, your D300s produces photos that have an aspect ratio of 3:2. That is, pictures are 3 units wide by 2 units tall — just like a 35mm film negative — which means that they translate perfectly to the standard 4-x-6-inch print size. (Most digital cameras produce 4:3 images, which must be cropped to fit a 4-x-6-inch piece of paper.)

If you want to print your digital original at other standard sizes — 5×7 , 8×10 , 11×14 , and so on — you need to crop the photo to match those proportions. Alternatively, you can reduce the photo size slightly and leave an empty margin along the edges of the print as needed.

As a point of reference, Figure 9-4 shows you a 3:2 original image. The outlines indicate how much of the original can fit within a 5-x-7-inch frame and an 8-x-10-inch frame.

Figure 9-4: Composing your shots with a little head room enables you to crop to different frame sizes.

Your camera's Trim feature, found on the Retouch menu, enables you to crop your photo, but only to five different aspect ratios (3:2, 4:3, 5:4, 1:1, and 16:9). See Chapter 11 for information. For other proportions, most photo editing programs offer very simple cropping tools. You also can usually crop your photo using the software provided at online printing sites and at retail print kiosks. But if you plan to drop off your memory card of original pictures at a lab, be aware that your pictures will be cropped if you select a print size other than 4×6 .

To allow yourself printing flexibility, leave at least a little margin of background around your subject when you shoot, as shown in Figure 9-4. Then you don't clip off the edges of the subject no matter what print size you choose. (Some people refer to this margin padding as *head room*, especially when describing portrait composition.)

Get print and monitor colors in synch

Your photo colors look perfect on your computer monitor. But when you print the picture, the image is too red, or too green, or has some other nasty color tint. This problem, which is probably the most prevalent printing issue, can occur because of any or all of the following factors:

Your monitor needs to be calibrated. When print colors don't match what you see on your computer monitor, the most likely culprit is actually the monitor, not the printer. If the monitor isn't accurately calibrated, the colors it displays aren't a true reflection of your image colors.

To ensure that your monitor is displaying photos on a neutral canvas, you can start with a software-based calibration utility, which is just a small program that guides you through the process of adjusting your monitor. The program displays various color swatches and other graphics and then asks you to provide feedback about what you see on the screen. Most calibration tools also help you analyze and adjust monitor brightness — a critical step if you want to be able to accurately gauge image exposure when you view your photos. (Newer monitors tend to be set to very high brightness levels by default, which is great for viewing Web pages and movies but can be misleading for photography work.)

If you use a Mac, the operating system offers a built-in calibration utility, called the Display Calibrator Assistant; Figure 9-5 shows the welcome screen that appears when you run the program. (To access it, open the System Preferences dialog box, click the Displays icon, click the Color button, and then click the Calibrate button.) The latest incarnation of the Windows operating system, Windows 7, has a similar tool called Display Color Calibration. You also can find free calibration software for both Mac and Windows systems online; just enter the term *free monitor calibration software* into your favorite search engine.

Figure 9-5: Mac users can take advantage of this built-in calibration tool.

Software-based calibration isn't ideal, however, because our eyes aren't that reliable in judging color accuracy. For a more accurate calibration, you may want to invest in a device known as a *colorimeter*, which you attach to or hang on your monitor, to accurately measure and calibrate your display. Companies such as Datacolor (www.datacolor.com), Pantone (www.pantone.com), and X-Rite (www.xrite.com) sell this type of product along with other tools for ensuring better color matching.

Whichever route you go, the calibration process produces a monitor *profile*, which is simply a data file that tells your computer how to adjust the display to compensate for any monitor color casts. Your Windows or Mac operating system loads this file automatically when you start your computer. Your only responsibility is to perform the calibration every month or so, because monitor colors drift over time.

✓ One of your printer cartridges is empty or clogged. If your prints look great one day but are way off the next, the number-one suspect is an empty ink cartridge or a clogged print nozzle or head. Check your manual to find out how to perform the necessary maintenance to keep the nozzles or print heads in good shape.

If black-and-white prints have a color tint, a logical assumption is that your black ink cartridge is to blame, if your printer has one. But the truth is that a printer that doesn't use multiple black or gray cartridges will always have a slight color tint. Why? Because in order to create gray, the printer instead has to mix yellow, magenta, and cyan in perfectly equal amounts, and that's a difficult feat for the typical inkjet

printer to pull off. If your black-and-white prints have a strong color tint, however, it could be that one of your color cartridges is empty, and replacing it may help somewhat. Long story short: Unless you have a printer that's marketed for producing good black-and-white prints, you'll probably save yourself some grief by simply having your black-and-whites printed at a retail lab.

When you buy replacement ink, by the way, keep in mind that third-party brands, while they may save you money, may not deliver the performance you get from the cartridges made by your printer manufacturer. A lot of science goes into getting ink formulas to mesh with the printer's ink-delivery system, and the printer manufacturer obviously knows most about that delivery system.

- ✓ You chose the wrong paper setting in your printer software. When you set up your print job, be sure to select the right setting from the paper-type option glossy, matte, and so on. This setting affects how the printer lays down ink on the paper.
- ✓ Your photo paper is low quality. Sad but true: The cheap, store-brand photo papers usually don't render colors as well as the higher-priced, name-brand papers. For best results, try papers from your printer manufacturer; again, those papers are engineered to provide top performance with the printer's specific inks and ink-delivery system.

Some paper manufacturers, especially those that sell fine-art papers, offer downloadable *printer profiles*, which are simply little bits of software that tell your printer how to manage color for the paper. Refer to the manufacturer's Web site for information on how to install and use the profiles. And note that a profile mismatch can also cause incorrect colors in your prints, including the color tint in black-and-white prints I alluded to earlier.

✓ Your printer and photo software are fighting over color-management duties. Some photo programs offer features that enable the user to control how colors are handled as an image passes from camera to monitor to printer. Most printer software also offers color-management features. The problem is, if you enable color-management controls both in your photo software and your printer software, you can create conflicts that lead to wacky colors. So check your photo software and printer manuals to find out what color-management options are available to you and how to turn them on and off.

Even if all the aforementioned issues are resolved, however, don't expect perfect color matching between printer and monitor. Printers simply can't reproduce the entire spectrum of colors that a monitor can display. In addition, monitor colors always appear brighter because they are, after all, generated with light.

Finally, be sure to evaluate your print colors and monitor colors in the same ambient light — daylight, office light, whatever — because that light source has its own influence on the colors you see.

DPOF, PictBridge, and computerless printing

Your D300s offers two technologies, called DPOF (dee-poff) and PictBridge, that enable you to print images directly from your camera or memory card, without using the computer as middle-machine. In order to take advantage of direct printing, your printer must also support one of the two technologies, and you must capture the images in the JPEG file format, which I explain in Chapter 3. (You can also capture the photo in the Raw format and then use your D300s's in-camera conversion tool to make a JPEG copy suitable for direct printing.)

DPOF stands for Digital Print Order Format. With this option, accessed via the Print Set option on your camera's Playback menu, you select the pictures on your memory card that you want to print, and you specify how many copies you want of each image. Then, if your photo printer has a memory card slot (SD or CompactFlash, depending on which type you use with your D300s) and supports DPOF, you just pop the memory card into that slot. The printer reads your "print order" and outputs just the requested copies of your selected images. (You use the printer's own controls to set paper size, print orientation, and other print settings.)

PictBridge works a little differently. If you have a PictBridge-enabled photo printer, you can connect the camera to the printer using the USB

cable supplied with your camera. A PictBridge interface appears on the camera monitor, and you use the camera controls to select the pictures you want to print. With PictBridge, you specify additional print options, such as page size and whether you want to print a border around the photo, from the camera as well.

Both DPOF and PictBridge are especially useful in scenarios where you need fast printing. For example, if you shoot pictures at a party and want to deliver prints to guests before they go home, DPOF offers a quicker option than firing up your computer, downloading pictures, and so on. And if you invest in one of the tiny portable photo printers on the market today, you can easily make prints away from your home or office — you can take both your portable printer and camera along to your regional sales meeting, for example.

For the record, I prefer DPOF to PictBridge because with PictBridge, you have to deal with cabling the printer and camera together. Also, the camera must be turned on for the whole printing process, wasting battery power. But if you're interested in exploring either printing feature, your camera manual provides complete details.

Preparing Pictures for E-Mail

How many times have you received an e-mail message that looks like the one in Figure 9-6? Some well-meaning friend or relative has sent you a digital photo that is so large that it's impossible to view the whole thing on your monitor.

The problem is that computer monitors can display only a limited number of pixels. The exact number depends on the monitor's resolution setting and the capabilities of the computer's video card, but suffice it to say that the average photo from one of today's digital cameras has a pixel count in excess of what the monitor can handle.

Figure 9-6: The attached image has too many pixels to be viewed without scrolling.

In general, a good rule is to limit a photo to no more than 640 pixels at its longest dimension. That ensures that people can view your entire picture without scrolling, as in Figure 9-7. This image measures 640 x 424 pixels. As you can see, it's plenty large enough to provide a decent photo-viewing experience. On a small monitor, it may even be *too* large.

This size recommendation means that even if you shoot at your camera's lowest Image Size setting (2144 x 1424 pixels), you need to dump pixels from your images before sending them to the cyber post office. You have a couple of options for creating an e-mail–sized image:

- ✓ Use the Resize feature on your camera's Retouch menu. This feature enables you to create your e-mail copy right in the camera.
- Downsample the image in your photo editor. *Downsampling* is geekspeak for dumping pixels. Most photo editors offer a feature that handles this process for you. Use this option if you want to crop or otherwise edit the photo before sharing it.

Figure 9-7: Keep e-mail pictures to no larger than 640 pixels wide or tall.

The next two sections walk you through the steps for both methods of creating your e-mail images. You can use the same steps, by the way, for sizing images for any onscreen use, whether it's for a Web page or multimedia presentation. You may want your copies to be larger or smaller than the recommended e-mail size for those uses, however.

One last point about onscreen images: Remember that pixel count has *absolutely no effect* on the quality of pictures displayed onscreen. Pixel count determines only the size at which your images are displayed.

Creating small copies using the camera

To create small, e-mailable JPEG copies of your images without using a computer, take advantage of your camera's Resize feature, found on the Retouch menu.

As with all the Retouch menu options, the camera doesn't destroy your original but instead makes a copy at the smaller size. Resized pictures are created in the JPEG format, but the JPEG quality level that's used depends on your original. For JPEG originals, your resized copy is saved at the same

Image Quality setting as the original (Fine, Normal, or Basic). Copies created from RAW, RAW+JPEG, or TIFF originals are saved at the top JPEG quality setting (Fine).

Step this way to create your small copy:

1. Choose Resize from the Retouch menu, as shown on the left in Figure 9-8.

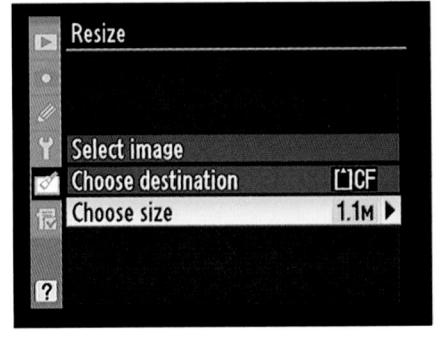

Figure 9-8: The Resize feature creates a low-resolution, e-mail—friendly copy of a photo.

2. Press OK.

You see the screen shown on the right in the figure.

3. If you have two memory cards installed, specify where you want to store the copy.

Make the call through the Choose Destination option. If you have only one card in the camera, you can skip this step.

4. Select Choose Size and press the Multi Selector right.

You see the screen shown in Figure 9-9.

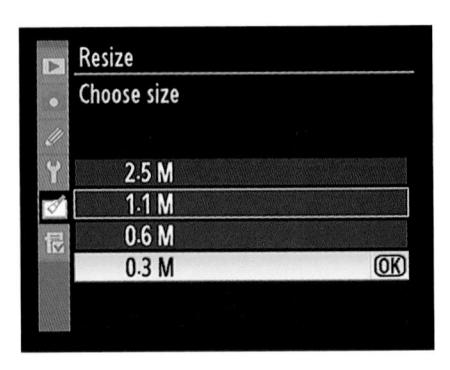

Figure 9-9: The 0.3M setting results in a 640 x 424-pixel copy, which is perfect for e-mail.

5. Select a picture size.

Choices are presented in terms of total resolution, in megapixels. To save you from having to do the math, here are the image *pixel*

dimensions (horizontal and vertical pixel count) you get with each setting:

• 2.5M: 1920 x 1280

• 1.1M: 1280 x 856

• 0.6M: 960 x 640

• 0.3M: 640 X 424

6. Press OK.

7. Choose Select Image, as shown on the left in Figure 9-10, and press the Multi Selector right.

You see thumbnails of all your pictures, as shown on the right in the figure.

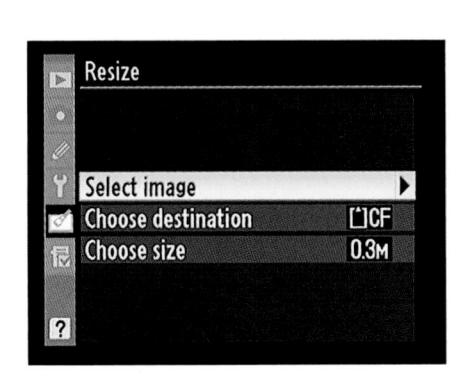

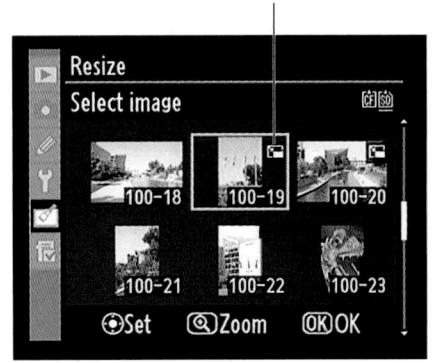

Resize icon

Figure 9-10: Press the Multi Selector center button to mark a photo for resizing.

8. Select a photo and then press the center button of the Multi Selector to tag it for resizing.

The yellow box indicates the selected photo; use the Multi Selector directional buttons to move the box over a photo you want to select. Then press the center button to place the little resize icon in the upperright corner of the thumbnail, as shown in the figure. Press the center button again to remove the tag if you change your mind.

9. After selecting all your pictures, press OK.

You see a screen asking you to confirm that you want to create small copies of the pictures.

10. Highlight Yes and press OK.

The camera creates your resized copy. Note that filenumbers are assigned automatically and don't match that of your original image even if you start with only a RAW or TIFF original.

When you view your resized copies on the monitor, you see the new file size and the Retouch icon, as shown in Figure 9-11. (The placement of the icon and file size depend on the playback display mode; check out Chapter 4 for details on changing the display mode.) Note that you can't zoom in to magnify the view of small-size copies as you can with your original images.

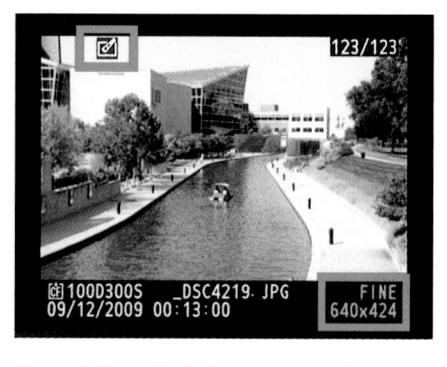

If you want to create a small copy of only one picture, you can set the camera to Playback mode, display the photo in full-size view, and then press OK to jump to the Retouch

Figure 9-11: In single-image playback, you can see the file size of the small copy.

menu. From there, choose the Resize option, select the memory card where you want to store the small copy, select the picture size, and then give the camera the go-ahead to make the copy.

Downsizing images in Nikon ViewNX

You can also create a low-resolution, JPEG copy of your image in ViewNX. However, be aware that the program restricts you to a minimum size of 320 pixels along the photo's longest side. If you need a smaller version, use your photo editing software to do the job.

Assuming that the 320-pixel restriction isn't a problem, the following steps show you how to create your small-size copy in ViewNX. You can use this process to create a small JPEG copy of JPEG, NEF (RAW), and TIFF originals.

1. Select the image thumbnail in the main ViewNX window.

Chapter 8 explains how to view your image thumbnails, if you need help. Just click a thumbnail to select it.

2. Choose File Convert Files.

You see the dialog box shown in Figure 9-12. (As with other figures, this one shows the box as it appears in Windows Vista; it may appear slightly different on a Mac or in other versions of Windows, but the essentials are the same.)

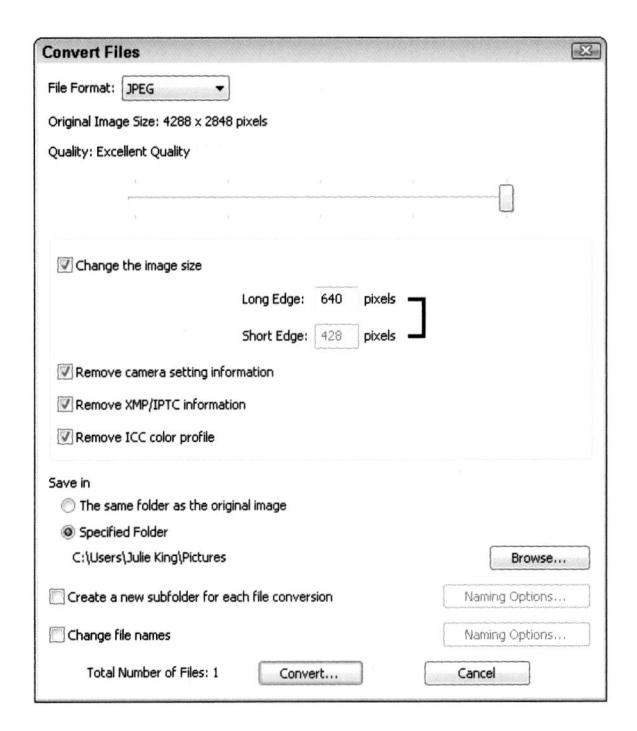

Figure 9-12: You also can use ViewNX to create a small-sized JPEG copy for e-mail sharing.

The other format option, TIFF, is a print format. Web browsers and e-mail programs can't display TIFF images, so be sure to use JPEG.

4. Select the Change the Image Size check box.

Now the Long Edge and Short Edge text boxes become available.

5. Type the desired pixel count of the longest side of your picture into the Long Edge box.

The program automatically adjusts the Short Edge value to keep the resized image proportional.

Again, to ensure that the picture is viewable without scrolling when opened in the recipient's e-mail program, I suggest that you keep the Long Edge value at 640 pixels or less.

6. Adjust the Quality slider to set the amount of JPEG file compression.

As Chapter 3 explains, a greater degree of compression results in a smaller file, which takes less time to download over the Web, but it reduces image quality. Notice that as you move the slider to the right, the resulting quality level appears above the slider. For example, in Figure 9-12, the level is Excellent Quality.

Because the resolution of your image already results in a very small file, you can probably use the highest quality setting without worrying too much about download times. The exception is if you plan to attach multiple pictures to the same e-mail message, in which case you may want to set the slider a notch or two down from the highest quality setting.

7. Select the next three check boxes (Remove Camera Setting Information, Remove XMP/IPTC Information, and Remove ICC Color Profile), as shown in Figure 9-12.

When selected, the three options save the resized picture without the original image metadata, the extra text data that your camera stores with the image. (Chapter 8 explains.) Including this metadata adds to the file size, so for normal e-mail sharing, strip it out. The exception is when you want the recipient to be able to display the metadata in a photo program that can do so.

8. Set the file destination.

In layman's terms, that just means to tell the program the location of the folder or drive where you want to store your downsized image file. You have two Save In options: Choose the first option to put the file in the same folder as the original, or select Specified Folder to put the file somewhere else. If you choose the first option, you're done. If you choose the second option, the last folder you specified is shown to the left of the Browse button. To choose a different folder, click that Browse button.

By selecting the Create a New Subfolder for Each File Conversion check box, you can create a new subfolder within your selected storage folder. If you do, the resized file goes into that subfolder, which you can name by clicking the Naming Options button.

9. (Optional) Specify a filename for the resized copy.

If you want to put the small copy in the same folder as the original, the program protects you from overwriting the original by automatically assigning a slightly different name to the copy. By default, the program uses the original filename plus a two-number sequential tag: If the original filename is DSC_0186.jpg, for example, the small-copy filename is DSC_0186_01.jpg. You can change a couple of aspects of this filenaming routine by selecting the Change File Names check box and then clicking the Naming Options button and adjusting the settings in the resulting dialog box. After making your wishes known, click OK to return to the Convert Files dialog box.

If you *don't* store the copy in the same folder as the original, the program doesn't alter the filename of the copy automatically. That can lead to problems down the road because you will end up with two files, both with the same name but with different pixel counts, on your computer. In this scenario, be sure to input your own filenames for your copies.

10. Click the Convert button to finish the process.

Creating a Digital Slide Show

Many photo editing and cataloging programs offer a tool for creating digital slide shows that can be viewed on a computer or, if copied to a DVD, on a DVD player. You can even add music, captions, graphics, special effects, and the like to jazz up your presentations.

But if you want to create a simple slide show — that is, one that simply displays the photos on the camera memory card one by one — you can create and run the show right on your camera by using the Slide Show function on the Playback menu. And by connecting your camera to a television, as outlined in the last section of this chapter, you can present your show to a whole roomful of people.

A couple of things to note about the Slide Show feature:

- ✓ The pictures displayed in the show depend on the current setting of the Playback Folder option on the Playback menu. For more about choosing which folder (and which memory card, if you're using two at a time) you want to view, see Chapter 4.
- Any pictures that you hid through the Hide Image function, also explained in Chapter 4, do not appear in the show.

With those details out of the way, follow these steps to present a slide show:

- 1. Display the Playback menu and highlight Slide Show, as shown on the left in Figure 9-13.
- 2. Press OK to display the Slide Show screen shown on the right in Figure 9-13.
- 3. Highlight Frame Interval and press the Multi Selector right.

On the next screen, you can specify how long you want each image to be displayed. You can set the interval to 2, 3, 5, or 10 seconds.

4. Highlight the frame interval you want to use and press OK.

You're returned to the Slide Show screen.

5. To start the show, highlight Start and press OK.

The camera begins displaying your pictures on the camera monitor.

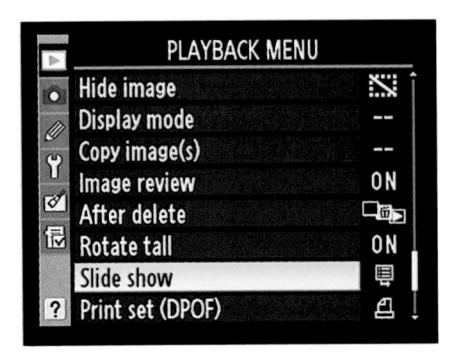

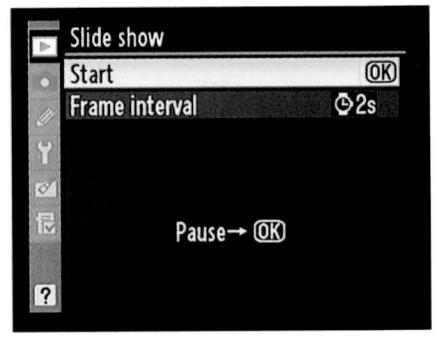

Figure 9-13: Choose Slide Show to set up automatic playback of all pictures on your memory card.

When the show ends, you see a screen offering three options: You can choose to restart the show, adjust the frame interval, or exit to the Playback menu. Highlight your choice and press OK.

During the show, you can control playback as follows:

- ▶ Pause the show. Press OK. Select Restart and press OK to begin displaying pictures again. When you pause the slide show, you also have the option to change the interval a handy option if the pace is too quick or slow or exit the show. To change the frame interval, highlight the option and press OK. Choose the desired interval from the next screen and press OK. Highlight Restart and press OK to restart the show with the new interval.
- **Exit the show.** You've got three options:
 - To return to full-frame, regular playback, press the Playback button.
 - To return to the Playback menu, press the Menu button.
 - To return to picture-taking mode, press the shutter button halfway.
- Skip to the next/previous image manually. Press the Multi Selector right or left.
- ✓ Change the information displayed with the image. Press the Multi Selector up or down to cycle through the info-display modes. (See Chapter 4 for details on what information is provided in each mode.)

Viewing Your Photos and Movies on a Television

Tired of passing your camera around to show people your pictures or movies on the monitor? Why not display them on a television instead? Your camera is equipped with both an HDMI outlet, or jack, for connecting the camera to a high-definition TV (or other video device), and an AV (audio/visual) jack. for connecting the camera to a regular TV or video device. Both connection points are tucked under the little rubber cover on the left-rear side of the camera and highlighted in Figure 9-13. A cable for making a regular video connection is included in the camera box. (It's the cable that has two plugs at one end, one white and one vellow.) For HDMI connections, you need to purchase a cable. You need something called a *Type C mini-pin* cable

Before connecting your camera, doublecheck the following menu options, both on the Setup menu and shown in Figure 9-15:

- ✓ Video Mode: You get just two options here: NTSC and PAL. Select the video mode that is used by your part of the world. (In the United States, Canada, and Mexico, NTSC is the standard.)
- ✓ HDMI: Unless you have trouble, stick with the Auto setting; the camera then automatically selects the right format for the HD device you're using. You also can select from four different formats, if you feel comfortable doing so.

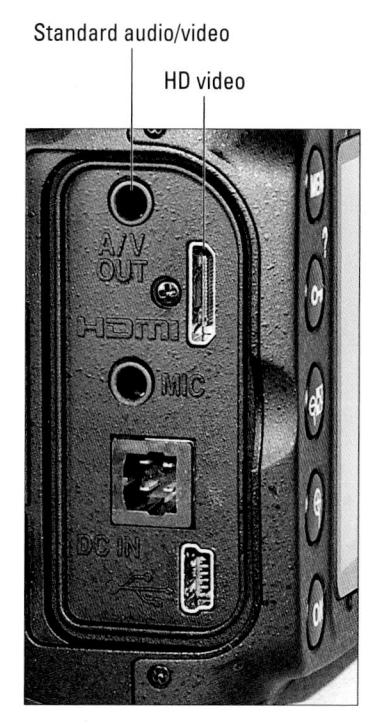

Figure 9-14: You can connect your camera to a television for big-screen playback.

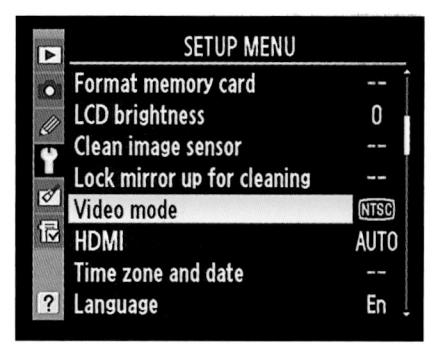

Figure 9-15: The options related to television playback live on the Setup menu.

Whether you go high def or regular def — what the industry now wants us to call *standard definition* — turn the camera off before connecting the devices. Then do the following:

- ✓ Regular A/V: For a regular video connection, plug the black end of the cable into the camera. Then connect the white plug at the other end of the cable into the audio input jack of your video device and the yellow plug into the video input jack. (You can leave the audio plug disconnected for still photos or movies recorded without sound.) During playback, your pictures will appear both on the camera monitor and the TV.
- ✓ HDMI: With HDMI, everything goes through a single connector. After the
 two are linked, you can press the Info button to toggle the monitor display on and off.

When the two devices are connected, turn the camera and TV or video device on. At this point, you need to consult your TV manual to find out what channel to select for playback of signals from auxiliary input devices like your camera. After you sort that issue out, you can control playback using the same camera controls as you normally do to view pictures and movies on your camera monitor. You can also run slide shows by following the steps outlined in the preceding section.

Part IV The Part of Tens

In this part . . .

n time-honored *For Dummies* tradition, this part of the book contains additional tidbits of information presented in the always popular "Top Ten" list format.

Chapter 10 details ten camera-customization options that haven't been covered in earlier chapters, while Chapter 11 introduces you to ten camera functions that I consider specialty tools — bonus options that, while not at the top of the list of the features I suggest you study, are nonetheless interesting to explore when you have a free moment or two.

Ten More Ways to Customize Your Camera

In This Chapter

- Creating and saving custom menu banks
- Adding copyright data and hidden text to picture files
- Using your own folder and filenames
- Changing the behavior of some buttons and dials

ave you ever tried to cook dinner in someone else's house or work from another colleague's desk? Why is *nothing* stored in the right place? The coffee cups, for example, should be stowed in the cabinet above the coffee maker, and yet there they are, way across the kitchen, in the cupboard near the fridge. And everyone knows that the highlighter pens belong in the middle top drawer, not the second one on the left. Yeesh.

In the same way, you may consider a particular aspect of the D300s design illogical or maybe just a tad inconvenient. You may find it more natural to use the command dial on the front of the camera to perform most operations rather than the one on the back, for example — which is the exact opposite of the way things are set up at the factory.

Well, as you've no doubt already deduced, Nikon is more than eager to let you customize almost every aspect of the camera's operation, from limiting the number of autofocus points in use to deciding which picture you want to see next after you delete a photo. In fact, about the only thing you can't customize is the way the battery fits into the battery compartment.

This chapter discusses ten customization options not yet considered in earlier chapters, including ways to embed a copyright notice in your picture files, create custom folder and file names, and even tweak the function of external controls — including the aforementioned command dials.

Creating Custom Menu Banks

After you gain some experience with your camera, you'll probably find that you routinely use certain Shooting menu and Custom Setting menu options for specific types of pictures. For example, you might prefer one set of options when shooting landscapes and another for shooting indoor sports. If you routinely spend a lot of time adjusting options on these menus for different scenes, you may want to investigate a feature called *menu banks*.

Menu banks enable you to store collections of Shooting menu and Custom Setting menu settings. When you want to use the settings in a collection, you don't have to restore each option individually — instead, you just select the bank you want to use, and the camera automatically restores all the saved settings for you.

Here are the banking details you need to know:

- ✓ You can create up to eight banks. You get four Shooting menu banks and four Custom Setting menu banks.
- Banks are assigned the names A, B, C, and D by default. You can create custom names to help you remember what each bank is designed to do, however.
- Initially, all banks use the camera's default settings, and the A banks are selected. To put it another way, you're provided originally with eight identical banks, all containing the default settings.
- ✓ You can select a bank via the menus or the Information screen. To select the Shooting menu bank, highlight Shooting Menu Bank on the Shooting menu, as shown in Figure 10-1, and then press OK to display the second screen in the figure. Highlight the bank you want to use and press OK. To select a Custom Setting bank, use the same process but go through the Custom Setting menu instead.

For a quicker option, press the Info button to display the Information screen, where the currently selected banks appear in the areas highlighted on the left in Figure 10-2. Press Info again to access the control strip, use the Multi Selector to highlight the bank you want to change, as

shown on the right in the figure, and press OK. You're whisked to the same list of banks you get when you go through the menus (the right screen in Figure 10-1).

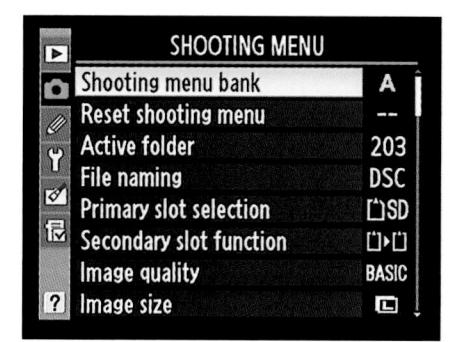

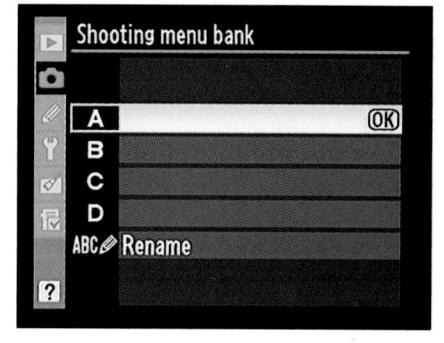

Figure 10-1: You can select the bank you want to use from the first option on the menu.

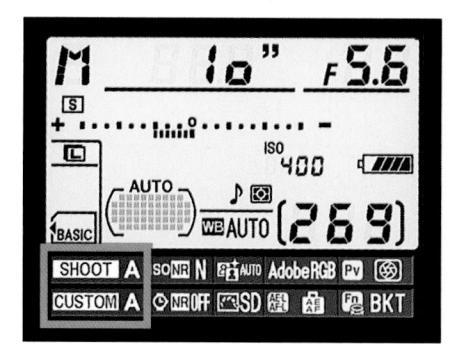

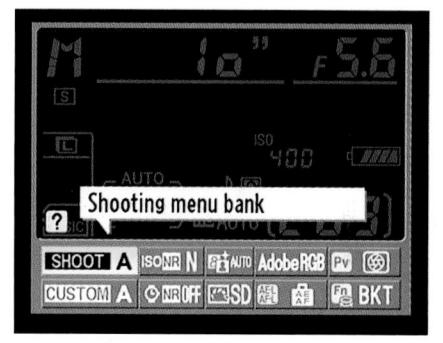

Figure 10-2: You can also switch between banks through the control strip in the Info screen.

✓ If you change a menu setting, it overrides the setting currently stored in the active bank. This behavior creates a problem, obviously, because it's easy to forget that you altered a setting or two when you're in the midst of shooting. And it doesn't take long before you tweak the options enough that the bank no longer really works for the type of scene it was designed to capture.

As a solution, you can use the Save/Load Setting option, introduced in Chapter 1, to save your banks as data files and store them on a memory card. Then whenever you want to get back to your original bank settings, you load the bank files onto the camera.

Use the Rename option to give each bank a custom name. After you get to the right screen in Figure 10-1, choose Rename and press the Multi Selector right to start the naming process. You first see the left screen shown in Figure 10-3. Highlight the bank you want to name and press the Multi Selector right again to display the little keyboard-like screen shown on the right in the figure.

Use these techniques to enter your name, which can be up to 20 characters long:

- To enter a character: Press the Multi Selector right or left to move the highlight over the letter that you want to add and then press the center button to enter the character.
- To move the cursor within the name field: Press and hold the Zoom Out button as you press the Multi Selector right or left.
- To scroll through all the available characters in the keyboard: Press the Multi Selector up and down.
- To delete a character: Move the cursor under the letter you want to zap and press the Delete button.

After you finish entering the bank name, press OK. You're returned to the main Rename screen, where you new name appears. Press OK again to exit to the main menu.

Figure 10-3: You can assign custom names to each bank.

Creating Your Own Menu

In addition to creating custom menu banks, you can build your very own, specialized menu that holds up to 20 of the options you use most frequently. And unlike the menu banks, which can store only options from the Custom

Setting and Shooting menus, your custom menu can contain selections from any menu. Check it out:

1. Display the My Menu menu, as shown on the left in Figure 10-4.

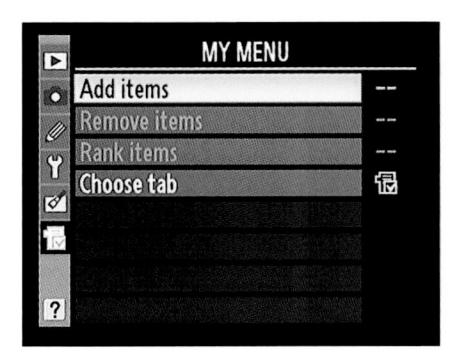

Figure 10-4: You can create a custom menu to hold up to 20 of the settings you access most often.

If the Recent Settings menu appears instead, scroll to the end of the menu, select Choose Tab, press OK, select My Menu, and press OK again. The My Menu screen then appears.

2. Highlight Add Items and press OK.

Now you see a list of the five main camera menus, as shown on the right in Figure 10-4.

3. Highlight a menu that contains an option you want to add to your custom menu and then press the Multi Selector right.

You see a list of all available options on that menu, as shown on the left in Figure 10-5.

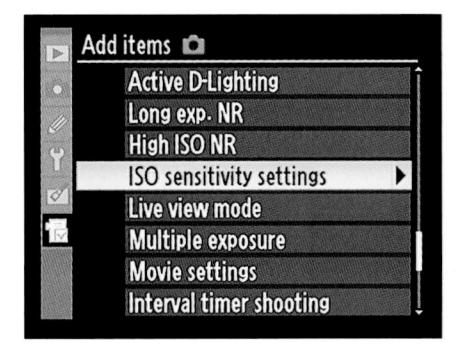

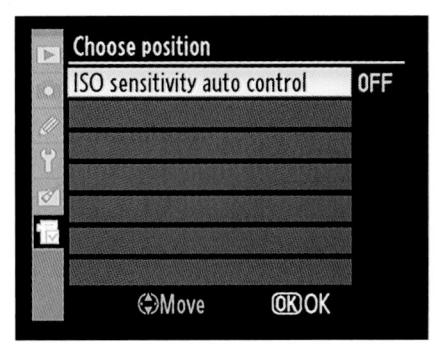

Figure 10-5: Highlight a menu item and press OK to add it to your custom menu.

A few items can't be added to a custom menu. A little box with a slash through it appears next to those items.

4. To add an item to your custom menu, highlight it and press OK.

Now you see the Choose Position screen, shown on the right in Figure 10-5, where you can change the order of your menu items. For now, just press OK to return to the My Menu screen; you can set up the order of your menu items later. (See the list following these steps.) The menu item you just added appears at the top of the My Menu screen.

5. Repeat Steps 2-4 to add more items to your menu.

In Step 3, a check mark appears next to any item that's already on your menu.

After creating your custom menu, you can access it by pressing the Menu button and choosing the Recent Settings/My Menu screen. (If you want to switch to the Recent Settings menu, select Choose Tab and then select Recent Settings.)

You can reorder the menu items and remove items as follows:

Change the order of menu options: Display your custom menu and highlight Rank Items, as shown on the left in Figure 10-6. You then see a screen that lists all your menu items in their current order. Highlight a menu item, as shown on the right in the figure, press OK, and then use the Multi Selector to move it up or down the list. Press OK to lock in the new position of the menu item. When you're happy with the order of the menu items, press the Multi Selector left to return to the My Menu screen.

Figure 10-6: Choose Rank Items to change the order of menu items.

Remove menu items: Again, head for the My Menu screen. Select Remove Items and press OK. You see a list of all the current menu items, with an empty box next to each item. To remove an item, highlight it and press the Multi Selector right. A check mark then appears in that item's box. After tagging all the items you want to remove, highlight Done and press OK. You see a confirmation screen asking permission to remove the item; press OK to go forward.

Adding Text Comments to Your Files

Through the Image Comment feature on the Setup menu, you can add text comments to your picture files. Suppose, for example, that you're traveling on vacation and visiting a different destination every day. You can annotate all the pictures you take on a particular outing with the name of the location or attraction. You can then view the comments either in Nikon ViewNX, which ships free with your camera, or Capture NX2, which you must buy separately. The comments also appear in some other photo programs that enable you to view metadata. Additionally, you can view comments in the Shooting Data display mode during playback.

Here's how the Image Comment feature works:

- 1. Display the Setup menu and highlight Image Comment, as shown on the left in Figure 10-7.
- 2. Press OK to display the right screen in the figure.

Figure 10-7: You can tag pictures with text comments that you can view in Nikon ViewNX.

3. Highlight Input Comment and press the Multi Selector right.

Now you see a keyboard-type screen like the one shown in Figure 10-8.

- 4. Use the Multi Selector to highlight the first letter of the text you want to add.
- 5. Press the center button on the Multi Selector to enter the letter into the display box at the bottom of the screen.
- Keep highlighting and entering letters to complete your comment text.

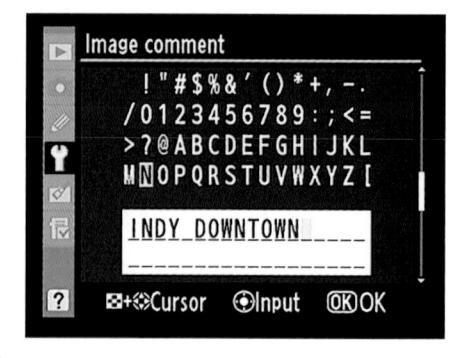

Figure 10-8: Comments can contain as many as 36 characters.

Your comment can be up to 36 characters long. You can use the same text entry tricks as when you rename custom menu banks:

- To move the text cursor: Press and hold the Zoom Out button as you press the Multi Selector in the direction you want to shift the cursor.
- *To delete a letter*: Move the cursor under the offending letter and then press the Delete button.
- 7. To save the comment, press OK.

You're returned to the Image Comment menu.

8. Highlight Attach Comment and press the Multi Selector right to put a check mark in the box.

The check mark turns the Image Comment feature on.

9. Highlight Done and press OK to wrap things up.

You're returned to the Setup menu. The Image Comment menu item should now be set to On.

The camera applies your comment to all pictures you take after turning on Image Comment. To disable the feature, revisit the Image Comment menu, highlight Attach Comment, and press the Multi Selector right to toggle the check mark off. Be sure to highlight Done and press OK to make the change official.

To view comments in Nikon ViewNX, display the Metadata tab and select an image by clicking its thumbnail. The Image Comment text appears in the File Info 2 section of the tab, as shown in Figure 10-9. (If that section is closed, click the little triangle next to *File Info 2.)* The same part of the tab shows embedded copyright information, an option discussed in the next section. Chapter 8 provides more details on using View NX.

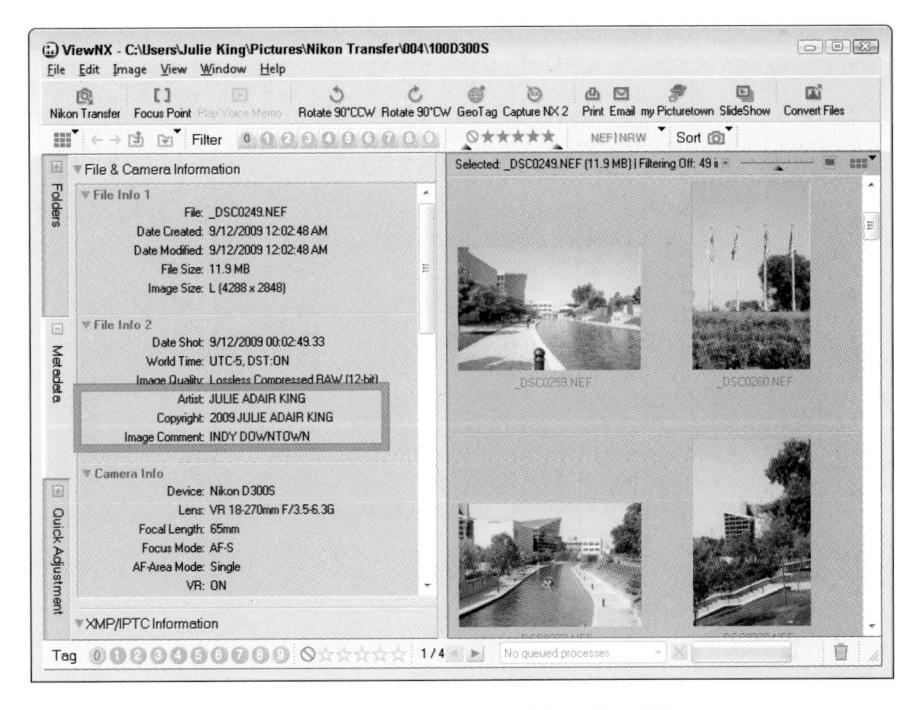

Figure 10-9: Comments appear with other metadata in Nikon ViewNX.

Embedding a Copyright Notice

By using the Copyright Information option on the Setup menu, you can load your personal copyright data into the camera's brain. Then, whenever you shoot a picture, your copyright information is recorded with the image file. As with comments that you add through the Image Comment option, you can view the embedded copyright data during playback, in Shooting Data display mode, and in many photo programs, including Nikon ViewNX, as shown in Figure 10-9.

Including a copyright notice is a reasonable first step to take if you want to prevent people from using your pictures without permission. Anyone who views your picture in a program that can display metadata (the extra data recorded with a digital photo file) will see your copyright notice. Obviously, that won't be enough to completely prevent unauthorized use of your images. And technically speaking, you hold the copyright to your photo whether you take any steps to mark it with your name. But if you ever come to the point of pressing legal action, you can at least show that you did your due diligence in letting people know that you hold the copyright.

To enter your copyright information, take these steps:

1. Display the Setup menu and highlight Copyright Information, as shown on the left in Figure 10-10.

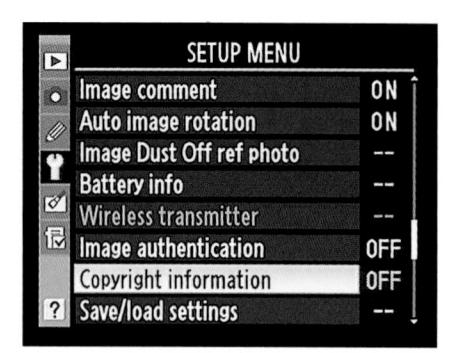

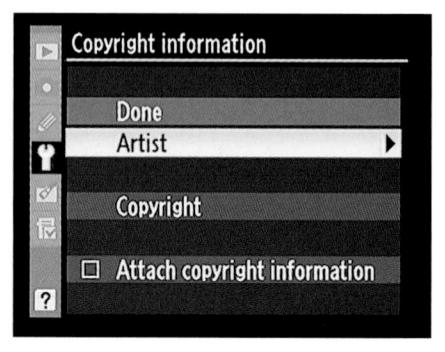

Figure 10-10: Use this feature to embed copyright information into each picture file.

- 2. Press OK to display the second screen shown in Figure 10-10.
- 3. Highlight Artist and press OK to display a text-entry screen.
- 4. Enter your name and then press OK.

The text-entry screen works just as when you add image comments. Use the Multi Selector to highlight a letter and then press the center button to enter that character. You can enter up to 36 characters.

To move the cursor within your text, press and hold the Zoom Out button as you press the Multi Selector in the direction you want to move the cursor.

To delete a character, move the cursor under it and press the Delete button.

5. Highlight Copyright, press OK, and then enter your copyright notice.

This time, you can enter a whopping 54 characters.

6. Press OK to return to the main Copyright Information screen.

The copyright information you entered should now appear on the screen, as shown in Figure 10-11.

Highlight Attach Copyright Information and press the Multi Selector right to place a check mark in the adjacent box, as shown on the left in Figure 10-11.

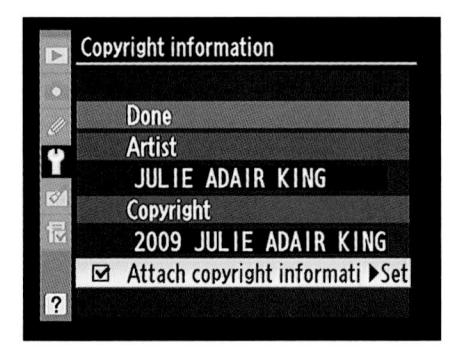

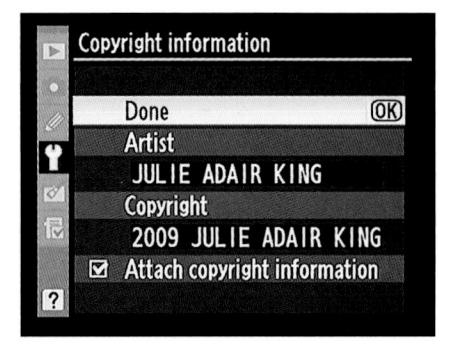

Figure 10-11: Press the Multi Selector right to toggle the Attach setting on and off.

8. Highlight Done, as shown on the right in Figure 10-11, and press OK.

Don't forget this step (as I always seem to do)! Otherwise, none of your changes will "stick" and you'll have to go through the whole process again. After you return to the Setup menu, the Copyright Information item on the Setup menu (left screen in Figure 10-10) should be set to On, indicating that the camera will now include your copyright text as part of the file metadata for all subsequent shots.

To stop adding the copyright data, just revisit the Copyright Information screen, toggle the Attach box off, and then select Done and press OK.

Choosing Your Own File and Folder Names

By default, your camera initially stores all your images in one folder, which it names 100D300S. Folders have a storage limit of 999 images; when you exceed that number, the camera creates a new folder, assigning a name that indicates the folder number — 101D300S, 102D300S, and so on.

If you choose, you can create your own folder-numbering scheme. For example, perhaps you sometimes use your camera for business and sometimes for personal use. To keep your images separate, you can set up one folder numbered 200D300S for work images and use the regular 100D300S folder for personal photos.

What's more, you can customize the first three letters of your picture filenames. Normally, filenames begin either with the characters DSC_, for photos captured in the sRGB color space, or _DSC, for images that use the Adobe RGB color space. (Chapter 6 explains color spaces.) So, for example, you could set the camera to replace DSC with TIM if you're taking pictures of your brother Tim's family and then change the characters to SUE when you move to cousin Sue's house.

The following steps show you how to create custom folders and filenames:

1. To create custom folders, display the Shooting menu and highlight Active Folder, as shown on the left in Figure 10-12.

Figure 10-12: You can create custom folders to organize your images right on the camera.

- 2. Press OK to display the screen shown on the right in Figure 10-12.
- 3. Highlight New Folder Number and press the Multi Selector right.

You see a screen like the one shown on the left in Figure 10-13.

4. Use the Multi Selector to set the new folder number.

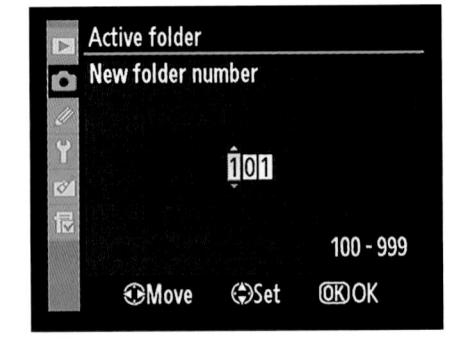

Figure 10-13: Highlight a number and press digit you want to change; press up the Multi Selector up or down to change it.

Press right or left to highlight the or down to adjust the value.

If a folder bearing the number you enter already exists, a little file-folder icon appears next to the number. An empty folder icon means that no pictures are currently stored in the folder; a half-full icon means that some pictures exist but more will fit; and the full icon means that the folder is stuffed to the max, and thus you can't store any more pictures in it.

5. Press OK to complete the process and return to the Shooting menu.

The folder you just created is automatically selected as the active folder.

6. To customize the first three characters of picture filenames, highlight File Naming, as shown on the left in Figure 10-14, and press OK.

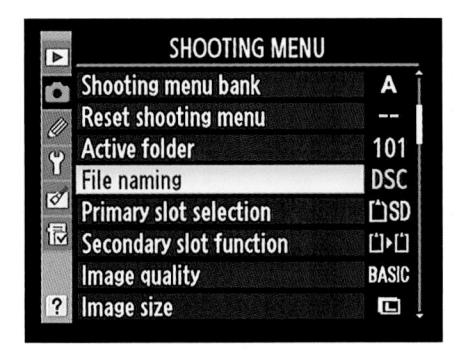

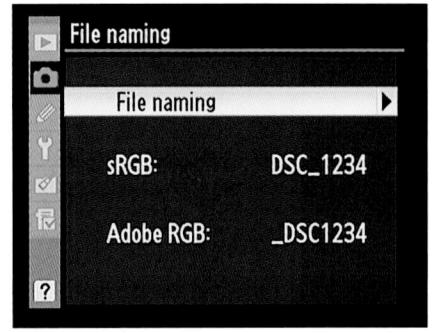

Figure 10-14: This option enables you to change the first three characters of filenames.

You see the screen shown on the right in the figure. The current file naming structure for sRGB and Adobe RGB files appears on the screen.

- 7. Select File Naming and press the Multi Selector right to display the text entry screen shown in Figure 10-15.
- 8. Enter your three custom characters.

Use the Multi Selector to highlight a character; press the center button to enter that character.

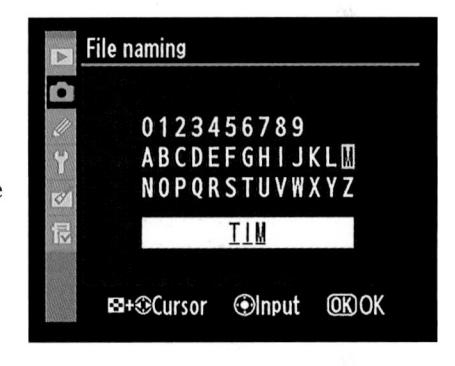

Figure 10-15: Highlight a character and press the Multi Selector center button to enter it.

To move the cursor within your text, press the Zoom Out button while pressing the Multi Selector right or left. To delete a character, move the cursor under it and press the Delete button.

9. Press OK.

You're returned to the Shooting menu. The Active Folder and File Naming options should reflect the changes you just made.

If you create custom folders, remember to specify where you want your pictures stored each time you shoot. Select Active Folder from the Shooting menu, as shown on the left in Figure 10-16, and press OK. Highlight Select Folder, as shown on the right, and press the Multi Selector right to display a list of all your folders. (If you're using both memory card slots, you first need to select a card.) Highlight the folder that you want to use and press OK. Your choice also affects which images you can view in Playback mode; see Chapter 4 to find out how to select the folder you want to view.

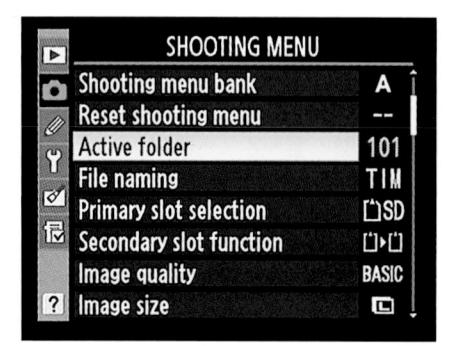

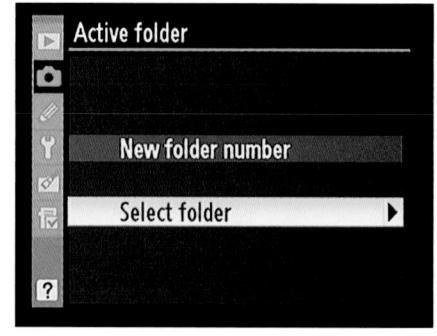

Figure 10-16: Remember to specify where you want to store new images.

Customizing a Trio of Buttons

Earlier chapters introduce you to the Fn (Function) button and Depth-of-Field Preview buttons, both shown on the left in Figure 10-17, and the AE-L/AF-L button, shown on the right. As a recap, the buttons are set by default to perform the following tasks:

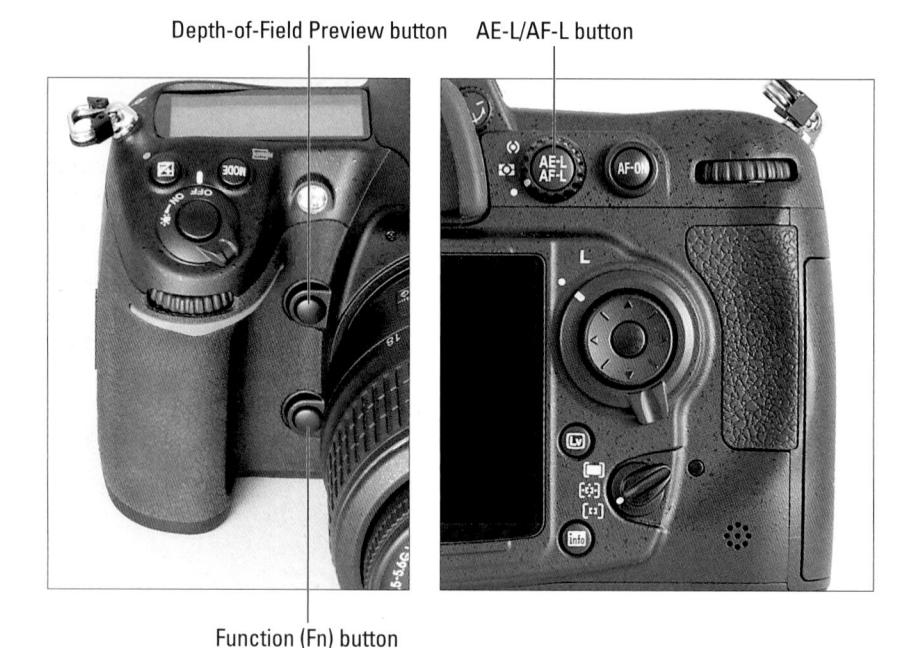

Figure 10-17: You can change the functions performed by these buttons.

- ✓ Fn button: If you enable bracketing, a feature introduced in Chapter 5, you press this button while rotating the main command dial to specify how many shots you want in each bracketed series. And you use the button in conjunction with the sub-command dial to set the increment of change you want to make between each bracketed shot. Press the button by its lonesome, and it displays the current bracketing settings in the Control panel and Information display.
- Depth-of-Field Preview button: When you look through the viewfinder and press the button, the display changes to give you an idea of how your current f-stop setting will affect depth of field.
- AE-L/AF-L button: Autofocus and autoexposure are locked when you press the button, and they remain locked as long as you keep your finger on the button.

While you're first learning your camera and especially while using this book as a reference, it's a good idea to stick with these defaults — otherwise, my instructions won't work (and neither will those you find in other instructional resources). But after you gain some experience, you may want to change the functions that are performed by the buttons.

For all three buttons, you can specify that you want a press of the button alone to perform any the functions listed in Table 10-1. You also can use the buttons in conjunction with command dials to accomplish the functions listed in Table 10-2.

Do note a couple of points before you dig in, however:

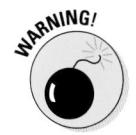

- Assigning some operations in Table 10-1 to a button prevents you from using the button-and-command dial combos listed in Table 10-2. I flagged these options in Table 10-1 and the camera displays a reminder alert when you select those functions as well. Additionally, if you set the button-press function to these flagged options and then select a button-dial setting other than None, the camera automatically resets the button-press setting to None. Again, the camera warns you when you select the conflicting button-dial setting.
- One button-press option, AF-On, is available only for the AE-L/AF-L button. And one button+command dial option, 1 Step/Spd Aperture, can't be assigned to that button.

You can set the function of a button in two ways:

✓ Via the Custom Setting menu: Select Assign Fn Button, shown in Figure 10-18, to customize the Function button; choose Assign Preview Button to customize the Depth-of-Field Preview button; and choose Assign AE-L/AF-L button to . . . well, you get the drift. Then press OK to display a screen that offers the two menu options that enable you to

modify the button's behavior. (The figure shows the screen that relates to the Fn button. Notice the red highlight indicating which button you're adjusting.)

Set up your buttons as follows:

- To perform an operation with the button only: To assign a function to the button alone, select the Button Press option and press OK. You then see a screen showing the options that are explained and listed in Table 10-1. Select your choice, and press OK.
- Change the operation performed by pressing the button and rotating a command dial: Select the Button + Dials option and press OK to access the options listed in Table 10-2. Highlight your choice and press OK again.
- ✓ **Via the Information screen:** Symbols representing the current button settings appear in the control strip area of the Information screen, as shown in Figure 10-19. For example, the little aperture symbol next to the Depth of Field Preview button item shows that pressing the button stops down the aperture so that you can preview depth of field in the viewfinder.

And the little dial symbol that appears with the Fn button label tells you that the button is set to its default — that is, you use the button with the command dials to adjust Bracketing (BKT) settings.

Press the Info button once to display the Info screen and then again to activate the control strip, as shown on the right in the figure, and then use the Multi Selector to highlight the button you want to change. Press OK to get to the same menu screens displayed when you set the button function through the Custom Setting menu.

As you're exploring the menu options, you can press the Protect button to display a Help screen that explains what each option accomplishes. See Chapter 1 for more about using the Help screens.

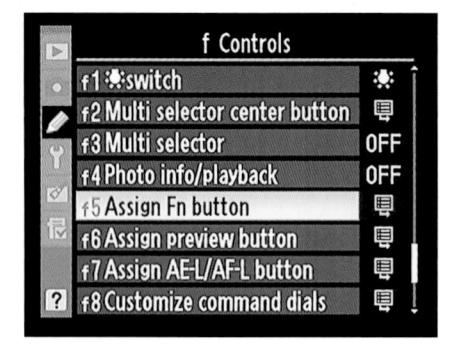

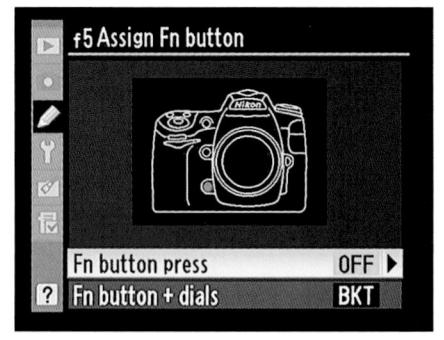

Figure 10-18: Head to the Controls submenu of the Custom Setting menu to get the job done.

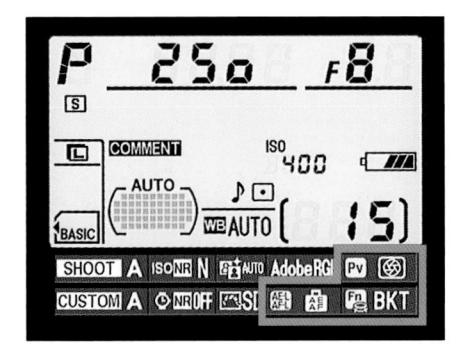

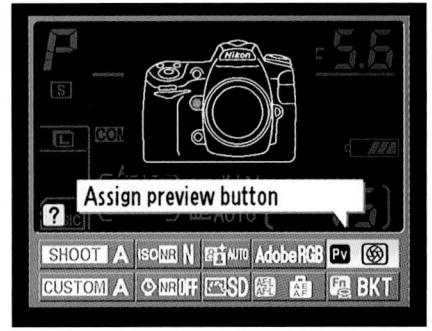

Figure 10-19: You can also adjust the button functions through the Information screen.

Fn, Depth-of-Field Preview, and AE-L/AF-L Button Settings
Pressing the Button Does This.
Default setting for the Depth-of-Field Preview button; displays in the viewfinder a preview of how your selected aperture setting affects depth of field.
Your first button press locks the flash exposure value (FV); the second press removes the lock.
Locks autofocus and autoexposure for as long as you hold the button.
Holding the button locks autoexposure only.
Locks autoexposure until you take the picture, the exposure meters turn off, or you press the button a second time.
Locks autoexposure until you press the button a second time or the exposure meters turn off.
Autofocus is locked as long as you press the button.
Initiates autofocus. (The button serves the same function as the AF-On button.)

(continued)

Table 10-1 (continued)		
If You Choose This Setting	Pressing the Button Does This.	
Flash Off	Holding the button as you press the shutter button disables the flash for your next shot.	
Bracketing Burst	When exposure or flash bracketing is enabled, Bracketing Burst records all images in the bracketed series with a single press of the shutter button even if Release mode is set to Single or Quiet. In Continuous Hi or Continuous Low Release mode or when white-balance bracketing is enabled, the camera records multiple bracketed series as long as the shutter button is pressed.	
Matrix Metering	Overrides the setting of the metering selector switch to set the metering mode to Matrix while the button is pressed.	
Center-Weighted Metering	Overrides the setting of the metering selector switch to set the metering mode to Center-Weighted while the button is pressed.	
Spot Metering	Overrides the setting of the metering selector switch to set the metering mode to Spot Metering while the button is pressed.	
Playback ¹	Performs the same function as the Playback button.	
Access Top Item in My Menu ¹	Displays the top item stored in a custom menu you create through the My Menu feature.	
+NEF (RAW) ¹	When the Image Quality is set to JPEG Fine, Normal, or Basic, pressing the button records a NEF (RAW) copy of the next picture you take. Kee the shutter button pressed halfway between shot to record a series of RAW+JPEG images.	
None	The button is inactive except when used in conjurtion with the command dials. However, pressing to Fn button still displays the bracketing settings.	

¹Choosing this setting disables the usual function performed by pressing the button and rotating the command dials.

²Available only for the AE-L/AF-L button

Table 10-2	Button + Command Dial Setting
If You Choose This Setting	Pressing the Button While Rotating a Command Dial Does This.
1 Step Spd/ Aperture ¹	Adjusts the current f-stop or shutter speed in increments of 1 EV (one stop) instead of using the current setting of the EV Steps for Exposure Control option. (See Chapter 5 for details on that setting and other exposure info.)
Choose Non-CPU Lens Number	Enables you to select a specific non-CPU lens number (relevant only if you enter data for the non-CPU lens option covered in Chapter 1).
Auto Bracketing	This button plus the main command dial adjusts the number of shots in a bracketed series; the button plus the sub-command dial adjusts the bracketing increment.
Dynamic AF Area	Enables you to rotate either command dial while pressing button to select the number of active autofocus points; works only when you use continuous-servo autofocus (AF-C) and set the AF-Area mode to Dynamic Area. See Chapter 6 for details.
None	Rotating the dials while pressing the button has no effect.

¹Not available for AE-L/AF-L button

Locking Exposure with the Shutter Button

Normally, pressing the shutter button halfway initiates autofocusing and, in single-servo autofocus mode, locks focus. Pressing the button halfway also

initiates exposure metering but doesn't lock exposure — the camera continuously adjusts the exposure settings as needed up to the time you take the picture. If you want to lock exposure, you can use the AE-L/AF-L button to do the job, as explained in Chapter 5.

You also have the option to set the shutter button to lock exposure and focus together. The setting in question is found on the Timers/AE Lock submenu of the Custom Setting menu and is called Shutter-Release Button AE-L, as shown in Figure 10-20. If you set the option to On, your half-press of

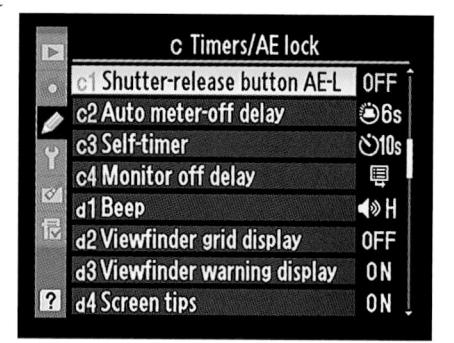

Figure 10-20: This option controls whether the shutter button can be used to lock focus and exposure.

the shutter button locks both focus and exposure. Whew, I'm giving myself a headache considering all these possible variations — you?

Changing the Behavior of the Command Dials

Through the Customize Command Dials option, found on the Controls section of the Custom Setting menu and shown in Figure 10-21, you can control several aspects of how the command dials behave, as follows:

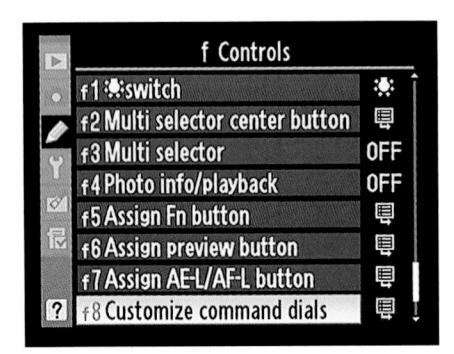

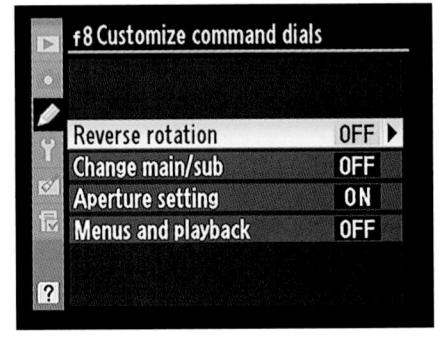

Figure 10-21: The right screen here shows the default setup for the command dials.

- ✓ Reverse Rotation: At the default setting, Off, the dials work as indicated throughout this book and the camera manual. Select Yes to reverse the direction you spin the dials to accomplish the various tasks they perform.
- ✓ Change Main/Sub: This setting controls which dial you use to adjust aperture and shutter speed. At the default setting, Off, the main command dial adjusts shutter speed, and the sub-command dial controls aperture. Select On to swap the dial roles.
- ✓ **Aperture Setting:** For this option, you have two settings:
 - Sub-command dial: This is the default setting; the sub-command dial controls aperture (assuming that you didn't alter the setting of the Change Main/Sub option just discussed). When you select this option, the Aperture Setting item on the menu appears set to On, as shown on the right in Figure 10-21.
 - Aperture ring: This setting relates only to lenses that have an aperture ring; if you select this option, you can adjust the f-stop only by using the aperture ring. Live View is disabled if you attach a lens with an aperture ring and use this setting. The Aperture Setting item on the menu appears set to Off when you select this option.

Menus and Playback: At the default setting, Off, you use the Multi Selector to scroll through your pictures and change the data-display style during playback. And during shooting, you use the Multi Selector to navigate menus.

By changing the setting to On, you can use the command dials during playback and while navigating menus as follows:

- Playback: Use the main command dial to scroll through pictures in single-image view and move the image-highlight box left or right during thumbnails playback. Use the sub-command dial to adjust the data-display mode during single-image playback and move the highlight box up and down through thumbnails.
- *Menu navigation:* Rotate the main command dial to scroll up and down through a menu. Rotate the sub-command dial right to display the submenu for the selected item; rotate left to jump to the previous menu.

Customizing the Multi Selector Center Button

You can customize the role that the center button on the Multi Selector plays during shooting and playback through the aptly named Multi Selector Center Button option, found in the Controls section of the Custom Setting menu, as shown on the left in Figure 10-22. Highlight the option and press OK to display the screen on the right in the figure.

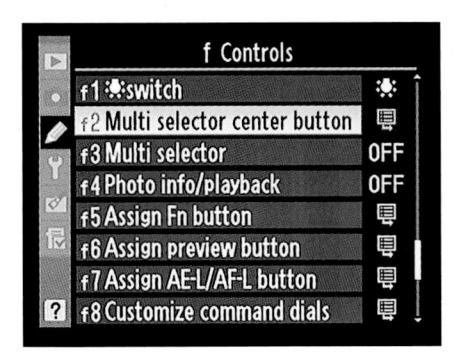

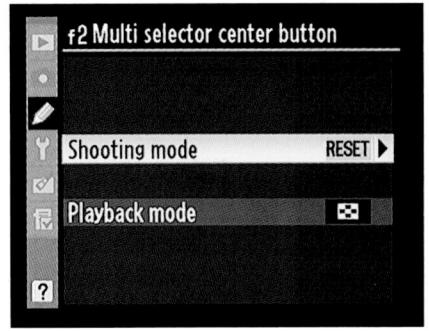

Figure 10-22: You can change the role the Multi Selector center button plays during shooting and playback.

The two options on the screen work like so:

- ✓ Shooting Mode: Select this option and press OK to display a screen
 offering the following three choices, which determine what the button
 does while you're taking pictures:
 - RESET (Select Center Focus Point): At this setting, the button automatically selects the center autofocus point. I think that's a pretty handy feature, so it's my choice. See Chapter 6 for help understanding autofocus points.
 - *Highlight Active Focus Point:* At this setting, pressing the button highlights the active focus point in the viewfinder.
 - Not Used: This setting disables the center button during shooting altogether — although I don't know why you would unless you somehow keep pressing the button by accident.
- ✓ Playback Mode: You get four options for how you want to use the center button during picture playback, which are:
 - Thumbnail On/Off: This setting is the default; pressing the button toggles you between thumbnail-sized image displays and full-frame view.
 - View Histograms: This one may win out over the default if you're
 a frequent histogram checker: If you select this option, you can
 press and hold the button to temporarily overlay a histogram over
 your image whether you're in full-frame or thumbnail view.
 - Zoom On/Off: At this setting, pressing the center button displays a
 magnified view of the current image. The zoomed view is automatically centered on the focus point you used when taking the image.
 If you select this option, you're taken to a screen where you can set
 the magnification level (low, medium, or high) for the zoomed view.
 - Choose Folder: This option enables you to use the center button to quickly access the menu option that enables you to specify which folder's images you want to view.

Note that you have other options for accomplishing these playback tasks; see Chapter 4 for details as well as for general playback information.

Uncoupling the Buttons and Command Dials

Under the normal camera setup, an operation that involves both a camera button and a command dial requires you to hold the button down while spinning the dial to get results. For example, to change the flash mode, you hold down the Flash Mode button while rotating the main command dial.

If you find it cumbersome to keep pressing the button while you rotate the dial, you can tell the two controls that you prefer them to dance separately instead of cheek-to-cheek. The relevant option is located on the Controls submenu of the Custom Setting menu; it's called Release Button to Use Dial, as shown in Figure 10-23. Set the option to Yes, and you let up on the button and then rotate the command dial to adjust a camera setting. So to change flash mode, for example, you press and release the Flash Mode button and then rotate the main command dial.

Figure 10-23: I think the default setting for this option is the safest way to go.

There's a little gotcha to remember if you accept this variation, however: The setting you're adjusting remains active until you press the button again, you press the shutter button halfway, or press the Mode, Exposure Compensation, Flash, ISO, QUAL, or WB buttons. And if you forget and leave the setting "open," you can easily adjust the setting with the command dial when you're meaning to do something else. For this reason, I prefer to use the default setting, No.

Ten Features to Explore on a Rainy Day

In This Chapter

- Removing red-eye
- Tweaking exposure and color
- Adding artistic effects
- Cropping away excess background
- Experimenting with time-lapse photography

onsider this chapter the literary equivalent of the end of one of those late-night infomercial offers — the part where the host exclaims, "But wait! There's more!"

The features covered in these pages fit the category of "interesting bonus." They aren't the sort of features that drive people to choose one camera over another, and they may come in handy only for certain users, on certain occasions. Still, they're included at no extra charge with your camera purchase, so check 'em out when you have a few spare moments. Who knows; you may discover that one of these features is actually a hidden gem that provides just the solution you need for one of your photography problems.

Applying the Retouch Menu Filters

Many of the features described in this chapter live on the Retouch menu, so I want to give you a brief overview of how these menu options work.

When you apply a correction or enhancement from the Retouch menu, the camera creates a copy of your original photo and then makes the changes to the copy only. Your original is preserved untouched.

You can get to the Retouch menu features in two ways:

✓ Display the menu, select the tool you want to use, and press OK. You're then presented with thumbnails of your photos. Use the Multi Selector to move the yellow highlight box over the photo you want to adjust and press OK. You next see options related to the selected tool.

Switch the camera to playback mode, display your photo in single-frame view, and press OK. (Remember, you can shift from thumbnail display to single-frame view simply by pressing the OK button.) The Retouch menu

then appears superimposed over your photo, as shown in Figure 11-1. Select the tool you want to use and press OK again to access the tool options. I prefer the second method, so that's how I approach things in this chapter, but it's entirely a personal choice.

However, you can't use this method for one Retouch menu option: Image Overlay, which combines two photos to create a third, blended image, requires you to use the first method of accessing the menu.

Figure 11-1: In single-frame playback view, just press OK to bring up the Retouch menu.

A few other critical factoids to note before you begin experimenting with the Retouch menu tools:

- ✓ The Image Overlay feature works only with NEF (RAW) files. The resulting picture is also saved in the NEF format. Chapter 3 explains the NEF file type; Chapter 8 shows you how to convert a RAW file to a standard file format.
- All other menu options work with JPEG, TIFF, or NEF originals, but the edited file is saved in the JPEG format. Again, see Chapter 3 for help understanding file formats.
- File numbers of retouched copies don't match those of the originals.

 Make note of the filename the retouched version is assigned so that you can easily track it down later. What numbering the camera chooses depends on the numbers of the files already on your memory card.

✓ You can compare the original and the retouched version through the Side-by-Side menu option. To use this feature, start by displaying either the original or the retouched version in full-frame playback. Then press OK, select Side-by-Side Comparison, as shown on the left in Figure 11-2, and press OK again. Now you see the original image on one side and the retouched version on the other, as shown in the second screen in the figure. At the top of the screen, labels indicate the Retouch tool that you applied to the photo. (I applied the Monochrome filter in Figure 11-2.)

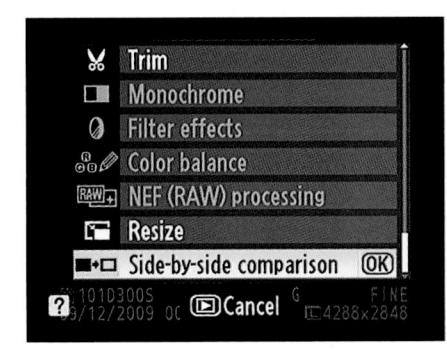

Figure 11-2: Use the Side-by-Side Comparison option to see whether you prefer the retouched version of a photo to the original.

These additional tricks work in Side-by-Side display:

- If you applied more than one Retouch tool to the picture, press the Multi Selector right and left to display individual thumbnails that show how each tool affected the picture.
- If you create multiple retouched versions of the same original for example, if you create a monochrome version, save that, and then crop the original image and save that you use a different technique to compare all the versions. First, press the Multi Selector right or left to surround the After image with the yellow highlight box. Now press the Multi Selector up and down to scroll through all the retouched versions.
- To temporarily view the original or retouched image at full-frame view, use the Multi Selector to highlight its thumbnail and then press and hold the Zoom In button. Release the button to return to side-by-side view.

To exit side-by-side view and return to single-image playback, press the Playback button.

•

Removing Red-Eye

From my experience, red-eye is not a major problem with the D300s. Typically, the problem occurs only in very dark lighting, which makes sense: When little ambient light is available, the pupils of the subjects' eyes widen, creating more potential for the flash light to cause red-eye reflection.

If you spot a red-eye problem, however, give the Red-Eye Correction filter a try:

1. Display your photo in single-image view and press OK.

The Retouch menu appears over your photo.

2. Highlight Red-Eye Correction and press OK.

If the camera detects red-eye, it applies the removal filter and displays the results in the monitor. If the camera can't find any red-eye, it displays a message telling you so.

Note that the Red-Eye Correction option appears dimmed in the menu for photos taken without flash.

3. Carefully inspect the repair.

Press the Zoom In button to magnify the display so that you can check the camera's work, as shown in Figure 11-3. To scroll the display, press the Multi Selector up, down, right, or left. The yellow box in the tiny navigation window in the lower-right corner of the screen indicates the area of the picture that you're currently viewing.

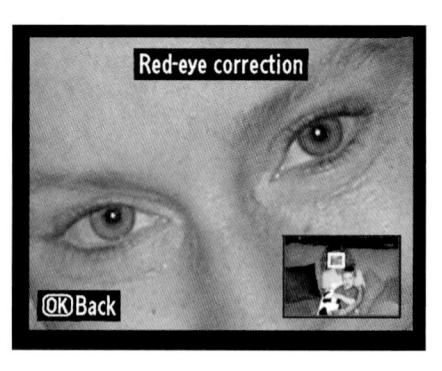

Figure 11-3: Zoom in to magnify the image and check the red-eye repair.

4. If you approve of the correction, press OK twice.

The first OK returns the display to normal magnification; the second creates the retouched copy.

5. If you're not happy with the results, press OK to return to normal magnification. Then press the Playback button to cancel the repair.

If the in-camera red-eye repair fails you, most photo editing programs have red-eye removal tools that should enable you to get the job done. Unfortunately, no red-eye remover works on animal eyes. Red-eye removal tools know how to detect and replace only red-eye pixels, and animal eyes typically turn yellow, white, or green in response to a flash. The easiest solution is to use the paintbrush tool found in most photo editors to paint in the proper eye colors.

Shadow Recovery with D-Lighting

Chapter 5 introduces you to a feature called Active D-Lighting. If you turn on this option when you shoot a picture, the camera captures the image in a way that brightens the darkest parts of the image, bringing shadow detail into the light, while leaving highlight details intact. It's a great trick for dealing with high-contrast scenes or subjects that are backlit.

You also can apply a similar adjustment after you take a picture by choosing the D-Lighting option on the Retouch menu. I did just that for the photo in Figure 11-4, where strong backlighting left the balloon underexposed in the original image.

D-Lighting, High

Figure 11-4: An underexposed photo (left) gets help from the D-Lighting filter (right).

Here's how to apply the filter:

- 1. Display your photo in single-image mode and then press OK to display the Retouch menu.
- 2. Highlight D-Lighting, as shown on the left in Figure 11-5, and press OK.

You see a thumbnail of your original image along with an after thumbnail, as shown in the second image in Figure 11-5.

3. Select the level of adjustment by pressing the Multi Selector up or down.

You get three levels: Low, Normal, and High. I used High for the repair to my balloon image.

To get a closer view of the adjusted photo, press and hold the Zoom In button. Release the button to return to the two-thumbnail display.

4. To go forward with the correction, press OK.

The camera creates your retouched copy.

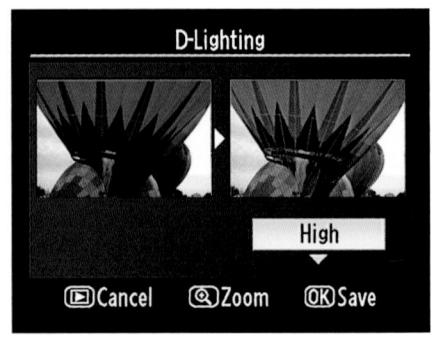

Figure 11-5: Apply the D-Lighting filter via the Retouch menu.

You can't apply D-Lighting to an image if you captured the photo with the Picture Control feature set to Monochrome. (See Chapter 6 for details on Picture Controls.) Nor does D-Lighting work on any pictures to which you've applied the Monochrome filter, detailed a little later in this chapter.

Two Ways to Tweak Color

Chapter 6 explains how to use your camera's White Balance and Picture Control features to manipulate photo colors. But even if you play with those settings all day, you may wind up with colors that you'd like to tweak just a tad. The Retouch menu offers two different tools for doing so: Through the Filter Effects option, you can apply a subtle warming effect, and through the Color Balance option, you can shift colors toward any part of the color spectrum and make a more pronounced color adjustment.

As an example, Figure 11-6 shows you an original image and three adjusted versions. As you can see, the Skylight and Warm filters are both very subtle; in this image, the effects are most noticeable in the sky. The fourth example shows a variation created by using the Color Balance filter and shifting colors toward the cool (bluish) side of the color spectrum.

To apply either filter, start by displaying your photo in single-frame playback mode and then press OK to display the Retouch menu over the photo. From there, proceed like so:

Filter Effects: Select this filter, as shown on the left in Figure 11-7, and press OK to display the right screen. Choose Skylight to apply a subtle warming effect, similar to what you can produce by placing a traditional skylight filter over your lens. For a stronger — but still pretty subtle — warming effect, choose Warm instead. Press OK to display a preview of the effect. If you like what you see, press OK again to create the warmed-up copy of the photo.

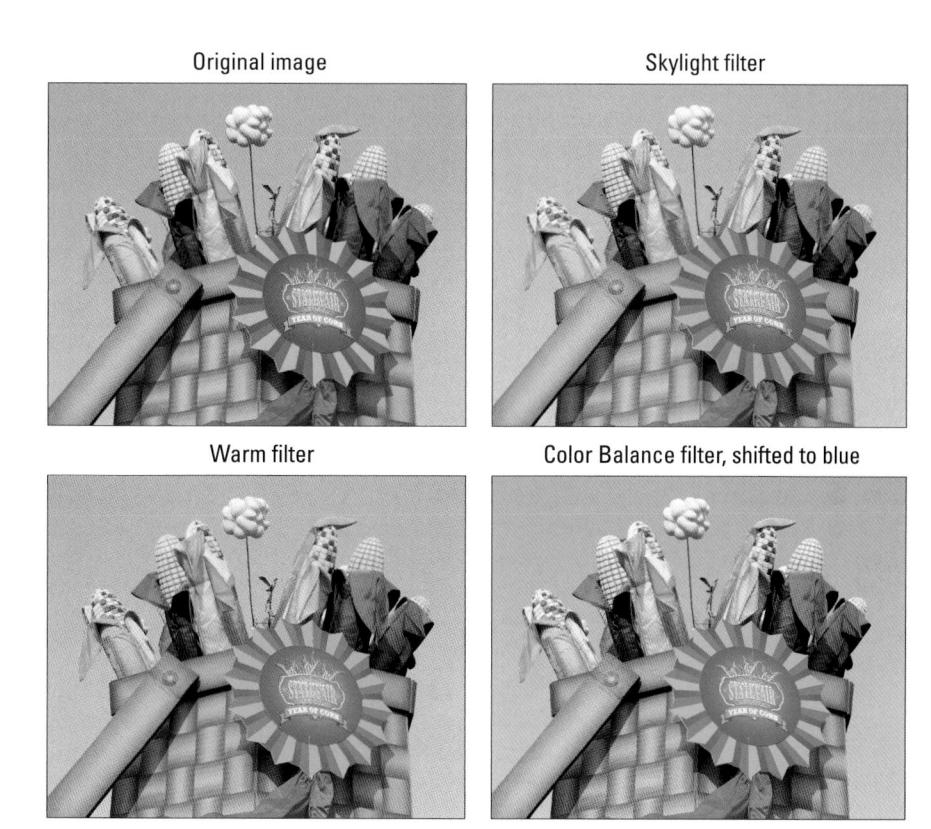

Figure 11-6: Here you see the results of applying two Filter Effects adjustments and a Color Balance shift.

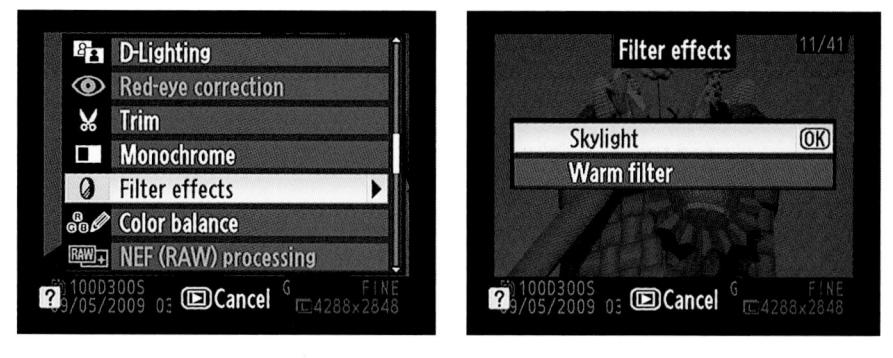

Figure 11-7: Both of these filters produce a slight warming effect; Warm creates a more pronounced result.

Color Balance: Through this filter, featured in Figure 11-8, you can gain much more control over color adjustments. After you select the filter and press OK, you see a screen with a little color grid, as shown on the right in the figure.

When the little black box is in the center of the grid, as in the figure, no color-balance adjustment has been applied. To manipulate colors, use the Multi Selector to move the black square in the direction of the color adjustment you want to make. The histograms on the right side of the display show you the resulting impact on overall image brightness, as well as on the individual red, green, and blue brightness values — a bit of information that's helpful if you're an experienced student in the science of reading histograms. (Chapter 4 gives you an introduction.) If not, just check the image preview to monitor your results. Press OK to create the color-adjusted copy of your photo.

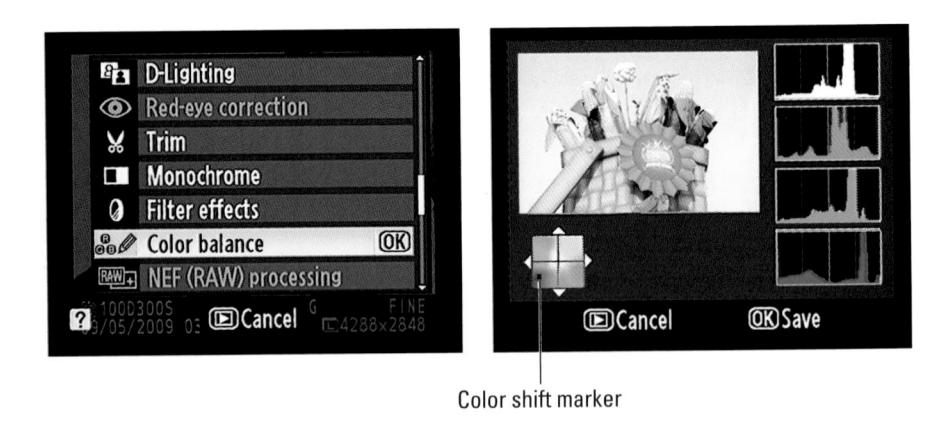

Figure 11-8: Press the Multi Selector to move the color-shift marker and adjust color balance.

Creating Monochrome Photos

With the Monochrome Picture Control feature covered in Chapter 6, you can shoot black-and-white photos. Technically, the camera takes a full-color picture and then strips it of color as it's recording the image to the memory card, but the end result is the same.

As an alternative, you can create a black-and-white copy of an existing color photo by applying the Monochrome option on the Retouch menu. You can also create sepia and *cyanotype* (blue and white) images via the Monochrome option. Figure 11-9 shows you examples of all three effects.

I prefer to convert my color photos to monochrome images in my photo editor; going that route simply offers more control, not to mention the fact that it's easier to preview your results on a large computer monitor than on

the camera monitor. Still, I know that not everyone's as much of a photo editing geek as I am, so I present to you here the steps involved in applying the Monochrome effects to a color original in your camera:

- Display your photo in single-image view and press OK to bring the Retouch menu to life.
- 2. Highlight Monochrome and press OK to display the three effect options, as shown in Figure 11-10.
- 3. Highlight the effect that you want to apply and press OK.

You then see a preview of the image with your selected photo filter applied.

4. To adjust the intensity of the sepia or cyanotype effect, press the Multi Selector up or down.

Original

ANDY LIND

ANDY LIND

AND LIND

AND

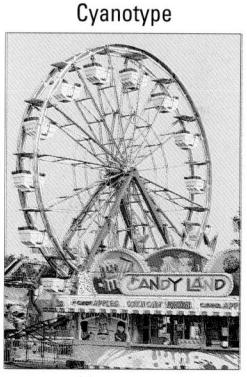

Figure 11-9: You can create three monochrome effects through the Retouch menu.

No adjustment is available for the black-and-white filter.

5. Press OK to create the monochrome copy.

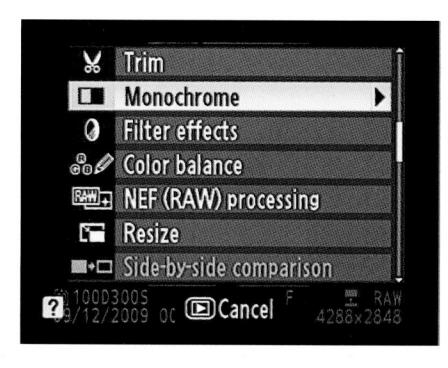

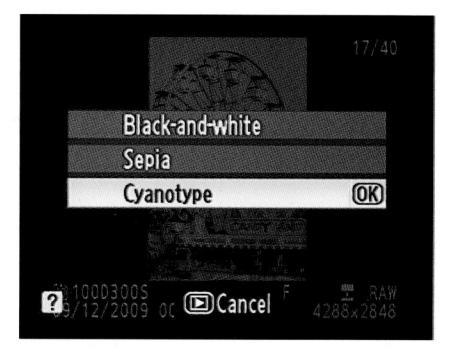

Figure 11-10: Select the filter you want to apply and press OK.

Cropping Your Photo

To *crop* a photo simply means to trim away some of its perimeter. Cropping away excess background can often improve an image, as illustrated by Figures 11-11 and 11-12. When shooting this scene, I couldn't get close enough to the ducks to fill the frame with them, so I simply cropped it after the fact to achieve the desired composition.

Figure 11-11: The original contains too much extraneous background.

Figure 11-12: Cropping creates a better composition and eliminates background clutter.

With the Trim function on the Retouch menu, you can crop a photo right in the camera. Note a few things about this feature:

- You can crop your photo to five different aspect ratios: 3:2, which maintains the original proportions and matches that of a 4 x 6-inch print; 4:3, the proportions of a standard computer monitor or television (that is, not a wide-screen model); 5:4, which gives you the same proportions as an 8 x 10-inch print; 1:1, which results in a square photo; and 16:9, which is the same aspect ratio as images on a wide-screen movie. If your purpose for cropping is to prepare your image for a frame size that doesn't match any of these aspect ratios, crop in your photo software instead.
- For each aspect ratio, you can choose from six crop sizes. The sizes are stated in pixel terms for example, if you select the 3:2 aspect ratio, you can crop the photo to measurements of 3424 x 2280 pixels, 2560 x 1704 pixels, 1920 x 1280 pixels, 1280 x 856 pixels, 960 x 640 pixels, and 640 x 424 pixels.
- After you apply the Trim function, you can't apply any other fixes from the Retouch menu. So make cropping the last of your retouching steps.

Keeping those caveats in mind, trim your image as follows:

- Display your photo in single-image view and press OK to launch the Retouch menu.
- 2. Highlight Trim, as shown on the left in Figure 11-13, and press OK.

Now you see a screen similar to the right side of the figure. The yellow highlight box indicates the current cropping frame. Anything outside the frame is set to be trimmed away.

Figure 11-13: Rotate the main command dial to change the proportions of the crop box.

3. Rotate the main command dial to change the crop aspect ratio.

The selected aspect ratio appears in the upper-right corner of the screen, as shown in Figure 11-13.

4. Adjust the cropping frame size and placement as needed.

The current crop size appears in the upper-left corner of the screen. (Refer to Figure 11-13.) You can adjust the size and placement of the cropping frame like so:

- *Reduce the size of the cropping frame*. Press and release the Zoom Out button. Each press of the button further reduces the crop size.
- Enlarge the cropping frame. Press the Zoom In button to expand the crop boundary and leave more of your image intact.
- *Reposition the cropping frame*. Press the Multi Selector up, down, right, and left to shift the frame position.
- 5. Press OK to create your cropped copy of the original image.

Two Roads to a Multi-Image Exposure

The D300s offers two features that enable you to combine multiple photographs into one:

- Multiple Exposure (Shooting menu): With this option, you can combine your next two to ten shots. After you enable the option and take your shots, the camera merges them into one NEF (RAW) file. The shots used to create the composite aren't recorded and saved separately.
- ✓ Image Overlay (Retouch menu): This option enables you to merge two RAW images that already exist on the memory card. I used this option to combine a photo of a werewolf friend, shown on the top left in Figure 11-14, with a nighttime garden scene, shown on the top right. The result is the ghostly image shown beneath the two originals. Oooh, scary!

On the surface, both options sound kind of cool. The problem is that you can't control the opacity or positioning of the individual images in the combined photo. For example, my overlay picture would have been more successful if I could move the werewolf to the left in the combined image so that he and the lantern aren't blended. And I'd also prefer to keep the background of image 2 at full opacity in the overlay image rather than getting a 50-50 mix of that background and the one in image 1, which only creates a fuzzy looking background in this particular example.

Figure 11-14: Image Overlay merges two RAW (NEF) photos into one.

However, there is one effect that you can create successfully with either option: a "two views" composite like the one in Figure 11-15. For this image, I used Image Overlay to combine the front and rear views of the antique match striker. But in order for this trick to work, the background in both images must be the same solid color (black seems to be best) and you must compose your photos so that the subjects don't overlap in the combined photo, as shown here. Otherwise, you get the ghostly portrait effect like what you see in my example.

To be honest, I don't use Image Overlay or Multiple Exposure for the purpose of serious photo compositing. I prefer to do this kind of work in my photo editing software, where I have more control over the blend. Understand, too, that neither feature is designed to produce an HDR (high dynamic range) image, which lifts different brightness ranges from different images to create the composite. For HDR, you need software that can do tone mapping, not just whole-image blending. (See the Chapter 5 section related to exposure bracketing for more about HDR.)

Figure 11-15: If you want each subject to appear solid, use a black background and position the subjects so that they don't overlap.

In the interest of reserving space in this book for features that I think you will find much more useful, I leave you to explore these two on your own. (The manual explains the steps involved in using each of them.) Again, though, I think that you'll find photo compositing much easier and much more flexible if you do the job in your photo editing software.

Exploring Automated Time-Lapse Photography

You can use the Interval Timer Shooting feature to automatically capture a series of pictures over a given period of time. The common photo lingo for this type of capture is *time-lapse photography*. Here's how to do it:

- Set the Release mode to any setting but Self-Timer or Mirror Up.
 Those modes aren't compatible with interval-timing shooting.
- 2. Display the Shooting menu, highlight Interval Timer Shooting as shown on the left in Figure 11-16, and press OK.

The screen on the right in Figure 11-16 appears.

3. To begin setting up your capture session, highlight Now or Start Time.

- If you want to start the captures right away, highlight Now, as shown on the right in Figure 11-16.
- To set a later start time for the captures, highlight Start Time.

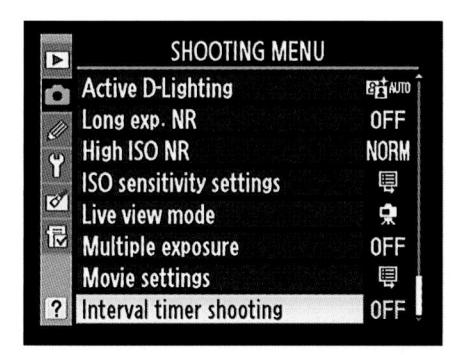

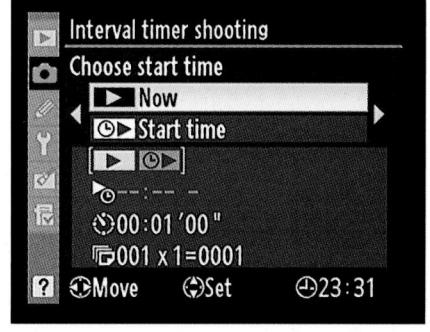

Figure 11-16: The Interval Timing feature enables you to do time-lapse photography.

4. Press the Multi Selector right to display the capture-setup screen.

If you selected Start Time in Step 3, the screen looks like the one in Figure 11-17. If you selected Now, the Start Time option is dimmed, and the Interval option is highlighted instead.

5. Set up your recording session.

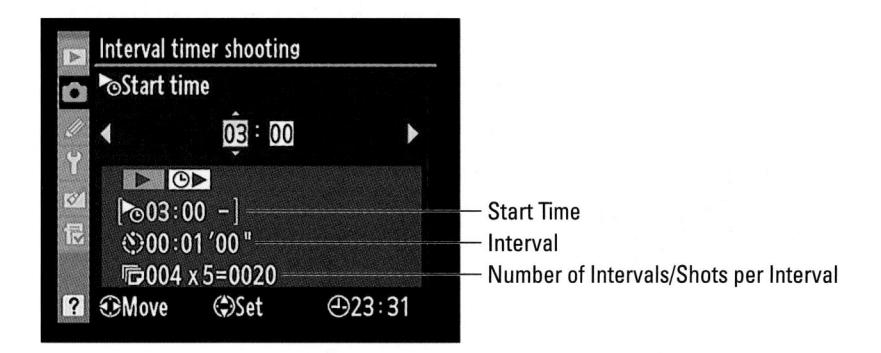

Figure 11-17: Press the Multi Selector right or left to cycle through the setup options; press up or down to change the highlighted value.

You get three options: Start Time, Interval (time between shots), and Number of Intervals and Number of Shots per Interval (determines total number of shots recorded). The current settings for each option appear in the bottom half of the screen, as labeled in Figure 11-17.

At the top of the screen, little value boxes appear. The highlighted box is the active option and relates to the setting that's highlighted at the bottom of the screen. For example, in the figure, the hour box for the Start Time setting is active. Press the Multi Selector right or left to cycle through the value boxes; to change the value in a box, press the Multi Selector up or down.

A few notes about your options:

- The Interval and Start Time options are based on a 24-hour clock. (The current time appears in the bottom-right corner of the screen and is based upon the date/time information you entered when setting up the camera.)
- For the Interval option, the left column box is for the hour setting; the middle, minutes; and the right, seconds. Make sure that the value you enter is longer than the shutter speed you plan to use.
- For the Start Time option, you can set the hour and minute values only. Again, the Start Time option is available only if you selected Start Time in Step 3.
- The Number of Intervals value multiplied by the Number of Shots per interval determines how many pictures will be recorded.
- 6. When you're done setting up the capture options, press the Multi Selector right until you see the On and Off options on the screen, as shown in Figure 11-18.

7. Highlight On and press OK.

If you selected Now as your interval-capture starting option, the first shot is recorded about three seconds later. If you set a delayed start time, the camera displays a "Timer Active" message for a few seconds and before returning to the Shooting menu.

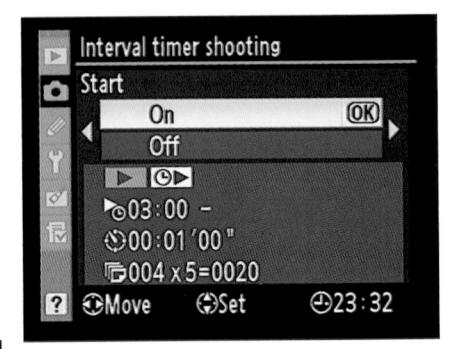

Figure 11-18: Highlight On and press OK to finalize the Interval Timing setup.
A few final factoids:

- ✓ **Interrupting interval shooting:** Just press the OK button between intervals or bring up the Interval Timing menu screen, highlight Start/Pause, and press OK. If you later want to resume the interval shooting, highlight Restart and press OK. To cancel interval timing altogether, select Start/Off and press OK.
- ✓ Bracketing: You can apply automatic bracketing during interval shooting. See Chapter 5 to find out what bracketing is all about.
- Autofocusing: If you're using autofocusing, be sure that the camera can focus on your subject. It will initiate focusing before each shot, and by default, won't record a picture if focusing can't be achieved. See Chapter 6 for details about autofocusing.

Index

active focus point, highlighting, 328 Numerics Active Folder option, 95, 318 Adobe Camera Raw (ACR), 276 0F (white balance bracketing), 236 Adobe Photoshop, 82 1 Step Spd/Aperture setting, 325 Adobe Photoshop Elements, 82, 276 3F (white balance bracketing), 236 Adobe RGB color mode, 237–239 5F (white balance bracketing), 236 AE & Flash bracketing, 187 7F (white balance bracketing), 236 AE Lock, 168 9F (white balance bracketing), 236 AE Lock (Hold) setting, 323 18-55mm AF-S VR Nikon lenses, 12 AE Lock Only setting, 323 AE Lock (Reset on Release) setting, 323 • A • AE Only bracketing, 187 AE-L/AF Lock setting, 323 A (aperture-priority autoexposure). See AE-L/AF-L button also exposure modes customizing, 320-325 aperture and shutter speed settings locking autoexposure with, 168 in, 155 locking exposure with shutter button, in close-up shots, 255 325-326 depth of field and, 219 locking flash exposure with, 181 exposure compensation, 165 overview, 30 in landscape photography, 252 AF Fine Tune, 40 overview, 148 AF Lock Only setting, 323 a2F (white balance bracketing), 236 AF-area mode a3F (white balance bracketing), 236 auto area, 200-201 AC adapter, 34 dynamic area, 200, 251 Access Top Item in My Menu setting, 324 overview, 196 ACR (Adobe Camera Raw), 276 single point, 51, 200 action shots. See also close-up shots; AF-area mode selector, 30, 167 landscape photography; still portraits AF-assist/Self-Timer/Red-Eye Reduction autofocusing, 204-210, 251 lamp, 33 composing subject in, 252 AF-C Priority Selection, 198–199 ISO setting, 251 AF-I Nikkor lens, 8 manual focusing, 252 AF-ON button, 30, 197, 212–213 overview, 250 AF-On setting, 323 rapid-fire shooting, 251 AF-S Priority Selection, 199 S (shutter-priority autoexposure), 251 AFS-Nikkor lens, 8 shutter speed, selecting, 251 all-purpose picture taking settings, 244 Active D-Lighting anti-shake. See vibration reduction (VR) bracketing, 170, 185, 192–193 aperture. See also focal lengths; ISO; disabling, 171 shutter speed matrix metering mode and, 170 A (aperture-priority autoexposure), 155

adjusting, 153-155

defined, 140

overview, 168-169, 335

turning on, 169–170

aperture (continued)	autofocus mode
depth of field and, 61, 142–143, 216	continuous-servo, 52
f-stops, 140–141	single-servo, 52
movie recording, 132	autofocus point, 52
overview, 140	autofocusing. See also manual focusing
aperture ring, 326	in action shots, 204–210, 251
aperture-priority autoexposure. See also	AF Point Illumination, 214
exposure modes	AF-area mode, 200–201
aperture and shutter speed settings	AF-C priority, 198–199
in, 155	AF-On for MB-D10, 214
in close-up shots, 255	AF-S priority, 199
depth of field and, 219	basic, 211–212
exposure compensation, 165	Built-in AF-Assist Illuminator, 214
in landscape photography, 252	continuous-servo, 197, 198
overview, 148	contrast-detection, 119
Auto Area mode, 200–201	Handheld mode, 119
Single Point AF, combining with, 211–212	interval shooting, 347
Auto Bracketing setting, 325	in Live View, 119
Auto FP option, 182–183	manual override, 13
Auto Image Rotation option, 38, 92	phase-detection, 119
Auto ISO Sensitivity, 157	single-servo, 196, 198
Auto White Balance mode, 222	with still subjects, 203–204, 247
autoexposure	switching to, 13
aperture-priority	Tripod mode, 119
aperture and shutter speed settings	automatic shooting
in, 155	flash, 55–56
in close-up shots, 255	flash modes, 56
exposure compensation, 165	flexible programmed autoexposure, 60–64
in landscape photography, 252	overview, 47
overview, 148	settings for, 48–51
bracketing, 187	ISO Sensitivity Auto Control option,
in Live View, 119	48–50
locking, 165–168	matrix metering, 50–51
programmed	P (programmed autoexposure), 48–49
aperture settings, 154–155	S (Single Frame) Release mode, 51
automatic shooting with, 48, 61	shutter-release mode, 56–60
exposure compensation, 165	taking pictures in, 52–53
flash modes, 56	A/V jack, 34, 303
overview, 148	axial color aberration, 280
setting exposure mode to, 48	10
shutter speed, 154–155	• B •
taking pictures in, 63	
shutter-priority	b2F (white balance bracketing), 236
in action shots, 251 aperture and shutter speed settings	b3F (white balance bracketing), 236
in, 155	background blurring, 220
	back-of-the-body controls. See also
exposure compensation, 165 overview, 148	external controls
Overview, 140	AE-L/AF-L button, 30

AF-area mode selector, 30
AF-ON button, 30
Delete button, 30
focus-point selector lock switch, 30
Info button, 30
Live View button, 30
main command dial, 29
Menu button, 31
metering mode selector, 30
Multi Selector, 30
OK button, 31
Playback button, 30
Protect/Help button, 31
Zoom In button, 31
Zoom Out/Thumbnail button, 31
Backup option, 23, 25
banding, 81
banks
saving settings in, 18
selecting, 308–309
switching between, 309
uses of, 308
Bat Meter data, 38
battery
age, 38
information, 38
order, 45
picture transfer and, 261
status indicator, 21
type, 45
Battery Age, 38
beep, 43
bit depth, 81
black-and-white photos
creating, 338–339
shooting, 240
black-and-white prints, 291–292
blinking highlights, 104
blown highlights, 103
blue-to-amber axis, 226, 234
blur tool, 158
blurry photos, 54, 210, 253
bracketing. See also exposure
Active D-Lighting, 192–193
disabling, 190
exposure and flash, 186–191
HDR imaging and, 185–186
interval shooting, 347

landscape photography, 254 overview, 185 white balance, 233–237 Bracketing Burst setting, 324 Brightness histogram, 106 buffer, 60 built-in flash master, 184 raising and closing, 171–172 shutter speed and, 174 telephoto lens and, 172 bulb mode, 154 burst mode, 57

· C ·

C (continuous-servo autofocus) mode. See also Focus mode in action shots, 251 Dynamic Area mode, combining with, 204-210 out-of-focus shots and, 198 overview, 197 taking pictures in, 52 calibration utility, 290 camera beep, setting, 43 connecting to computer, 260–261 copying pictures between memory cards, creating small image copies with, 295-298 customizing adding text comments to files, 313-315 AE-L/AF-L button, 320–325 command dials, 326-327 Depth-of-Field Preview button, 320-325 embedding copyright notice, 315–317 file and foldernames, 317-319 Function (Fn) button, 320-325 locking exposure with shutter button, 325-326 menu banks, 308-310 menus, 310-313 Multi Selector center button, 327-328 uncoupling buttons and command dials, 328-329 processing RAW images in, 276–278

camera menus	command dials
custom menu, creating, 17	aperture ring, 326
main menus, 15–16	aperture setting, 326
savings settings in banks, 18	changing main and sub-command, 326
selecting and adjusting functions, 17	customizing, 326–327
selecting menu, 17	menu navigation, 327
camera-to-subject distance, 218–219	menus, 327
Capture NX 2, 82, 91	reverse rotation, 326
Card and Folder Name, 102	sub-command dial, 326
card reader, 260–261	uncoupling buttons and, 328–329
cartridges, 291–292	commander mode, 184
center-weighted metering, 160–161, 324	CompactFlash (CF) cards (Type 1), 22-23
channels, 81	compatibility, lens, 8
Choose Folder option, 328	computer monitor, calibrating, 290–291
Choose Non-CPU Lens Number setting, 325	computers
Choose Slot and Folder, 94	connecting camera to, 260–262
Clean Image Sensor command, 37	memory card slot, 260
clipped highlights, 103	connections
clock, 38	AC adapter, 34
close-up shots. See also action shots;	A/V jack, 34
landscape photography; still portraits	flash sync terminal, 34
aperture-priority autoexposure mode, 255	HDMI jack, 34
depth of field, 255	stereo microphone jack, 34
diopters, 256	ten-pin remote terminal, 34
flash for outdoor lighting, 256	USB port, 34
indoor, 256	Continuous High mode, 58
macro lens, 256	Continuous Low mode, 56
manual exposure, 255	continuous-servo autofocus
minimum close-focusing distance	in action shots, 251
of lens, 255	Dynamic Area mode, combining with,
shutter speed, 255	204–210
zooming in/out, 255	out-of-focus shots and, 198
color	overview, 197
cast, 67	taking pictures in, 52
correcting with white balance, 220–223	contrast-detection autofocus, 119
fringing, 280	control panel, 19, 27
management, 292	controls, back-of-the-body
in movie recording, 127	AE-L/AF-L button, 30
overview, 220–221	AF-area mode selector, 30
saturation, 104	AF-ON button, 30
sRGB versus Adobe RGB, 237–238	Delete button, 30
temperature, 221–222	focus-point selector lock switch, 30
Color Balance filter, 338	Info button, 30
Color Booster slider, 280	Live View button, 30
color cartridges, 291–292	main command dial, 29
color space, 237–239	Menu button, 31
colorimeter, 291	metering mode selector 30

Multi Selector, 30
OK button, 31
Playback button, 30
Protect/Help button, 31
Zoom In button, 31
Zoom Out/Thumbnail button, 31
controls, front-left
Flash button, 31
Flash Mode/Flash Compensation
button, 32
focus mode selector, 32
Len-release button, 32
controls, front-right
AF-assist/Self-Timer/Red-Eye Reduction
lamp, 33
Depth-of-Field Preview button, 33
Function (Fn) button, 33
Sub-command dial, 32
controls, topside
Control panel, 27
Exposure Compensation button, 28
Flash hot shoe, 28
ISO button, 28
Mode button, 28
On/Off/Illuminate switch, 27
Qual button, 28
Release Mode dial, 28
shutter button, 27
WB button, 28
Controls option
No Memory Card option, 45–46
On/Off Light switch, 45–46
copyright information, 39, 315–317
Creative Lighting System (CLS), 182, 184
critical picture-taking settings, restoring,
46, 48–50
crop factor, 9–10
cropping, 72–73, 340–342
cross-type sensors, 202
Custom Setting menu
AF-area mode, 196
automatic monitor shutdown,
adjusting, 42
browsing, 41–42
controls, customizing, 45–46
Customize Command Dials option, 326
default settings, restoring, 46
5 , O,

Flash/Bracketing submenu, 182-183 Focus mode, 196 Focus Tracking with Lock-On option, 210 menu banks, 309 opening, 15 resetting, 46 restoring default settings, 49-50 shooting and display options, customizing, 42–45 Timers/AE Lock submenu, 325 Customize Command Dials option, 326 customizing camera adding text comments to files, 313-315 AE-L/AF-L button, 320-325 command dials, 326-327 Depth-of-Field Preview button, 320-325 embedding copyright notice, 315-317 file and foldernames, 317-319 Function (Fn) button, 320-325 locking exposure with shutter button, 325-326 menu banks, 308-310 menus, 310-313 Multi Selector center button, 327–328 uncoupling buttons and command dials, 328-329 cyanotype effect, 338–339

data

file information, 100-103 focus point, 100 GPS data, 109 hidden data-display options, enabling, 100-101 highlights, 101, 103-104 overview data, 109-110 RGB histogram, 105-107 shooting data, 107-108 viewing, 100-101 Datacolor, 291 date and time, 37, 103 default settings, restoring, 46 deleting photos all photos, 111-112 batch of selected phots, 112–113 one at a time, 110-111

depth of field. See also aperture; ISO Dynamic Area mode, 202	
aperture and, 142–143, 216 continuous-servo autofocus, combinin	ıg
aperture-priority autoexposure mode, 219 with, 204–210	
camera-to-subject distance and, 218–219 overview, 200	
defined, 9, 215	
distance of subject from background, 220	
focal length and, 216–218	
focusing and, 215 Easy Exposure Compensation, 165	
f-stop and, 142–143, 145, 216, 219–220 e-mail pictures	
in landscape photography, 252 creating small copies using camera,	
maximum, 219 295–298	
shallowest, 219 downsizing images in Nikon ViewNX,	
Depth-of-Field Preview button 298–300	
customizing, 320–325 overview, 293	
locking flash exposure on subject size recommendation, 294	
with, 181 EV (exposure value), 179	
overview, 33 EV Steps for Exposure Control, 151	
previewing effect of f-stop on depth of exposure	
field, 219–220 bracketing, 186–191	
detaching lenses, 12–13 in Live View, 119	
diffuser, 250 movie recording, 125–126, 128	
Digital Print Order Format (DPOF), 293 Exposure Compensation, 28, 46, 132, 15	1
diopter control, 14–15 163–166	1,
diopters, 256 Exposure Comp/Fine Tune, 151	
Display Calibration Assistant, 290 Exposure Comp/rine Tune, 131 Exposure Delay mode, 45	
Display Color Calibration, 290 exposure meter	
display options activating, 27, 152	
beep, 43 orientation, reversing, 152	
fla mumb an acquire at 14	
information display, 44 overexposure, 150 reading, 150	
LCD illumination, 44 settings, 151	
in Live View, 120–122 shut-off timing, adjusting, 152	
viewfinder grid display, 43 stops, 151 underexposure, 150	
viewfinder warning display, 43–44 viewing, 150	
D. I. I. I. Cl. 150 005 000	
DALLE MG GIL MAD ONE	
1 004	
1 : (1 :	
1.01. 00	
P	
01	
F1	
The state of the s	99
0 1 20 20 20 20 20 20 20 20 20 20 20 20 20	
9-point, 207–208 manual, 148, 155	
button + command dial setting, 325 programmed autoexposure, 148, 154–1	155

selecting, 149	built-in
shutter-priority autoexposure, 148, 155	disabling, 55
exposure settings	enabling, 55
aperture, 142–143	shutter speed in, 174–175
ISO, 145–146	through the lens, 173
shutter speed, 143–145	in close-up shots, 256
tips, 146–148	diffuser, 250
exposure value (EV), 163, 179	external
external controls	with rotating flashhead, 249
back-of-the-body controls, 29–31	slaves, 184
front-left controls, 31–32	in still portraits, 249
front-sight controls, 32–33	fill, 173
topside controls, 27–29	force, 173
external flash	hot shoe, 28
with rotating flashhead, 249	modeling, 184–185
slaves, 184	output, adjusting, 178–180
in still portraits, 249	in still portraits
external microphone, 129	diffuser, 250
Eye-Fi SD cards, 21	external flash with rotating flash
Eye-Fi upload, 40	head, 249
	red-eye reduction, 248
• F •	reducing shadowing, 249
	settings, 246
faces, inspecting, 99	slow-sync mode, 248–249
file formats, 74–75	Flash button, 31, 55
File Information mode, 101–103	Flash Cntrl for Built-in Flash, 173
file number sequence, 44	Flash Compensation, 172, 179–180
file size, 71–72	Flash Exposure button, 179
file storage	Flash hot shoe, 28
movie recording, 128	Flash Mode button, 172, 329
two-card system	Flash Mode/Flash Compensation button, 32
backup, 23	flash modes
options, 23–25	commander mode, 184
overflow, 23	displaying, 55
raw primary/JPEG secondary, 23	manual, 183
file types	repeating, 184
JPEG, 76–80	setting, 172–173
NEF (Raw), 80–85	Flash Off setting, 324
TIFF, 85–87	Flash Only bracketing, 187, 188
filenames, 102–103, 317–319	flash photography
file-protection feature, 101–103	built-in flash, 171–172
fill flash, 173	flash mode, setting, 172–173
film grain, 145	flash output, adjusting, 178–180
Filter Effects color tools, 335–336	front-curtain sync flash, 173–175
Fine-Tune Optimal Exposure option, 162	high-speed flash, 182–183
firmware version, 41	hot shoe, 171
flash	locking flash exposure on subject, 181
in automatic shooting, 55–56	modeling flash, 184–185
bracketing, 186–191	overview, 171

flash photography (continued)
rear-curtain sync, 177–178
red-eye reduction flash, 175–176
slow-sync flash, 176–177
slow-sync with red-eye reduction, 178
Flash Shutter Speed option, 175
flash sync speed, 154
flash sync terminal, 34
flash value lock, 181
Flash/Aperture bracketing, 188
Flash/Bracketing submenu, 182
Flash/Speed bracketing, 188
Flash/Speed/Aperture bracketing, 188
flexible programmed autoexposure, 63
fluorescent bulb type, 224–225
focal lengths
defined, 9
depth of field and, 216–218
focal plane position mark, 27, 28–29
focal point position mark, 27, 28
Focus mode
AF-C Priority Selection, 198–199
AF-S Priority Selection, 199
autofocusing, 196
C (continuous-servo autofocus) mode, 197
manual focusing, 197
overview, 196
S (single-servo autofocus) mode, 196
selector, 13–14, 32, 52
focus mode switch, 13–14
focus point
auto area, 200–201
cross-type sensors and, 202
dynamic area, 200
enabling, 100
locking, 201–203
overview, 102
selecting, 201–203
single point, 200
Focus Point Wrap-Around option, 202
Focus Tracking with Lock-On option, 210 focusing. <i>See also</i> autofocusing; manual
focusing with AF-ON button, 212–213
autofocusing, 196–198 basic autofocusing, 211–212
basics, 195–196
Dynamic Area, 207–209
DVIIAIIIIC ALGA, 401-403

f-stop number and, 61–62 manual, 197 movie recording, 128-129 on moving subjects, 204–207 on still subjects, 203–204 tips, 53 tracking with lock-on, 209-210 focusing ring, 13–14 focus-point selector lock switch, 30 folder, naming, 317–319 force flash, 173 Format Memory Card command, 26, 37 Frame Number/Total Pictures, 102 frame rate, 127 frame sizes, 289–290 Framing Grid option, 121 front-curtain sync flash, 56, 173-175 front-left controls. See also external controls Flash button, 31 Flash Mode/Flash Compensation button, 32 focus mode selector, 32 Len-release button, 32 front-right controls. See also external controls AF-assist/Self-Timer/Red-Eye Reduction lamp, 33 Depth-of-Field Preview button, 33 Function (Fn) button, 33 Sub-command dial, 32 f-stops. See also aperture aperture setting and, 140–141 depth of field and, 142-143, 145, 216, 219-220 focusing and, 61 movie recording, 125–126, 132 full-frame view jumping to, 97 returning to, 99 toggling between thumbnails and, 97, 328 Function (Fn) button, 33, 320–325 FV Lock setting, 181, 323

GPS, 39 GPS Data mode, 109 grayscale images, 240 green-to-magenta axis, 226, 234 grid display, 43 Guide Numbers, 183

• H •

Handheld mode. See also Live View mode: Tripod mode autofocusing in, 119 selecting, 118 shooting movie in, 131 taking pictures in, 125-126 HDMI (High-Definition Multimedia Interface), 37, 303-304 HDMI jack, 34, 303 HDMI option, 37 HDR imaging, 185–186 Help screen, 34, 35 hidden connections AC adapter, 34 A/V jack, 34 flash sync terminal, 34 HDMI jack, 34 stereo microphone jack, 34 ten-pin remote terminal, 34 USB port, 34 Hide Image option, 114 High Dynamic Range For Dummies (Correll), 186-187 high dynamic range (HDR), 185-186 High ISO Noise Reduction option, 158 Highlight Active Focus Point setting, 328 Highlight Protection option (ViewNX), 279 highlights, 101 Highlights display mode, 103-104 high-speed flash, 182-183 histograms Brightness, 106 RGB, 105 viewing, 94 hot shoe, 28, 171

• 1 •

Image Authentication feature, 39, 103 Image Comment feature, 38, 313–314 Image Dust Off Ref Photo feature, 38

image noise, 145-146 Image Overlay option, 342-344 image quality displaying, 103 file size and, 74 options, 17 Image Quality option, 74–75 Image Review period, 42 image sensor, cleaning, 37 image size displaying, 103 e-mail pictures, 294 print size and, 286 images creating small copies using camera, 295-298 deleting all photos, 111-112 batch of selected photos, 112-113 one at a time, 110-111 downsampling, 294 downsizing in Nikon ViewNX, 298–300 hiding during playback, 114–115 multiple, viewing, 96–98 resizing, 294 rotation of, 91–92 selecting, 97 side-by-side display of, 333 slide show, 301-302 viewing at same magnification, 99 viewing in playback mode, 94-96 zooming in/out, 98-99 indoor close-up shoots, lighting in, 256 indoor portraits, 246 Info button, 30 information display, 19-20, 44 Information Off mode, 121 Information On mode, 121 Information screen, 19–20, 322 ink, 291-292 instant review, 91 internal microphone, 130 International Press Telecommunication Council (IPTC), 273 interval shooting autofocusing, 347 bracketing, 347

interrupting, 347

interval shooting (continued) number of intervals, 346 number of shots per interval, 346 start time, 346 steps in, 344-345 Interval Timer Shooting option, 344-347 ISO in action shots, 251 button, 28 image noise and, 145-146 noise reduction, 158 overview, 141-142 settings, 156–157 values, 156 ISO Sensitivity Auto Control option, 50, 156 ISO Sensitivity Settings option, 156 ISO Sensitivity Step Value, 151 i-TTL (intelligent-Through the Lens), 178–179 i-TTL Balanced Fill Flash, 178

• 7 •

JPEG artifacts, 67 capture settings, 76–77 immediate usability, 76 lossy compression, 76 optimal quality, 77–79 size priority, 77–79 small files, 76 JPEG Basic, 74, 77–79 JPEG Compression option, 77, 87 JPEG Fine, 74, 77–78, 87 JPEG Normal, 74, 77–79

. K .

K White Balance setting, 224 Kelvin scale, 221

• [•

lamp lights, 53 landscape orientation, 92 landscape photography. See also action shots; close-up shots; still portraits bracketing, 254 depth of field, 252

nighttime city pics, 254 overview, 252 slow shutter for, 254 sunrise or sunset shots, 254 tripod, 253 waterfall shots, 254 Language option, 38 Launch Utility button (ViewNX), 279 LCD Brightness option, 37 LCD illumination, 44 LCD panel, 19 Len-release button, 32 lens dirt, 67 lens multiplier, 9 lenses attaching, 11–12 compatibility, 8 crop factor, 9–10 depth of field, 9 detaching, 12–13 focal lengths, 9, 216-218 focus mode selector, 13–14 focus mode switch, 13-14 focusing ring, 13–14 minimum-close focusing distance of, 255 telephoto, 9 vibration reduction, 10-11 wide-angle, 9 light sensitivity. See ISO Live View mode autofocusing, 119 damaging lens in, 117 display, customizing, 120-122 draining battery in, 117 enabling, 30 Handheld mode, 117-118, 125-126 manual focusing, 116 overview, 116 still life and table top photography, 117 - 118Tripod mode, 118–120, 122–124 using for extended period, 117 Lock Mirror Up for Cleaning, 37 Long Exposure Noise Reduction option, 158 long lens, 9 lossy compression, 76, 280

low battery warning, 43

LZW Compression option (ViewNX), 280

• M •	selecting, 308–309
7/1	switching between, 309
M (manual exposure). See also exposure	uses of, 308
modes	Menu button, 31
aperture and shutter speed settings	menus
in, 155	custom, creating, 17, 310–313
bracketing, 188–189	icons, 15–16
in close-up shots, 255	main, 14–15
in landscape photography, 252	recently adjusted items, viewing, 17
overview, 148	removing items, 17–18
macro lens, 256	reordering items, 312
magnified picture, viewing another	saving settings in banks, 18
part of, 99	selecting, 17
main command dial, 29, 75	selecting and adjusting functions, 27
manual flash, 183	metadata, 271–273, 314–315
manual focusing. See also autofocusing	metering mode
action shots, 252	center-weighted, 160–161, 324
setting to, 197	fine-tune optimal exposure, 162
switching to, 13	matrix, 159, 324
taking pictures in, 53	overview, 159
matrix metering, 159, 324	selecting, 30
matrix mode, 50	spot, 159–160, 324
MB-D10 battery pack, 214	microphone, 129–130
MB-D80 Battery Type option, 45	minimum pixel count, 286
megapixels, 69	mireds, 226
memory buffer, 60	mirror lock-up, 37, 59
memory card reader, 260	Mode button, 28
memory cards	modeling flash, 184–185
CompactFlash (CF) cards (Type 1), 22, 88	monitor
contact areas, avoiding, 23	automatic picture rotation, 91–92
copying pictures between, 282–284	automatic shutdown, 42
file size and, 74	File Information mode, 101–103
file storage for movie recording, 128	GPS Data mode, 109
formatting, 25–26, 37	Highlights display mode, 103–104
primary/secondary slot function, 23–24	multiple images, 96–98 Overview Data mode, 109–110
remaining shorts, 35	playback mode, 94–96
SD (Secure Digital) card, 21–22, 88	playback finde, 34–30 playback timing, 91–92
selecting, 94	RGB Histogram mode, 105–107
sending image to, 53	Shooting Data display mode, 107–108
symbols, 23–24, 25	zooming in/out, 98–99
two-card system, 23–25	Monitor Off Delay option, 42, 90
backup, 23	Monochrome option (Retouch menu),
overflow, 23	338–339
raw primary/JPEG secondary, 23	monochrome photos
menu banks	creating, 338–339
customizing, 308–310	shooting, 240
naming, 310	Monochrome Picture Control feature, 240
saving settings in, 18	monocinomo rictare control teatare, 2 10

selecting, 308-309

motion blur, 143-144 mounting index, 11-12 movie recording aperture, 132 color, 127 exposure, 128-129, 131-132 exposure adjustment, 119 exposure compensation, 132 file storage, 128 focus adjustments, 119 focusing, 128 frame rate, 127 Handheld mode, 131 Live View mode, 126 maximum file size, 127 maximum movie length, 127 microphone setting, 132 movie quality, 126–127 sound recording, 127, 129–130 time remaining, 132 Tripod mode, 131 video format, 128 movies editing, 134–135 playing, 133–134 viewing on television, 303-304 moving subjects, 201, 204–210 Multi Selector, 30 activating exposure meter with, 152–153 customizing function of center button, 93–94, 327 - 328swapping right/left and up/down functions, 93 fine-tuning white balance settings with, 227-228 functions, 92 navigating menu with, 16–17 Playback mode, 328 Shooting mode, 328 multi-image exposure, 342–344 Multiple Exposure (Shooting menu), 342-344 multiple images, viewing, 96-98 multiplier, lens, 9 My Menu menu custom menu, creating, 17–18, 311–312 opening, 16

· N ·

NEF (RAW) files. See RAW (NEF) files nighttime city pics, 254 Nikon Capture NX 2, 82 Nikon Transfer deleting original files after transfer, 268 downloading images with, 263-268 launching automatically, 267 opening destination files with other application after transfer, 268 overview, 263 transferring new photos only, 268 Nikon ViewNX automatic picture rotation in, 91 Axial Color Aberration, 280 browsing images in, 268–271 Color Booster slider, 280 D-Lighting HS option, 279 downsizing images in, 298-300 full screen view, 271 Highlight Protection option, 279 image viewer, 270 Launch Utility button, 279 overview, 263 processing RAW files in, 81, 278–282 protecting images in, 274 protecting photos in, 115 requirement, 268-271 Shadow Protection option, 279 thumbnail view, 269 viewing comments in, 314–315 No Memory Card option, 46 noise, 67, 117 exposure-related, reducing, 158 filters, 158 ISO-related, reducing, 158 noise-removal filters, 158 non-CPU lens, 8 non-CPU lens data, 40 NTSC video standard, 37, 303

OK button, 31 On/Off light switch, 45 On/Off/Illuminate switch, 27 Optimal Quality option, 77–79

outdoor portraits, 246	hidden data-display options, enabling, 100–101
overexposure, 150	highlights, 101, 103–104
Overflow option, 23, 25	overview data, 109–110
Overview Data mode, 109–110	
10	RGB histogram, 105–107
• p •	shooting data, 107–108
	viewing, 100–101
P (programmed autoexposure). See also	picture files
exposure modes	adding text comments to, 313–315
aperture settings, 154–155	browsing in Nikon ViewNX, 268–271
automatic shooting with, 61	copying between memory cards, 282–284
exposure compensation, 165	creating new folder for, 273
flash modes, 56	cropping, 340–342
overview, 148	deleting, 274
setting exposure mode to, 48	downloading with Nikon Transfer,
shutter speed, 154–155	263–268
taking pictures in, 63	hiding during playback, 114–115
PAL video standard, 303	hiding/displaying, 273
panel backlight, 27	image authentication, 39
Pantone, 291	metadata, 271–273
paper setting, 292	moving from one folder to another, 274
phase-detection autofocus, 119	naming, 317–319
Photo Info/Playback option, 93	organizing, 273–275
photo paper, 292	protecting, 115–116, 274
photos	selecting multiple files, 274
cropping, 340–342	sending to computer, 260–263
deleting	by connecting camera to computer,
all photos, 111–112	260–262
batch of selected photos, 112–113	using memory card reader, 260–261
one at a time, 110–111	side-by-side display of, 333
hiding during playback, 114–115	slide show, 301–302
protecting, 115–116	unlocking, 274
slide show, 301–302	uploading to computer, 260–263
viewing on television, 303–304	viewing in playback mode, 94–96
Photoshop Elements, 82, 276	picture quality
Pic Meter value, 38	color cast, 67
PictBridge, 293	JPEG artifacts, 67
Picture Controls	lens dirt, 67
monochrome mode, 240	noise, 67
neutral mode, 239	pixelation, 66
overview, 237	problems, diagnosing, 66–67
RAW (NEF) files, 240	sensor dirt, 67
standard mode, 239	pictures remaining, 21
vivid color mode, 240	picture-taking
	Handheld mode, 125–126
picture data file information, 100–103	steps in, 52–54
	Tripod mode, 122–124
focus point, 100	pixelation, 66, 287
GPS data, 109	P

pixels
dimensions, 69
file size and, 71–72
print quality and, 70
print size and, 286–287
resampling, 70
screen display size and, 70–71
setting, 68–69
playback
automatic picture rotation, enabling,
91–92
Multi Selector, customizing, 92–93
timing, adjusting
automatic shutoff, 90
instant review, 91
length of instant review period, 91
Playback button, 30
Playback Folder option, 94
Playback menu
Hide Image option, 114
opening, 15
playback mode, viewing images in, 94–96
Playback setting, 324
point-and-shoot camera, versus single-lens
reflex camera, 8
port, USB, 34, 260
portrait orientation, 92
posterization, 81
PRE (Preset Manual) White Balance
setting, 228–229, 230
Preview setting, 323
print quality, 70
printers
card reader, 260
cartridges, 291–292
color management, 292
profiles, 292
printing
Digital Print Order Format, 293
ink, 291–292
paper setting, 292
PictBridge, 293
print size, 289–290
printer profiles, 292
resolution, 286–288
synching monitor colors, 290–291
,

programmed autoexposure. See also exposure modes aperture settings, 154–155 automatic shooting with, 48, 61 exposure compensation, 165 flash modes, 56 overview, 148 setting exposure mode to, 48 shutter speed, 154–155 taking pictures in, 63 Protect Status icon, 102, 109 protected status, 115 Protect/Help button, 31

• 0 •

Qual button, 28, 46, 69, 75 Quiet mode, 60

rapid-fire shooting, 251 RAW (NEF) files bit depth, 81 choosing, 87 creative control in, 80-81 file size, 74, 82 image overlay, 332 in-camera converter, 82 Picture Controls, 240 picture quality, 81 processing in Capture NX 2, 275 in-camera, 276-278 options, 275-276 in ViewNX, 275, 278-282 third-party conversion tools, 275-276 RAW bit depth, 83 RAW capture settings, 82–84 RAW compression, 84 RAW converter, 81–82 RAW+JPEG, 83, 85, 87 Raw/JPEG option, 23, 25 rear-curtain sync, 177-178 Recent Settings menu, opening, 17-18 Red-Eye Correction filter, 334

red-eye reduction flash, 56, 175–176, 178, 248 reference cards, 228-229 Release Button to Use Dial option, 329 Release Mode dial, 28, 57 release modes Continuous High mode, 58 Continuous Low mode, 56 Mirror Up mode, 59 Quiet mode, 60 Self-Timer mode, 58–59 Single Frame mode, 56 remote terminal, ten-pin, 34 repeating flash mode, 184 replacement ink, 291 resampling, 70, 287 RESET (Select Center Focus Point) setting, 328 Reset all Custom Menu options, 46 Reset all Shooting Menu options, 46 Reset Meter-Off Delay option, 152 Resize feature, 294, 296 resizing images, using camera, 295-298 resolution file size and, 71-72, 74 print quality and, 70 print size and, 286–288 recommendations, 72 screen display size and, 70-71 setting, 68–69 Retouch Indicator icon, 102, 109 Retouch menu D-Lighting filter, 170 opening, 16 Resize feature, 294, 296 Trim feature, 290 Retouch menu feature Color Balance filter, 338 displaying, 332 D-Lighting filter, 335-336 Edit Move option, 134 file numbers of retouched files, 332 Filter Effects color tools, 336–337 Image Overlay feature, 33 Image Overlay option, 342-344 Interval Timer Shooting option, 344–347 Monochrome option, 338-339

Red-Eye Correction filter, 334 saving edited files, 332 shadow recovery with, 335–336 Side-by-Side menu option, 333 Trim function, 340–342 RGB histogram, 101 RGB Histogram mode, 105–107 RGB images, 103 Rotate Tall option, 92

• 5 •

S (shutter-priority autoexposure). See also exposure modes in action shots, 251 aperture and shutter speed settings in, 155 exposure compensation, 165 overview, 148 S (Single Frame) Release mode, 51 S (single-servo autofocus) mode. See also Focus mode out-of-focus shots and, 198 overview, 196 Single Point AF-area mode, combining with, 247 Single Point mode, combining with, 203-204 saturation, 104 Save/Load settings, 39 screen display size, 70-71 SD (Secure Digital) card, 21–22 Self-Timer mode, 58–59 sensor dirt, 67 sepia effect, 338-339 Setup menu AF Fine Tune, 40 Auto Image Rotation option, 38 Battery Info option, 38 Clean Image Sensor command, 37 Copyright Information option, 39, 315–317 Eye-Fi upload, 40 firmware version, 41 Format Memory Card command, 37 GPS, 39 HDMI option, 37 Image Authentication feature, 39

Setup menu (continued)	defined, 141
Image Comment feature, 38, 313–314	in flash photography, 175
Image Dust Off Ref Photo feature, 38	motion blur and, 143–145
Language option, 38	overview, 62, 141
LCD Brightness option, 37	shutter-priority autoexposure, 155
Lock Mirror Up for Cleaning, 37	shutter-priority autoexposure. See also
non-CPU lens data, 40	exposure modes
opening, 15, 36	in action shots, 251
Save/Load settings, 39	aperture and shutter speed settings
Time Zone and Date option, 37–38	in, 155
Video Mode, 37	exposure compensation, 165
virtual horizon, 39	overview, 148
Wireless Transmitter, 38	Shutter-Release Button AE-L, 325
Shadow Protection option (ViewNX), 279	shutter-release modes
sharpening, 239	continuous high, 58
Shooting Data display mode, 107–108	continuous low, 57–58
Shooting menu	mirror up, 59
Active D-Lighting, 170	quiet, 60
Active Folder option, 318	self-timer, 58–59
Image Quality option, 75	single frame, 56
Image Size option, 68–69	Side-by-Side Comparison option, 333
ISO Sensitivity Auto Control option, 156	Single Frame mode, 57
ISO Sensitivity Settings option, 156	Single Point AF mode, Auto Area mode,
JPEG Compression option, 77	combining with, 211–212
Multiple Exposure option, 342–344	Single Point AF-area mode, 247
opening, 15	Single Point mode
resetting, 46	autofocusing, 167
restoring default settings, 50	focus points, 202
Shooting Menu Bank, 308	overview, 200
Shooting Menu Bank, 308	single-servo autofocus, combining with,
Shooting/Display submenu	203–204
Battery Order option, 45	switching to, 51
beep, 43	single-lens reflex camera, versus point-and
Exposure Delay mode, 45	shoot camera, 8
file number sequence, 44	single-servo autofocus mode. See also
information display, 44	Focus mode
LCD illumination, 44	out-of-focus shots and, 198
MB-D80 Battery Type option, 45	overview, 196
screen tips, 44	Single Point AF-area mode, combining
viewfinder grid display, 43	with, 247
viewfinder warning display, 43	Single Point mode, combining with,
shutoff timing, 90	203–204
shutter button, 27, 53	taking pictures in, 52
shutter speed. See also aperture; ISO	Size Priority option, 77–79
in action shots, 251	slide show
adjusting, 153–155	changing information displayed with
blurry photos and, 210	image, 302
built-in flash and, 174–175	exiting, 302

overview, 301	thumbnails
pausing, 302	displaying, 94, 96
setting up, 301	jumping to first picture in folder, 98
skipping to next/previous image, 302	jumping to full-frame view, 96
slow-sync flash, 176–177	scrolling, 97
slow-sync mode, 248–249	toggling between full-frame view and,
sound recording, 127	97, 328
sports shooting, 199	viewing in Nikon ViewNX, 269–270
spot metering, 159–160, 324	TIFF files
sRGB color mode, 237–239	advantages of, 86
Standard i-TTL Flash, 179	disadvantages of, 86
stereo microphone jack, 34	file size, 74, 86
still portraits. See also action shots;	image quality, 86–87
close-up shots; landscape photography	overview, 85
autofocusing, 203–204	saving processed images as, 280–282
background, 247	when to use, 86–87
flash in	Time Zone and Date option, 37–38
diffuser, 250	time-lapse photography
external with rotating flash head, 249	bracketing, 347
red-eye reduction, 248	interrupting, 347
reducing shadowing from, 249	number of intervals, 346
settings, 246	number of shots per interval, 346
slow-sync mode, 248–249	overview, 344
indoor, 246, 247	start time, 346
outdoor, 246	steps in, 344–345
settings for	Timers/AE Lock (Custom Setting), 42, 90
A (aperture-priority autoexposure), 245	Timers/AE Lock submenu, 325
autofocusing, 247	tonal range, 106, 168–171
f-stop, lowest possible, 245	tone mapping software, 186
softening background, 245	topside controls. See also external controls
zooming in, 245	Control panel, 27
Tripod mode, 122–124	Exposure Compensation button, 28
white balance, 247	Flash hot shoe, 28
still subjects, 201, 203–204	ISO button, 28
sub-command dial, 33, 69, 326	Mode button, 28
sunrise shots, 254	On/Off/Illuminate switch, 27
sunset shots, 254	Qual button, 28
sync cable, 34	Release Mode dial, 28
	shutter button, 27
a T a	WB button, 28
	Trim function, 290, 341
taking pictures, 52–54	tripod, 253
telephoto lens, 9, 172	Tripod mode. See also Handheld mode;
television, viewing photos and movies on,	Live View mode
303–304	autofocusing in, 119
ten-pin remote terminal, 34	selecting, 118
Thumbnail On/Off, 94	shooting movie in, 131
mamonan on, on, or	taking still pictures in, 122–124

TTL (Through the Lens), 56, 173 two-button reset method, 46, 48–50 two-card system. *See also* memory cards backup, 23 overflow, 23 raw primary/JPEG secondary, 23 Type C mini-pin cable, 303 Type D lens, 8 Type G AF Nikkor lens, 8

· U ·

underexposure, 150 USB port, 34, 260, 261

. U .

vibration reduction (VR) AF-ON button and, 212-213 disabling, 10 overview, 10, 144 switching on, 10-11 Video Mode, 37, 303 View Histograms, 94 viewfinder diopter control, 14-15 focus, adjusting, 14-15 grid display, 43 overview, 20 warning display, 43 viewing images multiple images at a time, 96-98 picture data, 100-109 in playback mode, 94-96 zooming in/out, 98-99 virtual horizon, 39-40, 122 vivid color, 240

• W •

waterfall shots, 254 white balance adjusting through Shooting menu. 224 bracketing, 233-237 color temperature, 221-222, 224 fine-tuning settings, 225-226 fluorescent bulb type, 224-225 presets custom, 225 with direct measurement, 228-229 managing, 232-233 matching to existing photo, 229-231 selecting, 231 settings, 223-225 in still portraits, 247 wide-angle lens, 9 wireless transmitter, 38

· X ·

x250, 154 XMP (Extensible Metadata Platform), 273 XMP/IPTC Information, 273 X-Rite, 291

• Z •

Zoom In button, 31, 96, 98 Zoom On/Off (Multiselector), 94, 328 Zoom Out button, 31, 96, 98–99

Business/Accounting & Bookkeeping

Bookkeeping For Dummies 978-0-7645-9848-7

eBay Business All-in-One For Dummies, 2nd Edition 978-0-470-38536-4

Job Interviews For Dummies, 3rd Edition 978-0-470-17748-8

Resumes For Dummies, 5th Edition 978-0-470-08037-5

Stock Investing For Dummies, 3rd Edition 978-0-470-40114-9

Successful Time Management For Dummies 978-0-470-29034-7

Computer Hardware

BlackBerry For Dummies, 3rd Edition 978-0-470-45762-7

Computers For Seniors For Dummies 978-0-470-24055-7

iPhone For Dummies, 2nd Edition 978-0-470-42342-4 Laptops For Dummies, 3rd Edition 978-0-470-27759-1

Macs For Dummies, 10th Edition 978-0-470-27817-8

Cooking & Entertaining

Cooking Basics For Dummies, 3rd Edition 978-0-7645-7206-7

Wine For Dummies, 4th Edition 978-0-470-04579-4

Diet & Nutrition

Dieting For Dummies, 2nd Edition 978-0-7645-4149-0

Nutrition For Dummies, 4th Edition 978-0-471-79868-2

Weight Training For Dummies, 3rd Edition 978-0-471-76845-6

Digital Photography

Digital Photography For Dummies, 6th Edition 978-0-470-25074-7

Photoshop Elements 7 For Dummies 978-0-470-39700-8

Gardening

Gardening Basics For Dummies 978-0-470-03749-2

Organic Gardening For Dummies, 2nd Edition 978-0-470-43067-5

Green/Sustainable

Green Building & Remodeling For Dummies 978-0-470-17559-0

Green Cleaning For Dummies 978-0-470-39106-8

Green IT For Dummies 978-0-470-38688-0

Health

Diabetes For Dummies, 3rd Edition 978-0-470-27086-8

Food Allergies For Dummies 978-0-470-09584-3

Living Gluten-Free For Dummies 978-0-471-77383-2

Hobbies/General

Chess For Dummies, 2nd Edition 978-0-7645-8404-6

Drawing For Dummies 978-0-7645-5476-6

Knitting For Dummies, 2nd Edition 978-0-470-28747-7

Organizing For Dummies 978-0-7645-5300-4

SuDoku For Dummies 978-0-470-01892-7

Home Improvement

Energy Efficient Homes For Dummies 978-0-470-37602-7

Home Theater For Dummies, 3rd Edition 978-0-470-41189-6

Living the Country Lifestyle All-in-One For Dummies 978-0-470-43061-3

Solar Power Your Home For Dummies 978-0-470-17569-9

Internet

Blogging For Dummies, 2nd Edition 978-0-470-23017-6

eBay For Dummies, 6th Edition 978-0-470-49741-8

Facebook For Dummies 978-0-470-26273-3

Google Blogger For Dummies 978-0-470-40742-4

Web Marketing For Dummies, 2nd Edition 978-0-470-37181-7

WordPress For Dummies, 2nd Edition 978-0-470-40296-2

Language & Foreign Language

French For Dummies 978-0-7645-5193-2

Italian Phrases For Dummies 978-0-7645-7203-6

Spanish For Dummies 978-0-7645-5194-9

Spanish For Dummies, Audio Set 978-0-470-09585-0

Macintosh

Mac OS X Snow Leopard For Dummies 978-0-470-43543-4

Math & Science

Algebra I For Dummies 978-0-7645-5325-7

Biology For Dummies 978-0-7645-5326-4

Calculus For Dummies 978-0-7645-2498-1

Chemistry For Dummies 978-0-7645-5430-8

Microsoft Office

Excel 2007 For Dummies 978-0-470-03737-9

Office 2007 All-in-One Desk Reference For Dummies 978-0-471-78279-7

Music

Guitar For Dummies, 2nd Edition 978-0-7645-9904-0

iPod & iTunes For Dummies, 6th Edition 978-0-470-39062-7 Piano Exercises For Dummies 978-0-470-38765-8

Parenting & Education

Parenting For Dummies, 2nd Edition 978-0-7645-5418-6

Type 1 Diabetes For Dummies 978-0-470-17811-9

Pets

Cats For Dummies, 2nd Edition 978-0-7645-5275-5

Dog Training For Dummies, 2nd Edition 978-0-7645-8418-3

Puppies For Dummies, 2nd Edition 978-0-470-03717-1

Religion & Inspiration

The Bible For Dummies 978-0-7645-5296-0

Catholicism For Dummies 978-0-7645-5391-2

Women in the Bible For Dummies 978-0-7645-8475-6

Self-Help & Relationship

Anger Management For Dummies 978-0-470-03715-7

Overcoming Anxiety For Dummies 978-0-7645-5447-6

Sports

Baseball For Dummies, 3rd Edition 978-0-7645-7537-2

Basketball For Dummies, 2nd Edition 978-0-7645-5248-9

Golf For Dummies, 3rd Edition 978-0-471-76871-5

Web Development

Web Design All-in-One For Dummies 978-0-470-41796-6

Windows Vista

Windows Vista For Dummies 978-0-471-75421-3

Dummies products make life easier!

DVDs • Music • Games •
DIY • Consumer Electronics •
Software • Crafts • Hobbies •
Cookware • and more!

For more information, go to **Dummies.com**® and search the store by category.